American Pantheon

Presented to:

Butler Area Public Library

In Memory of
Mr. and Mrs. Jack Stern

Donor
Dr. Lamonte Crape

Perspectives on the Art and
Architectural History of the
United States Capitol

Donald R. Kennon, Series Editor

Donald R. Kennon, ed., *The United States Capitol: Designing and
Decorating a National Icon*

Vivien Green Fryd, *Art and Empire: The Politics of Ethnicity in the
United States Capitol, 1815–1860*

William C. Dickinson, Dean A. Herrin, and Donald R. Kennon, eds.,
Montgomery C. Meigs and the Building of the Nation's Capital

Donald R. Kennon and Thomas P. Somma, eds., *American Pantheon:
Sculptural and Artistic Decoration of the United States Capitol*

American Pantheon

Sculptural and Artistic Decoration
of the United States Capitol

EDITED BY DONALD R. KENNON
AND THOMAS P. SOMMA

published for the U.S. Capitol Historical Society by
Ohio University Press ATHENS

Ohio University Press books are printed on acid-free paper ⊗ ™

11 10 09 08 07 06 05 04 5 4 3 2 1

Library of Congress Cataloging-in-Publication Data

American pantheon : sculptural and artistic decoration of the United
States Capitol / edited by Donald R. Kennon and Thomas P. Somma.
 p. cm. — (Perspectives on the art and architectural history of
the United States Capitol)
Includes bibliographical references and index.
 ISBN 0-8214-1442-9 (cloth : alk. paper) — ISBN 0-8214-1443-7 (pbk. :
alk. paper)
 1. United States Capitol (Washington, D.C.) 2. Public art—Washington
(D.C.) 3. United States—In art. 4. Pantheon (Rome, Italy)—Influence.
5. Washington (D.C.)—Buildings, structures, etc. I. Kennon, Donald
R., 1948– II. Somma, Thomas P. III. Series.
 NA4411 .A59 2003
 725'.11'09753—dc22

 2003022674

Contents

Preface

The essays in this collection, the latest addition to the series on Perspectives on the Art and Architectural History of the United States Capitol, originated in three conferences held by the U.S. Capitol Historical Society from 1998 to 2000. Scholars at these conferences addressed a variety of specific topics related to the role of public art as expressed in the nation's leading political landmark. Although the essays vary in approach, scope, and subject matter, collectively they enrich our knowledge and understanding of the Capitol as receptor and disseminator of broad cultural themes.

Like the ancient Roman Pantheon, the U.S. Capitol was designed by its political and aesthetic arbiters to memorialize the virtues, persons, and events that best represented the nation's ideals—an attempt to raise a particular version of the nation's founding to the level of myth. This collection of essays examines not only the influences upon those virtues, persons, and events that were selected for inclusion in the American pantheon, but also those that were excluded. Two papers—one by Thomas P. Somma discussing a work of art rejected for the Capitol and the other by Vivien Green Fryd examining the Capitol's crowning Statue of Freedom that epitomizes the building in the public imagination—address the nineteenth century's virtual exclusion of slavery and African Americans from the art in the Capitol, a silence made all the more deafening by the major contributions of slaves and free African American workers in the construction of the building. Two authors, Kirk Savage and Teresa B. Lachin, consider the subject of women as artists, subjects, patrons, and proponents of art in the Capitol that began to emerge only in the second half of the nineteenth century.

The rotunda, the Capitol's principal ceremonial space, designed in part as an art museum of American history—at least the authorized version of it—is explored in several of the essays. These include William C. Allen's history of the architectural and functional evolution of the rotunda; two essays by Pamela Potter-Hennessey examining the influence of the early-nineteenth-century Italian sculptors who worked at the Capitol and provided the first sculptural reliefs for the room; Irma B. Jaffe's consideration of

Trumbull's effort to depict the republican virtues of the American Revolution in his four rotunda paintings; Francis V. O'Connor's analysis of the iconographic program of two committee rooms designed by mid-nineteenth-century Italian American artist Constantino Brumidi; and Barbara A. Wolanin's reexamination of Brumidi's contributions to the mix of allegory, mythology, and history that continues to imbue the aura of the rotunda and, indeed, of the Capitol itself.

The collection concludes with a look at the Capitol's influence on the artistic decoration of state capitols. Photographer Eric Oxendorf visually demonstrates the impact of Brumidi's dome ceiling mural on the decoration of central ceiling spaces in many state capitols. And art historian Francis V. O'Connor's second contribution provides a fitting conclusion to the volume. O'Connor observes that state capitols possess some of the nation's finest murals. Moreover, he persuasively argues that the rotunda of the U.S. Capitol formed the precedent and model for the painting of these murals during the phases of state capitol construction from the years just after the Civil War to the early decades of the twentieth century.

The editors wish to thank the Office of Architect of the Capitol Alan Hantman, specifically curator Barbara Wolanin and head of photography Wayne Firth, for generously permitting the use of many of the photographs reproduced in this volume. We also gratefully acknowledge the contributions of photographers Eric Oxendorf, Steve Miller, and Lloyd Grotjan.

DONALD R. KENNON
THOMAS P. SOMMA

American Pantheon

Pantheon on the Potomac

The Architectural Evolution of the Capitol Rotunda

William C. Allen

SYMBOLICALLY AND PHYSICALLY, THE ROTUNDA OCCUPIES THE HEART OF THE Capitol. It is the room under the magnificent dome, the vestibule of Congress, and a great historic place. It is the largest room in the Capitol, ninety-six feet in diameter with a floor area of about seven thousand square feet. It is almost twice as high as it is wide and encloses more than a million cubic feet of space. Perhaps surprisingly, these impressive dimensions were achieved with very simple materials: Seneca stone from Maryland was used to pave the floor; Virginia sandstone comprises the lower walls; and cast iron from New York and Baltimore forms the upper walls and inner dome. Architecturally, the rotunda is an eclectic mix of Grecian, neoclassical, and baroque styles. Its two-stage construction history is readily apparent. The stone floor and walls date from the time of James Monroe's presidency, while the painted ironwork above was constructed during the administrations of Franklin Pierce, James Buchanan, and Abraham Lincoln.

The rotunda and dome are such integral parts of the Capitol's image that it is difficult to imagine the building without them. Yet there was a time when the idea of an American capitol was so ambiguous that not even a basic design was certain, much less a dome and a rotunda. There were few precedents to draw upon in the late eighteenth century to help build the Capitol for a new nation with a new kind of government. As it turned out, the Founding Fathers were obliged to be as architecturally inventive as

they had been politically creative. To examine the rotunda, to understand its roots and significance, it is best to begin in the minds of George Washington and Thomas Jefferson.

Washington's Rotunda

In the Residence Act of 1790, Washington scored a magnificent personal victory, one that fulfilled his dream of locating America's capital on the Potomac River. He convinced Congress that the nation's capital should be located in his backyard, within sight of Alexandria, his hometown. Congress passed the Residence Act while sitting in Federal Hall, the former New York city hall that had been specially remodeled for its use. New Yorkers gambled that if Congress was comfortably accommodated, perhaps their city would become the permanent seat of government; however, their hospitality was not enough to keep the government from moving south. Another loser in the capital sweepstakes was Philadelphia, then America's largest city. Its consolation was a ten-year stint as the temporary residence of government. At the close of the second session of the First Congress, the infant government packed its bags, left Manhattan, and headed to Philadelphia for a decade's respite on the Delaware River before moving to the Potomac.

Some influential people viewed Washington's Potomac victory as tenuous and reversible. They thought that once Philadelphia became the seat of government, it could remain the capital forever. The city was stocked with comfortable boardinghouses and hotels, libraries and bookstores, restaurants, taverns, markets, and shops selling anything a member of Congress might want. The Philadelphia County Courthouse was fitted up especially for Congress to use, much as Federal Hall had been remodeled in New York. Along the Potomac, in contrast, nothing yet awaited Congress except the tobacco ports of Georgetown, Maryland, and Alexandria, Virginia, a few scattered settlements, and fields of tobacco and corn.

To answer doubters and critics of the Potomac capital, Washington developed an ambitious strategy. He commissioned a visionary plan for a great new city—not a town or a village—bigger than anything in America, a city to be distinguished by the largest and most beautiful public buildings in the country. It would overwhelm or convert its enemies by its grandeur and beauty. The city plan drawn by Pierre L'Enfant was not merely larger than Philadelphia, it was larger than either Paris or London. As Allan Greenberg has pointed out, L'Enfant's city occupied eleven square miles while London during this period covered just nine. With a population of one million souls, London

was the largest city in Europe, and the comparison is a useful benchmark to measure Washington's astounding ambition for the new federal city.[1]

Although Washington's general vision for the seat of government was clear and far-sighted, his thoughts regarding specific public buildings were murky. When his administration announced a design competition for the Capitol in 1792, it asked only for a two-story brick building with a Senate chamber, a House chamber, a conference chamber, and twelve rooms for committees—in all, fifteen rooms and two lobbies. There was no mention of porticoes, towers, colonnades, arcades, or allegorical statuary, nor was there mention of domes or rotundas. The tightly worded advertisement simply spelled out a list of rooms and gave their dimensions. It should not, therefore, be surprising that the results of the competition were disappointing. Charles Wintersmith's entry, for example, has been compared to an army barrack. James Diamond's design has been ridiculed for the plump bird atop its Gothic cupola. A plan drawn by Samuel McIntire had the dimensions necessary to impart a feeling of grandeur, and its Corinthian portico appealed to classical tastes, but there were serious circulation problems with its floor plan.

Washington's thoughts regarding the Capitol evolved as he looked over the drawings submitted in the competition. Although disappointed by the results, he did find certain things about certain designs that were appealing. In July 1792, while looking over a now-lost design by Judge George Turner, he admired its dome and said it would give the Capitol "beauty and grandeur." He also thought it would be a useful place to hang a bell or mount a clock.[2] Washington began to think of a dome as a highly desirable feature in the Capitol's design because it would impart a sense of grandeur to the building and would be a picturesque addition to the city's skyline. Since no domed building existed in America during this period, it would be an architectural innovation as well. And while he did not specify a rotunda per se, his desire for a dome paved the way for the magnificent space we see today.

Jefferson's Rotunda

If the Potomac capital was the fulfillment of Washington's long-held dream, then an American city graced with correctly designed classical buildings would be the fulfillment of Thomas Jefferson's dream. He served as secretary of state in Washington's

[1] Allan Greenberg, *George Washington: Architect* (London, 1999), pp. 112–13.
[2] Washington to the Commissioners, July 23, 1792, John C. Fitzpatrick, ed., *Writings of Washington,* 39 vols. (Washington, D.C., 1931–44), 32:93.

cabinet and took a vital interest in the architectural potential offered by the new federal city. He had already formulated ideas about city planning and public architecture from his involvement in moving Virginia's capital from Williamsburg to Richmond in the 1780s. Before going to Paris as America's minister to France in 1785, Jefferson began to think about housing the Virginia legislature in a modern re-creation of an ancient Roman temple. He continued and finalized these studies in France with the help of architect and antiquarian Charles-Louis Clérisseau. Together they produced a revolutionary design accommodating the needs of the Virginia legislature in a temple-form building based on the ancient Maison Carrée in Nîmes, France. The Maison Carrée was, in Jefferson's opinion, the "most precious morsel of architecture left us by antiquity."[3]

Jefferson saw the Virginia Capitol in the same light as he would come to see the public buildings in Washington and the Academical Village at the University of Virginia. He looked upon them as tools to teach fellow citizens about architecture, hoping to ignite a spark that would "kindle up their genius and produce a reformation in this elegant and useful art." Jefferson intended that public architecture should improve the artistic taste of Americans at home as well as improving their standing in world opinion.[4] In 1792 he told L'Enfant that he wanted the federal Capitol to be modeled upon an antique Roman temple, which had already enjoyed the world's approval for fifteen or sixteen hundred years. It was a cautious and conservative idea that was novel at the same time. His desire for a Capitol that was immune from ridicule reflected Jefferson's sensitivity to the world's opinion. This sensitivity, in turn, was partly national pride and partly a response to European theories regarding American inferiority, which he wished to prove false at every opportunity. The French naturalist Georges-Louis de Buffon, for instance, asserted that American animals and humans were smaller, weaker, degenerate versions of their European counterparts and reasoned that the New World was an inherently inferior place. In response, Jefferson in 1786 sent the bones and skin of a moose and the horns of various large deer to Buffon, which prompted the naturalist to retract his assertion.[5]

Jefferson would find it more difficult to defend America's place in the world of art unless every opportunity was taken to cultivate taste in music, painting, sculpture, and architecture. The public buildings in the new federal city would put American architecture on the right footing if they embraced the noble and timeless architecture of classical Rome. Since there was already a fine specimen of Roman *cubic* architecture at Richmond, Jefferson suggested an example of spherical architecture for the national Capitol. This meant a copy of the Roman Pantheon (fig. 1). Jefferson knew this great

[3]Jefferson to James Madison, Sept. 20, 1785, in Fiske Kimball, *The Capitol of Virginia* (Richmond, 1989), p. 12.
[4]Ibid., p. 13.
[5]Susan R. Stein, *The Worlds of Thomas Jefferson at Monticello* (New York, 1993), p. 64.

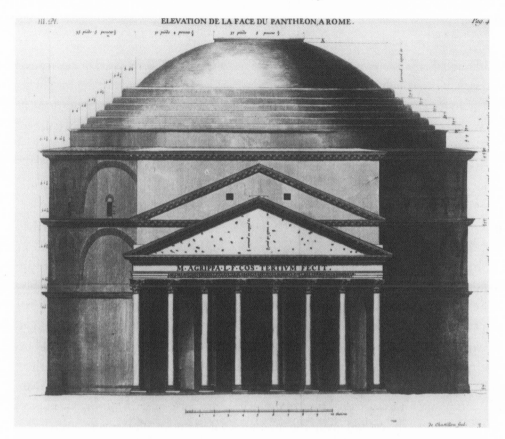

Fig. 1. The Pantheon, Rome, ca. A.D. 117–268. From Antoine Babuty Desgodetz, *Les Edifices antiques de Rome* (1779). *(Courtesy Collections of the University of Virginia Library.)*

structure from published sources such as Palladio's *Four Books of Architecture,* which he purchased in 1769. From Palladio he learned that the Pantheon was the most celebrated temple in Rome, built in the time of the Republic with the portico added by Agrippa in the Imperial age. (We know today that it was actually begun by Emperor Hadrian in A.D. 118.) To have the most authentic views, Jefferson sent for a complete set of Piranesi's drawings of the Pantheon in 1791, noting that they would be needed in designing the public buildings in the new city.[6] The only known design for the Capitol in Jefferson's hand illustrates the importance of the Pantheon in his thoughts: it shows the House, Senate, and "Courts of Justice" squeezed into elliptical chambers fitted into a circle. The space limitations rendered the plan impractical, however, and it was also too small to have a commanding presence over the federal city.[7]

[6]William Howard Adams, ed., *The Eye of Jefferson* (Charlottesville, 1976), p. 297.

[7]Jefferson later resurrected the plan for the rotunda at the University of Virginia, where it was used for classrooms and the library.

Thornton's Rotunda

Although their ideas about the Capitol were not always well formulated or clearly expressed, it is no doubt true that Washington wanted a grand domed Capitol for public relations purposes, while Jefferson wanted a copy of the Pantheon or some other ancient Roman temple for architectural education purposes. The design that eventually satisfied both requirements was submitted by Dr. William Thornton at the beginning of 1793 (see figs. 2 and 3). The most striking elements of the design were a rotunda topped by a low dome—both derived from the Pantheon. Wings flanking this central feature magnified the building's presence and provided the necessary working spaces within.[8] It had the size, style, and grandeur necessary to command that elusive quality called *respect.*

Inside, the dome covered a "Grand Vestibule," or rotunda, 114 feet in diameter. In Thornton's plan an inner dome was held on twenty-four columns thirty-four feet high. The interior would have been lighted by a central oculus like that at the Pantheon, except this one would be closed by a glass skylight. Thornton left no detailed description of what he expected his rotunda to look like, except to say that the columns would be Corinthian and that they should be made of Virginia freestone or white Italian marble.

It seems that Thornton was concerned less with the room's architectural effect than with its possible use as a setting for a monument honoring George Washington. Thornton first wanted the rotunda to house the equestrian statue of Washington authorized by Congress in 1783. This proposal was at odds with L'Enfant's city plan, which placed that statue on the Mall. Although the statue had not yet been commissioned, Thornton hoped to someday place it inside for its protection and to ornament the great room under the dome. His initial description of the rotunda, including the placement of the statue, was set forth in a letter written in April 1793, before the Capitol was begun and while the president enjoyed his usual good health.[9] In February 1800, however, a few weeks after Washington's death, Thornton proposed a new idea: a mausoleum for Washington's body in the center of the rotunda. This came on the heels of a congressional resolution directing that a tomb be prepared in the Capitol once the building was far enough along to receive Washington's remains. Thornton suggested a mausoleum composed of marble rocks featuring a winged figure of Eternity pointing skyward and leading Washington by the hand toward his spirit's home in heaven; a

[8]The rendering should be credited in part to Thornton's friend John Rivardi, a Swiss engineer who had served in the Russian army. (John Trumbull recalled that Thornton was aided by a "Russian Officer of Engineers.") Considering Thornton's extant drawings, it seems clear that he had significant help in producing this one.

[9]William Thornton to the Commissioners, ca. Apr. 10, 1793, C. M. Harris, ed., *The Papers of William Thornton,* 2 vols. (Charlottesville, 1995–), 1:244.

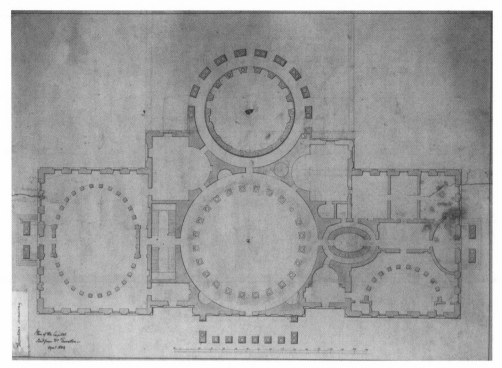

Fig. 2. William Thornton, plan of the Capitol, ca. 1797. *(Courtesy Library of Congress.)*

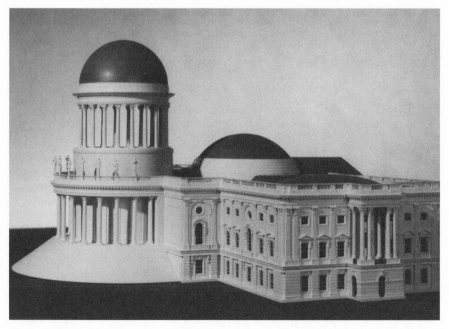

Fig. 3. Model of the Thornton design of 1797. *(Courtesy Office of Architect of the Capitol.)*

reclining figure of Time would invite the general's body to remain on Earth. Additional figures representing Independence, Victory, Liberty, Peace, Virtue, Prosperity, and Fame would occupy the lower reaches of the mausoleum. It was lucky, Thornton said, that the rotunda would be lighted by an oculus because it would place a view of heaven above the figures and contribute to the realism of the work.[10] It was perhaps luckier that his proposal came to naught.

Latrobe's Rotunda

Many changes were made to the Capitol's design during the administration of President Thomas Jefferson. At first he was reluctant to alter what Washington had approved, yet he was nudged in that direction by B. Henry Latrobe, the architect and engineer hired in 1803 to oversee the public buildings. It took Latrobe a year to convince the president that the arrangement of rooms in the Capitol's south wing required radical revision. Also, although the wing's exterior could not be altered because it had to match the north wing, which was already standing (albeit decaying rapidly), changes to the central section were allowed. For example, the circular conference room facing the Mall was removed from the Capitol's overall design in Jefferson's first term. It had not taken Latrobe long to appreciate the architectural catastrophe awaiting the Capitol's skyline if the building presented two domes of very different characters.[11] The stilted dome over the conference room would look ludicrous adjacent to the low Pantheon dome over the rotunda. Ridding the design of the conference room avoided a serious architectural problem and affirmed the primacy of the rotunda in the Capitol's architectural hierarchy.[12]

[10]Twenty years after proposing the monument, Thornton claimed (with typical humbug) that his design had been approved by the celebrated Italian sculptor Giuseppe Ceracchi (Thornton to Samuel Blodget, Feb. 21, 1800, Harris, *Thornton Papers,* 1:536).

[11]The editor of *The Papers of William Thornton* does not believe Thornton intended the Capitol to show two domes simultaneously (ibid., 1:526). This position ignores documentary and pictorial evidence to the contrary. In 1798, for instance, Alexander White reported that the Capitol "will contain a main body and two wings;—the main body is composed of two parts—a grand circular vestibule to the east, of 112 feet diameter and a conference room to the west, a circle of 90 feet diameter, both of full elevation—the first covered with a dome—the second with a temple" ("Report of the Committee to whom was referred, February 23, 1798, the President's Message inclosing a memorial from the Commissioners of the city of Washington, Mar. 8, 1798," quoted in *Documentary History of the Construction and Development of the United States Capitol Building and Grounds,* 58th Cong., 2d sess., House of Representatives Report No. 656 [Washington, D.C., 1904], p. 80).

[12]The conference room was also doomed by Jefferson's dread of making speeches. It had been intended for joint meetings of Congress, over which the president would preside and deliver his annual message on the state of the Union. Jefferson began a tradition of sending his annual message in writing, rather than delivering it in person. Thus he avoided delivering a long public address as well as the spectacle of senators and representatives calling on the president to make their replies. In 1913, Woodrow Wilson broke the tradition when he delivered his first annual message to Congress in person.

Jeffersonian republicanism, rather than aesthetic concerns, dealt the fatal blow to the rotunda mausoleum scheme.[13] No longer seen as a monument to George Washington, the rotunda was called "The Hall of the People" during the Jefferson administration. According to floor plans, it would serve as a place to hold inaugurations, impeachments, and divine services.[14] Holding religious services in the Capitol was nothing new: its chambers were routinely used on Sundays by clergy and citizens who had few places to assemble in the little city. Similarly, it was natural to assume inaugurals would be held in the rotunda. After all, they are the greatest occasion in the national political cycle, attended by as much pomp and ceremony as Americans can muster. By the time the rotunda was completed, however, the tradition of outdoor ceremonies had already taken root. (The first and only inaugural held in the rotunda was Ronald Reagan's second swearing in, held on January 20, 1985, when frigid conditions forced the ceremony indoors.)

Impeachment was another matter. Until recently, this subject was known mainly to students of Andrew Johnson's presidency or to historians specializing in the careers of a dozen U.S. district judges. Impeachment is an awesome congressional power that is carefully and infrequently exercised. Yet the Jefferson administration identified the Capitol's rotunda as the place where impeachments would be held. It is obvious that Jefferson considered the place worthy of the event.

In his first term Jefferson attempted to use impeachments to pry Federalists out of the judicial branch of government. Every judge in the land had been appointed by his two Federalist predecessors and there were those in his administration who sought to open some seats for members of their political party. The first target was John Pickering, a mentally unstable district judge from New Hampshire, who probably should have resigned for health reasons. Instead, he was prosecuted for improper conduct and convicted at the end of Jefferson's first term. Next, Jefferson's congressional lieutenants turned their attention to Samuel Chase, a justice of the U.S. Supreme Court known for his indiscreet behavior. Although the House voted articles of impeachment in December 1804, Chase was found not guilty in March 1805. Jefferson soon dropped impeachment as a political tool, having found it too slow and inefficient to satisfy his immediate goals. His experiences taught him that impeachment was an "impracticable thing, a mere scare-crow" that could not be so easily employed as a political weapon as he had once thought.[15]

[13]The Jefferson administration did not consider the rotunda an appropriate place to bury Washington. In 1829, however, a tomb was prepared two stories directly below the rotunda. In 1832 the idea of bringing Washington's remains to the Capitol was revived in anticipation of the centennial of his birth. However, objections from Washington's heirs and the Virginia legislature put an end to the reinterment scheme.

[14]See Latrobe's 1807 plan of the Capitol in the Prints and Photographs Division, Library of Congress.

[15]Jefferson to Thomas Ritchie, Dec. 25, 1820, quoted in Dumas Malone, *Jefferson and His Time,* 6 vols. (Boston, 1948–81), 4:482.

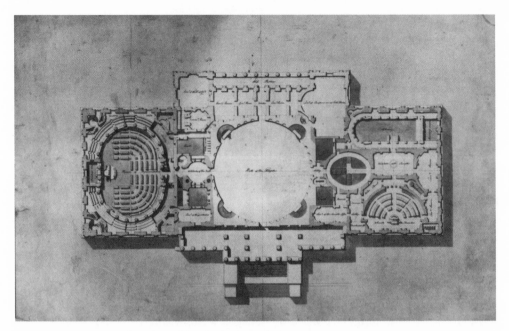

Fig. 4. B. Henry Latrobe, plan of the Capitol, ca. 1808. *(Courtesy Library of Congress.)*

These impeachment proceedings took place long before the rotunda was constructed. The drawings that Latrobe produced for the rotunda during the Jefferson administration illustrate a room ninety-six feet in diameter, almost twenty feet smaller than originally specified. Typically, Dr. Thornton condemned the reduction as the ruination of the whole design, but the change was necessary to accommodate better lobbies and stairways associated with the House and Senate chambers. Further, a rotunda ninety-six feet in diameter would still be an impressive room even by European standards. Latrobe's 1806 studies indicate that he planned heroic niches to occupy the spaces between the four doors located at the cardinal points of the room. Circular staircases would lead down to a room called the "lower rotunda" or "crypt." By 1808, his plans showed twenty-four smaller niches added to the rotunda walls and the stairs removed to the large niches (fig. 4). There, circular stairs would descend around and behind pedestals that were provided for additional sculpture. It has been suggested that the rotunda in this plan was intended to be an American Hall of Fame similar to William Kent's Temple of British Worthies at Stowe in Buckinghamshire.[16] With so many places to display portrait busts, it seems likely that Latrobe had such a use in mind.

[16]Jeffery A. Cohen and Charles E. Brownell, *The Architectural Drawings of Benjamin Henry Latrobe,* 2 vols. (New Haven, 1994), 2:409.

It is easy to believe that Jefferson was behind the idea of placing busts of American worthies in the rotunda. He was, after all, an avid collector of portrait sculpture and a patron of sculptors. From the time he lived in Paris, Jefferson collected busts of famous men and displayed them at Monticello. In the tea room, for instance, busts of Franklin, Washington, Lafayette, and John Paul Jones were mounted on brackets in what Jefferson called his "most honorable suite." They were displayed alongside thirty additional portraits of people who influenced Jefferson or otherwise made a contribution to the American Revolution. He owned busts of Voltaire, Napoleon, Czar Alexander I of Russia, John Adams, James Madison, and Andrew Jackson. His own bust stared straight ahead at a bust of Alexander Hamilton in the entrance hall. Beginning in 1818 he commissioned busts of himself and all grown members of his family from English sculptor William Coffee. He also purchased porcelain figures for table decorations. With a lifelong devotion to the art of sculpture, Jefferson most certainly was responsible for the way Latrobe arranged sculptural portraits to be displayed in the rotunda as a shrine to notable Americans.

Jefferson maintained a lively interest in the public buildings in Washington following his retirement in 1809, but he never returned to see their progress. Nor did he see their burned-out shells following the British invasion of 1814. Latrobe was recalled in 1815 to plan the restoration of the Capitol and immediately implemented changes to the floor plans. In the case of the long-awaited center building and the rotunda, Latrobe reverted to his early scheme by eliminating the little niches and retaining the large niches that first appeared in his 1806 plan (fig. 5). What prompted this change of heart is unknown, but Jefferson's retirement may have been a key factor.

Bulfinch's Rotunda

Latrobe's resignation in November 1817 came before restoration of the wings of the Capitol was finished and before the center building was begun. His designs were inherited by Charles Bulfinch, a Boston architect whose most famous work had been the Massachusetts Statehouse, America's first domed building. Bulfinch arrived in Washington in January 1818 and picked up where Latrobe left off. In much of the two wings there was no alternative but to continue what had been begun, but in the center building he was free to devise his own plan and designs.

From the onset of his Capitol career, Bulfinch grappled with a perplexing problem. A year before he arrived in Washington, Congress commissioned four paintings from John Trumbull that would depict two civil and two military events of the Revolutionary

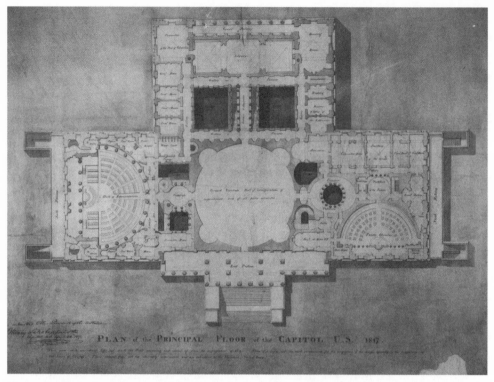

FIG. 5. B. Henry Latrobe, plan of the Capitol, 1817. *(Courtesy Library of Congress.)*

War. These canvasses were to be twelve feet tall and eighteen feet wide with life-size figures. The paintings were intended to hang in the rotunda once it was ready to receive them. Yet there were also those in Congress who wanted to scrap the rotunda altogether and reallocate that space for committee rooms. During this period Congress was experiencing a rapid growth in the number of its committees, and providing them with meeting rooms became an important part of Bulfinch's job.

The development of the committee system is a topic of considerable importance to the history of Congress and the Capitol. When Washington's administration wrote specifications for the Capitol in 1792, it called for only twelve committee rooms. At that time, the House had only one standing committee (Elections) and one permanent joint committee with the Senate (Enrolled Bills). The Senate had no standing committees of its own. Like the House, it operated with ad hoc committees that were appointed to examine limited questions and dissolved once the assignment had been completed.

As time went by, more standing committees were created to deal with ongoing issues and problems. The House of Representatives had fifteen standing committees by the time Bulfinch arrived in 1818; by the next year the Senate had seventeen standing as

well as nine select and two joint committees. And, of course, the House and Senate committees all wanted their own rooms in the Capitol.

In 1818 some in Congress thought the rotunda (which was still nothing more than a circle of ink on a piece of paper) a waste of space and a needless extravagance. They spoke with Bulfinch and asked him to devise a plan to locate committee rooms where the rotunda was to be built and to find somewhere else to hang Trumbull's paintings. On January 19, 1818, the architect wrote Trumbull (a friend of twenty years) about an idea to place a picture gallery above a floor devoted to committee rooms. Instead of a rotunda, there would be committee rooms and an entrance hall with a double spiral staircase like the one he admired in the new City Hall in New York. Trumbull was disturbed by the suggestion, because illumination would be bad in a gallery lighted by windows placed under a portico. He said he would be mortified to have his paintings placed across from such "disadvantageous light"[17] and claimed that a rotunda with an oculus at its apex was the perfect environment to show paintings to advantage.

With conflicting pressures to retain the rotunda and to provide more committee rooms, Bulfinch searched his mind for a solution to the dilemma. By mid-March he hit upon the idea of placing an additional story in the west section of the center building to take advantage of the sloping ground on which it was to be built. The center building would be four stories high on the west while remaining three stories on the east. A new ground story would provide twelve more committee rooms. By reducing the size of light wells, corridors, and the rooms themselves, Bulfinch was able to fit forty committee rooms where Latrobe had planned only twenty-four. When Bulfinch's arrangement was approved, the Capitol's rotunda was literally rescued from space-hungry committees.

Bulfinch began construction of the center building on August 24, 1818, the fourth anniversary of the British invasion and the humiliating burning of the Capitol. Work on the rotunda's foundations began at that time, and its superstructure gradually rose as the center building grew higher. The rotunda walls were started in 1820 and were finished two years later. The interior dome was made of stone, brick, and wood covered with plaster. In the early part of 1823 the framing for the wooden exterior dome was completed, and it was covered with copper roofing later that year. The paving of the rotunda's floor was finished in 1824. A circular opening in the center of the floor provided the lower crypt with light from the dome's oculus.

Bulfinch's design for the rotunda departed from Latrobe's and Thornton's earlier concepts except in its diameter, which was fixed by existing conditions. He eliminated

[17]Trumbull to Bulfinch, Jan. 28, 1818, *The Autobiography of Colonel John Trumbull,* ed. Theodore Sizer (New Haven, 1953), p. 263.

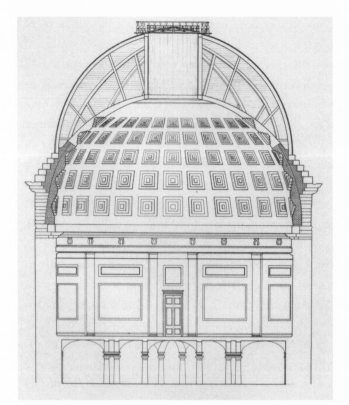

FIG. 6. Section of rotunda and dome, 1824–55; conjectural reconstruction, 1989. *(Courtesy Office of Architect of the Capitol.)*

Latrobe's huge niches and designed the walls with Doric pilasters holding a simple entablature (fig. 6). The pilasters divided the walls into twelve compartments: eight large ones for historical paintings and four smaller ones to frame doorways. According to Bulfinch's 1823 written description of the room, he placed wreaths in the entablature to honor the subjects of the historical paintings positioned below. The design of the walls was derived from the Choragic Monument of Thrasyllus (fig. 7), which the architect knew from a plate in James Stuart and Nicholas Revett's landmark publication *The Antiquities of Athens* (1762). The plain pilasters and an entablature without triglyphs appealed to Bulfinch because he sought a "bold simplicity" appropriate for a vestibule leading to the more richly finished legislative chambers.[18] (Apparently the pilasters were ultimately considered too simple, because stone cutters were dispatched to flute the shafts after they had been installed. It cost thirty-six dollars to flute each one.) The stone wall supported the interior dome, which had a series of five graduated coffers and a central oculus. The height of the dome (ninety-six feet) matched the room's diameter and thus replicated exactly the interior proportions of the Pantheon. The collar of the oculus was decorated with anthemion, a Grecian honeysuckle ornament.

[18]"Report of the Architect of the Capitol," Dec. 6, 1823, quoted in *Documentary History,* p. 257.

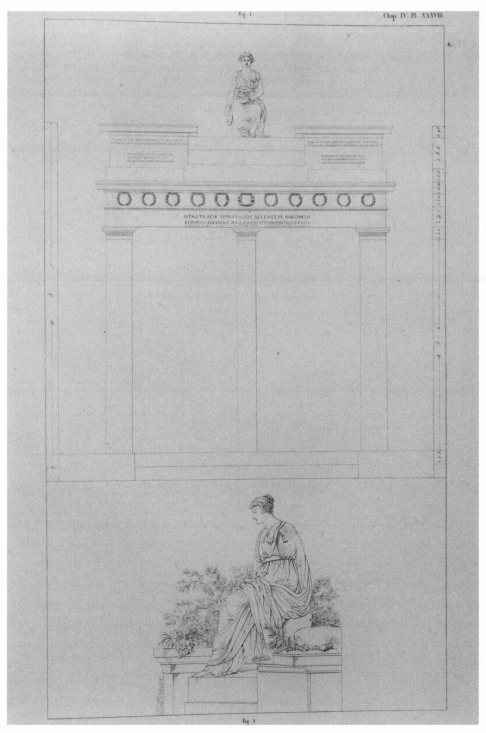

FIG. 7. Choragic Monument of Thrasyllus. From the 1825 edition of *The Antiquities of Athens* by James Stuart and Nicholas Revett. *(Courtesy Office of Architect of the Capitol.)*

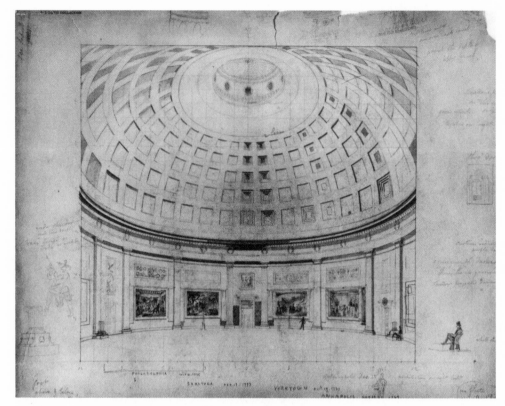

Fig. 8. Alexander Jackson Davis, the rotunda. ca. 1832. *(Courtesy Avery Architectural and Fine Arts Library, Columbia University.)*

Views of the rotunda in its original form are rare. Perhaps the best is a pencil sketch drawn about 1832 by the New York architect Alexander Jackson Davis (fig. 8). It shows Trumbull's paintings draped with curtains (noted as being reddish-purple) that could be drawn when the floor was swept or when the room was infested with flies: the artist claimed that dust and the "filth of flies" were the two greatest enemies of paintings. At Trumbull's insistence, the opening in the floor had been closed in 1828. Apparently, warm, damp air rising through this aperture had already damaged his paintings, which had been on view in the room for only two years. Congress asked him to restore the four paintings, and this process could begin only after the opening was closed.

Most accounts of the rotunda during the antebellum period focus on the paintings and sculpture displayed in the room. The architecture was usually portrayed as less interesting and less instructive than the artwork. Yet the rotunda's architecture was regarded well enough to influence similar spaces in several state capitols. From 1821

to 1838, architect William Nichols designed capitols for the states of North Carolina, Alabama, and Mississippi, all with central rotundas that functioned as grand vestibules. In Raleigh, the rotunda was the setting for a magnificent statue of George Washington by Antonio Canova. After that building burned in 1831, the firm of Town and Davis was retained to design its replacement. Its central rotunda bears a striking resemblance to the national Capitol's rotunda, although in reduced and simplified form.[19]

The rotunda in Washington attracted a variety of activities, some of which were far afield from government business. In 1824, the year it opened, a reception for the Marquis de Lafayette was held in the rotunda. In 1825 an exhibition of foreign and domestic cloth, furniture, and hardware was set up there. Two years later a congressman described the rotunda as an unruly place where inventors, artists, and peddlers hawked their wares.[20] When President Andrew Jackson took the oath of office on the east portico, an exhibition of American ingenuity took place inside the rotunda. According to the *Nashville Republican and State Gazette,* a railway car with eight passengers was pulled across the rotunda by a single thread of fine, American-made sewing cotton.[21]

On January 30, 1835, President Jackson returned to the Capitol to attend a funeral in the House chamber. After the service Jackson entered the rotunda, where he encountered Richard Lawrence, a deranged English house painter, who stepped forward and fired two pistols at the startled president. Both guns misfired and the would-be assassin was quickly arrested. Later he explained his action by claiming that Jackson was responsible for blocking his family's claim to the English throne. Rumors soon spread that Lawrence was a dupe in the hands of Jackson's political enemies in the Senate, particularly George Poindexter of Mississippi. To clear his name, Poindexter called for the Senate to investigate the matter. While the accusation was proved groundless, Poindexter's political career was ruined.

In 1852 the first lying-in-state was held in the rotunda, beginning a tradition of honoring notable Americans in that room that has been repeated twenty-seven times. During the Civil War the Eighth Massachusetts Regiment was bivouacked in the rotunda. Over the years it has proved to be a most adaptable and useful room.

[19]It is worthy of note that Charles Bulfinch designed Maine's capitol while he was working in Washington. In 1827 authorities in Maine asked Bulfinch for an economical version of the Massachusetts statehouse, which he had designed in the 1780s. As in Boston, the statehouse in Augusta was capped by a dome with the space below occupied by a legislative chamber rather than a rotunda. No reference to the architecture of the nation's Capitol can be detected in the design of the Maine statehouse.

[20]House proceedings of Feb. 23, 1827, *Register of Debates,* 19th Cong., 2d sess., p. 1364, quoted in *Documentary History,* p. 293.

[21]*Nashville Republican and State Gazette,* Mar. 24, 1829.

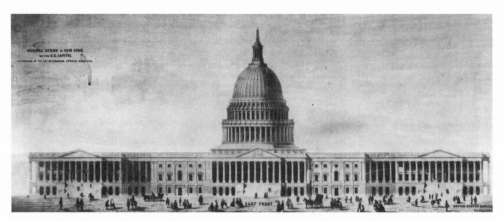

Fig. 9. Capitol with a new dome by Thomas U. Walter, 1854. Photograph of a lost elevation. *(Courtesy Office of Architect of the Capitol.)*

Walter's Rotunda

The rotunda that Bulfinch built lasted only thirty-one years. Beginning in 1855, it was transformed into the soaring space we know today by a massive construction project that rid the Capitol of its ungainly wooden dome and replaced it with a magnificent creation in cast iron. These improvements were undertaken while the Capitol itself was being enlarged by marble wings, which tripled its floor space. Thomas U. Walter of Philadelphia was the architect of both the extension and the new dome.

The need for a new dome became painfully evident on Christmas Eve in 1851 when the Library of Congress in the west center building was destroyed by fire. The nearby dome was saved only by the heroic efforts of the Marine Corps, which chopped down a wooden staircase that would have carried the fire to the dome. In 1854 Joseph Chandler of Pennsylvania warned his colleagues in Congress that there was not a "shanty within a hundred miles of this city which is such a complete tinder-box as is this Capitol."[22] He suggested that unless the dome was rebuilt with incombustible ma-terials, the whole Capitol was in danger of being destroyed. This warning came just as Walter finished an impressive rendering of the Capitol showing the extension with a splendid new cast-iron dome over the center building. In December 1854, the archi-tect hung this seven-foot-long drawing in his office, where legislators came to have a look and discuss the possibility of building a new dome on top of the old rotunda. The original drawing has been lost for years, but fortunately it is known through a period photograph (fig. 9).

[22]House proceedings of June 14, 1854, *Congressional Globe,* 33d Cong.,1st sess., p. 1393, quoted in *Documen-tary History,* p. 609.

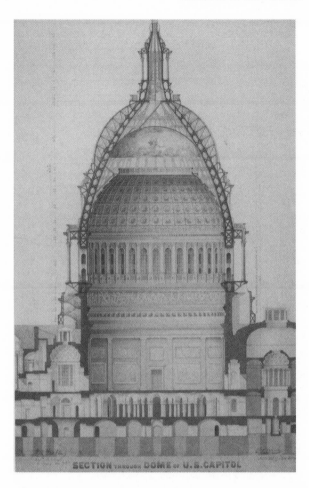

FIG. 10. Thomas U. Walter,
section of the rotunda and dome,
1859. *(Courtesy Office of Architect of
the Capitol.)*

Inside, Walter's design called for preserving the stone walls of Bulfinch's rotunda and building a vast vertical addition to them. There would be two new interior domes held by two rows of Corinthian pilasters set between seventy-two windows. The new rotunda would soar to more than two hundred feet above the floor. It is doubtless true that Walter's first design sought to make the rotunda as high as possible without regard to aesthetics or proportion—in America, where bigger is always better, this goal was not particularly surprising or out of place. This design did not last long, however. In the spring of 1859 Walter made adjustments to his plans for the inside and outside of the new dome. He redesigned the rotunda by providing for a monumental painting to hover over the oculus of a new inner dome (fig. 10). The idea was derived from one of Walter's favorite European buildings, the church of St. Genevieve in Paris, also known as the Panthéon, which he had closely inspected in 1838. The proportions of the rotunda were greatly improved by lowering the height of the inner dome to 150 feet above the floor, and the monumental painting produced a dramatic finale.

FIG. 11. August Schoenborn, proposed improvements to the rotunda, 1901. *(Courtesy Office of Architect of the Capitol.)*

The biggest problem with Walter's rotunda was the architectural connection between his work and the earlier Bulfinch-era walls. The stone pilasters of the lower walls were designed for a much smaller space and could look out of scale and anemic in the vastly enlarged room. Other carved or painted decorations also appeared crude and unsophisticated in many eyes. Walter and his contemporaries did not seem bothered by these problems, but during the early twentieth century—the heyday of the City Beautiful movement, with its love of grand civic spaces and swashbuckling classicism—there were proposals to redecorate the rotunda. It appeared particularly shabby to those who came to the Capitol after visiting the dazzling new Library of Congress across the street, which opened in 1897. A 1901 design for upgrading the rotunda proposed to replace the pilasters with columns, raise the historical paintings, label them grandly, and add a ring of portraits as a Hall of Fame (fig. 11). This design was prepared by August Schoenborn, who began his Washington career as a draftsman in Walter's office in

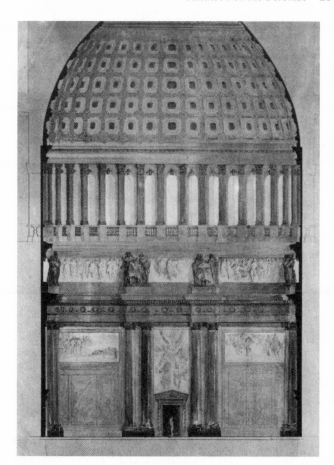

Fig. 12. Gutzon Borglum, proposed improvements to the rotunda, 1905. *(Courtesy Office of Architect of the Capitol.)*

1851. Now seventy-three years old, Schoenborn was not at the peak of his powers, and, thankfully, the proposal went nowhere. A more sophisticated and appealing design was worked up by Gutzon Borglum in 1905 (fig. 12). He proposed removing the history paintings altogether, lining the walls with marble, installing tall Ionic columns in pairs around the room, retrimming the doorways, and placing sculptural groupings above a new entablature. A new marble frieze representing scenes from American society would replace the unfinished painted frieze. A new floor would be tiled with a compass rose and Bancroft's famous epigraph: "Westward the star of empire takes its way." These modifications would have transformed the rotunda into a room on par with the great urban libraries, train stations, and state capitols that were being built during this period.

But nothing came of Borglum's proposal. The only work done in the rotunda during the early twentieth century was a so-called restoration of the walls in 1905 (fig. 13). This entailed removing layers of paint from the stone, despite the fact they were originally painted to disguise rust-colored streaks and other natural imperfections. Except

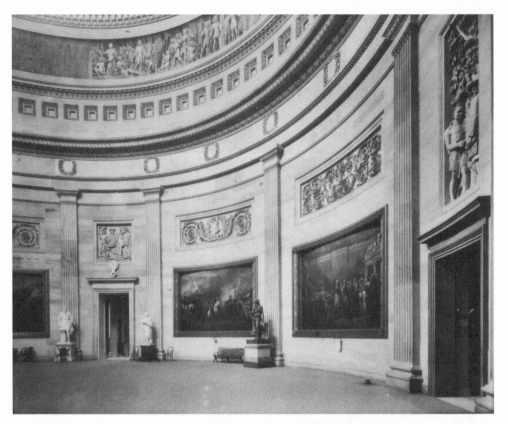

FIG. 13. The rotunda ca. 1905. *(Courtesy Office of Architect of the Capitol.)*

for the paint removal, the rotunda remains today as Walter left it at the close of the Civil War.

Begun almost as an afterthought to George Washington's desire for a dome, the Capitol rotunda has been reconceived over the years as a teaching tool, a hall of impeachments, a temple of worthies, and a monument to the Revolution. It has been a place of commerce, inauguration, and attempted assassination. It is where Americans have mourned presidents, legislators, soldiers, and policemen. It remains today a versatile and noisy room that drops the jaws of about four million people a year. The rotunda's evolution has been a distinctly American journey.

The Italian Influence on American Political Iconography

The United States Capitol as Lure and Disseminator

PAMELA POTTER-HENNESSEY

A T THE END OF THE EIGHTEENTH AND THE BEGINNING OF THE NINETEENTH centuries there were no trained sculptors in America. Italians traveled here to fill the vacuum. First lured to Philadelphia and New York by the artistic needs of the new republic, they were among the first to create portraits of America's political and cultural leaders. When the Capitol moved to Washington in 1800, they rushed to compete for the Capitol building projects, and several worked in neighboring Baltimore, designing many of the first significant public sculptures in the nation. America owes a great debt to these creative men who left a strong Italian imprint on her most important early monuments. Since that time, Italianità has been steadily seeping into the American consciousness.

The Capitol functioned as a magnet for these artists and as the distributor of their artistic style—a disseminator of the new American political iconography, some of which was formulated with images and ideas imported by the Italian adventurers. America's Founding Fathers perceived a need to define America iconographically and they understood the potential of sculpture to aid in that process.[1] A tradition of festivals and

[1] In their travels, Thomas Jefferson, Benjamin Franklin, and other early American political leaders witnessed the successful use of monumental sculpture to manipulate ideas and ideals.

parades held in celebration of political events was established, and the ephemeral sculptures, floats, and other three-dimensional constructions used in these events implanted a visual language that could be understood by all.[2] Along with this sensitivity to visual props came the widespread knowledge of the subtleties of gesture and expression, a language passed on to Americans from the tradition of Roman oratory.[3]

In addition to the Founding Fathers' political need for iconography was the ambitious desire to establish an artistic climate during America's infancy that would support art and architecture in future competition with the best in Europe. As Thomas Jefferson mused in a letter written to James Madison from Paris in 1785, he saw the arts as a way "to improve the taste of my countrymen, to increase their reputation, to reconcile to them the respect of the world, and procure them its praise."[4] Jefferson favored the neoclassical style—the primary visual language of the Italians who ventured here—as the appropriate artistic mode in America, in part for its potential to impart information and concepts clearly and quickly.[5] Furthermore, educated Americans were steeped in the classical tradition and they understood and assimilated the conflated meanings of the sculpted motifs and the subjects drawn from both Greek and Roman antiquity.[6] The Founding Fathers shared with many fellow citizens a common knowledge of venerated ancient commonwealths—classical virtues held up in the New World as models of Republicanism—and they plundered the classics and classical mythology for an instant history.

There is much yet to be done to piece together the entire Italian story and to assess

[2] For further information about America's pageants, parades, celebrations, and the dynamics that helped shape the new nation, see David Waldstreicher, *In the Midst of Perpetual Fetes: The Making of American Nationalism, 1776–1820* (Chapel Hill, 1997); Simon P. Newman, *Parades, Festivals, and the Politics of the Street: Popular Political Culture in the Early American Republic* (Philadelphia, 1997). Some of the best-known examples of sculptured symbols and allegorical figures used for political purposes were those made by Charles Willson Peale in honor of the Treaty of Peace in 1783. Peale's "triumphal arch that stretched 56 feet over Philadelphia's Market Street, towered 40 feet into the air, and was covered with historical and allegorical figures and symbols" (Whitfield J. Bell, Jr., "The Federal Processions of 1878," *New York Historical Society Quarterly* 46 [1962]:6).

[3] There were a number of texts and guides to oratory and understanding visual language available in early America, including *The Elements of Gesture, Illustrated by Four Elegant Copper-Plates; Together with Rules for Expressing, with Propriety, the Various Passions and Emotions of the Mind* (Philadelphia, 1790). For a recent study of gesture and American independence, see Jay Fliegelman, *Declaring Independence: Jefferson, Natural Language, and the Culture of Performance* (Stanford, Calif., 1993).

[4] Thomas Jefferson to James Madison, Paris, Sept. 20, 1785, Merrill D. Peterson, ed., *Thomas Jefferson Writings* (New York, 1984), p. 830.

[5] Jefferson expressed a preference for Roman architecture and ornament over Greek, believing that it would promote Roman civic virtues to the American viewers.

[6] The Founding Fathers shared with many citizens a common knowledge of venerated ancient commonwealths, heroes and statesmen, and classical virtues—all held up in the New World as models of Republicanism. They plundered the classics and classical mythology for an instant history that would also distance them from contemporary European governments. For a discussion of the use of the classical tradition in America, see Meyer Reinhold, "Classical Influences and Eighteenth-Century American Political Thought," *Classica Americana: The Greek and Roman Heritage in the United States* (Detroit, 1984); John E. Ziolkowski, *Classical Influences in the Public Architecture of Washington and Paris: A Comparison of the Two Cities* (New York, 1988); Wendy A. Cooper, *Classical Taste in America, 1800–1840* (New York, 1993).

the influence of Italy on our earliest efforts to define ourselves. One of the most daunting tasks is the preliminary work still to be accomplished in Italy. The bits and pieces of information necessary to create the narrative are scattered, if they exist at all, and access to libraries and archives is often limited. A liberal policy of ready admission to collections, as experienced in the United States, is unusual in Italy, and when permission is granted there are often constraints, such as a severe limit on the number of documents that may be viewed per day. Yet another complication is the lack of the anecdotal information often found in letters, diaries, notebooks, and sketchbooks—the contemporary commentary that fleshes out a story. Italians preserve and guard their family histories very carefully, and family treasures are rarely sent to archives for the public's perusal. Moreover, there are few entities similar to the U.S. Capitol Historical Society or government repositories such as the U.S. Capitol Archives to help in the research process. However, as each scholar adds his or her contributions to the conversation, the story will unfold and the depth and breadth of the Italian impact on American political iconography will become clear.

MANY OF THESE long-forgotten sculptors brought their families with them to America, intending to stay to become part of the exciting young nation and its artistic future. Conditions did not always live up to the artists' expectations for many reasons, including too few projects to provide a steady income to support themselves and their families, a dearth of local materials and expertise, and a lack of appreciation by their patrons and the public. Some actually felt defrauded by their commissioners, and a good number of the artists left in disgust and disappointment.

Giuseppe Ceracchi (1751–1802) is one of the most interesting early characters in the Italian saga and one of the most significant artists to have visited America in our earliest years.[7] He ventured here in 1791 and landed in Philadelphia, the primary locus of intellectual and political discussion and national identity. The enthusiastic Ceracchi arrived prepared and eager to make sculptures for the new republic.[8]

The son of a goldsmith, Ceracchi was born in Rome and studied at the Accademia di San Luca, where he won the prestigious Annual Prize in 1771.[9] Although there is

[7]Ceracchi was the most notable artist except for the French sculptor Jean-Antoine Houdon (1741–1828), perhaps the greatest French sculptor of the eighteenth century. On September 14, 1785, Houdon appeared in Philadelphia on his way to Mount Vernon to begin the preliminary work on the statue of George Washington in the rotunda of the State Capitol Building.

[8]The exact date of Ceracchi's arrival is unknown, according to Ulysse Desportes, Ceracchi's principal biographer. For further information about Ceracchi's visits to America, see "Giuseppe Ceracchi in America and His Busts of George Washington," *Art Quarterly* 26 (963):140–78; "Ceracchi's Bust of Alexander Hamilton," *Currier Art Gallery Bulletin* (1969); "Great Men of America in Roman Guise Sculptured by Giuseppe Ceracchi," *Antiques* (1969).

[9]*Archivio dell'Accademia di San Luca* (Rome), 7:14. Other bits and pieces of information about Ceracchi's earliest days as an artist can be found in the libraries of the American and British Academies in Rome.

little to be found in the Accademia's records to tell us what he studied, it is certain that Ceracchi knew the city well and was familiar with the important sculptures and the incidental busts, reliefs, and sculptural decorations that are to be found on bridges, fountains, walls, and the facades and interiors of churches, palazzi, and government buildings. Like all young artists working in Rome, he also would have been aware of the treasures of the Vatican and other private collections. Further, it was the habit of sculptors to draw from both original works and historical casts and to take copious visual notes of the city's decorations.[10] Rome is a treasure trove of incidental visual material, and all of these resources would have become part of Ceracchi's cache of references for his future work.

Ceracchi came to America on a lark, planning to find further fame and fortune. As a rabid Republican and defender of freedom, the sculptor also hoped to meet with comrades in Republicanism with whom he could debate contemporary politics. He may have intended his contribution to the discussion to help formulate an appropriate American political iconography that would reflect some of his Republican ideals. It is also probable that Ceracchi counted on his Masonic connections to bring sculptural commissions as they had in Europe.[11] Masonic membership was at its peak in America at the time of his arrival, and many of the most influential and progressive-minded men, such as Benjamin Henry Latrobe, William Strickland, Charles Willson Peale, Benjamin Franklin, and George Washington were members.

As a rising success in Europe, with significant commissions in many capitols, Ceracchi undertook a substantial career risk by coming to America.[12] His contemporaries describe him as restless and impulsive, and so it was in character that this political enthusiast traveled here. Leaving his Viennese wife and children in Europe, Ceracchi landed in New York with a studio assistant, modeling tools, and a plan in response to Congress's call for an equestrian monument to George Washington.[13] His model for a sixty-foot, multifigured neoclassical pile, surmounted by a bronze equestrian of Washington, was exhibited in Philadelphia, where it was most likely made soon after

[10]Valuable insight into this working method can be found in a sketchbook by Felice Giani, ca. 1810, located in the collection of Cooper-Hewitt Museum, Smithsonian Institution, New York (1901-39-2463). Giani's drawings include monuments and other sculptures found in Rome and Bologna.

[11]Ceracchi joined the Lodge auf Wahrenden Eintracht in Vienna sometime between 1783 and February 1785. He subsequently sculpted the busts of prominent members of that and other European lodges. Desportes, "Ceracchi in America," p. 143.

[12]Ceracchi completed numerous significant commissions in Europe before venturing to America. He worked in many of the capitols of Europe, including London, Berlin, Florence, Milan, Vienna, and Rome, making portrait busts of cardinals, kings and queens, poets, and ordinary citizens of Europe. For more information about these commissions, see Desportes, "Ceracchi in America" and Regina Soria, "Early Italian Sculptors in the United States," *Italia Americana* 2 (1976):169–87.

[13]The congressional resolution passed on August 7, 1783. Washington was to be depicted in Roman dress, and on the base of the monument would be mounted four bas-reliefs to represent the four important events of war: the evacuation of Boston, the battles of Princeton and Monmouth, and the surrender at Yorktown. Desportes, "Ceracchi in America," p. 146.

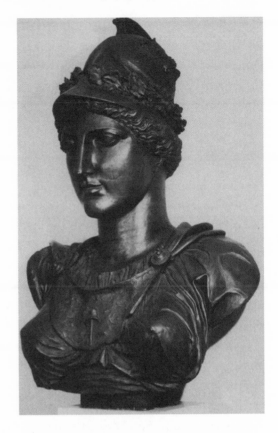

FIG. 1. *Minerva as the Patroness of American Liberty,* Library Company of Philadelphia, 1792, patinated terra-cotta bust. *(Courtesy Library Company of Philadelphia.)*

Ceracchi's arrival. Jefferson and others were very impressed with Ceracchi's design. Jefferson wrote to the artist: "The title to the execution is engraved in the minds of those who saw your work." Despite the positive reception of the piece and Jefferson's enthusiasm, Ceracchi's project, estimated to cost more than $30,000, never came to fruition for lack of funds.

While waiting for support, and to demonstrate his ability to work in the colossal mode, Ceracchi executed a huge clay bust of *Minerva as the Patroness of American Liberty* (fig. 1).[14] This five-and-one-half-foot work was made of Schuylkill River clay, fired in a Philadelphia brick kiln, bronzed, and then presented to Congress and installed by ship riggers behind the Speaker's chair in Congress Hall. Ceracchi's Minerva wears her traditional garb of helmet and cuirass, but her breastplate sports the liberty cap and pike, adding a modern Republican meaning to the statue.[15]

As part of his artistic campaign, Ceracchi also made busts of the famous men of the

[14]For a discussion of Minerva as an American allegorical figure, see Pamela Scott, *Temple of Liberty: Building the Capitol for a New Nation* (New York, 1995), p. 13; E. McClung Fleming, "The American Image as Indian Princess, 1765–1783," *Winterthur Portfolio* 2 (1965):65–81, and "From Indian Princess to Greek Goddess: The American Image, 1783–1815," *Winterthur Portfolio* 3 (1967):37–66.

[15]*Minerva* was given to the Library Company of Philadelphia when Congress moved to Washington in 1800. Today the huge sculpture is mounted on the wall of the librarian's office, where it towers over visitors. For details of the sculpture's provenance, see Desportes, "Ceracchi in America," p. 175 n. 33.

day—all modeled from life. Most notable of the group are those he made of Washington, who sat for the artist. A larger-than-life-size terra-cotta original, now in the Nantes Museum, was used as a model for at least two marble copies—one at the Metropolitan Museum of Art and the other at the Gibbes Museum in Charleston, South Carolina. Other copies, done either by Ceracchi himself or later by other hands, include a bust in the lower-level gallery of the Washington Monument in Baltimore (figs. 2, 3) and another in the National Portrait Gallery in Washington. These portraits were considered by Washington's relatives to be closer in resemblance to the first president than Houdon's famous depiction, and although eventually supplanted in the American memory by Houdon's bust, which was copied many times and distributed widely, Ceracchi's images were well known during the nineteenth century and appeared with regularity as the iconic image in children's textbooks and biographies of Washington (fig. 4).[16] Ceracchi also sculpted busts of Thomas Jefferson, Benjamin Franklin, John Paul Jones, and David Rittenhouse. The presence of the many busts did much to establish sculptured portraiture in the United States, providing a new level of artistic excellence and firmly implanting the neoclassical style.

Ceracchi's interest in helping establish the arts in America is demonstrated by his enthusiasm in joining a group of artists, including Charles Willson Peale and William Rush, in a futile attempt to form an art academy in America—the Columbianum in Philadelphia. An agreement was adopted and signed by sixty-two artists, including Ceracchi, but the group was divided: the recent émigrés from England wanted to offer honorary leadership of the organization to George Washington, placing him in the same position as the king of England in relationship to the Royal Academy. Ceracchi was the most uncompromising of all in his opposition to this plan. As an outspoken supporter of democracy, he believed the proposition was inconsistent with the principles of American liberty, and his impassioned objections led to the dissolution of the group.

Ceracchi's confrontational manner alienated him from most of the artists with whom he had hoped to associate in America, and he found few political friends; instead, he quickly became an unappreciated outsider. Further disappointments forced Ceracchi to return to Europe. The most serious was the decision on May 7, 1792, by a committee of the House of Representatives to postpone plans for a monument to Washington—the project to which Ceracchi was most committed and the one he hoped would make his reputation in America: "Mr. Ceracchi is an artist of great reputation in Europe, a gentleman of respectable character, and has been actuated by the most honorable motives in offering to dedicate his genius and labors to the United States. It appears, however, to [the] committee, that, at present, it would not be expedient to go into the

[16]Illustration at the head of chapter 1 in J. Frost, *Pictorial Life of George Washington* (Philadelphia, 1854), p. 13. The image was identified at the time as having been derived from Ceracchi's bust.

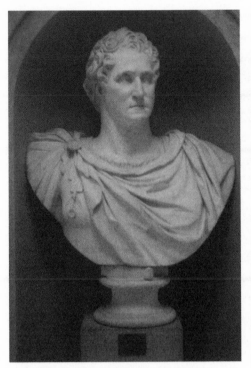

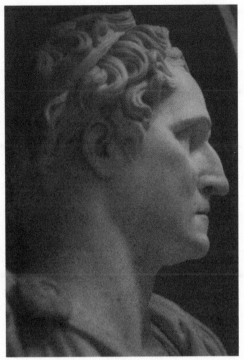

FIG. 2. Giuseppe Ceracchi, *Washington,* Washington Monument, Baltimore, Maryland.
(Photograph courtesy the author.)

FIG. 3. Giuseppe Ceracchi, *Washington,* Washington Monument, Baltimore, Maryland.
(Photograph courtesy the author.)

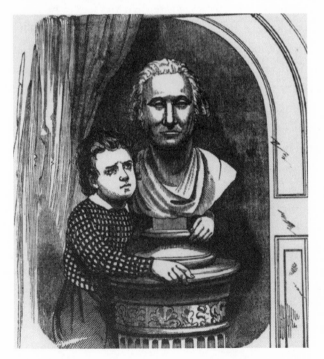

FIG. 4. Child Adoring the Bust of Washington. From J. Frost, *Pictorial Life of George Washington* (Philadelphia, 1848).

expenses which the monument voted by Congress on the 7th August 1783 would require, especially with the additional ornaments proposed by the artist."[17] Discouraged by his failure to secure the monument commission, and unsuccessful in his attempt to become part of the political and artistic communities, Ceracchi left Philadelphia at the end of the summer. He stopped in New York, where he modeled portraits of Gov. George Clinton and Supreme Court Justice John Jay. These busts were left with the sitters when he sailed for Genoa, but Ceracchi took with him more than two dozen life portraits of America's most significant men. Most of these sculptures have not been located.[18]

Back in Italy, Ceracchi's liberal political views brought him into disfavor with the papal government, which banished the sculptor from both Rome and Florence. In the fall of 1794 he reappeared in Philadelphia with two of the marble busts of Washington and other American portraits, including Jefferson, Alexander Hamilton,[19] and David Rittenhouse. With the exception of the Rittenhouse bust, which was presented to the American Philosophical Society, the portraits were offered as gifts to the sitters. After Hamilton's famous 1801 duel with Aaron Burr that ended in his death, Ceracchi's portrait of the leading Federalist was copied numerous times. In 1870, for example, Ceracchi's bust appeared on the thirty-cent U.S. stamp. Earlier in the century, the painter John Trumbull had used the bust as a model for his portrait of Hamilton that was later engraved on the ten-dollar bill.

Ceracchi also brought to America another design for a grandiose monument, this one a colossal, multifigured statue dedicated to Liberty. More than 100 feet in height, with a 300-foot circular base, it was described by the artist as "a monument designed to perpetuate the memory of American Liberty." The sculpture was characterized in *Il Quotidiano di Bologna* as bizarre in detail.[20] Rising from the base were five allegorical groups. Capping the monument, a 15-foot Goddess of Liberty, surrounded by a rainbow, descended through the clouds in a chariot. Liberty's right hand, held aloft in an oratorical gesture toward her audience, carried a flaming dart to disperse the clouds and illuminate the universe. When it became apparent that this massive project would not be funded by the government, George Washington suggested to Ceracchi that he finance his scheme by subscription. Washington was the first supporter to sign over funds, placing his name at the beginning of the subscription list, and a circular letter

[17] *Journal of the House of Representatives,* May 7, 1792.

[18] "A treasure trove of extraordinary interest to students of early American art and history may wait unrecognized in some storeroom in Florence. More than two dozen life portrait busts of America's Founding Fathers were left in the Tuscan capital by their author, Giuseppe Ceracchi, a Roman sculptor and political exile. The busts, in terra-cotta, were modeled in the United States in 1791–1792. . . . Ceracchi had been obliged to abandon them in Florence when he fled from the city under pressure from the local authorities. Also left behind was his model for an equestrian monument to George Washington" (Desportes, "Busts of George Washington," p. 141).

[19] Desportes, "Ceracchi's Bust of Alexander Hamilton."

[20] *Il Quotidiano di Bologna,* Oct. 10, 1797.

printed over the sponsors' names was made available to the public.[21] Too bombastic for American taste, and far too expensive for Congress's depleted coffers, the project never got off the ground.

Ceracchi left Philadelphia for the last time in May 1789. Disappointed, dejected, and impoverished, he returned to Europe and established himself in Paris, where he insinuated himself into the inner circles of the directory. In 1790 Napoleon granted Ceracchi a few portrait sittings and promised support for a grandiose monument to glorify *Le Grande Armée*.[22] More involved in politics than with his sculpture, Ceracchi by the end of the decade had moved on to Rome, where he agitated for a Republican form of government. When Napoleon later favored the pope, Ceracchi and several accomplices plotted the assassination of Bonaparte. Ceracchi was arrested on October 10, 1800, during a premiere at the Paris Opera, a dramatic and well-publicized capture that was carefully orchestrated by the artist.

Giuseppe Ceracchi was guillotined with his three coconspirators a year after his arrest on January 30, 1802. According to eyewitnesses, the artist who so loved liberty and democracy went to the scaffold dressed like an ancient Roman.[23] With Napoleon's permission, he rode to his demise on a triumphal, gilded chariot that he designed for his own execution (fig. 5). The American painter John Vanderlyn, who happened to be in Paris at the time, witnessed the event. Vanderlyn reported that Ceracchi "ascended the scaffold with an air of dauntless courage and firm step." Italian newspapers noted that as Ceracchi was led to the guillotine he proclaimed loudly to his audience: "we are slaves, we are all slaves."[24]

Ceracchi's sculptures were not the only Italian works of note in Philadelphia in the 1790s. About the time of Ceracchi's first arrival in America, a well-known larger-than-life-size statue (93 x 34 x 23 in.) of Benjamin Franklin was put into place in a large niche on the facade of the new Library Company of Philadelphia (fig. 6). William Bingham, a local merchant and future U.S. senator, commissioned the marble portrait of the library's founder, and Francesco Lazzarini sculpted the piece in his Carrara studio in 1791.[25] Bingham provided the artist with a bust of Franklin and a pen-and-ink sketch indicating his physique.[26] Before his death Franklin had indicated that he wished to be depicted as a Roman, with "a gown for his dress and a Roman head." Lazzarini

[21]"A Description of the Monument Consecrated to Liberty," Washington Papers, vol. 271, pp. 47–48, Library of Congress.

[22]A Ceracchi portrait bust of Napoleon can be found in the Maryland Historical Society collection.

[23]*Rassegna Storica del Risorgimento,* Istituto Poligrafico dello Stato, Roma (1960).

[24]*Mémoires de Madame la Duchesse d'Alroutès* (Paris, 1835), 2:293–94.

[25]The Lazzarini family's Carrara studio, closed in 1926, was active for about 250 years. Many famous eighteenth-century works were executed in this studio, including Ceracchi's busts of Napoleon. Regina Soria, *American Artists of Italian Heritage, 1776–1945: A Biographical Dictionary* (Cranberry, N.J., 1993), p. 101.

[26]*Columbian Magazine or Monthly Miscellany,* Jan. 25, 1790. This sketch is located in the Chicago Historical Society.

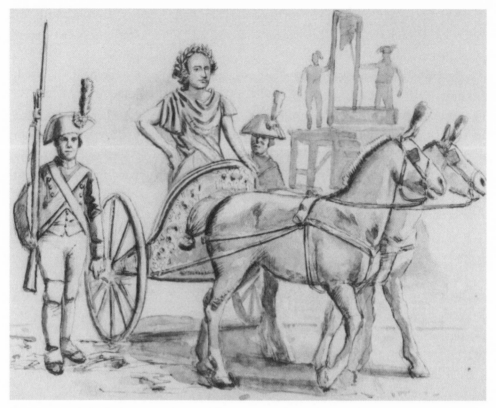

FIG. 5. *Ceracchi on the Way to the Scaffold,* from contemporary descriptions. *(Drawing by the author.)*

rendered him as requested, in Roman garb with a stack of books for an armrest, in reference to Franklin's erudition and skill as an orator. A downturned scepter in the figure's left hand alludes to the American patriot's aversion to monarchies. Lazzarini completed the portrait in less than a year and shipped it to Philadelphia, where it arrived in 1792, soon after Franklin's death. With great fanfare the figure was quickly hoisted up into its niche on the facade of the library building. *Dunlap's Daily Advertiser* and the *Gazette of the United States* announced its arrival in Philadelphia, and the *Universal Asylum and Columbian Magazine* (April 1792) applauded the city's procurement of another superior Italian sculpture.[27]

[27]"If the intrinsic merit of this master-piece of art did not speak its value, the name of the artist, where he is known, would evince it. Here perhaps price may give the best idea of its worth. We have heard that it cost above 500 guineas." A number of other Italians left their mark on the Giuseppe Iardella *Drama* and *Music,* which were sculpted about 1795 for Robert Morris's mansion on Chestnut Street. Iardella had been brought from Italy by Pierre L'Enfant to execute the sculptural decorations. The panels were salvaged by Benjamin Henry Latrobe and put into the facade of the Chestnut Street Theater in 1806, when Morris's folly was demolished. Iardella made other architectural decorations for prominent buildings during his brief stay, and although his work was not political in nature, it helped inculcate a taste for public sculpture and for classical motifs.

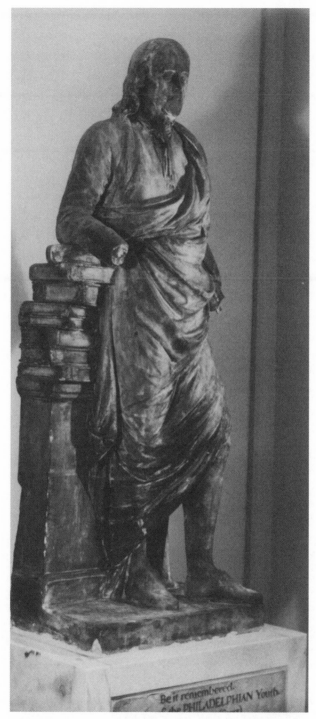

FIG. 6. Francesco Lazzarini, *Benjamin Franklin.* *(Courtesy Library Company of Philadelphia.)*

By 1800 the nation's government left Philadelphia to create a new establishment along the mudflats of the Potomac River. It was widely held that the creation of the Federal City was the equivalent to the building of a new Rome. Both Washington and Jefferson had spoken of a "New Rome," and it was hoped that at some period the Federal City would emulate the Italian Capitol in splendor and significance. Even the little stream that flowed at the foot of Capitol Hill—Goose Creek—was called the Tiber, after the much grander river that courses through the ancient city. Jefferson also made it known that he preferred Italian models for the Capitol and the president's residence —the Roman Pantheon for a domed Capitol and Palladio's Villa Rotunda for the president's house. The allusions to Roman architecture, landscape, and the glories of the Roman Empire created the perfect opportunity for Italian sculptors and artisans to assist in symbolizing the new nation in stone. Their imprint is strong on the Capitol, the most important American structure and the new locus of political meaning. Except for three works by the American sculptor Horatio Greenough and one sculptural relief by a Frenchman, all other sculptural ornamentations of the Capitol prior to the 1850 extension were executed by Italians.

When architect Benjamin Henry Latrobe sought assistance with the embellishments of the Capitol, he knew it would be imperative to gather a group of significant artists to complete the task. In March 1805 Latrobe wrote to Philip Mazzei, Thomas Jefferson's good friend in Rome, and asked for his help in procuring a "first-rate sculptor" and an assistant, noting that Antonio Canova was the most famous neoclassical sculptor in the world.[28] Latrobe asked Mazzei to inquire how much the aging Canova would charge for carving a nine-foot figure of Liberty for the House of Representatives chamber. Canova declined the commission, but a year later Giuseppe Franzoni (d. Apr. 6, 1815) and his brother-in-law Giovanni Andrei (1770–1824) arrived to begin work on the Capitol.[29] Franzoni was the son of the president of the Accademia di Belle Arti in Carrara and was an experienced sculptor with numerous projects to his credit in Rome and Florence.[30] Andrei had also worked in Florence, creating the balustrade for Santa Maria Novella.[31]

[28]Benjamin Henry Latrobe wrote to Philip Mazzei on March 6, 1805. Cited in Charles E. Fairman, *Art and Artists of the Capitol of the United States of America* (Washington, D.C., 1927), pp. 3–4.

[29]Curator of the Capitol Charles E. Fairman told the story of the two Italians in a speech given to the House of Representatives in 1930 at the instigation of Fiorello LaGuardia ("Art of the Italian Artists in the United States Capitol," Remarks added to an address given by the Hon. Fiorello LaGuardia of New York in the House of Representatives, January 29, 1930; *Congressional Record,* [cited in Regina Soria, "Early Italian Sculptors in the United States," *Italian Americana* 2 (1976), and in Fairman, *Art and Artists of the Capitol*]).

[30]Emilio Lazzoni, *Carrara e la sua Accademia di Belle Arti: Riassunto storico del Conte Emilio Lazzoni* (Pisa, 1869), p. 46; Regina, Soria, *American Artists of Italian Heritage,* p. 89.

[31]Alfonso Panzetta, *Dizionario degli scultori italiani dell'ottocento* (Naples, 1991), p. 14; Soria, *American Artists of Italian Heritage,* p. 26; Richard R. Borneman, "Franzoni and Andrei: Italian Sculptors in Baltimore, 1808," *William and Mary Quarterly* 3, no. 1 (1953):108–11.

Franzoni modeled a great eagle for the Hall of Representatives and also made an eagle for the gate of the Navy Yard. Steeped in Italian neoclassicism, he worked from Roman prototypes.[32] During the initial stages of sculpting the Hall of Representatives eagle, Latrobe was complimentary in his assessment of the work, noting that "there is not in ancient or modern Sculpture an Eagles [*sic*] head which is in dignity and spirit and drawing Superior to Franzoni's."[33] However, as the work progressed, Franzoni found himself in disagreement with Latrobe, who considered the artist's design far too Italian. The two argued and Latrobe, who wanted an American bald eagle as the model for this important image, wrote to Charles Willson Peale requesting a sketch of the bird to be used by Franzoni as reference. Latrobe wrote: "One of [the sculptors] is now modeling an eagle, but it is an Italian, or a Roman, or a Greek eagle, and I want an American eagle."[34] Peale responded by sending the head and neck of a bald eagle for Franzoni's use.

Franzoni also created a plaster figure of Liberty that was set up in the Hall of Representatives. This sculpture also displeased Latrobe, who had envisioned Liberty as a slightly larger-than-life-size seated figure surrounded by the appropriate Republican symbols. Instead, Franzoni had depicted a mammoth warlike Liberty, with weaponry and a fasces, the symbol of Roman authority and union, at her side. Writing to John Lenthall, clerk of the works, Latrobe stated: "I do not like Franzoni's model. It may be correct symbology or emblematology to give Dame Liberty a club or shelalah [*sic*], but we have no business to exhibit it publicly. I must have one arm close to her side, resting on her lap. The other may be raised and rest on a block or capped stick."[35] Unfortunately, we will never know whether Franzoni acquiesced to Latrobe's preferences, because the Liberty was destroyed during the War of 1812 when British soldiers and sailors burned the Capitol in 1814.[36]

Although Latrobe was adamant about using the American bald eagle as the model for Franzoni's eagle in the Hall of Representatives, and he highly disapproved of the overly Roman and warlike Liberty, Latrobe himself looked to classical sources and

[32]An eagle very similar in design is located in the vestibule of the Church of Santi Apostoli in Rome. This is one example of many.

[33]Commissioner's Letters, vol. 5, pt. 1, Aug. 27, 1806, Office of the Architect of the Capitol. Latrobe also mentioned that Franzoni was ill. "Unfortunately . . . he was this morning seized with a spitting of blood and being of a weakly constitution and still weaker nerves, I fear we will not be able to keep him long. He will want to return to Italy."

[34]Benjamin Henry Latrobe to Charles Willson Peale, Apr. 18, 1806, Library of Congress.

[35]Benjamin Henry Latrobe to John Lenthall, Dec. 31, 1806. Cited in Fairman, *Art and Artists of the Capitol,* p. 12.

[36]Latrobe also planned that Franzoni would create a group of seventeen female figures for the Hall of Representatives. These were never completed, although Franzoni's brother Carlo made plaster models of the group for the rebuilt Senate chamber in 1816. Pamela Scott, *Temple of Liberty: Building the Capitol for a New Nation* (New York: Oxford University Press, 1995), pp. 86, 147 n. 42.

FIG. 7. Benjamin Henry Latrobe, *Athena as American Liberty,* ca. 1811. *(Courtesy Library of Congress.)*

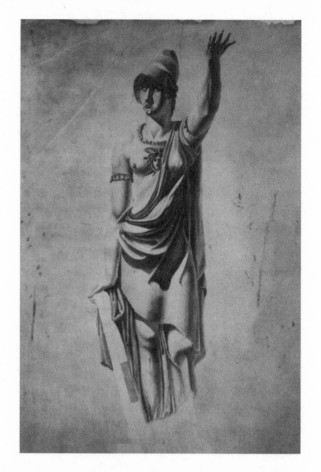

iconography in his development of ideas for the allegorical sculptures in the Capitol. His own drawing of a colossal "Athena as American Liberty," planned at one point for the west front of the Capitol, depicts a female figure with an upraised left arm in a Roman oratorical gesture (fig. 7). Her right hand rests on a tablet, probably the Constitution. She wears an outer garment similar to a toga and an undergarment decorated with a Medusa head, as Minerva would have sported on her cuirass.

The figure's liberty cap is an unusual shape, with a visorlike projection in the front, while both the Roman pileus and the Phrygian cap are brimless. Latrobe's direct source was the ancient sculpture *Pallas of Velletri,* now in the Louvre.[37] It was Latrobe's reference to this ancient work that accounts for the odd, helmetlike shape of the American Athena's liberty cap, as well as her distinctive heavy face and thickset neck. The famous Roman copy of a Greek original had only been discovered in 1797, and it

[37]For an illustration of the *Pallas of Velletri,* see Francis Haskell and Nicholas Penny, *Taste and the Antique* (New Haven, 1981), p. 285, fig. 150.

was the subject of political controversy at the time Latrobe made this drawing. The French had seized the statue upon their arrival in Rome in 1798, and the Neapolitans took possession of the ancient sculpture when they occupied the city in 1799. In March 1801 the statue was returned to the French under the terms of the Treaty of Florence, an event that was reported worldwide.[38] Aside from the familiarity of the sculpture because of the recent press coverage of its capture and return, Latrobe would have chosen the *Pallas* for its aesthetic merits. Contemporary critics rated the *Pallas* as highly as the *Apollo Belvedere* and the *Laocoön,* two well-known ancient works in the Vatican collections.

Whether or not Latrobe objected strongly to the Italian nature of some of the sculptures produced by Franzoni and Andrei, he thought enough of the artists' work to loan the two Italians to his good friend, architect Maximilian Godefroy in Baltimore. Jefferson's austere 1808 budget proposal meant there was not enough work at the Capitol, and so Franzoni and Andrei traveled to the nearby city where they carved the Gothic decorations for the interior of St. Mary's Chapel. They were awarded other commissions as well. The most notable at the time was the thirty-foot sandstone lunette for the pediment of the Union Bank, a prominent building designed by Baltimore architect Robert Cary Long. The sculpture depicts a static Ceres draped in classical robes, seated on a cornucopia and holding a bundle of wheat in her right hand. She is truly Roman in spirit, the reincarnation of the Roman Tellus, or Mother Earth figure. The nude Neptune, reclining on the right, holds a trident in his right hand and reclines on a waterwheel while a sea monster emerges in the corner at the far right. Michelangelo's figures in the Medici Chapel in Florence have been suggested as prototypes, but a Roman river god is a more probable visual parallel.[39] The ancient figures flank the modern emblems of the State of Maryland, the combination of ancient and modern symbols formulating new meaning.

Franzoni and Andrei stayed in Baltimore for four months and by September were back at work in Washington, where Andrei began carving Corinthian capitals while Franzoni designed a figure of Justice for the Supreme Court room and relief figures representing Agriculture, Art, Science, and Commerce, which were placed over the entrance to the House of Representatives. Franzoni also carved the famous corn cob capitals for the vestibule outside the Supreme Court chamber. Franzoni evidently traveled back to Baltimore in 1812 or 1813 to complete at least one more project, a huge

[38]Anatole de Montaiglon, ed., *Correspondence des directeurs de l'Academie de France à Rome avec les Surintendants des Batiments,* 18 vols. (Paris, 1887–1912), 8:280, cited in Haskell and Penny, *Taste and the Antique,* pp. 284–85.

[39]Not only does the figure resemble a river god, but the water reference is appropriate to Baltimore, a port city located on the river basin leading to the great Chesapeake Bay. The lunette is in the collection of the city's Peale Museum.

Fig. 8. Spandrel Arch, figure of Ceres supporting a fasces, Commercial and Farmer's Bank, Baltimore, Maryland, ca. 1813, Collection Baltimore Museum of Art. *(Photograph courtesy the author.)*

sandstone spandrel arch for the Commercial and Farmer's Bank, erected in 1813 on what is now the corner of Howard and Redwood Streets (fig. 8). The larger-than-life-size reclining, stylized figures of Mercury and Ceres support a mammoth over the ground-floor archway, a bold statement of Roman origin and meaning.[40]

Franzoni and Andrei continued to make sculptures for the Capitol until the outbreak of war with England. Both men had planned to return to Italy, but war postponed their trip home. Not long after he witnessed the destruction of much of his Washington work, Giuseppe Franzoni died on April 6, 1815. Andrei was then sent to Italy to supervise the carving of some capitals. When he returned to the United States he brought with him Giuseppe's brother Carlo Franzoni (1786–1819) and Francesco Iardella. They immediately went to work for Latrobe. Iardella is best known for carving the tobacco-leaf capitals of the small Senate rotunda and the series of sandstone panels with busts of famous explorers set in roundels flanked by floral decorations, which he carved with Enrico Causici and Antonio Capellano.

[40]The building no longer exists, but the spandrel was salvaged and is now located in the Baltimore Museum of Art.

FIG. 9. Carlo Franzoni, *Justice,* lunette, Old Supreme Court Chamber, 1817. *(Courtesy Office of Architect of the Capitol.)*

A lunette attributed to Carlo Franzoni in the Old Supreme Court chamber was one of the first sculptures completed after the destruction of the Capitol (fig. 9). Justice, dressed in classical garb, holds the scales in her left hand and a sword in her right. On Justice's throne is an eagle, and another is perched beside law books as a symbol of authority, unity, and wisdom. Justice seems to have been directly inspired by both the ancient *Seated Agrippina,* from Rome's Capitoline Museum, and Canova's seated *Madame Mère,* finished in 1804, a visual link between ancient and contemporary masters, connections Franzoni must not have been able to resist.[41] More recent inspiration for a winged young boy would have been the many genius figures found on neoclassical tombs. Identified as the Young Nation, he functions here as the genius of the nation and also as the figure of History, holding a tablet on which is inscribed "The Constitution of the United States."

The significance of the boy has been problematic in previous interpretations.[42] Although he is clearly representative of the youthful nation, the confusion seems to focus on the celestial reference—the star shape that flares prominently behind his head. This may indicate that the figure is a conflation of the nation and Apollo. Well-known Revolutionary iconography included Apollo, the god of Light, hence of Enlightenment and Reason, and here Apollo/Nation holds the ultimate document of Reason, the Constitution, as he flanks Justice, the arbiter of Reason and in this context the mother of our Republican ideals—the conflation of antique and modern ideals.

[41]Franzoni would have been familiar with both sculptures. Canova had been accused of using *Agrippina* as the model for his famous portrait of Napoleon's mother, a charge he denied. Haskell and Penny, *Taste and the Antique,* p. 133.

[42]For a discussion of the problem, see Vivien Green Fryd, *Art and Empire: The Politics of Ethnicity in the United States Capitol, 1815–1860* (New Haven, 1992), p. 253 n. 6.

Franzoni also designed the *Car of History* in 1819, which was placed directly above the entrance to the House of Representatives chamber (fig. 10). Its well-modeled personification of History, harking back to classical models, records the major events of the nation. Her winged chariot, representing Time, is decorated with a relief portrait of Washington, who is trumpeted by a figure of Fame, positioned at the front of the car like a ship's figurehead. The work was prophetic for Franzoni, who had been in ill health. He died soon after completing the work.

Franzoni and Andrei were not the only Italian artists with Capitol connections to work in nearby Baltimore. Giuseppe Valaperta arrived in the city in 1815, after serving as one of the major sculptors at Napoleon's palace, Malmaison. He immediately advertised his skill at making portraits in colored wax and ivory in the *Baltimore Daily Advertiser* and the *Federal Gazette*. His talent is demonstrated by a series of delicate wax portraits of notable Americans now in the collection of the New-York Historical Society.[43] Valaperta came to the attention of the architect Godefroy, who asked him to design a female figure to surmount the monument commemorating the Battle of Baltimore in the War of 1812. Valaperta agreed to a fee of $3,000, but delayed the process in a futile search for a perfect piece of marble in the nearby quarries in Baltimore County. His procrastination lost the project to another Italian, Antonio Capellano.

When the battle monument project fell through, Valaperta traveled on to Washington, where he carved the great eagle on the frieze of the Hall of Representatives—another very Italian-looking eagle. Although a reviewer for the *National Intelligencer* characterized the sculpture as being without compare in Europe, in general the response was not as enthusiastic as Valaperta had hoped. Disappointment over his work in America and long-term uncollected debts owed by European patrons threw him into despair and may have caused him to commit suicide. It is said that he threw himself into the Potomac River. Valaperta's body was never found.[44]

Following Valaperta's sudden disappearance, the commission he had won to execute a statue of George Washington for the state of North Carolina went to the famous Canova, who began to work on the figure in 1819 in his Italian studio. In the finished piece Washington is dressed as a Roman general, and he is rendered larger than life, with bare legs and sandals that bracket the sword he has placed on the ground. He writes on a tablet: "Georgio Washington al Popolo degli Stati Uniti 1789 Amici e

[43]The New-York Historical Society has five red-wax portraits by Valaperta, representing Thomas Jefferson, Albert Gallatin, Andrew Jackson, James Madison, and James Monroe. *New-York Historical Society Quarterly Bulletin* 11 (1927):54.

[44]An advertisement appeared in the *National Intelligencer* on March 11, 1817, that noted Valaperta had disappeared.

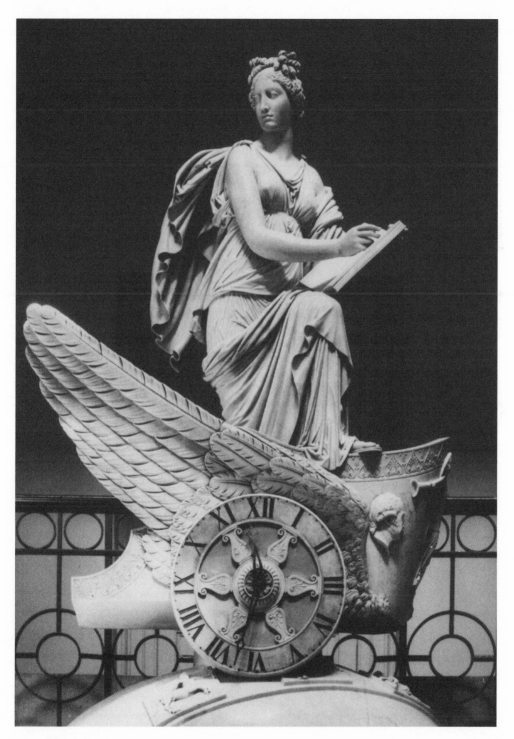

Fig. 10. Carlo Franzoni, *Car of History,* 1819. *(Courtesy Office of Architect of the Capitol.)*

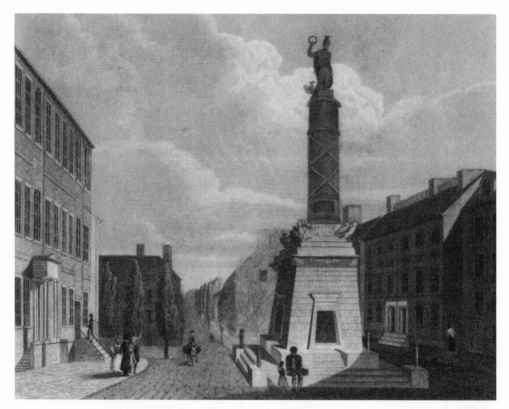

FIG. 11. Antonio Capellano, *Battle Monument,* Baltimore, Maryland, ca. 1815, author's collection.

Concittadini." Canova used one of the Ceracchi busts as his only model, and Washington's classical countenance can be described as more Italian than American.[45] In the 1820s Canova's statue was one of the best-known works of art in America, and it played a large role in establishing monumental statuary around the country. Unfortunately, the work was destroyed in 1830 when the State House in Raleigh burned. Had the marble survived, it would have been an even more powerful influence on American sculptors just beginning to make their mark when the sculpture was lost.

Antonio Capellano, a pupil of Canova who came to Baltimore in 1815, worked on the battle monument, creating the four griffins that symbolized the combined qualities of watchfulness and courage found in the eagle and the lion (fig. 11). He also carved the two tablets at the base of the shaft, which was sculpted as a colossal fasces. His eight-and-a-half-foot female figure at the summit is a combined allegory of Peace and Fame, crowning the victorious Baltimore troops with a laurel wreath. She is also a personifi-

[45]His Roman attire did not go unnoticed by a reporter at the unveiling in Raleigh in 1821: "North Carolinians were struck dumb by the fact that the Father of [their] Country was dressed in a Roman General's costume." Cited in Wayne Craven, *Sculpture in America* (New York, 1968), p. 63.

FIG. 12. *St. Paul's Church,* Baltimore, Maryland, with two relief panels depicting *Moses with the Tables of Law* and *Christ Breaking Bread.* From George H. Howard, *The Monumental City: Its Past History and Present Resources* (Baltimore, 1873).

cation of Baltimore, identified as a city figure by the crenellated crown of city ramparts, reminiscent of ancient Roman Tellus figures.

Capellano sculpted other prominent works in Baltimore, including two large relief panels for St. Paul's Church, depicting *Moses with the Tables of Law* and *Christ Breaking Bread* (fig. 12). He also hoped to win the job of carving the statue of Washington for the crown of Robert Mills's monument in Mount Vernon Square. His recent success with the battle monument and an enthusiastic recommendation by Thomas Jefferson seemed to indicate that he would design the first public monument to the first president, but the commission was awarded to another Italian, Enrico Causici.[46]

Enrico Causici arrived in America in 1822, and after brief stays in New York and Baltimore he moved on to Washington, where he first modeled the clock for the Senate chamber. Next, he turned his attention to the Capitol rotunda, carving two awkward reliefs, *The Landing of the Pilgrims* and *Daniel Boone in Conflict with the Indians.*

[46]Capellano also carved a prominent sandstone relief for the Capitol rotunda entitled *The Preservation of John Smith by Pocahontas.*

FIG. 13. Enrico Causici, *Genius of the Constitution,* 1817–19, U.S. Capitol, Statuary Hall. *(Courtesy Office of Architect of the Capitol.)*

Together with Capellano and Iardella he also carved a series of sandstone reliefs for the rotunda, memorializing the great explorers Christopher Columbus, John Cabot, Sir Walter Raleigh, and La Salle. Causici's most important work in the Capitol is a great plaster statue, *The Genius of the Constitution,* which was placed above the Speaker's chair in the House chamber (fig. 13).[47] Causici's robust allegory is a heavily draped, neoclassical figure with an eagle at her right and a serpent entwined around a bundle of fasces at her left. Still more Roman than American, the neoclassical figure, the fasces, and the eagle became prototypes for others to follow.

Causici soon found himself without steady work at the Capitol, and so he traveled between New York, Baltimore, and Washington, hoping to win further commissions.[48] While maintaining a studio on Wall Street, Causici modeled a plaster model of an equestrian statue of Washington in expectation of creating a sculpture for that city. The plaster maquette was set up outside City Hall, but the work was never cast in bronze as the artist had planned. During the same period Causici approached the

[47]The sculpture has been misidentified by historians as a figure of Liberty. As Vivien Green Fryd points out, her traditional symbols are absent, and Latrobe identified the scroll in her hand as the Constitution. Fryd, *Art and Empire,* p. 187.

[48]J. Elgar, Clerk to the Commissioner of Public Buildings, wrote to Causici on January 17, 1822: "Sir: I am directed by the President of the U. States to furnish you with a copy of the attorney general's opinion in your case, and to inform you that you are no longer to consider yourself in the employment of the U. States" (Letters of Commissioners of Public Buildings, vol. 7, p. 310, National Archives and Records Commission).

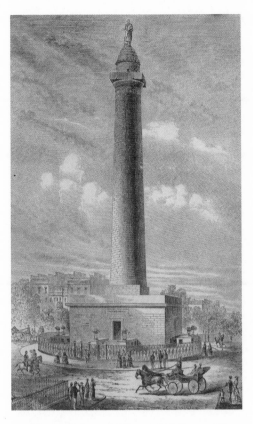

FIG. 14. Robert Mills, *Washington Monument,* figure by Enrico Causici, erected in 1829. From George H. Howard, *The Monumental City: Its Past History and Present Resources* (Baltimore, 1873).

architect Robert Mills and Robert Gilmore, Baltimore collector and chairman of the Washington Monument Committee, and suggested that they purchase a bronze bust of William Pinkney, the famous Baltimore lawyer and senator. Causici cast the bust in New York, creating the first foundry-cast bronze sculpture in America:

> [my] respect for that gentleman [William Pinkney] has induced me since my arrival in this city to execute a most perfect likeness of him in Bronze—The Bust is of the same dimensions as the model I left for some time in possession of Mr. Meredith and is the first specimen ever executed in America. . . . I am willing to relinquish to the Bar of Baltimore, the Bronze Bust in consideration of $700 dollars. You will please to submit my offer to some of your distinguished friends and favor me with a reply as soon as possible.

The artist noted that it was customary in Europe to have busts made in bronze, "as they are infinitely more durable than marble."[49] The members of the bar never purchased the bust, but they did approve Causici's proposal for the Washington figure to surmount their classical shaft, recently designed for the city by architect Robert Mills (fig. 14).

[49]Washington Monument Papers, vol. 1, Maryland Historical Society.

FIG. 15. *Seal of Baltimore.*
(*Courtesy the author.*)

Causici was not the only competitor for the monument commission. There were eight others, including Antonio Capellano, who had recently completed the successful Baltimore battle monument. The positive reception of Capellano's sculpture and its incorporation into the official seal of Baltimore (fig. 15) suggested to the artist that he would be the favored sculptor in this new venture. Believing he had the commission in hand, Capellano wrote to architect Robert Mills on May 29, 1827:

> I will execute the colossal statue of Washington in marble, agreeably to the model presented by me, for twelve thousand dollars; payments to be made as the work shall progress. I am not prepared to give an estimate of the cost of the material, not knowing what kind of Marble is to be used, but I can at any time furnish the dimensions of the blocks, and would take the liberty to recommend that the statue be composed of not more than two pieces, the projecting arm to be worked out of the solid. Neither can I state with any precision the expense of hoisting and fixing the statue when it shall be completed, but presume it would be the same whatever model may be adopted.

Capellano's reluctance to estimate labor and material expenses probably cost him the project. Another competitor, Nicholas Gevelot, was more specific about expenditures,

but Gevelot's project would have cost the Washington Monument Committee more than $18,000.[50] Causici's proposal was half that cost at $9,000, and this was certainly one of the reasons he won the contract. His model also impressed the commissioners. Gilmore recorded in his diary that on June 2 the managers of the Washington Monument met to consider the models submitted by the artists: "Morning spent in business of the Managers of the Washington Monument at 9 this morning. We decided on Mr. Causici's model of a statue for our column as the best. There were three others: two by Mr. Genelot [*sic*], and one by Capellano, but Causici's was certainly the best. It was commanding, well draped, and the attitude and likeness good. The height to be colossal, viz. fifteen feet. He offers to execute it of white marble and place it on the top for 9000 dollars."[51]

On January 22, 1828, Causici submitted a contract and waited for the marble to arrive from the nearby Baltimore County quarry. Mills insisted that the figure should be sculpted on the monument site, and so Causici moved to Baltimore from his New York studio, built a shed in which to work near the shaft, and awaited the marble. However, the Baltimore County quarry did not ship the marble for nearly a year, and in frustration Causici began to commute between Baltimore and New York in the hope of securing another commission. In June the frustrated artist wrote to Robert Gilmore from a Baltimore hotel with an ultimatum: "I am very sorry to give you notice that if the blocks of marble are not in the City in the course of three days, that I cannot do the Statue in Baltimore; I shall go to Italy to execute it."[52] The threat worked and Mills made certain the blocks were quickly delivered.

Causici could not have predicted the financial difficulties inherent in his association with Mills and the commission. Assuming that the prominent men involved would honor the conditions of his contract, Causici moved to Baltimore, where he married a local woman and set up housekeeping in his father-in-law's house. Work progressed well on the monument, but Causici was forced into grinding debt while awaiting his first payment from the committee. He soon owed money to his new father-in-law and

[50] 1st the cost of executing the figure agreeable to the design of the model will be seven thousand dollars

2nd The cost of executing the four trophies—seven thousand dollars

3rd The labor & materials for fixing the figure in its place will be agreeably to the cost of raising the statue of the Battle Monument about 2,000 dollars

4th The cost of the marble for the figure will not exceed one thousand dollars

5th The cost of the marble for the trophies—twelve hundred

6th The fixing of the trophies in their places, as they will be cut in their places will be nothing

7th The time to finish the Statue and Trophies will probably be from 18 to 24 months

8th I am not certain that I shall want my money in advance should I, approved security will be given! Or if I should need money as the work progresses, security for the amount I may need, if required, will be likewise given.

[51] Diary of Robert Gilmore, Maryland Historical Society.

[52] Enrico Causici to Robert Gilmore, June 28, 1828, Washington Monument Papers, Maryland Historical Society.

to his numerous creditors in New York. Causici's contract stated that his first payment of half the $9,000 cost was to be paid a year into the project; however, the commissioners arbitrarily decided to start counting the months after the delivery date of the marble blocks, thus extending the period for more than a year. Having trusted Gilmore and the other members of the Baltimore bar who made up the commission's membership, Causici had floated a bond in New York against payment of his fee. As Causici was contending with angry creditors and disgruntled relatives, the quarry demanded payment for the blocks and increased the cost from an estimated $500 to $600. In frustration, Causici wrote to the treasurer of the commission, David Winchester:

> I have been decieved [*sic*] so much about the statue of Washington, that I must in my present situation, related [*sic*] to you all about it. When Mr. Mills the Architect of the monument wrote to me in New York for the purpose of a model I refused it, because I had been decieved [*sic*] as everybody know [*sic*] about the bust of Pinkney—But Mr. Mills induced me to do it by telling me in letters, that I will show you that the committee would be pleased if I would do the work and execute it in this city; that every kind of assistance would be gived [*sic*] to me by the men employed to the monument, that the committee wished me to use the Maryland marble, that it would cost me 500 dollars, and that also the committee would pay the marble, when delivered in Baltimore. Instead of this I find the contrary to ever thing.[53]

In his reply, Winchester expressed regret that Causici had been "deceived by the representatives of Mr. Mills," but he hoped that Causici would "exonerate the Committee from any participation in them." He also refused to pay Causici the money owed: "However much Mr. Gilmore & myself may lamente [*sic*] the occurinces [*sic*] you mention, you must be sensible, that they cannot in any manner weaken the obligations of the contract you have entered into with us. It was wholely [*sic*] voluntary on your part, you fixed the price of the statue, & the periods when you were to be paid for its execution."[54]

Faced with bankruptcy, Causici borrowed more money from his New York creditors and continued with the project until its completion in the late summer of 1829. Realizing that he did not have the knowledge, the equipment, or the skilled labor at his disposal to raise the huge twenty-one-ton figure to the top of the shaft, Causici again pleaded with the committee to engage architect Mills for the task.[55] Treasurer Winchester agreed but also cut $1,500 from the artist's final payment. In the end, the monument cost Causici $2,000 more than he was paid for his several years of labor.

[53]Enrico Causici to David Winchester, Treasurer of the Washington Monument Society, July 1828, Washington Monument Papers, Maryland Historical Society.

[54]David Winchester to Enrico Causici, July 24, 1828, Washington Monument Papers, Maryland Historical Society.

[55]To facilitate the hoisting operation, the gigantic Washington was cleverly constructed in three sections. Despite this precaution, Causici knew that he did not have the experience, nor could he afford the equipment and crew necessary, to raise the sculpture to the summit.

Despite this mistreatment, Causici attended the raising of the final section of the statue on November 25, 1829, a significant event attended by hundreds of proud Baltimoreans. Although years of weathering have decreased the sharpness of detail, today's visitors to the monumental shaft can still distinguish from street level that Washington wears a military uniform under a great classical drape and that he is shown in the act of resigning as general—a depiction heartily approved of at the time as worthy for the first monumental sculpture of Washington in the nation.

Bankrupt and "in an agony of disappointed hopes and frustrated success,"[56] Causici was forced to leave America in search of work. The citizens of Baltimore and the many artists Causici had met in America all lamented the departure of the erudite Italian. Ironically, Gilmore expressed surprise at Causici's departure in a letter written to the artist in January 1833: "It has given me pain to learn through Winchester that your necessities, want of patronage where you are, or some other equally adverse cause drives you from our shores as I had hoped that your talents would have never waited employment, and till lately believed you engaged on works of magnitude."[57] The nineteenth-century historian of the arts William Dunlap reported that Causici left America soon after and died of cholera in Havana, Cuba.[58]

Another significant Italian artist, Luigi Persico (1791–1860), came to Washington via the Philadelphia region. Persico first appeared in Lancaster, Pennsylvania, in 1818; there he set up shop as a miniature painter and drawing teacher and made close friends who would help him in his later career in this country.[59] A native of Naples, Persico had studied at the Accademia di Belle Arti in Naples, where he took on small commissions, including a figure of "Religion" for the Church of San Francesco in Gaeta, not far from Naples. According to Accademia records, Persico also produced funerary monuments for several other churches in the Naples region.[60]

After Persico's stay of several years in Lancaster, where he perfected his English, he traveled to Harrisburg to find work in the new state capitol and soon moved to New York, where he sculpted portrait busts, the bread and butter of nineteenth-century sculptors. He subsequently worked in Philadelphia, modeling a colossal head of Lafayette that was used as a decoration at the dinner held in Washington Hall in honor of the general's visit in 1824. He also sculpted busts of Washington and other notable Philadelphians.

Persico left Philadelphia in 1825 for Washington, where architect Charles Bulfinch granted him the commission for the sculpture in the central tympanum of the east

[56]*Niles Register,* Sept. 21, 1833, p. 53.

[57]Robert Gilmore to Enrico Causici, Jan. 17, 1833, Washington Monument Papers, Maryland Historical Society.

[58]William Dunlap, *The Rise and Progress of the Arts of Design in the United States* (New York, 1834).

[59]W. U. Hensel, "An Italian Artist in Old Lancaster, Luigi Persico—1820," a paper read before the Lancaster County Historical Society, Mar. 8, 1912.

[60]Accademia di Belle Arti, Naples.

Fig. 16. Luigi Persico, *Genius of America,* 1825–28, U.S. Capitol east facade, central portico. *(Courtesy Office of Architect of the Capitol.)*

front of the Capitol, the *Genius of America* (fig. 16). President John Quincy Adams had mandated the design after an unsuccessful competition. Thirty-six models had been submitted by sculptors and architects, but Adams found none to be acceptable. Adams cautioned against using mythological characters or Victory figures, and most of the characters and iconography of Persico's original design were discarded as too Roman or too heathen for Adams's taste. In the final version his Hercules was eliminated, as were a Roman fasces and a Liberty cap. Much toned down, the group was described by Bulfinch: "A figure of America occupied the centre . . . her left hand pointing to the figure of Justice, while on the left . . . is the eagle, and the figure of Hope resting on her anchor. . . . The figures are bold, of nine feet in height, and gracefully drawn by Mr. Persico, an Italian artist." Although acquiescing to the president's plan, Persico's figures are typical of his work, and his eagle retains a distinctive Italian weightiness and demeanor that belies its perch on an American building.

The companion pieces, *Peace* and *War,* sculpted for the niches (figs. 17 and 18), were completed in 1834. The two Washington figures are typical static neoclassical renditions of ancient Roman sculptures of Mars and Minerva. Persico won this commission thanks to James Buchanan, Democratic senator and later fifteenth president, who was a friend from the Italian's early days in Lancaster. It is interesting to note that a Neapolitan newspaper lists Persico as a competitor in a similar competition for a larger-than-life-size figure to occupy a ground-floor niche on the facade of the Palazzo Reale, an edifice in Naples equivalent in meaning to the U.S. Capitol. Persico's competition drawings or models for the Italian competition have yet to be found, but the idea of transnational artistic interchange is intriguing.

FIG. 17. *Peace,* 1834,
U.S. Capitol, east facade,
central portico. *(Courtesy
Office of Architect of the
Capitol.)*

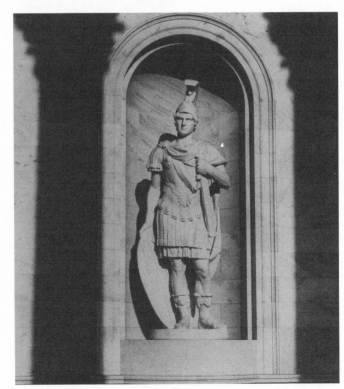

FIG. 18. *War,* 1834,
U.S. Capitol, east facade,
central portico. *(Courtesy
Office of Architect of the
Capitol.)*

Persico's final work, the group called *Discovery of America* (fig. 19), located on the left of the staircase on the east facade, was not completed until 1844. As of this writing, the work is in storage, along with the companion piece, the *Rescue,* by American Horatio Greenough. By the time Persico began work on the sculpture in the late 1830s, he was less indebted to ancient Roman models than he was to contemporary Italian sculptures, such as Lorenzo Bartolini's well-known monument to Alberti in Santa Croce, dating from 1838. Although the subject is different, Bartolini's sculptural style —the frontality and natural, planar simplicity of form—is reminiscent of Persico's Columbus and the Indian maid. The crouching hesitant maiden is a modern Niobe figure, and Columbus is a modern incarnation of the explorer, handing the hemisphere to the modern world. After Persico's time, Capitol commissions began to be won by Americans trained in Italy.

THE DIFFICULTY IN assessing the Italian influence on American political iconography and the Capitol's role in its formulation and its dissemination is compounded by the destruction of the earliest Italian works in the fire of 1814. We also have little anecdotal evidence from the artists to tell us of their direct sources and their considerations about crafting icons for a country that was not their own. Our records, many of them payment records, tell a skewed story that places emphasis on the intentions of the commissioners or documents the artists' complaints about money matters rather than revealing their ideas. And, our earliest assessment of the Italian production was formulated by critics who were, for the most part, provincial in their taste and knowledge of art and visual history. However, we can be certain that some of the Italians came with an interest in and an enthusiasm for American politics and that all arrived with the lore of ancient and modern Rome and Roman imagery firmly entrenched in their creative beings. These artists were also conversant with contemporary Revolutionary imagery. The American Revolution preceded the many revolutions in Europe, and so Revolutionary subjects and symbols were familiar to the Italians. We also know that they tended to be gregarious and were eager to make contact, and so they passed on their skills, ideas, and visual resources to the budding American sculptors and craftsmen who assisted them in their projects.

The pervasiveness of the Italian influence and its dispersion from the Capitol to the far reaches of the nation can be traced in more mundane venues than monumental sculpture—such as schoolbooks, coins, and even stationery. An engraving of an American youth embracing Washington—the frontispiece for a book on Washington's life published in 1848 and reprinted many times—was modeled after Ceracchi's bust, the bust that Washington's own relatives said looked most like the first president than any other (fig. 4). The same illustration is also found in children's textbooks from the period,

Fig. 19. Luigi Persico, *Discovery of America,* 1837–44, in storage since 1958. *(Courtesy Office of Architect of the Capitol.)*

FIG. 20. Carlo Marocchetti, *George Washington,* ca. 1852. *(Courtesy the author.)*

demonstrating how specific images of Washington became easily assimilated into the American consciousness via educational literature.

At a given point, the Italians' authority waned as American sculptors, informed by study in Italy, took over the job of making their nation's monuments. Italians, though, were still competing for the opportunity to create our political icons.[61] This interest is obvious in the sculptures featured in the Italian sections of the Fine Arts Buildings in the three major expositions held in the United States in the nineteenth century.[62] At each event an Italian artist sent a work intended to be sold to the American government for installation in the Capitol rotunda.

The centerpiece of the main building at the New York Crystal Palace exhibition in 1853 was a massive equestrian sculpture of George Washington (fig. 20) executed in 1852 by Carlo Marocchetti (1805–1867), one of Italy's best-known nineteenth-century sculptors. As a contemporary commentator noted, Marocchetti's Washington "stands just under the center of the dome, just where, in obedience to a proper patriotic senti-

[61]This study of sculptures for the Capitol ends with Persico's involvement. Many other Italians worked on later projects, although the details of much of their association have not been recorded. As Americans took on the most prominent commissions, Italian craftsmen still labored on the building and offered their assistance to the artists.

[62]For further information about Italian sculpture at the various international expositions of the nineteenth century, see Pamela Potter-Hennessey, "Sculpture at the 1893 Chicago World's Fair: International Encounters and Jingoistic Spectacles," Ph.D. diss., University of Maryland, 1995.

Fig. 21. Pietro Guarniero, *Bust of Washington,* ca. 1876. From Edward Strahan [Earl Shinn], *Masterpieces of the Centennial Exhibition*, vol. 2 (Philadelphia, 1876).

ment, it ought to stand as the boldest feature of the American exhibition."[63] The popular sculpture became the informal emblem of the exhibition, and, for a time, was also used to illustrate children's textbooks. Marocchetti's work, though, never made it to the Capitol, and it was shipped back to Italy when the exhibition closed.

During the 1876 Philadelphia Centennial Exhibition, an Italian portrait bust of George Washington created quite a stir when the artist advertised his intention to sell his sculpture to the American government and have it placed in the Capitol rotunda. Within Memorial Hall in Fairmount Park, hundreds of foreign and American sculptures were viewed by the 10,000 visitors who flocked to the exhibition from every region of the nation. Through the main entrance, visitors passed into the South Hall, where Italian marbles lined the walls. At the north end of the hall, three large archways spread into the rotunda. Prominently positioned in front of the arches was a colossal bust of Washington by Pietro Guarniero (1842–1881) of Milan (fig. 21). The reception of the bust was hardly the positive response expected by the artist. Dubbed "Washington on a Chicken" by the American press,[64] the sculpture was disliked intensely and became the butt of numerous jokes. Guarnerio had haplessly depicted a half-length Washington carried off by Jupiter's eagle. If Guarnerio had chosen to keep

[63]Ibid., p. 30.
[64]Ibid., p. 57.

FIG. 22. Ettore Ferrari, *Dying Lincoln*, ca. 1893. *(Photograph courtesy the author.)*

Washington in this earthly realm, the sculpture might have fared better. American critic Edward Shinn claimed the portrait was ridiculed "because the lower part of the bust was finished off with a gigantic eagle," and because the "average American's superb ignorance of things classic and traditional" meant viewers were incapable of understanding the sculpture's iconography.[65] Whether it was the truncation of the bodily president, Washington's conveyance to heaven by an eagle, or the odd juxtaposition of man and bird that turned the public against this work, Guarnerio never found a buyer. The Washington *Evening Star* reported the sculpture sold at auction for nonpayment of custom duties.[66] In Italy, the newspaper *La Reppublica* reported a different story, claiming Guarnerio's sculpture had been bought by the government—and would have been sent to the Capitol, except for confiscation by greedy customs officials.[67]

By the 1893 Columbian Exposition, Italian artists had become even more unaware of what the American public would understand and tolerate. At this final nineteenth-century exhibition, several Italians shipped large-scale marble sculptures destined, as

[65]Edward Strahan [Earl Shinn], *Masterpieces of the Centennial Exposition,* vol. 2, *Fine Arts* (Philadelphia, 1876), p. 58.

[66]*Evening Star* (Washington, D.C.), as reported in the *New York Tribune,* Feb. 21, 1878, p. 1.

[67]*La Repubblica,* undated clipping, Bibliothèque Nationale, Paris, France.

Fig. 23. Adolfo Apolloni,
American Mythology, ca. 1893.
From Hubert Howe Bancroft,
*The Book of the Fair: An Historical
and Descriptive Presentation of
the Worlds of Science, Art, and
Industry, as Viewed through the
Columbian Exposition at Chicago in
1893* (New York, 1894).

far as they were concerned, for the Capitol. The most discussed was a life-size marble of the *Dying Lincoln* by Ettore Ferrari (1848–1929) (fig. 22). Although Ferrari's portrait was historically incorrect (Lincoln was portrayed dying in an armchair instead of a bed), American critics and fairgoers alike were impressed with the skill of the artist. The *Dying Lincoln* remained in the United States after the fair closed, but it never reached the Capitol rotunda, and it has been impossible to trace.

The focal point of the Italian display was another sculpture the artist hoped would travel to the Capitol. Adolfo Apolloni's (1855–1923) *American Mythology* (1892, fig. 23), a life-size marble allegory of America as a capering nude female figure perched on a pedestal with a telephone receiver pressed to her ear, was meant to be understood as a compliment to American ingenuity—the personification of the "spirit of new world progress." The marble tribute received mixed reviews, and most critics thought the sculpture was inappropriate for the Capitol. Although offered to the government, nothing came of Apolloni's inquiries and *American Mythology* was returned to Italy.

By the end of the nineteenth century, Italian artists had lost touch with America's requirements for monumental sculpture. Their predecessors, though, had understood their political time and used the inherently abstract nature of classical sculpture to offer the political leaders of eighteenth-century America an ideal template through which to mobilize ideas. The neoclassical bodies of these idealized stone characters can be seen as a mirror of the body politic, as a cipher for a deeper set of social concerns, their planar surfaces providing visual evidence of their structural integrity. The absence of specificity and mundane narratives in these early works provided an abstract trigger, prompting the viewer to complete the meaning of the sculpture by imaginative association. The Capitol, the final locus of political meaning, was studied by Americans for its symbolic significance. Whether the sculptures were all understood by the average American is unclear, but what is certain is that a debt is owed by the Capitol builders and by future generations of Americans to the Italian sculptors for their contributions to our national iconography.

A New World Pantheon

Italian Sculptural Contributions in the Capitol Rotunda

Pamela Potter-Hennessey

After the British burned the Capitol in the summer of 1814, a second phase of construction began on this important symbol of American democracy and liberty. Benjamin Henry Latrobe, who had retired as architect of the Capitol, was brought back to oversee the rebuilding until 1817, and then from 1818 to 1829 Charles Bulfinch took over the project. It was during Bulfinch's tenure that the sculptural decorations inside the rotunda were commissioned and completed. These embellishments include four sandstone relief panels over the doorways that illustrate stories from America's colonial past—the *Preservation of Captain Smith by Pocahontas* (fig. 1) over the west door, the *Landing of the Pilgrims* (fig. 2) above the east door, the *Conflict of Daniel Boone and the Indians* (fig. 3) above the south door, and *William Penn's Treaty with the Indians* (fig. 4) over the north entrance. There also are four portrait busts in relief of explorers—John Cabot (fig. 5), Christopher Columbus (fig. 6), Robert La Salle (fig. 7), and Sir Walter Raleigh (fig. 8)—a group representative of American history before European settlement. The Italian sculptors Enrico Causici and Antonio Capellano executed three of the four panels and the four portraits with the assistance of Francesco Iardella.[1] The carver of the fourth panel, French

[1] Francesco Iardella (1793–1831) worked as a "carver" at the Capitol and is credited for modeling the tobacco capitals in the north wing. According to Fairman, Iardella was brought to America to carve decorations for the mansion of Robert Morris (Charles E. Fairman, *Art and Artists of the Capitol of the United States of America* [Washington, D.C., 1927], p. 2). Iardella has been incorrectly credited with sculpting the rotunda panels because he is listed in payment records (see Kathleen Castiello, "The Italian Sculptors of the United States Capitol, 1806–1834," Ph.D. diss., University of Michigan, 1974). Little is known about Iardella. He is listed with the correct spelling of his first name in Afonso Panzetta, *Dizionario degli scultori italiani dell'ottocento* (Naples, 1991), p. 42.

FIG. 1. Antonio Capellano, *Preservation of Captain Smith by Pocahontas,* 1825. *(Courtesy Office of Architect of the Capitol.)*

sculptor Nicholas Gevelot, was trained in Italy and spent much time studying and working in Rome and Florence before traveling to America. The Italian influence on the interior of this American pantheon is undeniably significant and perhaps more pervasive than suggested in the past.

The Roman influence on the concept of the Capitol has long been acknowledged, and its link to the Roman Pantheon and to Capitoline Hill, the highest spot in Rome and the locus of political power, is well known.[2] The American cult of antiquity was at its height at the turn of the eighteenth and nineteenth centuries when the builders of the Capitol formulated their plan for the structure. The founding generation shared a common core of knowledge of Rome, its myths, its building programs, and its emblems. In their efforts to formulate a distinctive national culture and to create viable institutions, classical virtues were held up as models of Republicanism, lessons from the past were used as exemplars of civic virtue, and Roman icons were incorporated into a new American visual language. However, by the 1820s classical education in America was on the wane.[3] This shift was coupled with a new search for what was truly American about life and culture in the New World, and citizens began to pay less attention to the debts owed to ancient cultures and to the influences of foreign nations,

[2] For the Pantheon's pervasive influence on later architecture, see William Lloyd MacDonald, *The Pantheon: Design, Meaning, Progeny* (Cambridge, Mass., 1961).

[3] For further information about classical education and tradition in America, see Louis Cohn-Haft, "The Founding Fathers and Antiquity: A Selective Passion," *Smith College Studies in History* 66 (1980):137–53; John W. Eadie, ed., *Classical Traditions in Early America* (Ann Arbor, 1976); Wolfgang Haase and Meyer Reinhold, eds., *The Classical Tradition and the Americas,* vol. 1, "European Images of the Americas and the Classical Tradition" (New York, 1994); Edwin A. Miles, "Young American Nation and the Classical World," *Journal of the History of Ideas* 35 (1974):259–74; Frederick Rudolph, *Curriculum: A History of the American Undergraduate Course of Study Since 1636* (San Francisco, 1977).

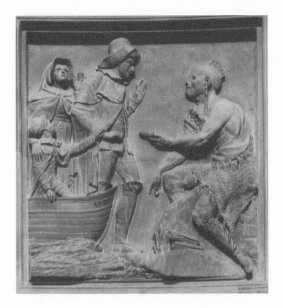

FIG. 2. Enrico Causici, *Landing of the Pilgrims,* 1825. *(Courtesy Office of Architect of the Capitol.)*

FIG. 3. Enrico Causici, *Conflict of Daniel Boone and the Indians,* 1826–27. *(Courtesy Office Architect of the Capitol.)*

FIG. 4. Nicholas Gevelot, *William Penn's Treaty with the Indians,* 1827. *(Courtesy Office of Architect of the Capitol.)*

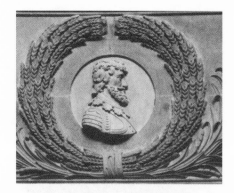

Fig. 5. Francisco Iardella, *John Cabot,* 1828. *(Courtesy Office of Architect of the Capitol.)*

Fig. 6. *Christopher Columbus,* attributed to Francisco Iardella. *(Courtesy Office of Architect of the Capitol.)*

Fig. 7. *René Robert Cavelier Sieur da La Salle,* Francisco Iardella, 1829. *(Courtesy Office of Architect of the Capitol.)*

Fig. 8. Attributed to Francisco Iardella, *Sir Walter Raleigh. (Courtesy Office of Architect of the Capitol.)*

ancient or modern.[4] By the time the Italian sculptors began their work in Washington, Americans viewed them as strangers, immigrants who did not speak their language and with whom they had little in common. It is unlikely that the makers of the rotunda sculptures discussed their subjects and compositions with reporters, politicians, or with many ordinary citizens. Their contact with the populace was limited. When the projects were completed for this sacred American space, it is also doubtful that visitors recognized any Italian influences injected into the structure via the sculptures. The subjects illustrated by the panels were American, and their meanings for the average citizen would only have been linked to American history.

The rotunda reliefs have been dealt with iconographically by historian Vivien Green Fryd, who has done a remarkable job of assessing and interpreting the works while documenting the chronology of all the rotunda decorations.[5] Fryd characterizes the stories illustrated as the colonists' interaction with the native population and discusses how the panels explore the progression in the relationship from "assimilation" to "segregation" to the final "subjugation" of the Indians. This essay will not offer further interpretations but rather will flesh out the story of the Italian sculptors' contributions to the Capitol and begin to assess their impact.

The Italian sculptors who came to America in the early years of the Republic have tended to be dismissed as mere opportunists, and it has been suggested that when they found the market less lucrative than expected they quickly left the country for better opportunities. In most cases this was not true, although many were disappointed by their American experiences, and several of the artists were driven from our shores, both bankrupt and disillusioned. They all relocated here at great expense, moving families, studio assistants, and materials across the ocean in hopes of finding a new market for monumental sculpture. For some, the prospect of contributing to the New World republican experiment was a tremendous lure—an opportunity to help formulate political icons for a cause in which they believed.[6] Regardless of their enthusiasms, the problems the Italians faced as foreigners in this country were numerous and often insurmountable. Even those with extensive business experience found it difficult to negotiate with American patrons who did not speak their language. Neophytes and

[4] In 1829 Caleb Cushing wrote that "time has been, when all that was most perfect in matters of taste . . . was claimed as the exclusive birthright of the ancients . . . In many things the ancients were unquestionably inferior to us . . . any alleged superiority . . . would not prove that we cannot surpass the ancients" (*North American Review* 28 [1829]:313–14).

[5] Vivien Green Fryd, *Art and Empire: The Politics of Ethnicity in the United States Capitol, 1815–1860* (New Haven, 1992). Chapter 1 deals with the rotunda reliefs. Fryd also discusses the procurement of Italian sculptors to work on Capitol projects and sketches the chronology and events of the formation and decoration of the rotunda.

[6] Italian interest in American politics and the Italian sculptors' participation in early projects is mentioned in connection to Jean-Jacques Caffieri's bust of Washington in *Galleria storica universale di ritratti: Raccolta di 300 reitratti dei più celebri personaggi di tutti ipopoli e di tutte le condizioni dal 1300 in poi tolti dai migliori origniali del tempo, con cenni biografici illustrativi,serie secondo* (Milan, 1890).

veterans alike were taken advantage of by a wide variety of contacts, including land-lords, patrons, architects, stone masons, and government officials. In addition, their initial assessment of the American market was far too optimistic, not taking into account the lack of government funds and the generally pragmatic approach to architecture and its decoration. Most arrived in New York with great expectations, but the sculptures the Italians produced in New York, Philadelphia, and Baltimore often fell short of their ideals—limited by the lack of quality materials, inadequate financial support, and a generally lukewarm commitment to the arts in this country. After these disappointing experiences, the prospect of steady work on Capitol building projects lured them to Washington. It was a profound disappointment to the sculptors when commissioners hired them by the job, despite the government's hint of well-paying commissions and regular employment.[7] Every sculptor who worked on the Capitol found himself out of work between projects.[8]

It has also been suggested that the Italians came to America to establish their artistic reputations because they held little hope of competing with more talented sculptors in Italy. Instead, most artists who ventured here had already produced significant works in Europe, including the sculptors who worked on the rotunda reliefs.[9] Capellano and Causici arrived with outstanding credentials. Both had been pupils of the venerated Italian sculptor Antonio Canova, and both had assisted the great artist on a number of his Roman projects. Causici also worked for Berthel Thorvaldsen, helping to carve the *Tomb of Cardinal Consalvi* in the Pantheon, a much-publicized project initiated a decade before the cardinal's death in 1824.[10] Canova and Thorvaldsen, the most famous neoclassical sculptors in the world at the time, would not have hired Capellano and Causici to assist them if the two men had not been talented and competent. Furthermore, by the time Capellano immigrated to America, he was an established sculptor in Genoa with a wide patronage and an active studio in the center of the city. He also held a prestigious position as professor of marble at Genoa's Accademia di Belle Arti.[11]

[7]When Bulfinch wanted to entice Causici to participate in the sculpture program for the rotunda, he hinted at also awarding the sculptures for "the Tympanum of the great pediment of the portico" and encouraged the artist to create a model for a clock project. Neither project materialized for the artist. Bulfinch to Causici, July 8, 1822, Commissioners of Public Buildings, RG 42, National Archives and Records Administration (NARA).

[8]A typical response to all the artists' pleas for regular payment is found in correspondence between the commissioner of public buildings and Causici as early as 1819: "I have given your demand for compensation during the last quarter my most serious consideration & I am sorry to find myself compelled to disallow it. . . . I have only to add that your services are no longer required." Commissioner of the Public Buildings to Causici, Apr. 7, 1819, NARA.

[9]Regina Soria acknowledged the previous experience of many of the sculptors who came to America in "Early Italian Sculptors in the United States," *Italian Americana* 2 (1976).

[10]Consalvi's tomb is located next to the much-visited tomb of Raphael.

[11]Capellano taught at the Accademia and maintained a private studio near the Ponte della Legna in the vicinity of the harbor. His most lucrative projects were for Genoa's cemetery, Staglieno.

Why then did these successful men remove themselves to a country with no artistic history? The answer must differ for each, but both artists may have taken advice from their mentor Canova, who knew firsthand of the need for sculptors in America.[12] In addition, many other Italian sculptors had preceded them to America, including the infamous Giuseppe Ceracchi, considered second only to Canova during his lifetime and whose American connections were well known in Europe.[13] Italian admiration for the nascent United States and interest in our Republican experiment was widespread, and so the Capitol sculptors must have reveled in the prospect of participating in the birth of sculpture in America.[14]

In addition, personal circumstances persuaded some to move across the ocean to unknown territory. Capellano, for example, sailed for America with his wife and five children in 1815 to seek, as he put it, "asylum in this country."[15] Increasing pressure from his creditors meant that he faced prosecution for unpaid debts, and unspecified political difficulties that arose while working for the Bonapartes in Madrid were also worrisome to Capellano.[16] In order to avoid prison and to find new patronage he abandoned his studio and relinquished his position at the Accademia.[17] He may have selected America as his new home because of an early encounter with Thomas Jefferson in Genoa. Capellano had met Jefferson in 1787 when the young American diplomat visited his studio to inquire about marble mantelpieces for Monticello.[18] It is probable that Jefferson waxed enthusiastic about the future of the arts in America, and this meeting may have helped Capellano decide that America was the country to which he should retreat.

[12]Benjamin Henry Latrobe contacted Philip Mazzei about hiring Canova to produce the first sculptures for the Capitol. Mazzei replied that Canova was unavailable. Letter from Latrobe to Mazzei, Mar. 6, 1805, cited in Fryd, *Art and Empire,* p. 216 n. 10.

[13]Ceracchi worked in America first in 1791, producing a number of sculptures in New York and Philadelphia, including many portrait busts of significant Americans. Unsuccessful in sparking interest in a monument to Washington, he returned to Italy and then reappeared briefly in Philadelphia in 1794 with marble busts that were given as presents to the sitters. He hoped to promote a huge monument project dedicated to Liberty, failed in his efforts, and left again for Italy, where he was guillotined in 1802 for his part in a plot to assassinate Napoleon (Ulysse Desportes, "Ceracchi in America," *Art Quarterly* [1963]:141–78).

[14]For a discussion of the Italian interest in America, see Giorgio Spini, *Italia e America dal Settecento all'età dell'imperialismo* (Rome, 1976).

[15]Antonio Capellano to Robert Cary Long, Nov. 20, 1818, Manuscript Collection, Long Correspondence, Maryland Historical Society, quoted in I. T. Frary, "The Sculpted Panels of Old St. Paul's Church, Baltimore," *Maryland Historical Society Magazine* 34 (1939):65.

[16]Capellano worked as first sculptor to the Napoleonic court in Madrid (Regina Soria, *American Artists of Italian Heritage, 1776–1945: A Biographical Dictionary* [London, 1993], p. 53).

[17]Capellano lamented to Long that "the circumstances which induced me to seek an asylum in this Country are well known—the embarrassments in which they have thrown me are so great, that I must pass over in silence a subject so painful" (Frary, "Sculpted Panels of Old St. Paul's," p. 65).

[18]The encounter took place in April 1787 in Capellano's studio (George Green Shakleford, "A Peep into Elysium," *Jefferson and the Arts: An Extended View* [Washington, D.C., 1976], p. 256).

Enrico Causici also arrived in America about 1815. After a brief stay in New York, where he modeled an equestrian portrait of George Washington, he moved on to Baltimore to win the much sought-after commission for the 16½-foot, 17½-ton figure of Washington for Robert Mills's monument to the first president.[19] Before completing the Baltimore project, he created his most famous work in America, the *Genius of the Constitution* (1817–19), sculpted in plaster for the Capitol building. When placed over the Speaker's chair in the House chamber, now Statuary Hall, the heavily draped female figure looked more Roman than American, a fact that must have been obvious to the artist. She is a formidable presence, with an eagle at her right and a snake-entwined fasces—the Roman symbol of power and authority—on her left.

Causici's two sandstone panels for the rotunda are less monumental, in part because they are sculpted in relief rather than in the round.[20] Surprisingly, the artist determined the subjects, the *Conflict of Daniel Boone and the Indians* and the *Landing of the Pilgrims.* Bulfinch had the authority to choose the artists and topics. When he contacted Causici in Baltimore, offering the commission for two of the four panels, he stated that the works might represent "either the discovery of America by Columbus, or . . . the landing of Capt. Smith in Virginia; & the other, the Declaration of Independence, or the adoption of the Federal Constitution." He left the final decision to the sculptor.[21] Causici rejected the four topics suggested by Bulfinch and chose subjects that he preferred, with the potential for dramatic results that would "read" well from below. There are no extant documents to suggest that Bulfinch or any other government official objected to his selection.

While both reliefs are competent works, neither resembles Causici's other American

[19]The equestrian portrait of Washington was never cast in bronze. Only the two models were completed, and although the one based on the Roman equestrian of Marcus Aurelius was lauded as "an inimitable model," no sponsor came forward to pay for the finished work (*Niles Register,* Sept. 21, 1833, p. 53). The work did travel to Washington, where it was put on display. "The original model of an Equestrian Statue, designed for the city of New York, by Mr. Causici, will be exhibited in the Rotundo of the Capitol to-day. The statue itself will be slightly colossal—the model is on a much smaller scale, but gives a correct idea of the merit of the design. Mr. C. executed for the city of New York two models, one possessing much action; the other, (the present one) less, and is in the style of the celebrated Roman statue of the Emperor Aurelian" (*Daily National Intelligencer* [Washington, D.C.], Feb. 3, 1825).

[20]Sandstone was a disappointment to Causici, who preferred marble. Sandstone does not hold an edge, and its matte surface does not have the reflective qualities admired in marble. Causici's *Genius of the Constitution* also was made of an inferior material, plaster. The artist expected to be able to translate the work into marble one day, but the opportunity never arose, once more due to lack of funds.

[21]Bulfinch cautioned the artist, who had stated a preference for working in marble, that the project would likely be executed in stone, a more affordable material. He also solicited a design for the building's central tympanum and noted that the budget for the year did not include funds to pay for the sculptures. He suggested that Causici begin a design for sculpture to accompany a clock in the Senate chamber, a project that Congress might agree to in marble. The subject would be at the artist's discretion, as long as the figure of Time appeared in the composition. Causici was paid $2,000 for a model, but the project was dropped because of the proposed expense. Unfortunately, no drawing exists to show Causici's design. Charles Bulfinch to Enrico Causici, July 8, 1822, Commissioner of Public Buildings, RG 42, NARA.

productions stylistically. There is a continuity among all of the rotunda panels. Perhaps Causici and his fellow sculptors, Capellano and Gevelot, agreed upon an approach to the entire group, although no document has been located to tell us if there was consensus. All four sculptures were heartily criticized throughout the nineteenth century for perceived aesthetic shortcomings and for inaccuracy in depicting subjects and characters.

To observers, the newly arrived protagonists in Causici's *Landing of the Pilgrims* (1825), for example, appeared more European than American and their costumes were a disappointment. One critic noted:

> The Indians on the rocks, the shore, the sea, are all well executed; but the artists mistook the character of the comers to the New World; he has given the religious hat of the ancient Pilgrim, and the dress also; when nothing would be farther from the truth. They were puritanical adventurers, not crusading pilgrims. The subject is much better for the pencil than the chisel; but it was given to illustrate a portion of American history, and the artist was told the story by those who, probably did not precisely understand the capacities of his art, and he set about it as it was, a subject dictated to him. The Pilgrims of that day never thought of their glory in stone.[22]

Causici was unfamiliar with American Pilgrims' mode of dress, and so he gave them soft, low-crowned hats with wide turned-up brims, which he patterned after European and the biblical pilgrims' headgear. Unlike the high-crowned, stiff hat of the New World Pilgrim, Causici's portrayal drew immediate criticism from American viewers.

Causici's second panel, *The Conflict of Boone and the Indians* (1826–27), fared better with the critics, who pronounced the work more accurate than the *Landing of the Pilgrims.* The artist was commended for his recognizable likeness of Boone, whose curly hair and features were approved of by Boone's own relatives. Architect Robert Mills passed judgment by stating publicly that "full justice has been done to the form and features of the intrepid Boone, whose cool resolution and self-possession are strongly contrasted with the ferocity and recklessness of the savage."[23] The active scene and the demeanor of the figures conformed to America's view of the Indian as bloodthirsty and savage. A critic wrote in 1848:

> Some years ago a band of Winnebagos came through the Rotundo. They were all notable fellows, dressed in their own barbaric uniform. Their faces were painted various colors, and in their belts were their scalping knives and tomahawks, and over their backs their long iron looking bows and arrows. As they were passing through the Rotundo,

[22]Samuel L. Knapp, *The History and Topography of the United States of North America from the Earliest Period to the Present Time* (Boston, 1834), pp. 426–27.

[23]Robert Mills, *Guide to the Capitol and to the National Executive Offices of the United States* (Washington, D.C., 1834), p. 34.

their attention was arrested by this group of statuary—Boone killing the Indians. They formed a semi-circle, and the headman stepped forward and stood before the rest. They looked intently for some moments, scrutinizing and recognizing every part of the scene, and suddenly, as of one impulse, they raised their dreadful war-cry and ran hurriedly from the hall.[24]

If we follow Fryd's interpretation of the decorations and agree that the narrative illustrates the subjugation of the Indian population, we can understand the audience's more positive reception to this second panel. Boone's superiority, with distinctive knife and rifle, spells defeat for the Indians, while the scene in the *Landing of the Pilgrims* only suggests the settlers' dominance over the native population.

Antonio Capellano's contribution, *Preservation of Captain Smith by Pocahontas* (1825), sparked mixed reactions. The characters' Italian features were not missed. An 1832 account in *Atkinson's Casket* noted:

> This is the work of Capelano [*sic*], an artist of considerable talent; but he had seen more Italians than Indians, and his savages are Italian banditi, and his intended child of the forest an Italian Queen. In this picture, however, not withstandin [*sic*] all its defects, there is more variety of expression in the countenances of the group than is generally found in stone. The work attracts much attention, and elicits many criticisms; but it will continue to be admired in spite of its faults.[25]

At the heart of the criticism was the question of ethnicity, while the action and narrative appealed to most observers who recorded their reactions to Capellano's panel. The story, one of assimilation, tells us of Pocahontas's good deed, while her gesture of supplication and the lamentation-like pose of Smith tell us of her later religious conversion.

Nicholas Gevelot's contribution to the group, *William Penn's Treaty with the Indians* (1827), is the least active composition among the four panels and the most vigorously critiqued.[26] The artist followed a well-known pose of Penn derived from the Silvanus Bevan William Penn Medal (1720), and so responsibility for the static quality of the composition cannot be given to Gevelot entirely.[27] Both the static nature of the composition and the depictions of Penn and the Indian elicited an avalanche of negative response. In 1830 a Washington chronicler condemned the pose: "contrasted with the

[24]*Picture of Washington and Its Vicinity for 1848* (Washington, D.C., 1848), pp. 60–61.
[25]*Atkinson's Casket, or Gem of Literature, Wit and Sentiment* 7 (1832):315.
[26]Very little is known of Gevelot. He was born in France, but it appears that he studied and worked in Rome for a number of years and then traveled to America. Information found thus far about Gevelot's career ends with his Capitol commission.
[27]Discussed and illustrated in Fryd's *Art and Empire,* p. 30. The Bevan peace medal as prototype for Gevelot's panel is also mentioned in an anonymous, unpaginated manuscript about the life of William Penn in the Pennsylvania Historical Society.

animated and spirited efforts of Causici and Capellano . . . it is thought heavy and dull in its execution."[28] A contributor to *Hinton's History and Topography of the United States* also disdained the work:

> [Penn] is holding the parley, in the fearlessness of innocence with the savages, who seemed to have caught the same spirit to be governed by the same peaceful principles. This treaty is worthy of all praise, for it was kept inviolate for seventy years; but the moral sublimity of the subject must be fully understood before you can relish the design. There is neither beauty nor attraction in it, taken by itself, the capacities of art do not reach such a subject. The painter would do better here. Gods, not men should breathe in stone. They are only seen in naked majesty.

The writer preferred the timeless nudity of classical sculpture to the modern, overdone dress of William Penn. He protested that "Phidias could not have given immortality to a modern martinet, in dress, with all his frogs and taggery."[29] Pennsylvanians subjected the panel to the greatest scrutiny and the harshest judgments. One complained bitterly that "no person could cast his eye on the figure intended for the great and venerable person, and not turn away in disgust."[30]

Whether nineteenth-century observers disliked or admired the sculptures, they drew much attention from passersby. Their success in attracting an audience and relaying an understandable story can be attributed to the simple, straightforward compositions and the shallow space defined by boxlike framing. Limited distractions help focus the narrative. The group is reminiscent of the simplified conceptions found in Roman Imperial sculptures, and the artists may have consciously used ancient reliefs as their prototype to ensure that the panels would be decipherable in the grand space of the rotunda. As with classical reliefs, the frames of the panels define a tract of space, marking the limits of an imaginary scene in which the action takes place. It is not so much a window through which to view an infinite landscape as it is the proscenium opening, regulating the height and breadth of the stage.

Further links to ancient Roman art can be found in the portraits of the explorers. All are evocative of Roman funerary reliefs in their makeup and in their meaning— the raising of the dead to a special status. They transmitted to the American audience a particularly Christian way of thinking, that typological method whereby the old presaged the new, and the present—our push to acquire new territory and explore farther west—was foreshadowed by the past. The garlands surrounding the heads must

[28]Jonathan Elliot, *Historical Sketches of the Ten Miles Square Forming the District of Columbia* (Washington, D.C. 1830), p. 27.

[29]Knapp, *History and Topography of the United States,* p. 427.

[30]U.S. Congress, *Register of Debates,* House, 19th Cong., 1st sess., May 18, 1826, cited in Fryd, *Art and Empire,* p. 36.

have been inspired by the ubiquitous floral motifs on Imperial buildings and on Roman sarcophagi.

Still, the question of the degree of Italian influence and reception by the audience remains. Even if a conscious goal of the artists was to impart an Italian nature to the Capitol, it is difficult to determine the response to that quality by the rotunda visitors. We have no idea if viewers understood the visual and historical connections to Roman art and history. Furthermore, the 1814 fire destroyed most of the Italian works preceding the rotunda panels and portraits, thus limiting the scope of the Italian impact on future audiences. Yet, when it comes to assessing the importance the Italians themselves gave to all their Capitol projects, we can be assured they believed their work was extremely valuable. Letters exchanged with Capitol officials state this conviction repeatedly, telling us that the Italians were eager to leave their mark on the country's most important monuments. It was very difficult for these men, who had honed their skills in a country steeped in artistic tradition, to comprehend the more pragmatic American approach to building decoration and monument making—the generally held view that embellishments should not be ostentatious in a democratic nation. They may have understood the intrinsic value of their art and the potential of sculpture to shape a nation's image better than many of their commissioners. Capellano expressed this expectation in a letter to Baltimore architect Robert Cary Long: "my work in Philadelphia, Baltimore and in Washington will be important in the future."[31]

The Italians would be disappointed to know that their names have been long forgotten and credit is rarely given to them for their rotunda creations. All came here with great expectations and all left the country soon after the panels were set into place. Gevelot returned to Europe to work as a sculptor, although little is known about his later career and whether he was satisfied with his American experience. Causici died in 1833, having been bankrupted by his decision to move to America. First deceived by his Baltimore patrons, he went into debt for more than $7,000 long before he began work on his Capitol projects. When he moved to Washington, his pleas for a steady income were denied repeatedly by Bulfinch and Joseph Elgar, the commissioner of public buildings. Eventually Causici was forced to leave America—broke and disillusioned. He planned to return home to Italy but died in Havana on the way. The *Niles Register* reported that he succumbed to cholera: "this celebrated sculptor, and pupil of Canova, died recently at Havana of Asiatic cholera, after an illness of fifteen minutes."[32]

Capellano, who was an experienced businessman, fared much better than the luck-

[31]"[N]el futuro il mio lavoro . . . Pensilvania, Baltimora, Washington, sarebbe importante." Antonio Capellano to Robert Cary Long, Sept. 1823, Washington Monument Papers, Maryland Historical Society.

[32]*Niles Register,* Sept. 21, 1833, p. 53.

less Causici. He saved enough money to return to Italy and buy a small villa in Florence. In 1830 his good friend Raphaelle Peale, who had helped the artist secure work in Baltimore, happened upon Capellano in Florence's Boboli Gardens. Years later, Peale reminisced about the encounter in the *Crayon:* "I was surprised one afternoon in the Boboli gardens, at Florence, on being accosted by a well-dressed *Signor,* with his gay wife and five fine children. It was Capellano; who acknowledged my timely service to him, and informed me that having made money enough in America, he had brought *uno piccolo palazzo,* to enjoy the remainder of his days in his native city."[33]

Whether successful in their endeavors or disillusioned by their American experiences, all the Italian sculptors who came to the early Republic left an artistic legacy in Washington and their stamp on other East Coast cities.[34] Perhaps most significantly they introduced the neoclassical style to public places in America, the appropriate idiom for a country aligned politically with ancient Rome. When today's visitors step into the rotunda, they are unlikely to recognize the Italian influence on this sacred space, although it is there. Causici, Capellano, and Gevelot did their jobs well. Their sculptures merge into the rotunda's decorative program rather than dominating the space, and so most viewers assume the decorations are part of the endless production of the government machine, a program worked out by a vast and unidentifiable force. Yet we know the sandstone reliefs were created by a few Italian artists who enthusiastically shared their expertise with us at a time when we had too few artists of our own to complete much-needed projects. The reporter for the *Niles Register* who wrote of Causici's demise in Havana ended with this encomium: "Alas, [Causici] has fallen victim to his dire pestilence, and while we commiserate his fate, it is to pay his memory this parting token of admiration and applause."

And so in the twenty-first century we should still applaud not only Causici, but all the Italian artists who helped formulate our earliest political images, decorate the Capitol building, and assist in defining a path while setting the standard for the American sculptors who took over the enterprise.

[33]*Crayon,* January 1856, p. 6.

[34]Soria, *American Artists of Italian Heritage.* Soria provides a list of many of the Italian sculptors in early America.

Virtue and Virtual Reality in
John Trumbull's "Pantheon"

IRMA B. JAFFE

THE FOUR PAINTINGS BY JOHN TRUMBULL THAT HANG IN THE GREAT CAPITOL rotunda—the Hall of the Revolution, Trumbull called it—represent the artist's solution to his lifelong conflict between the claims of virtue, which demanded his energies be spent in a serious pursuit for the public good, and the need to earn his living by making portraits, which he considered frivolous and simply catering to his selfish pride. The four paintings include *The Declaration of Independence, The Surrender of General Burgoyne at Saratoga, The Surrender of Lord Cornwallis at Yorktown,* and *The Resignation of General Washington* (figs. 1–4).

Trumbull's paintings respond to one of the traditional functions of visual art: to satisfy human curiosity about the world by purporting to show what things or events there are, or were, or could be in it. Ever since Giotto, Western art has been engaged in deepening this innocent and creative deception so that gradually, by stages, the imitation of sensual reality became increasingly more like the actual sense experience. The aim all along has been to persuade viewers that they were virtual witnesses—witnesses in essence and effect although not in fact.

Photography took over this service when art moved to abstraction and nonrepresentation, and today, with television and the print media, our curiosity about wonderful and terrible events and people can be satisfied more than ever as if we were actually in their space. The reality of the physical world is virtually brought into our homes, where we see hurricanes, soldiers in combat—anything happening anywhere in the

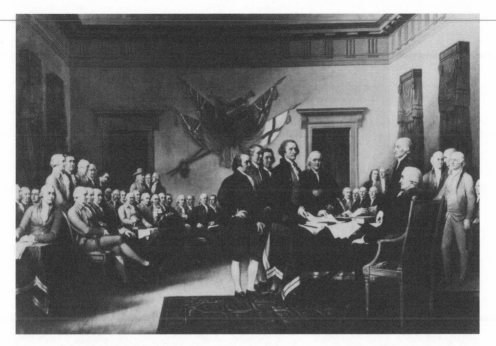

Fig. 1. John Trumbull, *The Declaration of Independence,* 1818. U.S. Capitol rotunda. *(Courtesy Office of Architect of the Capitol.)*

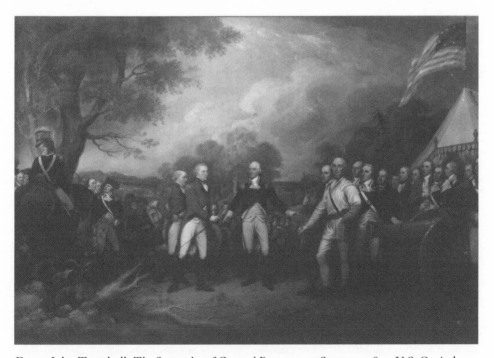

Fig. 2. John Trumbull, *The Surrender of General Burgoyne at Saratoga,* 1821. U.S. Capitol rotunda. *(Courtesy Office of Architect of the Capitol.)*

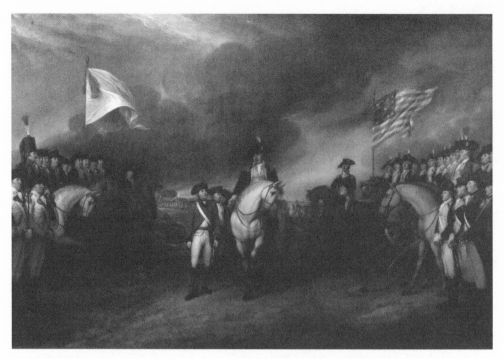

FIG. 3. John Trumbull, *The Surrender of Lord Cornwallis at Yorktown,* 1820. U.S. Capitol rotunda. (See also color plate 15.)*(Courtesy Office of Architect of the Capitol.)*

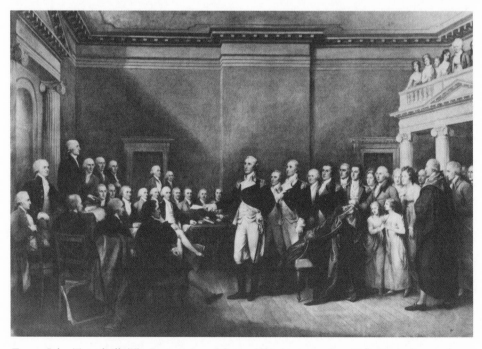

FIG. 4. John Trumbull, *The Resignation of General Washington,* 1824. U.S. Capitol rotunda. *(Courtesy Office of Architect of the Capitol.)*

Fɪɢ. 5. David James in *Saving Private Ryan,* a Paramount Pictures film. *(Courtesy Dreamworks.)*

world *while it is happening.* Photography has advanced far beyond painting in picturing the world beyond our personal purview. I want to locate John Trumbull's paintings in the Capitol rotunda in this technical evolution of virtual reality.

But the idea of virtue has also undergone a parallel cultural evolution. Where art once followed society in perceiving and depicting virtues as attributes of the socially great and powerful, modern representational art, particularly in fictional films, reflects the social changes that have created the perception that all individuals have the capacity to be virtuous, by virtue of being human. Since World War II, the fictional battlefield of the movies has increasingly centered on the soldier rather than the officer in considering the virtue of courage, as in the film *Saving Private Ryan,* in which a detail of soldiers is sent on what results in a self-sacrificing mission to save the eponymous private (fig. 5). I therefore want to locate Trumbull's paintings in the *social* evolution of virtue alongside the technical evolution of virtual reality.

The word *virtue* comprises a number of virtues and has several meanings. It may refer to efficacy, or to superior moral and intellectual goodness, or to a favorable circumstance. Socially, virtue was defined as an attribute of a nobleman, and it was considered beyond attainment by the common man. For Machiavelli, for example, the virtuous prince was virtuous by virtue of—by the favorable circumstance of—his noble birth and by his efficacy in protecting his lands: let him put above all else the welfare of his estate, and if cruelty and fraud are necessary to do this successfully, so be it. This kind of virtue is like that of a sharp knife; it is a good knife because it cuts well. Louis XIV

defined himself as virtuous because he believed that he embodied all of virtue's traditional meanings: "To be King," he wrote, "is to be the summit of superiority, and the elevation of rank is all the more assured when it is supported by unique merit."[1] The totally virtuous king, as he saw himself, noble-protector-hero of France, was, of course, the image of the king as he was portrayed by Charles Le Brun and Adam van der Meulen in the series of *Louis XIV's Conquest of Flanders*. Although traditional in their interpretation of virtue, the paintings of Louis XIV's conquests in the context of virtual reality represent an advance in the evolution of representing factual events, since Van der Meulen actually went to the places of combat and not only depicted the actual sites but also made authentic portraits of the leading figures who had been present, although not in actual combat.

The word *virtue* is thought to be related to *virile* and thus denotes qualities seen historically as belonging to virtuous men: superior physical strength and physical courage, together with superior intelligence. Eventually women came to be seen as being capable of possessing virtue, but the virtues were different and intimately tied to their subordinate relationship with men, chastity being the indispensable attribute of the virtuous woman. The multitude of paintings depicting men in virtuous action or portraits accompanied by virtuous attributes far outnumber depictions of virtuous women who virtuously mourn their hero-husbands or kill themselves because their chastity has been violated. Only in religion and mythology, together with allegorical figures, has there been pictorial parity, not in numbers but in virtue: Mary is the epitome of virtue, and male and female martyrs equally underwent torture and death for their faith; Athena was the goddess of war and victory and presided over the moral and intellectual aspects of human life. Her temple was the temple of wisdom. Women were also considered virtuous by virtue of their ability to please men with domestic and social graces, as defined by Castiglione in *The Courtier*. A radical change in the image of women's virtue occurred in a World War II poster called "Rosie the Riveter," which showed a beautiful young woman contributing to the war effort by doing "man's work."

In the eighteenth century, the nation as a political entity emerged as a coherent unifying power within certain geographic boundaries, supplanting the universal Church, and national patriotism began to supplant religious faith as a requisite attribute of virtue, with moralizing fervor providing the emotional experience formerly given to religion. The fast-developing scientific spirit had awakened curiosity not only about the facts of the perceived world but also about the events of the past, and by the eighteenth century historicism won major intellectual and aesthetic attention. Classical history centered on "the grandeur that was Rome," Roman heroes became the ideal subject in the art academies, and the realism of Roman art such as the relief sculptures of the

[1] Quoted (with revisions by the present author) in Carol Blum, *Rousseau and the Republic of Virtue* (Ithaca, N.Y., 1986), p. 23.

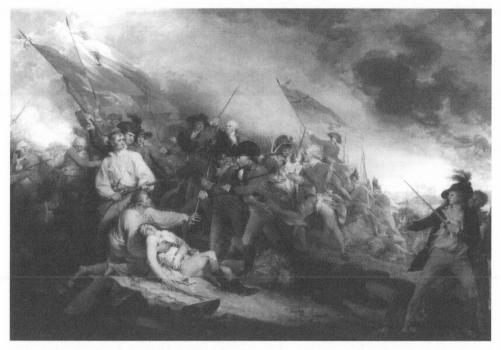

Fɪɢ. 6. John Trumbull, *The Death of General Warren at the Battle of Bunker's Hill,* 1786. *(Courtesy Yale University Art Gallery.)*

Column of Trajan were favorite sources for heroic compositions. In 1785, Trumbull, while working on *The Death of General Warren at the Battle of Bunker's Hill* (fig. 6), visited Rev. Samuel Preston, in whose library he was able to study engravings after the sculptural reliefs on the Column of Trajan. The motif of the dying warrior in the arms of his comrades was adopted by many artists, such as John Singleton Copley in his *Death of Major Pierson* (fig. 7). Furthermore, awakened interest in the past helped direct attention to the importance of preserving the present for posterity. As a consequence of these ontological and epistemological changes in Western thought, accelerating as the century unfolded, secular and religious values were joined in governing the social view of character. The recently dead national hero replaced the ancient Roman Christian saint as the emblem of virtue. Artists responded to the challenge of the new cultural reality with images that fused Christ, who died for humankind, with the fallen patriot, who died for his country, in paintings that were ever more realistic and vivid, as in *The Death of General Wolfe* by Benjamin West (fig. 8).

But one man's virtue can be another man's vice: Jean Paul Marat, a regicide and Jacobin who during the Reign of Terror had called for "another three hundred thousand heads to roll,"[2] was seen as the epitome of a virtuous national martyr, depicted as

[2]Ibid., p. 227.

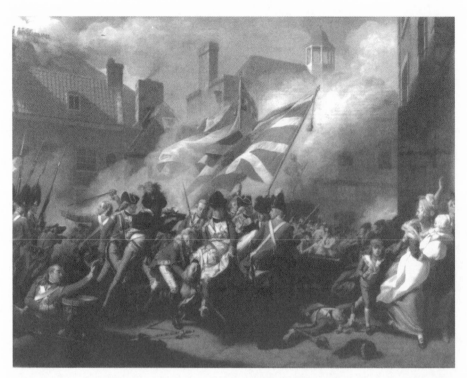

FIG. 7. John Singleton Copley, *The Death of Major Pierson,* 1782–84. *(Courtesy Tate Gallery, London.)*

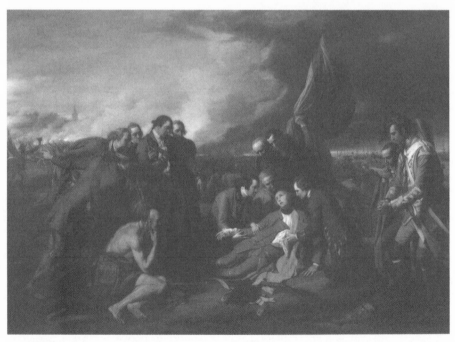

FIG. 8. Benjamin West, *The Death of General Wolfe,* 1771. *(Courtesy National Gallery of Canada.)*

FIG. 9. Jacques Louis David,
The Death of Marat, 1793.
(Courtesy Versailles Museum.)

such by Jacques Louis David (fig. 9). When John Trumbull was in Paris in 1797 on a diplomatic mission, he had occasion to meet David, whom he knew from previous trips to Paris. In the course of their conversation, the talk turned to the French Revolution. Trumbull recalled later in his autobiography how he shuddered when David, acknowledging that "much blood had been shed," echoed and outdid his hero Marat, adding that "it would have been well for the republic, if five hundred thousand more heads had passed under the guillotine."[3] Alas, when the ideologically zealous pass for the rationally virtuous! Considering virtue in the eighteenth century, one cannot neglect invoking the name of Jean-Jacques Rousseau, who turned virtue outside-in, believing he, and others like him, were virtuous because subjectively they *knew* themselves to have good, moral feelings. Rousseau, who was the ideological fountainhead for Robespierre's conception of virtue that was fulfilled in the Terror: *le peuple* (the people), all collectively, were virtuous, the nobility all vicious.

[3]John Trumbull, *Autobiography, Reminiscences and Letters of John Trumbull* (New Haven, 1841). All quotations from Trumbull's autobiography and other original sources cited in this chapter can also be found in Irma B. Jaffe, *John Trumbull: Patriot-Artist of the American Revolution* (Boston, 1975). The quote cited here is found on p. 180.

John Trumbull was twenty-nine years old when he began the first of what would be ultimately a series of eight paintings on the subject of the American Revolution. The idea for the series that would bring him lasting fame and produce an icon of American art had several sources, including, probably, the plan of his father, Jonathan Trumbull, to write the history of the Revolution. There is a certain irony in this since his father, who had been opposed to his desire to become an artist, seeing no practical or moral virtue in such a profession, never completed his history, while Trumbull achieved lasting honor with his. His father refused to allow him to go to Boston, as he pleaded, to study art with John Singleton Copley; he must go to Cambridge, to Harvard College, to gain the kind of knowledge that would prepare him for a useful profession, such as the ministry or law, worthy of his family's social standing. Moreover, the virtue of an honorable profession would be enhanced by the further virtue of being self-supporting. Jonathan's argument illuminates the broadened definition of virtue as it reflected the growing impact of middle-class values on society's views of the good and worthwhile, adding to strength, courage, and moral righteousness the virtue of financial independence. It is useful to compare the aristocratic view of the virtuous man, still prevalent earlier in the century. Jonathan Richardson wrote in 1715 that "'twas never thought unworthy of a Gentleman to be master of the *theory of painting* or for a Gentleman to paint for his pleasure, without reward, but to take money for this Labour of the Head and Hand is dishonorable, this being a sort of letting himself to hire to whosoever will pay him."[4] Aristocratic virtues clearly could never have included self-support.

Trumbull arrived in London to study with Benjamin West in November 1783, and a year later he began to think about the great work that led to his paintings on the rotunda walls. He wrote his father that West had invited him to make a copy of his painting *The Battle of La Hogue,* which he was eager to do since, as he explained,

> West's pictures are almost the only examples in Art of that particular style which is necessary to me—pictures of modern times and manners. In almost every other instance the art has been confined to the History, Dresses, Customs, &c. of antiquity. . . . It would be of infinite use if I should live to execute the plan I have in view . . . painting a Series of pictures of our Country, particularly the great Events of the revolution. . . . If I do succeed, it makes me master of my time & disengages me from all the trumpery & caprice & nonsense of mere copying faces & places me the servant not of Vanity but of Virtue.[5]

[4]Jonathan Richardson, *An Essay on the Theory of Painting* (London, 1715), pp. 29–30.

[5]John Trumbull to Jonathan Trumbull, Sr., Nov. 3, 1784, Trumbull Papers, Connecticut Historical Society; John Trumbull to Jonathan Trumbull, Sr., Nov. 15, 1784, and Jan. 18, 1785, Trumbull Papers, Beinecke Library, Yale University Library. Jaffe, *Trumbull,* pp. 69–71.

Unfortunately, the commission made it necessary for Trumbull to give up his plan to travel to Italy and he never did make the trip.

Probably because he had been stationed near Roxbury, Massachusetts, about four miles from Bunker Hill, and had heard the sounds of the battle ("as the day advanced, the firing increased" he recalled in his autobiography), he undertook this event as the first of his series. The painting, *The Death of General Warren at the Battle of Bunker's Hill* (fig. 6) owes its iconography to Benjamin West's *The Death of General Wolfe* (fig. 8), which, in turn, owes its iconography to Death of Christ compositions such as the Giotto *Lamentation* and its many progeny. West's *General Wolfe,* the first eighteenth-century painting of a modern hero in contemporary dress, was a stunning innovation after almost half a century of obsession with classical heroes and ancient costume, testifying to the heightened desire for virtual reality in painting.

Bunker's Hill, with its iconographic dependence is thus not an eyewitness account, but three of the portraits were from life, and it is evident that Trumbull examined the site in order to enhance the realism of the scene: the general lay of the land is correct, showing Boston Harbor in the background. The hand-to-hand combat, and the face of General Warren, bloody from the shot that killed him, represents an advance over its prototype in the depiction of virtual reality and shows that Trumbull did research for the purpose of making his scene conform with the historical facts. However, the dramatic detail of the British General Small arresting the arm of the unnamed officer about to bayonet the fallen General Warren was an invention, Trumbull wrote, "to afford an opportunity to do honor to Major Small who . . . was distinguished for his humanity and kindness to prisoners."[6] Of particular interest in the present context is how Trumbull handled the issue of virtue. He depicts General Small in this noble act because a noble hero, such as Dr. Warren, requires a noble adversary—there was no virtue in fighting against an inferior enemy. Trumbull assumed an officer in the British army must be an aristocrat and thus virtuous by virtue of birth. Nevertheless, although Trumbull related personal morality to high social rank, as a Connecticut Yankee he shared his culture's perception that success in middle-class endeavors was a warrant of the favor of providence and a promise of heavenly salvation, and as such it could also make a man a gentleman. The gentlemanly Trumbull himself was the son of a merchant. Dr. Joseph Warren was a very successful Boston doctor, and his death in battle made him a hero worthy of the immortality that art could give him. Notice in the sketch for the key (fig. 10) that the numbered figures are all officers. No yeomen are represented in the scene although more than one hundred were killed, equally heroic, equally virtuous.

[6]Benjamin Silliman, "Notebook." Unpublished biographical sketch of John Trumbull, 1857, Trumbull Papers, Yale. Cited in Jaffe, *Trumbull,* p. 90.

KEY

The Death of General Warren at the Battle of Bunker's Hill June 17, 1775
1786

1. Maj. Gen. Joseph Warren, Massachusetts Militia (killed)
2. Col. Israel Putnam, 3rd Connecticut Regt.
3. Col. William Prescott, Massachusetts Militia
4. Col. Thomas Gardner, Massachusetts Regt. (mortally wounded)
5. Liet. Col. Moses Parker, Bridge's Massachusetts Regt. (mortally wounded)
6. Capt. Thomas Knowlton, 3rd Connecticut Regt.
7. Maj. Andrew McClary, 1st New Hampshire Regt. (killed)
8. Maj. Willard Moore, Doolittle's Massachusetts Regt. (killed)
9. 2nd Lieut. Thomas Grosvenor, 3rd Connecticut Regt., and Peter Salem, his servant.
10. Rev. Samuel McClintock, Chaplain, 2nd New Hampshire Regt.
11. Maj. Gen. Sir William Howe, K.B., British
12. Lieut. Gen Sir Henry Clinton, British
13. Lieut. Col. Sir Robert Abercromby, British, 37th Regt. of Foot
14. Maj. John Pitcairn, British, Royal Marines (mortally wounded)
15. Maj. John Small, British, 84th Regt. of Foot
16. Lieut. William Pitcairn, British, Royal Marines
17. Lieut. Francis, Lord Rawdon, British, 63rd Regt. of Foot

Fig. 10. After William Mercein, Key for *The Battle of Bunker's Hill*. *(Courtesy Yale University Art Gallery.)*

As I observed earlier, in today's art form, the lowly private has made it into heroism in the fictionalized virtual reality of the movies.

Trumbull continued to work on his "great project," as he called it, and by 1789 when he returned to the United States he had finished *The Battle of Bunker's Hill* and *The Death of General Montgomery at Quebec,* and had almost completed *The Declaration of Independence.* Personal and public events forced him to interrupt his work, and 1793 found him back in London, not as an artist but as a member of the Jay Treaty Commission, charged with making a treaty that would settle dangerous frontier and commercial issues between the United States and Britain. It was in this capacity that he traveled several times to Paris in the 1790s. Trumbull had already visited the newly completed Church of Saint Genevieve when he was in Paris in 1786, but in the wake of the revolution, the church had become the Pantheon, burial place of the revolution's heroes. The great domed building might have inspired his idea of a Hall of the Revolution for America's heroes, not as their burial place but as a shrine where they would be represented forever alive through his paintings. There was as yet no building in the United States that could house such a grand undertaking, but Trumbull knew the plans for the Capitol in Washington, then under construction; William Thornton had shown Trumbull his drawings for the competition for designing the U.S. Capitol and had asked the artist to show and recommend them to Washington, which he successfully did. The design included a central rotunda, which Trumbull of course saw would provide space to hang paintings. His Revolutionary War pictures would be exactly what the nation needed to preserve forever the memory of its painful birth, and since there was no other artist in America who could match him in artistic skill and knowledge, he could have been justifiably confident that the time would come when he would be called upon to contribute to the historical and aesthetic needs of the United States, to enshrine its heroes, and also to achieve the immortality he craved. As it happened, he had rather a long time to wait.

It was not until 1815 that the building for which he had been waiting began to be realized. Benjamin Latrobe was commissioned to repair the two wings of the Capitol, which had been damaged by British fire during the War of 1812, and to construct the central section. Trumbull set out to submit to the government of the United States a proposal to memorialize the Revolution and its heroes with paintings that would forever remind Americans of what they owed to the virtue of those heroes. But first there was some pride to be swallowed: President James Madison and Secretary of State James Monroe had both been the object of his blunt criticism, and Monroe was a follower of Jefferson, with whom, after a close friendship, he had had a painful falling-out. Their relationship had become "cold and distant." Now, however, he needed Jefferson's help and accordingly wrote describing his plan and asking for his support, which Jefferson

gave him, writing to Sen. James Barbour: "The subjects on which Col. Trumbull has employed his pencil are honorable to us, and it would be extremely desirable that they should be retained in this country as monuments of taste as well as of the great revolutionary scenes of our country."[7]

Trumbull also wrote to his old friend John Adams, whose letter in reply is a model of the contemporary American Establishment mind with regard to art. "Your design has my cordial approbation and best wishes. But you will please to remember that the Burin and the Pencil, the Chisel and the Trowell, have in all ages and countries . . . been enlisted on the side of Despotism and Superstition. . . . Architecture, Sculpture, Painting, and Poetry have conspir'd against the Rights of Mankind; and the Protestant religion is now unpopular and Odious because it is not friendly to the Fine arts. I am not, however, a Disciple of Rousseau. Your country ought to acknowledge itself more indebted to you than to any Artist who ever existed."[8] Despite his disclaimer, however, Adams did share with Rousseau the conviction that art's only justification could be in contributing to public virtue.

On February 6, 1817, Congress approved a resolution to commission Trumbull to execute four paintings on the subject of the Revolution, the first great commission awarded to an American artist. It appeared that his dream was finally to be realized, but it almost disappeared under pressure from Congress to eliminate the rotunda to make room for more office space. Charles Bulfinch, who was appointed architect of the Capitol when Latrobe resigned in 1817, wrote to Trumbull that he was considering redesigning the central hall on the plan of the New York City Hall, with a similar grand staircase; Trumbull's paintings would then hang in a picture gallery devised in the space. The artist was horrified, realizing that such a plan would take his Hall of the Revolution away from him. "I feel the deepest regret at abandoning the circular room," he wrote Bulfinch. "I should be deeply mortified, if, after having devoted my life to recording the great events of the Revolution, my paintings . . . should be placed in disadvantageous light. In truth, my dear friend, it would paralyze my exertions."[9] Trumbull's letter persuaded Bulfinch to retain the rotunda, and he eventually satisfied Congress with a plan that lowered the central section one story and projected it from the wings, which allowed for the working space that Congress was demanding.

Trumbull's first step upon winning the commission was to consult President Madison

[7]Jefferson to Barbour, Jan. 19, 1817, James Barbour Papers, New York Public Library, also quoted in Jaffe, *Trumbull,* p. 235.

[8]Adams to Trumbull, Jan. 1, 1817, in Trumbull's interleaved autobiography, Franklin Collection, vol. 1, Yale University Library. Also quoted in Jaffe, *Trumbull,* p. 236.

[9]See Latrobe to Trumbull, July 11, 1817, Yale. Latrobe to Monroe, in Charles Fairman, *Art and Artists of the Capitol of the United States of America* (Washington, D.C., 1927), pp. 39–41. Trumbull to Bulfinch, Jan. 25, 1818, *Autobiography,* pp. 265–72. Also quoted in Jaffe, *Trumbull,* p. 251.

as to the size of the paintings and to decide which subjects should be chosen for this commission. The artist had planned paintings of six by nine feet, but the president realized better than the artist that they would be lost in the vast space of the rotunda. Madison insisted that they be painted on canvases of such a size as to permit the representation of figures at life-size. As for the subjects, the president first mentioned *The Battle of Bunker's Hill.* Trumbull agreed that if the commission were for eight works, as he had proposed, that would have been his first choice. With only four subjects, he thought otherwise and proposed two military and two civil scenes. One was the surrender of General Burgoyne at Saratoga, a stunning victory that took an entire army prisoner and persuaded the French to enter the war on the side of the Americans, who now looked like winners. Historians have concurred with Trumbull's perception of the importance of this battle, calling it one of the most decisive battles in world history. There are a number of virtual and virtuous issues of interest here.

In the interest of realism, Trumbull went to Saratoga to view the actual scene for his *Surrender of General Burgoyne at Saratoga, 16 October 1777* (fig. 2),[10] as we know from a sketch of the landscape, on the back of which he noted, "Saratoga, seen from the rising ground nigh the Church, on which was Gen. Gates' Marquee:—Sept. 28th 1791."[11] He represents the surrender ceremony at the moment when General Burgoyne tenders his sword, and Gen. Horatio Gates, instead of taking it, gestures toward the tent where dinner will be served. This was quite close to the way the real surrender took place: Burgoyne rode out in a splendid uniform to meet Gates, and greeted him, saying, "The fortune of war, General Gates, has made me your prisoner." Gates replied with virtuous magnanimity, "I shall always be ready to testify that it has not been through any fault of your Excellency."[12] The senior officers of both sides then went in to dinner. Burgoyne's disarmed men marched past the tent and the two generals emerged. By prearrangement Burgoyne handed Gates his sword, which the American returned. Trumbull altered the facts by compressing these events, and, more significantly, by altering the image of Gates. Not only does he make the American general, who was small, appear tall, but he has also dramatically changed his costume, giving him an elegant officer's uniform rather than showing him as he appeared at the surrender, plainly clad. Obviously, a hero, according to Trumbull, had to look the part—and act the part: Gates's gestures, refusing the proffered sword with his right hand and indicating the tent with his left, express his virtuous magnanimity toward his defeated adversary. One wonders if Trumbull was aware of Gates's servant-class birth as the son of the Duke of Leeds's housekeeper.

[10]The correct date is October 17, 1777.

[11]See Jaffe, "Fordham University's Trumbull Drawings," *American Art Journal* 3 (1971): fig. 22.

[12]Mark M. Boatner III, *Encyclopedia of the American Revolution* (New York, 1976), p. 979.

There was another hero of Saratoga who did not make it into Trumbull's painting. During the battle, Benedict Arnold, not yet a traitor, pointed out to Col. Daniel Morgan that a British officer on a gray horse was, as he said, "a host in himself and must be eliminated." An American sharpshooter, Tim Murphy, hit and mortally wounded this man, Gen. Simon Frazier, bringing the battle to a victorious end for the Americans. It is possible, of course, that Trumbull had not heard that story; it is also possible that the artist omitted Tim Murphy from the scene because he was not an officer and it did not occur to the artist to consider the virtue of a common soldier. It should furthermore be noted that Gen. Benedict Arnold had acted with outstanding courage in the battle at Saratoga. Although seriously wounded in the leg, he was probably present at the surrender; but his later treason canceled his virtue and eliminated his place in the painting.

The second military scene of course had to be *The Surrender of Lord Cornwallis at Yorktown, 19 October 1781* (fig. 3; color plate 15), which effectively ended the war. On Trumbull's list for an exhibition of his paintings, the artist noted, "composed in London 1787, the portraits of the French officers painted the same year in Paris—finished since in America."[13] In 1788 Trumbull had been a guest of Thomas Jefferson, then minister to France, at his home, the Hotel de Langeac, in Paris. "I have been in this capitol of dissipation & nonsense near six weeks for the purpose of getting the portraits of the French Officers who were at Yorktown," he wrote his father on February 6, 1788.[14] Most of the portraits of Americans were probably done from life between 1790 and 1793, when Trumbull was back in the United States. There is more drama in the scene than at first appears: the victorious French and American armies form along the Hampton Road, where the defeated British march. Washington watches as his aide, Maj. Gen. Benjamin Lincoln, supposedly receives the surrender. Cornwallis, who had claimed illness, delegated his aide, General O'Hara, to act in his place. Mounted in three-quarters view at the center of the scene, Lincoln extends his right arm, his hand open to receive Cornwallis's sword, which would be handed over, according to custom. Cornwallis, however, seems not to have given O'Hara his sword to tender, and the aide, looking rather defiant, stands with his right hand hanging loosely at his side, not even having removed his hat. In one of the sketches for the painting (fig. 11; color plate 16), Lincoln is shown mounted from the rear with O'Hara standing in front of him. O'Hara has removed his hat as a symbol of surrender, reminding us of the Le Brun–Meulen *Surrender of Marsal,* which Trumbull most certainly saw at Versailles. In this painting, the king is seen mounted three-quarters from the rear, with his adversary hatless. In another sketch, Lincoln is holding a sword, presumably Cornwallis's, pointing toward

[13]Trumbull, draft exhibition list [1831], no. 10, Munn Collection, Fordham University.

[14]John Trumbull to Jonathan Trumbull, Feb. 6, 1788, Trumbull Papers, New-York Historical Society. Also quoted in Jaffe, *Trumbull,* p. 320.

Fig. 11. Oil sketch for *The Surrender of Lord Cornwallis at Yorktown,* 1787. (See also color plate 16.) *(Courtesy Detroit Institute of Arts.)*

Washington.[15] In the final work—no sword, hat on—Trumbull apparently decided to dramatize the British defeat by showing how bitterly they accepted it. The actual facts with regard to the sword are still a matter of controversy.[16]

For the two civil scenes, one of course would be *The Declaration of Independence, 4 July 1776* (fig. 1). "What would you have for the fourth?" Madison asked Trumbull. "Sir, I replied, I have thought that one of the highest moral lessons ever given to the world was that presented by the conduct of the commander-in-chief, in resigning his power and commission as he did."[17] There had been in fact a serious effort to persuade Washington to become king of the United States. When in May 1782 he received from one of his officers, Lewis Nicola, a letter urging him to take this course, Washington replied, "No occurrence in the course of the war has given me more painful sensations than your information of there being such ideas existing in the army."[18] Alexander Hamilton was a leader in the plan to establish a monarchy with Washington as king.

The Resignation of General Washington, 23 December 1783 (fig. 4), was begun in 1822

[15]Illustrated in Jaffe, *Trumbull,* fig. 104.
[16]See Boatner, *Encyclopedia of the American Revolution,* p. 1247.
[17]John Trumbull, *Autobiography,* p. 263. See also Jaffe, *Trumbull,* p. 236.
[18]James Thomas Flexner, *Washington: The Indispensable Man* (Boston, 1974), p. 170.

and finished in 1824. In an effort to make his representation as realistic as possible, Trumbull wrote to congressmen and others asking for information about who was present, since most of those actually present when Washington resigned in 1783 were now dead. In the end, only three portraits, James Monroe, Benjamin Walker, and Jeremiah Chase, were painted from life. For the others he used portrait miniatures he had painted himself or portraits by other artists; for example, that of James Madison, who was not in fact present but whom Trumbull wanted to include so that he could represent all four presidents from Washington's home state of Virginia—Washington, Jefferson, Madison, and Monroe. Washington is copied with a slight change of pose from Trumbull's portrait of the general at Verplanck's Point, which he painted in 1790.[19]

The *Resignation* is an image of lofty-minded dedication to republican principles. "The Caesars, the Cromwells, the Napoleons," Trumbull wrote, "yielded to the charm of earthly ambition. . . . Washington alone aspired to . . . that imperishable glory, to that glory which virtue alone can give."[20]

The Declaration of Independence is Trumbull's most significant painting. Trumbull correctly saw the vote for declaring independence as representing an epic moment in world history and the participants as epic heroes. They were in reality men of singular virtue, for, whatever human flaws doubtless blemished the character of each one, from whatever mixed motives they might have acted, those who voted for independence knowingly risked their lives for the ideals specified in the document drafted by Thomas Jefferson, with revisions by Adams and Franklin. In voting for the resolution to declare independence, they proved their moral strength and physical courage, for if the declaration led to war, which seemed inevitable, and if they lost, they would surely be hung for treason. With their vote they had, as the declaration stated, pledged their lives, their fortunes, and their sacred honor. Of this Trumbull was deeply aware.

The challenge of composing a scene on canvases of such size—twelve by eighteen feet—with such a large number of heroes was great indeed, and the artist's accomplishment is a triumph equal to the challenge. In the interest of virtual realism, he applied to Jefferson for help in depicting the room and the forty-eight men portrayed (there were fifty-six signers). Trumbull painted thirty-six from life; others he painted from memory, description, or, in the case of Stephen Hopkins, from Hopkins's son, while the likenesses of others were provided by pictures painted by other artists. Somehow, the key identifying each of the figures contains errors, which I have detailed elsewhere.[21] The corrections include number 8, keyed as George Clinton, who is actually

[19]Illustrated in Jaffe, *Trumbull,* pl. 9.

[20]Trumbull, *Description of the Four Pictures, from Subjects of the Revolution* (New York, 1827), p. 8. See also Jaffe, *Trumbull,* p. 263.

[21]Jaffe, *Trumbull,* pp. 114–17. See also Jaffe, *Trumbull: The Declaration of Independence* (London, 1976), pp. 79–87.

FIG. 12. Asher B. Durand, Key for *The Declaration of Independence,* 1820. *(Courtesy New York Public Library.)*

Stephen Hopkins (from his son); number 23, keyed as Hopkins, who is John Dickinson; and number 45, keyed as Dickinson, who is Clinton (fig. 12).

As for virtue, no insight into the meaning of that word held by Jefferson and Adams, and probably by most of the others, can be clearer than that afforded by those men in agreeing with the artist to include the nonsigner John Dickinson in the painting. Dickinson had been tireless in the struggle against England's oppressive measures that led to the Declaration, but he became "the most eloquent and powerful opponent of the [declaration], not indeed of its principle, but of the fitness of the act at that time which he considered premature."[22] They perceived Dickinson as a man who had the virtue of maintaining his beliefs against the majority, and they respected his probity.

Trumbull's *Declaration of Independence,* like the Declaration itself, although American to the core, may be said to be an ultimate statement of European Enlightenment. Without a flourish, without heroic gesture, with the associations of power and elegance transformed into sobriety and determination, Trumbull's masterpiece nevertheless achieves grandeur. There is not another like it in the world. Planned in company with Adams and Jefferson, it expresses in visual form the clear, direct rhetoric of the document those men laid on the desk of John Hancock on July 4, 1776, and must be accounted one of the most extraordinary collaborations of its kind in the history of civilization.

[22]Trumbull, *Autobiography,* p. 8; Jaffe, *Trumbull,* p. 116.

"Lost in America"

David d'Angers's Bronze Statue of Thomas Jefferson, 1832–1833

Thomas P. Somma

Twentieth-century scholarly and curatorial opinion has long acknowledged the bronze statue of Thomas Jefferson by the French sculptor Pierre-Jean David d'Angers (1788–1856) as one of the more valuable works of art installed at the U.S. Capitol (fig. 1). The first full-scale portrait statue to be placed within the Capitol, David's *Jefferson* was also "the first bronze statue to occupy a public place in America," and "for almost forty years . . . the only lost-wax statue in the United States."[1] Moreover, the bronze *Jefferson* played a pivotal role in the development of David's career as one of the most influential sculptors of his time, eventually affecting the entire course of nineteenth-century public portrait sculpture.

Breaking with the international classicism that still dominated French sculpture in the 1830s and benefiting from the timely example set by Jean-Antoine Houdon's famous marble *George Washington,* 1788, at the Virginia State Capitol (fig. 2), David's *Thomas Jefferson* was the first and most characteristic example of a historical portrait type invented by David in which traditional allegory is rejected in favor of naturalism, modern dress, and readable, commonsense attributes. Furthermore, and in contrast to Houdon's *Washington,* the more relaxed arrangement of limbs, vigorous modeling, and flickering surface textures of *Jefferson*—David's first statue planned from the start for bronze rather than marble—revealed on a monumental scale the French sculptor's in-

[1]Michael Edward Shapiro, *Bronze Casting and American Sculpture, 1850–1900* (Newark, Del., 1985), pp. 30–31, 115.

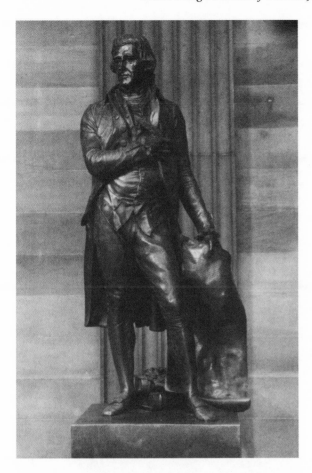

FIG. 1. Pierre-Jean David d'Angers, *Thomas Jefferson,* 1832–33. Bronze, U.S. Capitol rotunda, gift of Uriah P. Levy. *(Courtesy Office of Architect of the Capitol.)*

novative plastic handling of the bronze medium to render a more vivid and engaging image of a contemporary figure.[2] By introducing the new bronze aesthetics to portrait statuary, David's *Thomas Jefferson* initiated a modern tradition to which belong countless later derivations, including such masterworks of late-nineteenth-century American figurative sculpture as Augustus Saint-Gaudens's *Admiral David Farragut,* 1881; Frederick MacMonnies's *Nathan Hale,* 1890; and Paul Wayland Bartlett's *Michelangelo,* 1894–98 (fig. 3).[3]

However, despite the art historical significance now attributed universally to David's *Jefferson,* for decades following its initial placement in the Capitol rotunda in 1834, the statue's ultimate fate stood in serious doubt. In fact, originally denounced by Congress and almost entirely unknown to the public for more than a half century, David's bronze *Thomas Jefferson* vies with Horatio Greenough's marble *George Washington* (fig. 4)—

[2]James Holderbaum, "Portrait Sculpture," in *The Romantics to Rodin: French Nineteenth-Century Sculpture from North American Collections,* ed. Peter Fusco and H. W. Janson (New York, 1980), pp. 41–42.

[3]Ibid., p. 41; June Hargrove, "Pierre-Jean David d'Angers," in *The Romantics to Rodin,* p. 211; cat. no. 99, 220.

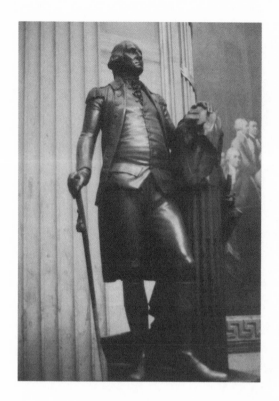

FIG. 2. Jean-Antoine Houdon, *George Washington,* 1788. Marble, Virginia State Capitol, Richmond. *(Courtesy Virginia State Capitol.)*

FIG. 3. Paul Wayland Bartlett, *Michelangelo,* 1909. Bronze, East Aurora, N.Y. Copy of 1894–98 original in Library of Congress. *(Courtesy the author.)*

Fig. 4. Horatio Greenough, *George Washington,* 1832–41. Marble, National Museum of American History, Smithsonian Institution. *(Courtesy Smithsonian Institution.)*

with whom it shared rotunda space for a short time in 1841–42—as the most notable nineteenth-century example of America's enduring dysfunctional relationship with monumental portrait statuary. Even today the public record concerning the statue's early treatment, location, and movements remains confused and lacking in important details.

Following the dramatic death of Thomas Jefferson on July 4, 1826, the fiftieth anniversary of the formal adoption of the Declaration of Independence, many Americans had hoped for some type of permanent national monument to the great republican that would enshrine their collective sense of gratitude. But, while various public projects were suggested, none materialized.[4] Surely part of the problem was the continuing and near total absence in America in the 1820s of the European tradition of monumental portrait statuary. In Jefferson's case, however, the situation was complicated further by the ideological nature of his contributions and the illusive character of the man himself. As Merrill Peterson explains in *The Jefferson Image in the American Mind:*

> He remained an enigma, a figure of contradiction, a man of many faces. Unlike Washington—the savior by the sword, the godlike being, exalted in life as in death—Jefferson assailed the conventions of heroism. His triumph was of the mind. His character was not crystalline. He was a man of phrases, doctrines, and causes. And, most

[4] Merrill D. Peterson, *The Jefferson Image in the American Mind* (New York, 1960), pp. 3–6, 12–13.

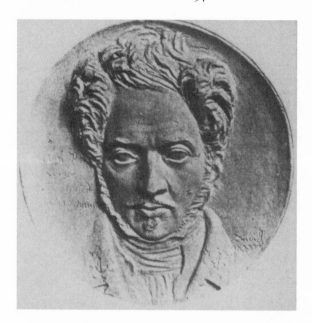

FIG. 5. Pierre-Jean David d'Angers, *Uriah P. Levy,* 1833. Portrait medallion. From *Les Médaillons de David dAngers* (Paris, 1867).

important, the ideas and ideals he exemplified . . . addressed the future; they were bound into the living tissues of a growing democracy; they bred contention and strife.[5]

Given the lack of a prevailing and coherent national context for the symbolic portrayal of Jefferson, it is not surprising that the first expression in monumental form of the nationalistic sentiment surrounding his death would be commissioned by a private individual and executed by a foreign sculptor.

In the spring of 1832, Uriah Phillips Levy of Philadelphia, a lieutenant in the U.S. Navy on extended leave from active duty, traveled to France to order a statue of Thomas Jefferson, which he intended to offer as a gift to his fellow citizens back in the United States (see fig. 5). Levy, an intensely patriotic, fifth-generation American and one of the first ever Jewish officers in the U.S. Navy, had long admired Jefferson's political and social philosophies, particularly his libertarian views on religious freedom.[6] Described in one recent source as the father of historic preservation, Levy would, in 1836, buy Jefferson's Monticello, restoring substantially and at his own personal cost the long-neglected buildings and grounds. The Levy family owned and maintained Monticello until 1923, when jurisdiction over the properties was transferred to the Thomas Jefferson Memorial Foundation.[7]

[5]Ibid., p. 13.

[6]William Howard Adams, *Jefferson's Monticello* (New York, 1983), p. 251. For basic biographical information on Levy, see Ira Dye, "Levy, Uriah Phillips," *American National Biography* (New York, 1999), 13:553–55.

[7]*An American, a Sailor, and a Jew: The Life and Career of Commodore Uriah P. Levy, USN (1792–1862)* (Washington, D.C., 1997). See also Charles B. Hosmer, *Presence of the Past: A History of the Preservation Movement in the United States before Williamsburg* (New York, 1965), and Marc Leepson, "The Levys of Monticello," *Preservation* (1998):44–51.

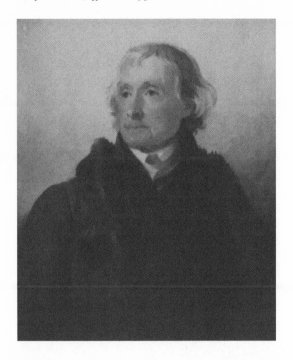

Fig. 6. Thomas Sully, *Thomas Jefferson,* 1821. Oil on canvas, American Philosophical Society, Philadelphia. From Alfred A. Bush, *The Life Portraits of Thomas Jefferson* (Charlottesville, 1987).

In France, Levy visited Lafayette, whom he had met on a trip to Europe eight years earlier, to discuss his desire to commission a statue of Jefferson. Delighted with the American's intended gift, Lafayette presented Levy to David, a close friend and fellow republican. Finding David's previous works "magnificent," Levy quickly offered him the commission. Reflecting his personal interest in the project, Lafayette lent David his copy of Thomas Sully's 1821 life portrait of Jefferson to aid the sculptor in producing an accurate likeness (see fig. 6).[8]

Levy's decision to commission the statue from David was no doubt encouraged by the fact that two other works by the eminent French sculptor had already been offered to and accepted by the American Congress—a bust of George Washington, probably in bronze, funded in France through national subscription and executed by David in 1826, and a marble bust of Lafayette, carved in 1828. France had presented the bronze *Washington* to the United States in 1827; David had personally offered the marble *Lafayette,* through President John Quincy Adams, to the U.S. Congress in early 1829.[9] In a letter to President Adams, David had expressed his hope that the two works be placed side by side, adding that "the two brothers in arms . . . should not be more separated in

[8]Donovan Fitzpatrick and Saul Saphire, *Navy Maverick: Uriah Phillips Levy* (Garden City, N.Y., 1963), p. 128; Hargrove, *Romantics to Rodin,* p. 218; "Story of the Jefferson Statue," *Sunday Star* (Washington, D.C.), Jan. 8, 1950. For more information on Sully's portrait of Jefferson, see "Life Portraits of Thomas Jefferson," *McClure's Magazine* (May 1898):47–55.

[9]*Compilation of Works of Art and Other Objects in the United States Capitol* (Washington, D.C., 1965), pp. 169–70, 193, 195, 396–97; Architect of the Capitol, *Art in the United States Capitol* (Washington, D.C., 1976), pp. 196, 218, 413; Mary T. Christian, "The Capitol Sculpture of David d'Angers," *Capitol Dome* 25 (1990):4–5.

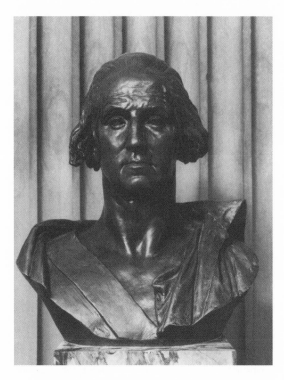

Fig. 7. Pierre-Jean David d'Angers, *Bust of George Washington,* modeled 1826, cast 1905. Bronze, U.S. Capitol rotunda, gift of the French nation, 1905. *(Courtesy Office of Architect of the Capitol.)*

Fig. 8. Pierre-Jean David d'Angers, *Bust of Lafayette,* 1830. Marble, U.S. Capitol rotunda. *(Courtesy Office of Architect of the Capitol.)*

Fɪɢ. 9. Pierre-Jean David d'Angers, *Sketch Model for Thomas Jefferson,* modeled 1832–33, cast after 1892. Bronze, National Gallery of Art, Washington, D.C., Ferdinand Lammot Belin Fund, 1975.11.1. *(Courtesy National Gallery of Art.)*

our admiration than they were in their wishes and in their perils."[10] In 1832, the busts were on display in the congressional library, located at the time in the Capitol, but were later destroyed in the disastrous Library of Congress fire on December 24, 1851. Fortunately, Congress acquired replicas of both busts in the early twentieth century (figs. 7 and 8), and today they flank the main eastern doorway into the rotunda.[11]

By June 1832 David was hard at work on the *Jefferson,* hoping to complete the model within the next few months. A lost sketch model for the statue probably dating from that spring or summer is the source of a series of bronze casts scattered among various French and American museums (see fig. 9). While the circumstances surrounding the individual castings vary, all the statuettes are close in scale and handling and reveal in preliminary form David's final conception—a tall, lean figure in eighteenth-century dress; left leg forward, head looking right; the raised right hand holding a quill pen, the left holding a scroll (which in the final statue is inscribed with the text of the Declaration of Independence).[12]

[10]David d'Angers to John Quincy Adams, Sept. 11, 1828, in *Marble Bust of General Lafayette,* S. R. 2544, 57th Cong., 2d sess., Jan. 20, 1903, p. 3.

[11]See *Marble Bust of General Lafayette;* and *Proceedings in Connection with the Formal Presentation of a Reproduction of a Bust of Washington by Certain Citizens of the Republic of France* (Washington, D.C., 1905).

[12]See Hargrove, *Romantics to Rodin,* p. 221; and Henry Jouin, *David d'Angers: Sa vie, son oeuvre, ses écrits et ses contemporains* (Paris, 1878), 2:512.

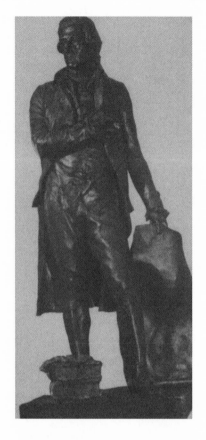

FIG. 10. Pierre-Jean David d'Angers, *Thomas Jefferson,* 1832–33. Full-scale plaster model, patinated, City Hall, New York, gift of Uriah P. Levy, 1834. From Frederick S. Voss, *John Frazee 1790–1852 Sculptor* (Washington, D.C., 1986).

In late January 1833, the full-scale plaster model was finally finished and the prominent French founder Honoré Gonon (1780–1850) began the long and difficult process of casting the statue in bronze. Still free from active naval duty, Levy stayed in France to witness the entire operation firsthand. David chose Gonon to cast *Jefferson* because of the French founder's singular expertise in the ancient methods of lost-wax (*cire-perdue*) bronze casting. In contrast to the less demanding sand-casting process, this method allowed an incredible degree of exactitude in the rendering of surface details as well as the potential for casting even large bronze sculptures in a single piece. Francisque-Joseph Duret's *Young Neapolitan Fisherboy,* Antoine-Louis Barye's *Tiger and Gavial,* and David's *Thomas Jefferson,* all cast about 1832, inaugurated a brilliant series of major bronzes cast by Gonon during the 1830s, upon which his reputation as a founder of exceptional ability now rests.[13]

As Gonon's work on the final bronze *Jefferson* neared completion, Levy ordered a full-scale bronzed plaster model of the statue (fig. 10) sent to his cousin, Mordecai Noah, in New York City. Levy had instructed Noah, a successful newspaperman and prominent New York politician, to present the bronzed plaster as a gift to the city. However, the model was damaged in transit, and upon its arrival in July 1833, Noah asked New York sculptor John Frazee (1790–1852) to repair the plaster statue before it could be shown publicly. Frazee agreed despite the fact that it jeopardized his own statue of Jefferson, the commission for which he was then seeking congressional approval.[14]

Frazee liked David's characterization of Jefferson, writing to his chief studio assis-

[13]Shapiro, *Bronze Casting and American Sculpture,* pp. 114–15, 189; Hargrove, *Romantics to Rodin,* pp. 219–20.
[14]Frederick S. Voss, *John Frazee, 1790–1852: Sculptor* (Washington, D.C., 1986), p. 37.

tant that "it represents the old Republican having finished writing the Declaration, standing with the document in his left hand, and his right on his heart firmly, as if ready to seal with his hearts blood the last words 'our Sacred Honor.'"[15] "But," Frazee continued, "the costume I hate. It is the old quaker coat [and] vest, breeches, shoes [and] buckles; and has more the appearance of an old farmer than the statue of a great personage."[16] As an American neoclassicist unaccustomed to lost-wax bronze sculpture, Frazee's critique of *Jefferson* was understandable; lacking the idealism and formal "purity" of the classical tradition, with its allusions to moral virtue, the statue seemed intentionally vulgar and demeaning. Interestingly enough, critics back in France had praised this characteristic of the *Jefferson,* celebrating David's ability to capture an immortal personality while remaining true to modern historical dress.[17]

This particular attribute clearly links David's statue to the late-eighteenth-century history paintings of American artists Benjamin West (1738–1820), John Singleton Copley (1738–1815), and John Trumbull (1756–1843), who likewise embraced contemporary fact versus ideal fiction in representing recent historical subject matter. As for Jefferson himself, he would surely have preferred breeches and buckles to Roman togas, having once confided to Washington that representing a modern figure in antique dress would be as much "an object of ridicule as a Hercules . . . with a periwig and chapeau bras."[18]

On January 27, 1834, the Board of Aldermen of the City of New York accepted the plaster model of David's *Jefferson.* For his generous gift, Levy, recently returned from France, received the "Freedom of the City of New York" award—Common Council of New York's highest honor—in the form of a large gold snuffbox.[19] Before installing the model permanently in City Hall (it was originally placed in the governor's room and eventually moved to council chambers), Levy charged admission to view the statue at 355 Broadway, donating all the proceeds to help feed the city's poor.[20]

Levy himself owned a second full-scale plaster model of the *Jefferson,* unbronzed, which for many years resided at Monticello, eventually passing into the hands of Levy's descendants. This model is almost certainly the work donated to the Musée David

[15]John Frazee to Robert Launitz, July 16–17, 1833, Robert Launitz Papers, Boston Public Library, quoted in Voss, *Frazee,* p. 37.

[16]Ibid.

[17]Gustave Planche, "Statue de Jefferson," *L'Artiste* 6 (1833):198–99; Hargrove, *Romantics to Rodin,* p. 220.

[18]Quoted in *Bronze Statue of Washington,* H.R. 1957, 56th Cong., 1st sess., June 4, 1900, p. 4.

[19]Jonas P. Levy to Justin S. Morrill, Chair of Committee on Public Buildings and Grounds, Feb. 16, 1874, copy, Records of the Architect of the Capitol (hereafter cited as RAC); Henry R. Marshall to Captain C. Q. Wright, Mar. 4, 1924, RAC; Hargrove, *Romantics to Rodin,* p. 219; Leslie M. Freudenheim, "City Hall Restoration Should Return Jefferson to Place of Honor," *New York Times,* Jan. 5, 1995.

[20]The money was sufficient to allow Levy to distribute 1,200 loaves of bread to the poor. See Freudenheim, "City Hall Restoration."

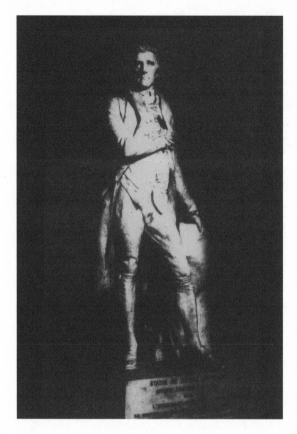

Fig. 11. Pierre-Jean David d'Angers, *Thomas Jefferson,* modeled 1832–33; cast 1833?, 1905? Plaster, Galerie David d'Angers (formerly Musée David), Angers, gift of Jefferson M. Levy, 1905. From *Reception de la Statue de Thomas Jefferson* (Mesnil, France, 1905).

(now the Galerie David d'Angers) in Angers, France, in 1905 by Levy's nephew and former member of Congress Jefferson M. Levy (see fig. 11).[21]

The strong cultural relations between France and America at the turn of the century elicited an unprecedented number of public statues and monuments demonstrating French-American amity. These included the replicas of David's busts of *Lafayette* and *Washington,* which were acquired for the Capitol in 1904 and 1905 respectively; the Capitol's bronze version of Houdon's *Washington,* one of four replicas cast by the

[21]Various sources state that the plaster Jefferson Levy donated to Angers is a surmoulage he commissioned in 1905 from the full-scale bronze statue. See Suzanne Lindsay, soon to be published manuscript, Files of the National Gallery of Art, Washington, D.C.; and Georges Chesneau and C. Metzger, *Ville d'Angers, Musée des Beaux-Arts, Les Oeuvres de David d'Angers* (Angers, 1934), cat. no. 25, pp. 50–52. But this is unlikely since there is no record in the files of the Office of the Architect of the Capitol that such a casting was ever made. Lami claims the working plaster model for *Jefferson* is located at Monticello and was the source for a surmoulage: "Le modèle est conserve dans l'ancienne propriété de Jefferson, a Monticello, en Virginie. Un exemplaire en plâtre, moulé sur le modèle, a été donné en 1905 au Musée David, à Angers" (S. Lami, *Dictionnaire des sculpteurs de l'école frangaise au dix— neuvième siècle* [Paris, 1916], 2:83); Fitzpatrick and Saphire claim that Levy originally purchased two plaster copies of the figure (Fitzpatrick and Saphire, *Navy Maverick,* p. 133). Today, Monticello does not possess a full-scale plaster of the figure. Thus, it seems most likely that the full-scale plaster at the Galerie David is an original plaster copy of the statue dated from about 1833 and that it had remained in the possession of the Levys until Jefferson Levy donated it to the French museum in 1905.

Gorham Manufacturing Company in 1909; and Paul Bartlett's *Equestrian Lafayette,* 1898–1908 (fig. 12), America's reciprocal gift to France for the Statue of Liberty. In the spirit of this ongoing cultural exchange between the two nations, French ambassador to the United States Jules Jusserand had visited Jefferson Levy at Monticello in December 1904 to express Angers's interest in getting a reproduction of David's statue. The town officially accepted Jefferson Levy's gift of the plaster model on September 16, 1905. Those in attendance at the ceremonies marking the statue's inauguration included Levy; Jusserand; Robert S. MacCormick, American Ambassador to France; Henry Jouin, secretary of the École des Beaux-Arts and David's biographer; and Madame Leferme, David's daughter.[22]

A third full-scale model of David's *Jefferson* is of a more modern vintage (fig. 13). In 1973, the State Department, with the approval of the Joint Committee on the Library, commissioned Hoheb Studios of Bayside, New York, to produce a fiberglass sur-moulage of the bronze statue to complement the remodeling of the Thomas Jefferson Reception Room. The mold was made in the rotunda directly from the bronze and under the scrutiny of the Office of the Architect of the Capitol. The fiberglass model was "unveiled" on the occasion of the reopening of the room on October 4, 1974.[23]

Returning to the chronology of the bronze: in mid-March 1834, Levy traveled to Norfolk, Virginia, to meet the U.S. Navy flagship bringing the finished full-scale bronze *Jefferson* to America. He personally supervised the unloading of the statue and on horseback accompanied its shipment to Washington.[24] Finally, on March 21, upon a suitable marble pedestal that Levy had previously ordered from Philadelphia, David's *Thomas Jefferson* was set up in the rotunda of the U.S. Capitol. Later that day, Benjamin Brown French, then employed in the clerk's office of the House of Representatives, noted in his journal: "This day, was placed in the centre of the rotunda, at the Capitol a bronze statue of Thomas Jefferson. From descriptions of the man and from portraits I have seen of him, I should think it was a very good likeness, and certainly the bust is admirably executed."[25]

Two days later, on March 23, 1834, Levy addressed a letter to Andrew Stevenson, Speaker of the House of Representatives, asking him to present in the House his offer

[22]See *Reception de la statue de Thomas Jefferson, troisième président des Etats-Unis, oeuvre de David d'Angers offerte a la ville d'Angers* (Mesnil, France, 1905).

[23]See Clement Conger to George White, May 8, 1973, Lucien Nedzi to George White, May 14, 1973, George White to Clement Conger, July 31, 1973, and George White to James B. Allen, Aug. 11, 1975, RAC; Dorothy McCardle, "Return with Us Now to the Time of Jefferson," *Washington Post,* Dec. 30, 1973, pp. D11–12; and McCardle, "Henry Kissinger: Upstaging Thomas Jefferson," *Washington Post,* Oct. 5, 1974, p. B3.

[24]Fitzpatrick and Saphire, *Navy Maverick,* p. 131.

[25]Benjamin Brown French Journal, Mar. 21, 1834, Benjamin Brown French Papers, Manuscripts Division, Library of Congress.

Fɪɢ. 12. Paul Wayland Bartlett, *Equestrian Statue of Lafayette,* 1898–1908. Bronze, marble pedestal, Cours la Reine, Paris. *(Courtesy the author.)*

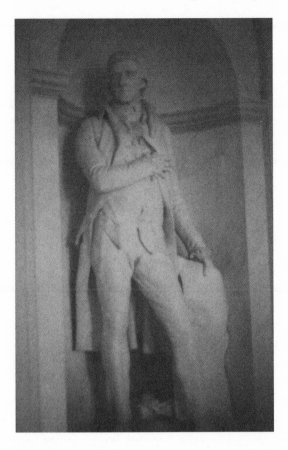

FIG. 13. Pierre-Jean David d'Angers, *Thomas Jefferson,* modeled 1832–33; cast 1973. Full-scale fiberglass model, Thomas Jefferson State Reception Room, Department of State, Washington, D.C. *(Courtesy the author.)*

"of a colossal statue in bronze of the immortal Jefferson to my country." Levy further stated that the statue had been made at his "private expense" and "under his immediate superintendence." On March 25, Stevenson laid Levy's letter before the House; the day before, a copy of the letter had been communicated to the Senate. According to precedent, both Houses referred the matter to the Joint Committee on the Library.[26] Then, on June 27, 1834, about three months after David's *Jefferson* first arrived at the Capitol, Edward Everett of the Joint Committee on the Library reported a joint resolution in the House as follows: "Resolved by the Senate and House of Representatives of the United States of America in Congress assembled, That the bronze statue of Thomas Jefferson, presented to the people of the United States by Lieutenant Levy, be

[26]*House Journal,* 23d Cong., 1st sess., Mar. 25, 1834, p. 453; Levy to Andrew Stevenson, Mar. 23, 1834; *Senate Journal,* 23d Cong., 1st sess., Mar. 24, 1834, pp. 193–94; *Congressional Globe,* 23d Cong., Mar. 24, 1834, p. 262; *House Journal,* 23d Cong., 1st sess., Mar. 25, 1834, p. 453; *Congressional Globe,* 23d Cong., Mar. 25, 1834, p. 265; *Senate Journal,* 23d Cong., 1st sess., May 6, 1834, pp. 246–47; *Report of the Library Committee on the Letter of Lieutenant Levy Presenting a Bronze Statue of Thos. Jefferson,* RG 128, Box 3–7, National Archives and Records Administration; *Senate Journal,* 23d Cong., 1st sess., May 12, 1834, p. 263.

placed in the square on the eastern front of the Capitol."[27] But Congress would never pass this joint resolution, and David's *Jefferson* would never be placed before the eastern front of the Capitol.

As a matter of fact, Levy's gift to the nation was in jeopardy right from the start. There were several strong objections raised immediately in the House regarding the statue's official acceptance and placement. For one thing, many of the members were clearly unsettled by the dark, roughly textured surfaces of the bronze statue, preferring the traditional white, smoothly polished surface treatment typical of marble, still the medium of choice for American portrait statuary in the 1830s. One particularly uncouth congressman even scoffed that the statue had made Jefferson into a "negro."[28] Other members believed that it was inappropriate to consider any portrait statues for the Capitol until after Horatio Greenough's monumental *George Washington,* ordered by Congress for the center of the rotunda only two years earlier, was completed and safely installed.[29] Some in the House even worried that by accepting such a prominent gift from a private citizen they would be setting an unwelcome precedent. One member, for example, argued that "if Congress desired to have a statue of this distinguished man [Jefferson], it would be more consistent with propriety to procure one for themselves than to be indebted for it to any person whatever."[30]

This last response to Levy's gift was most likely motivated, at least in part, by personal objections to Levy himself, who, as a U.S. naval officer, had acquired a reputation as a troublemaker and malcontent. But, as Levy's biographer, Ira Dye, explains,

> [m]ost of Levy's problems in the navy resulted from prejudice and his strong-minded reaction to it. Throughout his career he faced the attitudes, common in the officer corps, that those promoted to lieutenant from the rank of sailing master were socially and professionally inferior to officers who had entered as midshipmen. [Levy had enlisted in 1812 as a sailing master and was promoted to lieutenant in 1817.] Further, although there seems to have been little or no bias against Jews in the pre-1815 navy, in the following years Levy was increasingly the object of anti-Jewish bigotry. He refused to accept any of this biased treatment and always fought back vigorously.[31]

The results of Levy "fighting back" were often calamitous. In 1817 he had killed a fellow officer in a duel, and over the next ten-year period—from 1817 to 1827—he

[27]*House Journal,* 23d Cong., 1st sess., June 27, 1834, p. 854; *Congressional Globe,* 23d Cong., June 27, 1834, p. 475; *Gales and Seaton's Register,* June 27, 1834, p. 4787.

[28]See Hargrove, *Romantics to Rodin,* pp. 220–21; Peterson, *Jefferson Image,* p. 13; and Wilhelmus Bogart Bryan, *A History of the National Capitol,* 2 vols. (New York, 1916), 2:329 n. 3. For the congressional debates regarding Levy's offer, see Committee on Public Buildings and Grounds, S. Rept. 138, 43d Cong., 1st sess., Feb. 25, 1874, pp. 1–3.

[29]S. Rept. 138, Feb. 25, 1874, p. 2.

[30]Ibid.

[31]Dye, "Levy," *American National Biography,* 13:554.

underwent an unprecedented five courts-martial. Although the accusers in most cases were severely reprimanded as well, a disgruntled Navy Department finally removed Levy from active duty in 1827; he was not fully reinstated until eleven years later.[32]

Nevertheless, despite these various initial objections to Levy's offer, the House passed the joint resolution accepting the statue and the following day, June 28, 1834, sent the resolution to the Senate for its concurrence. But the Senate ordered it tabled, effectively ending the possibility of any joint action in the matter.[33] Eight months later, as a consequence of the Senate's continuing lack of interest, the House proposed that the *Jefferson* be removed "from the rotunda to some suitable place for its preservation, until the final disposition of it be determined by Congress."[34] Apparently, over the next few years, David's *Jefferson* was shuffled about within the building, sometimes on display in the rotunda and sometimes stored in the basement.[35]

Actually, despite the Senate's reluctance to approve the gift and the generally low esteem in which the bronze statue was held, information from various sources suggests that *Jefferson* spent most of the next ten years or so somewhere within the rotunda. It was there in the spring of 1836; and in 1839, according to a contemporary guidebook, the statue occupied the rotunda's center, "elevated on a pedestal" and "well represented by [an] accompanying plate" (see fig. 14). In late March 1840, one local newspaper, anticipating the arrival of Greenough's much-heralded *Washington,* boldly stated that "the old bronze statue of Jefferson" would "probably be disposed of, as Mr. Greenough proposes to place his work where that now stands."[36] *Jefferson* was even there to witness George's *grande entrée* into the rotunda on December 1, 1841. Lamenting the nearly universal contempt soon heaped upon *Jefferson*'s new seminude "roommate," B. B. French recorded in his journal eleven days later that "the coat [and] breeches on the bronze Jefferson have risen 50 per cent in the opinions of many since *the* Washington, in *God's own costume,* was placed upon its pedestal."[37]

David's *Jefferson* and Greenough's *Washington* shared rotunda space at least through June 1842. But by the following year, the *Jefferson* was gone, presumably into storage, and the *Washington* had been relocated to the grounds east of the building, where it stood until 1908, when it was removed to the "shelter" of the Smithsonian.

[32]Ibid.

[33]The resolution passed in the House 69 to 55. See *House Journal,* 23d Cong., 1st sess., June 27, 1834, p. 854; *Congressional Globe,* 23d Cong., June 27, 1834, p. 475; *Gales and Seaton's Register,* June 27, 1834, p. 4787; and *Senate Journal,* 23d Cong., 1st sess., June 28, 1834, pp. 368–70.

[34]*Compilation of Works of Art in the United States Capitol,* p. 270; S. Rept. 138, Feb. 25, 1874, p. 2.

[35]Bryan, *History of the National Capitol,* 2:329.

[36]See *Public Buildings and Statuary of the Government: The Public Buildings and Architectural Ornaments of the Capitol of the U. States at the City of Washington* (Washington, D.C., 1939), pp. 10, 13–14; and *Evening Post* (New York), Mar. 31, 1840, 2:2.

[37]B. B. French Journal, Dec. 12, 1841, French Papers.

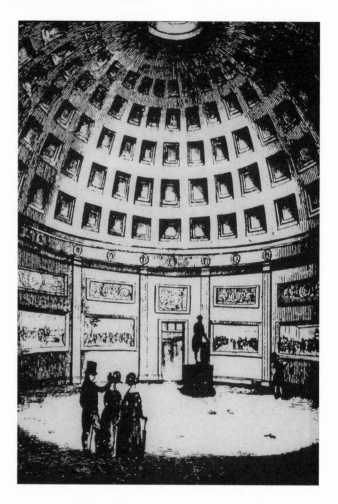

FIG. 14. *Grand Rotunda.* From
*Public Buildings and Statuary
of the Government: The Public
Buildings and Architectural
Ornaments of the Capitol of the
U. States, at the City of Washing-
ton* (Washington, D.C., 1839).

And what of the *Jefferson*? Well, once again the facts elude us. But on some undis-
closed date—most likely between 1845 and 1847—and by some undisclosed means,
the statue was transferred to the north grounds of the White House, by permission—
and probably on the orders—of President James K. Polk. Visible in photographs of
the north portico taken during the 1850s and 1860s (see fig. 15), the statue stands in the
center of the lawn atop a simple pedestal of stuccoed brick set off from the portico drive-
way by a low rectangular arrangement of bushes.[38]

Polk (fig. 16), a member of the House of Representatives from 1827 to 1839 (Speaker
of the House, 1835–39) and eleventh president of the United States (1845–49) was a
southern Democrat in the tradition of Andrew Jackson, who, like most Jacksonians,

[38]Bryan, *History of the National Capitol,* 2:329; Jonas P. Levy to Justin S. Morrill, Feb. 16, 1874 (published in
S. R. 138, Feb. 25, 1874, pp. 3–4); Chalmers M. Roberts, *Washington Past and Present: A Pictorial History* (Wash-
ington, D.C., 1949–50), pp. 58–59; Hargrove, *Romantics to Rodin,* p. 219.

FIG. 15. North Front of the White House, ca. 1860. Photograph from William Seale, *The White House: The History of An American Idea* (Washington D.C., 1992).

was indebted to the political and social ideologies of Thomas Jefferson. For Jacksonians like Polk, as Merrill Peterson explains, "Jefferson appeared not only as the sainted Father of Democracy but also as the symbol of a pure and noble way of life.... Whether conscious or unconscious, ingenious or manipulative, the Jefferson symbol played a major role in the Jacksonian mind."[39]

Polk, who consciously styled himself Jeffersonian, even copied out long extracts from Jefferson's *Memoirs* for his own personal and political use.[40] As a champion of "Manifest Destiny," Polk perhaps followed closest in the steps of his forebear in his dedication to expansionism, doing more than any president since Jefferson to build America into a truly continental nation. No doubt an admirer of David's bronze *Jefferson* from the time of his tenure on Capitol Hill, Polk apparently rescued the statue from storage and had it installed on the White House grounds within a year or two after his inauguration in 1845.[41]

While some sources state that the statue was subsequently moved east to a small plot of green between the White House and the Treasury Building, "where it could only be viewed from an elevation of some twelve feet or more," it probably stood on the

[39]Peterson, *Jefferson Image,* p. 70.
[40]Ibid.
[41]See William Seale, *The White House Garden* (Washington, D.C., 1996), pp. 102–3; Seale, *The White House: The History of an Idea* (Washington, D.C., 1992), p. 105; Seale, *The President's House: A History,* 2 vols. (Washington, D.C., 1986), 1:252.

FIG. 16. *James K. Polk as President-Elect, 1844.* Drawing, Prints and Photographs Division, Library of Congress. From Charles A. McCoy, *Polk and the Presidency* (Austin, 1960).

center of the north lawn until 1874, when it was replaced by a fountain.[42] In any case, by the early 1870s, years of neglect exiled at the opposite end of Pennsylvania Avenue had reduced the bronze statue to such a miserable condition that contemporary observers described it as "eaten full of holes" and "so dark that it was frequently referred to as the 'Black Thomas Jefferson.'"[43] Then, just when the deteriorating *Jefferson* seemed destined for the scrap heap, new motivations conspired to save it.

One contemporary published source claims that noted mid-nineteenth-century American sculptor Henry Kirke Brown (1814–1886) "discovered" the *Jefferson* one day as he strolled around the White House grounds. Scratching through the surface corrosion and finding David's name, Brown quickly pronounced the statue the "best piece of sculpture at the Capitol City" and publicly questioned why it had been "banished to a garden."[44] Writing in 1881, leading art critic and historian of American and French sculpture Truman Howe Bartlett—Paul Bartlett's father—credited General Orville F. Babcock, Ulysses S. Grant's Commissioner of Public Buildings and Grounds,

[42]C. N. D., "D'Angers's Statue of Jefferson," *American Architect and Building News,* Aug. 6, 1881, p. 66; Glenn Brown, *History of the United States Capitol,* 2 vols. (Washington, D.C., 1903), 2:179; Seale, *President's House,* pp. 475–76.

[43]C. N. D., "D'Angers's Statue of Jefferson," "Story of the Jefferson Statue."

[44]"Note on Commodore Levy's Gift of a Statue of Jefferson," unidentified newspaper clipping. I am indebted to Ira Dye for knowledge of this clipping.

with *Jefferson*'s rescue. Singling out David's *Jefferson* as a most notorious example of America's innate lack of positive sentiment for sculpture, Bartlett gave the following imaginative account of the statue's ignominious past:

> As tradition goes, it was never accepted [by Congress], sculpture being at that time a subject of little interest. The gardener of the White House, out of compassion, placed it in a clump of bushes in front of that building, where it remained for nearly forty years as much forgotten as though it had never existed. When General Babcock became superintendent of the public grounds and began to clear away the incipient forests that were fast hiding the stately grandeur of the home of the presidents, he came across the Jefferson, blued, greened and blackened with the merciless vinegar of the . . . atmosphere. . . . To find such a mass of poisonous verdigris within breathing distance of human habitation was a sufficient reason for the adoption of vigorous measures of reform, and the neglected, despised, and unfortunate Jefferson was started toward the junk shop. . . . Some wag proposed that as copper was rated low in the market, the Jefferson would not bring a price due its age and distinguished origin, and that it would be better to clean it, place it among its kind and wait for a rise in metal. The suggestion was practical and amusing. It was adopted. A generous bath of soap and water was given the assiduous author of the Declaration of Independence, and lo! a beautiful piece of bronze appeared to astonish and charm the metallic speculator. Such an example of statuesque reform was sufficient glory for any single administration. . . . It is not only the finest portrait statue in America, but it has more art in it than all the public sculptures in Washington put together.[45]

To the speculations of Brown and Bartlett we might add a third—the approach of 1876 could have inspired some centennial-minded Washingtonians to reconsider the disposition of the city's only outdoor public statue commemorating the author of the Declaration of Independence.

In any event, meaningful government action was finally at hand. On February 13, 1874, Charles Sumner introduced the following resolution in the U.S. Senate:

> Resolved, That the Committee on Public Buildings and Grounds be instructed to consider the expediency of providing for the protection of the statue of Jefferson now in the open air in the grounds of the Executive Mansion, the same being a work of art by an eminent French sculptor.[46]

Three days later, Jonas P. Levy—brother of Uriah, who had died in 1862—learning of Sumner's resolution, wrote the Committee on Public Buildings and Grounds. Noting

[45]T. H. Bartlett, "Civic Monuments in New England–V," *American Architect and Building News,* July 16, 1881, p. 28 n. 1.

[46]S. R. 123, Feb. 25, 1874, p. 1.

that the *Jefferson* had never been officially received by Congress, he asked that a resolution to that effect be offered; if Congress refused, Levy, as heir to the property, requested that the statue be returned to him as soon as possible.[47]

Jonas Levy's letter energized the committee, for they reported back to the Senate in less than ten days, confessing that while the record regarding the statue was "confused and rather unsatisfactory," it did seem that the intention of Congress had been "to accept, certainly not to refuse, the statue." The committee then offered the following resolution:

> Resolved by the Senate and House of Representatives of the United States of America in Congress assembled, That the bronze statue presented in 1834 by Lieutenant Uriah P. Levy, of the United States Navy, of Thomas Jefferson be accepted with grateful appreciation, and that the officer in charge of public buildings and grounds be directed to properly prepare and place the same in the National Statuary Hall of the Capitol.[48]

By late June 1874, the resolution had been approved and $1,013 had been appropriated to repair and finish the statue "in a thorough and complete manner" and to procure for its installation "a suitable marble base and pedestal." On August 11 the statue was sent to Robert Wood & Co., of Philadelphia, for the necessary repairs; and, in late 1874 or early 1875, the newly restored *Jefferson* was set up in Statuary Hall (Old House of Representatives).[49] In 1900 it returned to the rotunda and today stands just east of the south doorway opposite the Capitol's 1909 bronze cast of Houdon's *George Washington,* a public memorial not only to Thomas Jefferson but also to the nation's contradictory and often antagonistic attitude toward monumental portrait statuary.[50]

[47]Levy to Morrill, Feb. 16, 1874, in S. R. 138, pp. 3–4.

[48]S. R. 123, p. 5.

[49]*Statutes at Large,* 43d Cong., 1st sess., 1874, vol. 18, pp. 143, 285–86; Edward Clark, Architect of the Capitol, to Wood and Co., Aug. 11, 1874, Letter Book 18, 40, RAC. At the time of the installation of the *Jefferson* in Statuary Hall, there were only six other statues; two each from Rhode Island, Connecticut, and New York. See Charles E. Fairman, *Art and Artists of the Capitol of the United States of America* (Washington, D.C., 1927), p. 261.

[50]Brown, *History of the United States Capitol,* 2:179. Apparently, the statue stood north of the east door for a time in 1909. See Senate Committee on the Library to Elliot Woods, Aug. 5, 1909, RAC.

The Problem with Public Art

Henry Kirke Brown's Thinking Negro *(1855) from*
His Pedimental Design for the United States Capitol

Thomas P. Somma

SIX YEARS BEFORE THE START OF THE CIVIL WAR, THE AMERICAN SCULPTOR Henry Kirke Brown of Brooklyn, New York, submitted a design for the sculptural decoration of the House pediment of the U.S. Capitol. Despite Brown's strong abolitionist stance, his design included a slave mournfully sitting on a bale of cotton, a figure the sculptor referred to as a *Thinking Negro* (fig. 1). Several years later, Brown produced another design also depicting slavery for the pediment of the South Carolina Statehouse in Columbia (fig. 2). Neither design was ever completed in stone. Nonetheless, Brown's two slavery projects have been described as "the most politically explosive and iconographically complex imagery in the history of American sculpture."[1]

Essentially unknown for more than a century, Brown's sculptural monuments to slavery have only recently begun to attract scholarly attention. Vivien Green Fryd's *Art and Empire: The Politics of Ethnicity in the U.S. Capitol, 1815–1860* (1992) analyzes Brown's sketch for the House pediment with respect to the iconography of national expansion that characterizes much of the Capitol's nineteenth-century sculpture and murals.[2] In *The Apotheosis of Democracy, 1908–1916: The Pediment for the House Wing of the United States Capitol* (1995), I discuss Brown's designs within the context of the

[1]Wayne Craven, "H. K. Brown and the Black Man in the Pediments," paper delivered at the annual meeting of the College Art Association, Chicago, Feb. 1976, p. 2.

[2]Vivien Green Fryd, *Art and Empire: The Politics of Ethnicity in the United States Capitol, 1815–1860* (New Haven, 1992).

Fig. 1. Henry Kirke Brown, *Thinking Negro,* detail from Brown's first design for the House pediment of the U.S. Capitol, 1855. No longer extant. *(Courtesy Library of Congress.)*

Fig. 2. Henry Kirke Brown, design for the pediment of the South Carolina Statehouse, 1859–61. No longer extant. *(Courtesy Library of Congress.)*

more than half-century-long struggle to decorate the Capitol's House pediment.[3] And, most recently, Kirk Savage's *Standing Soldiers, Kneeling Slaves: Race, War, and Monument in Nineteenth-Century America* (1997) situates Brown's imagery, especially his design for the South Carolina pediment, within a larger study of Civil War–era public monuments and memorials.[4] This chapter approaches Brown's slave imagery as an opportunity to explore the essentially problematic nature of public art, especially government-sponsored public sculpture.[5]

Although never completed, Brown's ill-fated designs are important, for they represent the earliest concerted effort by an American sculptor to create a socially conscious public art. Most significantly, Brown's figures were calculated to challenge rather than to celebrate prevailing public attitudes, with the aim, ultimately, of effecting meaningful political and social change. As such, they provide a compelling historical perspective regarding the daunting stylistic, thematic, and moral questions that American artists faced during the middle decades of the nineteenth century. Furthermore, Brown's example illustrates the storm of conflicting values, personal motives, culture-based power relationships and moral ambiguities that often—both then and now—swirl about politically conscious public art.

On the Fourth of July 1851, President Millard Fillmore laid the cornerstone for a major extension to the U.S. Capitol. As designed by Thomas U. Walter, the general outline of the extension called for two wing buildings to be placed to the north and south of the Old Capitol but connected to it by corridors. In March 1853, jurisdiction over the Capitol Extension was transferred from the Department of the Interior to the War Department. Soon thereafter, Secretary of War Jefferson Davis appointed an army engineer, Capt. Montgomery C. Meigs, as superintendent of the extension, giving him full authority over the planning, construction, and decoration of the new buildings.[6]

The final designs for the Capitol Extension included a pediment over the east front of each wing (fig. 3). Captain Meigs had insisted on the addition, believing the

[3]Thomas P. Somma, *"The Apotheosis of Democracy," 1908–1916: The Pediment for the House Wing of the United States Capitol* (Newark, Del., 1995).

[4]Kirk Savage, *Standing Soldiers, Kneeling Slaves: Race, War, and Monument in Nineteenth-Century America* (Princeton, 1997).

[5]For other relevant discussions of the various problems unique to government-sponsored public monumental sculpture, see Michele H. Bogart, "In Search of a United Front: American Architectural Sculpture at the Turn of the Century," *Winterthur Portfolio* 19 (1984):151–76, and *Public Sculpture and the Civic Ideal in New York City, 1890–1930* (New York, 1989); Harriet F. Senie and Sally Webster, eds., *Critical Issues in Public Art: Content, Context, and Controversy* (New York, 1992); and Thomas P. Somma, "The Sculptural Program for the Library of Congress," in *The Library of Congress: The Art and Architecture of the Thomas Jefferson Building,* ed. John Y. Cole and Henry Hope Reed (New York, 1997), pp. 227–51.

[6]For the controversy surrounding control over the 1851 Capitol Extension, see Lillian B. Miller, *Patrons and Patriotism: The Encouragement of the Fine Arts in the United States, 1790–1860* (Chicago, 1966), pp. 68–69; and Somma, *Apotheosis of Democracy,* pp. 17, 34, 125 n. 79.

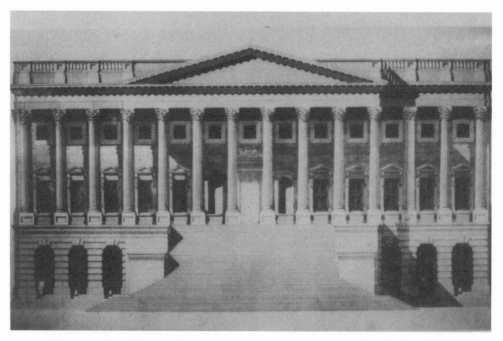

FIG. 3. Exterior design for east portico of the north and south wings of the U.S. Capitol, 1853. From Glenn Brown, *History of the United States Capitol* (Washington, D.C., 1900–1903). (*Courtesy Office of Architect of the Capitol.*)

pediments would improve the aesthetic presentation of the entire building as well as provide a singular opportunity for American sculptors to display their developing talents. The pediment for the north wing (Senate) was designed by Thomas Crawford; entitled *Progress of Civilization* (fig. 4), 1853–63, it illustrates the progressive development of the North American continent from a primitive state to a domesticated condition of material progress. But for the south pediment (House), Davis and Meigs were unable to attract immediately a native-born sculptor of sufficient skill or reputation.[7]

Brown was the first American sculptor officially to seek the commission to decorate the House pediment, completing his initial sketch model in December 1855. Although Brown's sketch no longer exists, a photograph of the model survives in the Henry Kirke Bush-Brown Papers at the Library of Congress (fig. 5). It reveals a composition dominated at center by a majestic personification of America, while to either side are arranged an assortment of figures representing the various economic and political interests of the country.

[7] The House pediment was initially offered to Hiram Powers, who refused the commission. See Somma, *Apotheosis of Democracy,* pp. 19–21.

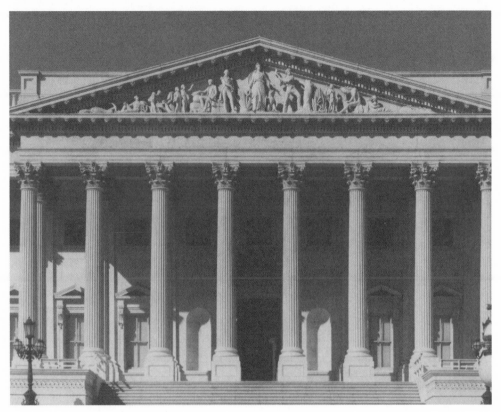

Fig. 4. Thomas Crawford, *Progress of Civilization,* 1853–63. Marble, pediment for the Senate wing of the U.S. Capitol. *(Courtesy Office of Architect of the Capitol.)*

Fig. 5. Henry Kirke Brown, *America,* first design for the House pediment, 1855. No longer extant. *(Courtesy Library of Congress.)*

By far the most curious part of the design is Brown's *Thinking Negro,* which the sculptor included to represent the American institution of slavery. The presence of a southern slave in a design submitted by a northern abolitionist, of course, raises questions concerning its intended purpose; one would assume that Brown's strong opposition to slavery would have precluded such imagery. After all, a public monument usually depicts something the artist has deemed worthy of national reverence. Brown's slave would have had the opposite effect, monumentalizing for posterity an institution that Brown in fact despised.

The paradoxical nature of the *Thinking Negro* largely determined Brown's stylistic and conceptual approach to the figure. In terms of mood and pose, Brown's slave parallels Thomas Crawford's *Dying Indian Chief, Contemplating the Progress of Civilization* (fig. 6), 1853–56, from the Senate pediment. Both, in fact, are derived from the same antique prototype, the *Belvedere Torso,* ca. 150 B.C.E., by Apollonios of Athens (Rome, Vatican Museums); more significantly, however, each contemplates a similar fate—subjugation on the basis of race. In mythological terms both figures represent the "Suffering Hero," a type that can be traced back to the Ancient Greeks; other prominent examples include the *Fallen Warrior* from the east pediment of the Temple of Aphaia at Aegina, ca. 490 B.C.E. (Munich, Glyptothek), *Dying Gaul* (fig. 7), late third century B.C.E., and *Seated Boxer,* first century B.C.E. (Rome, Museo delle Terme). In practical terms, the intended audience for such "fallen" figures was often assumed by the artist to be of a higher political, social, or moral status; and one of the artist's chief concerns was to defuse any sense of threat or insecurity the subject might engender in that audience by encouraging feelings of empathy and pity rather than fear or hostility.

What distinguishes the *Thinking Negro* from Crawford's figure is Brown's rejection of the idealized form and smoothly polished surfaces typical of Italianate neoclassicism. As a young sculptor, Brown had received a thorough training in the classical tradition during a lengthy stay in Italy. However, unlike Crawford and most American sculptors working in Italy during the 1840s and 1850s, Brown became convinced that only back in the United States could a truly authentic American sculptural tradition take root and flourish.[8] Consequently, in 1846 Brown had returned to his native country eager to pursue a native sculptural art based strictly on American meanings. Soon after his return to America, Brown began to loosen the grip of the antique on his work by adopting a new, vigorous style more dependent on the close observation of nature than on worn-out classical formulas. In a letter to Captain Meigs in early February

[8]For Brown's early years in Italy, see Wayne Craven, "Henry Kirke Brown in Italy, 1842–1846," *American Art Journal* 1 (1969):65–77. For Brown's personal commitment to a distinctly American art form, see Wayne Craven, "Henry Kirke Brown: His Search for an American Art in the 1840s," *American Art Journal* 4 (1972):44–58; Michael Edward Shapiro, *Bronze Casting and American Sculpture, 1850–1900* (Newark, Del., 1985), pp. 44–50; and Somma, *Apotheosis of Democracy,* pp. 21–30.

Fig. 6. Thomas Crawford, *Dying Indian Chief, Contemplating the Progress of Civilization,* 1853–56. Marble. *(Courtesy New-York Historical Society.)*

Fig. 7. *Dying Gaul.* Roman copy after a bronze original of late third century B.C.E. Marble. *(Courtesy Capitoline Museum, Rome.)*

1856, Brown wrote: "My feeling is that all art to become of any national importance or interest must grow out of the feelings and habits of the people and that we have no need of the symbols and conventionalities of other nations to express ourselves."[9] Brown did continue to rely on figural types derived from antique sources, but he updated or "modernized" his figures by selecting characteristically American subject matter and by relating the aesthetic experience as directly as possible to the visual and emotional experience of everyday life.

Thus, nationalistic sentiment played an important part in Brown's decision to abandon the surface aesthetics of neoclassical marble sculpture. However, Brown also had a moral reason. The white, unblemished marble "skin" of Crawford's *Dying Indian* was meant to express aesthetically certain absolute, abstract ideals that transcend the imperfect realities of everyday life (in this case, a heroic and blameless resignation in the face of impending doom). But the success of this strategy also deflects the viewer's attention away from the true historical reality of the subject—the displacement and near eradication of native peoples from the North American continent. The duplicitous nature of Crawford's statue, in effect, offered American viewers a kind of moral "comfort zone," an aesthetic and psychological distance from which to consider without guilt or recrimination a contemporary human tragedy. Crawford, in other words, acknowledged the special needs and reinforced the prevailing attitudes of his viewers with respect to the subject matter of his statue. By contrast, Brown's slave, rooted in realism and essentially free of neoclassical pretense and the "fantasy" of idealization, was intended to confront the viewer directly with an oppositional point of view, to cause discomfort rather than relieve it, in the hope of raising social consciousness and effecting political change.

Both Brown's *Thinking Negro* and Crawford's *Dying Indian* are also related to traditional images of Melancholy, the mythic daughter of Saturn. Albrecht Dürer's master engraving from 1514, *Melancolia I* (fig. 8) is a characteristic example. Melancholy, one of the four temperaments according to medieval physiology, was identified by Renaissance humanists such as Dürer with the introspective qualities of the ideal, contemplative man.[10] Often depicted in an attitude of despair, resting head in hand, the figure personifies temporal knowledge that without divine inspiration lacks the ability to act; or, in more pedestrian terms, the struggle of human ambition to transcend human frailty. By connecting his slave to this tradition, Brown endowed him with a stoicism that comes from thoroughly understanding the limitations of one's material condition.

[9]Henry Kirke Brown to Montgomery C. Meigs, Feb. 12, 1856, Records of the Architect of the Capitol, Washington, D.C. The complete letter is published in Charles E. Fairman, *Art and Artists of the Capitol of the United States of America* (Washington, D.C., 1927), pp. 191–92.

[10]James Hall, *Dictionary of Subjects and Symbols in Art*, rev. ed. (New York, 1974), pp. 130–31.

Fɪɢ. 8. Albrecht Dürer, *Melancolia I, 1514*. Engraving. *(Courtesy National Gallery of Art, Washington, D.C.)*

Other Renaissance versions of the melancholic figure include Michelangelo's well-known *Prophet Jeremiah* (fig. 9), 1508–12, from the Sistine ceiling and *Lorenzo de' Medici,* 1519–34, from the New Sacristy of San Lorenzo in Florence. More directly, Brown's slave also refers to Michelangelo's famous series of bound and struggling slaves executed for the tomb of Pope Julius II; the *Young Slave* (fig. 10), 1530–34, provides a particularly apt comparison. In posture and gestures, especially the awkward placement of the right arm behind the back, Brown's figure echoes the Italian master's exploration of the more expressive possibilities of the human body. Similar to the figure of Melancholy, Michelangelo's slaves evoke the alienated individual in crisis, denied yet forever seeking salvation, enlightenment, or the divine.

The various art historical references apparent in the *Thinking Negro* allowed Brown to connect his figure to respected masters and established motifs of the past, always an important motive for a nineteenth-century American artist, especially a sculptor trained in the classical tradition. But more important to Brown, it lent a deeper resonance to the figure's contemporary meanings, helping to establish the social effectiveness of his statue and its relevance to a modern audience. Brown firmly believed that art could operate as an active agent for social change. And, as a legitimate public artist, he was determined to create works that engaged the significant public issues of the day, even —perhaps especially—if those issues were distasteful or embarrassing. Brown wrote that he hoped his slave would "move and awaken a national feeling in regard to its importance"; that is, a monument to slavery on America's most visible public building might force a resolution to the slavery question once and for all.[11]

Brown was not preaching to the converted; the point was to change the minds of those who opposed his point of view. Postrevolutionary southern slave owners who believed "that all men are created equal" had to believe that black slaves were less than fully human, so they would often portray blacks as stupid or childlike. Thus, to a contemporary proslavery viewer, an intentionally provocative characteristic of Brown's figure was its designation as a "thinking Negro." Still, we might reasonably ask why Brown's figure did not adopt a more critical or accusatory tone.

The simple answer is that as a public sculptor Brown's options were limited. For one thing, the notion that an artist was responsible to society, that it was an artist's duty to provoke the public into addressing issues it would rather ignore (ideas traceable to late-eighteenth- and early-nineteenth-century European art and central to mid-nineteenth-century French art) had no real precedent in American art before Brown. Complicating matters further, Brown's patron, the federal government, was less than sympathetic to

[11]Henry Kirke Brown, undated notes, Henry Kirke Bush-Brown Papers, Manuscripts Division, Library of Congress.

FIG. 9. Michelangelo, *Prophet Jeremiah,* 1508–12. Detail from the ceiling of the Sistine Chapel. *(Courtesy the Vatican, Rome.)*

FIG. 10. Michelangelo, *Young Slave,* 1530–34. Marble. *(Courtesy Academy, Florence.)*

his cause. Control of the Capitol Extension and its decoration came under the juris-
diction of the War Department, and the secretary of war in 1855 was Jefferson Davis,
a slaveholder and the future president of the Confederacy. Even many of those in the
government who personally supported the abolition of slavery still preferred compro-
mise over confrontation, fearing that an eruption of the volatile feelings surrounding
the issue would seriously threaten the future of the Union. If that were not enough,
the War Department itself was at this moment coming under severe criticism from
Congress for its handling of the sculptural decoration of the new wings. Speaking to
Congress in March of 1856, Edward Ball of Ohio remarked: "Are gentlemen aware
that this Government has become an extensive manufacturer of statuary? It is even so.
Just around the corner may be found two shops filled with Italian and German sculp-
tors busily engaged in manufacturing statuary to be placed in the east pediment. . . .
The statuary in question does not seem designed to commemorate any historical events
or personages connected with this country. . . . The graven images have the likeness to
nothing in the Heaven above or the earth below."[12]

With so many obstacles in its path, Brown's *Thinking Negro,* realistically, had little
chance of making it onto the Capitol pediment. Regardless of any possible artistic merit,
politically speaking, it was inconceivable. Soon after receiving official word from Meigs
and Davis that his designs for the House pediment had been rejected, Brown wrote to
a friend that he "could not fail to see what restraint rests upon all who desire success
in our governmental affairs. They have to skulk and dodge in many ways, which must
be repulsive to them. The friends of slavery and their opponents are more numerically
even now than formerly and we trust that the day is not far distant when the gag may
be taken from the mouths of all men, and that without outrage we may put these out-
rageous habits by, as worn out garments."[13]

At that moment, Brown could not have anticipated that he would soon get another
chance to place before the public a bold sculptural statement regarding the "outra-
geous habit" of slavery. In the spring of 1859, Brown was offered and accepted a com-
mission to execute the statuary for the central pediment of the statehouse then under
construction in Columbia, South Carolina. The project assumed a national as well as
local importance, for there were those in the South who already believed secession was
inevitable, and that once it occurred, Columbia would become the capital of the south-
ern confederacy; the statehouse would then, in effect, become a national capitol.[14]

Brown's pediment for the South Carolina Statehouse was never completed; the start
of the Civil War forced the sculptor to suspend all work on the project in May 1861,

[12]Ball's remarks, delivered in Congress on March 26, 1856, are quoted in Fairman, *Art and Artists,* p. 165.
[13]Henry Kirke Brown to William Morris Davis, Jan. 27, 1856, Brown Papers, Library of Congress.
[14]Craven, "Black Man in the Pediments," p. 11.

and, eventually, the models and several marble figures that Brown had produced were destroyed by General Sherman in 1865 during his march to the sea. However, photographs from the Henry Kirke Bush-Brown Papers show Brown's sketch models for the commission (see figs. 2 and 11–13). As the photographs indicate, three classically inspired female personifications occupied the middle portion of the design—the central South Carolina flanked to her immediate right and left by Liberty and Justice respectively. But the two remaining sides of the composition, recalling Brown's *Thinking Negro,* were completely filled with docile black men and women quietly working the fields under the watchful eye of a white plantation overseer on horseback (located just to the left of Liberty).

For an insightful and more comprehensive discussion of this remarkable chapter in American sculptural history, readers should consult Kirk Savage's book *Standing Soldiers, Kneeling Slaves.*[15] What concerns us here is the pediment's defining characteristic —its disquieting objectivity. Knowing Brown's personal beliefs, we can assume that he intended his pediment to be a public indictment of slavery. Surely, Brown would have approved of the interpretation given to the design by his close friend and fellow abolitionist William Morris Davis: "A mind educated in the belief that the laborer is worthy of his hire, while admiring the majesty and beauty of the central figures. . . . might question, whether the stooping slave bearing the rice sheaf, is not borne down by a burden greater than the grained straw? Whether the low-crouched form, the abject helplessness expressed in every feature, tell not a piteous tale of a crushed manhood and an outraged spirit within."[16] But despite Davis's description, the truth is that, visually speaking, there is nothing even remotely negative about Brown's imagery. In fact, Brown's southern patrons saw his pediment as a resounding confirmation of the validity of slavery as an American cultural institution. The cynic among us might conclude, with some justification, that Brown was more concerned with adding a prominent pediment to his professional résumé than remaining true to his moral convictions.

In all fairness to Brown, the ambivalence of his design for South Carolina is a characteristic shared by most images of blacks found in American art before the Civil War. Consider, for instance, the genre paintings of William Sydney Mount, long considered the first fine artist in America to produce sympathetic portrayals of black men and women.[17] In *Farmers Nooning* (fig. 14), 1836, a typical example of Mount's approach,

[15]See Savage, *Standing Soldiers, Kneeling Slaves,* pp. 36–51.

[16]"Heroism in Art," William Morris Davis to Henry Kirke Brown, Brown Papers, Library of Congress.

[17]See Karen M. Adams, "The Black Image in the Paintings of William Sydney Mount," *American Art Journal* 7 (1975):42–59; Alfred V. Frankenstein, *William Sydney Mount* (New York, 1976); Bruce Robertson, "*The Power of Music:* A Painting by William Sydney Mount," *Bulletin of the Cleveland Museum of Art* 79 (1992):38–62; and Deborah J. Johnson and Elizabeth Johns, *William Sydney Mount: Painter of American Life* (New York, 1998).

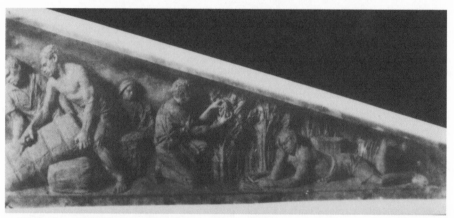

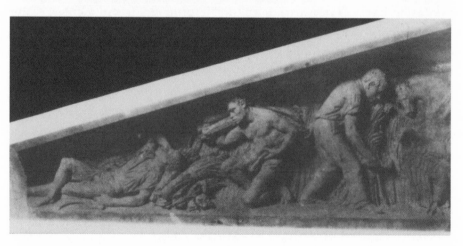

Figs 11–13. Henry Kirke Brown, sketch models for the Pediment of the South Carolina Statehouse, 1859–61. No longer extant. *(Courtesy Library of Congress.)*

the mood seems good-natured enough as the black "farmer" is made the unsuspecting object of a playful and apparently harmless prank. Only after realizing that Mount has presented the black man in the drunken, lascivious pose of the *Barberini Faun* (fig. 15), first century B.C.E., a kind of high-style antique "pornography," does one begin to suspect strongly the painting's air of glib condescension. At least Brown's pedimental figures, by contrast, are grounded in a more genuine socioeconomic context.

Negro Life at the South (fig. 16) by Eastman Johnson, an enormously popular painting following its initial exhibition at the National Academy of Design in 1859, provides another interesting comparison. As Albert Boime has pointed out in *The Art of Exclusion: Representing Blacks in the Nineteenth Century* (1990), the success of Johnson's "benign view of slave existence" rested largely on its ability—as with Brown's contemporary pediment—to appeal to both sides of the slavery debate. "Southerners and their partisans claimed to see a confirmation of what they had been saying all along about slave conditions," Boime writes, "whereas abolitionists perceived in the crumbling and decaying architecture a sign of the impending crisis."[18] Brown's handling of slave imagery differed from that of Johnson's in that his figures no longer hid behind a mask of affability; instead, Brown hoped their thoughtful, somewhat brooding demeanor would give silent testimony to the tragic emotional and psychological consequences of slavery.

Nevertheless, the fact remains that the equivocal nature of Brown's pedimental design reflected the extent to which the sculptor had to disguise or submerge his private intentions in order simply to complete the commission. The end result is so ambiguous that both the southern slave owner and the northern abolitionist, despite their contradictory points of view, could see in the work exactly what each wanted to see. The ambivalence of Brown's design is instructive, for, while it may represent an extreme example, all public art, especially government-sponsored public art, is subject to similar pressures and constraints that often conspire to strip it of any distinctive artistic or critical voice.

Brown's experience also supports the premise held by many modern historians that one true, objective reading of a set of historical data is, in fact, impossible, and that any interpretation despite the most scrupulous attempts at objectivity is inherently value laden, subject to the presumptions and biases of the interpreter.[19] The corollary to this

[18] Albert Boime, *The Art of Exclusion: Representing Blacks in the Nineteenth Century* (Washington, D.C., 1990), p. 111.

[19] For some basic scholarship on the issue of historical objectivity, see Ernst Breisach, *Historiography: Ancient, Medieval, and Modern,* 2d ed. (Chicago, 1994), pp. 329–37; and Hayden White, "The Fictions of Factual Representation," in *Tropics of Discourse: Essays in Cultural Criticism* (Baltimore, 1978), pp. 121–34. For reviews on the recent impact of this issue in the museum world, see Ken Ringle, "Can Art Be Honest and Politically Correct?" *Des Moines Sunday Register,* Apr. 14, 1991; and "Historical Shows on Trial: Who Judges?" *New York Times,* Feb. 11, 1996.

FIG. 14. William Sydney Mount, *Farmers Nooning,* 1836. Oil on canvas. Gift of Frederick Sturges, Jr., 1954. *(Courtesy the Museums at Stony Brook, New York.)*

FIG. 15. *Sleeping Satyr (Barberini Faun),* first century B.C.E. Marble. *(Courtesy Glyptothek, Munich.)*

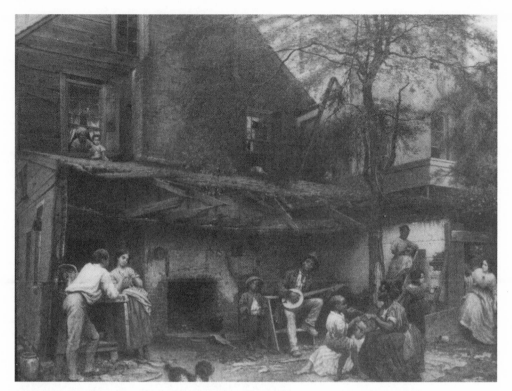

FIG. 16. Eastman Johnson, *Negro Life at the South,* 1859. Oil on canvas. *(Courtesy New-York Historical Society.)*

is to acknowledge that the very structure of our language (including visual language) is tainted with various built-in cultural misconceptions and inconsistencies that contaminate any discourse between two individuals. Another element that should impact our modern understanding of Brown's imagery is the awareness of "the look of the other"; that is, realizing the limitations of trying to describe an ethnic or racial group from the viewpoint of an outside observer. Such an exercise tends to define the group in terms of its relationship to the observer rather than any intrinsic qualities that may be unique to its own identity—what it is not, as opposed to what it is.[20] This consideration seems particularly relevant to Brown's South Carolina pediment, where the black men and women exist only in alienated relation to the white plantation overseer and the three classically derived central personifications.

Although Brown's models were never realized in permanent form, the publicly active, socially conscious character of his monuments to slavery anticipate and probably

[20]For a useful discussion of this topic with respect to Brown's pediment, see Alan Read, ed., *The Fact of Blackness: Frantz Fanon and Visual Representation* (Seattle, 1996), pp. 16–35.

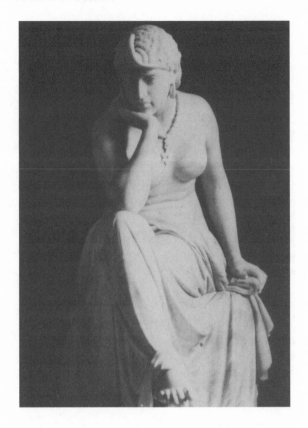

FIG. 17. William Wetmore Story, *The Libyan Sibyl,* 1861–68. Marble. *(Courtesy National Museum of American Art, Smithsonian Institution, Washington, D.C.)*

influenced a handful of later American sculptures of similar subject matter. For example, in mood, conception, and art historical sources, Brown's *Thinking Negro* offers the most immediate precedent for *The Libyan Sibyl*, 1861–68, by William Wetmore Story (fig. 17). African American art historian Freeman H. M. Murray in his *Emancipation and the Freed in American Sculpture: A Study in Interpretation* (1916), described Story's statue as a rare example of an American depiction of a black person that actually did justice to the subject.[21] Story, in a letter to his friend Charles Eliot Norton, professor of art history at Harvard, claimed it was his best work, explaining that he had made it, as far as he could, "luxuriant and heroic." "She is looking out of her black eyes into futurity and sees the terrible fate of her race," Story continued. "This is the theme of the figure—Slavery on the horizon, and I made her head as melancholy and severe as possible."[22] A formal link between *The Libyan Sibyl* and Brown's slavery images is unlikely; all the same, no black figure with a similar thoughtful dignified disposition predates Brown's *Thinking Negro* in the history of American sculpture.

[21]Freeman H. M. Murray, *Emancipation and the Freed in American Sculpture: A Study in Interpretation* (Washington, D.C., 1916), quoted in Boime, *Art of Exclusion,* p. 158.

[22]Henry James, *William Wetmore Story and His Friends,* 2 vols. (Boston, 1903), 2:69–70, quoted in Boime, *Art of Exclusion,* p. 158.

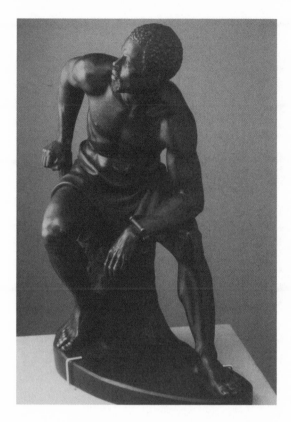

Fɪɢ. 18. John Quincy Adams Ward, *The Freedman,* 1863. Bronze. *(Courtesy the Metropolitan Museum of Art, New York City.)*

Brown's influence on *The Freedman*, 1863, by John Quincy Adams Ward is more direct (fig. 18). Ward had studied with Brown from 1849 to 1856, "during which time," as Lewis I. Sharp writes in his 1985 monograph on Ward, the older sculptor "exerted a profound influence on him, helping to shape not only his sculptural style and technical proficiency but also his attitudes toward art in general."[23] Clearly a postemancipation version of Brown's *Thinking Negro*—derived, like Brown's figure, from the *Belvedere Torso*—Ward's *Freedman,* broken shackles hanging from his wrists, no longer assumes the bent posture and passive gestures of confinement and alienation; instead, poised and outward-looking, he is shown in the act of raising himself, both physically and metaphorically, to an upright position.

Most intriguing, however, Brown's slave prefigures by twenty-five years one of the best-known and most recognizable statues in late nineteenth-century sculpture—*The Thinker,* 1879–89, by Auguste Rodin (fig. 19). A later French romantic version of a figural type whose line extends back through Brown's *Thinking Negro, The Thinker,* from his original perch atop Rodin's celebrated *Gates of Hell,* contemplates not only a private fate but also the collective destiny of all humankind.

[23]Lewis I. Sharp, *John Quincy Adams Ward: Dean of American Sculpture* (Newark, Del., 1985), p. 30.

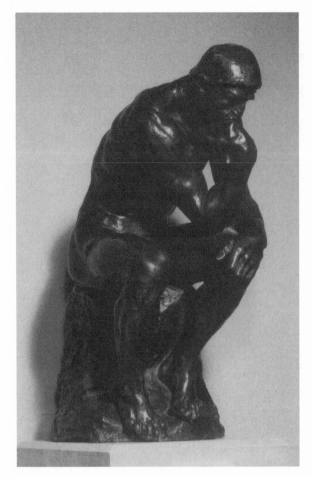

FIG. 19. Auguste Rodin, *The Thinker,* 1879–89. Bronze. *(Courtesy the National Gallery of Art, Washington, D.C.)*

While Brown's slave imagery may have signaled the appearance of a nascent social conscience in American art just prior to the Civil War, a sustained social realist impulse did not take hold until the 1930s. Isabel Bishop, a leading social realist painter from the 1930s and 1940s, reestablished the Greco-Roman figurative tradition in light of the economic and political realities of the Great Depression, much the way that Brown had sought to reformulate classical art for the Civil War era.[24] In paintings like *Preparation,* 1944, and *Nude in Interior,* 1947 (fig. 20), the claustrophobic, generalized nonspaces, introverted gestures, and suggestively compromised, almost eroded, surfaces transform Bishop's antique sources into a modern visual language that evokes damaged personalities struggling nobly to cope with social conditions utterly beyond their control.

[24]The scholarship on Bishop is not extensive. For helpful sources, see Karl Lunde, *Isabel Bishop* (New York, 1976), and Helen Yglesias, *Isabel Bishop* (New York, 1989).

FIG. 20. Isabel Bishop, *Nude in Interior,* 1947. Oil and tempera on canvas. *(Courtesy New Britain Museum of American Art, New Britain, Connecticut.)*

FIG. 21. Leon Golub, *Wounded Warrior,* 1968. Acrylic on linen. *(Courtesy Ronald Feldman Fine Arts, New York City.)*

Perhaps Brown's closest ideological descendant in the twentieth century, however, is the contemporary New York artist Leon Golub (b. 1922). In works from the late 1950s and 1960s such as *Wounded Warrior,* 1968 (fig. 21), and *Burnt Man,* 1969, Golub rediscovered, as few post–World War II artists have, the enduring capacity of the human figure to convey vital information about the human condition. Reinterpreting classical figurative art, like Brown, by configuring his imagery according to contemporary cultural values (post-Holocaust/post-Vietnam), Golub has gone on to create universal images of power and powerlessness, aggression and resignation, conflict and complacency.[25] Typical examples include *Two Black Women and a White Man,* 1986, and *The Site,* 1991 (fig. 22). In their expressionist distortion, awkward gestures, and

[25]Selected primary bibliography on Golub includes James A. Miller and Paul Herring, *The Arts and the Public* (Chicago, 1967); Max Kozloff, "The Late Roman Empire in the Light of Napalm," *Art News* (1970):58–60, 76–78; Irving Sandler, "An Interview with Leon Golub," *Arts Magazine* (1970); Lawrence Alloway, "Art and Politics," *Artforum* (1974):66–71; Joseph Dreiss, "Leon Golub's Gigantomachies: Pergamon Revisited," *Arts Magazine* (1981):174–76; Donald Kuspit, *Leon Golub: Existential/Activist Painter* (New Brunswick, N.J., 1985); Rosetta Brooks, "Undercover Agent," *Artforum* (1990):114–21; Gerald Marzorati, *A Painter of Darkness: Leon Golub and Our Times* (New York, 1990); Shelley F. Adams and Justin Carlino, "An Interview with Leon Golub," *Rutgers Art Review* 12–13 (1991–92):70–86; and Leon Golub, *Leon Golub: Do Paintings Bite?* ed. Hans-Ulrich Obrist (Ostfildern, Germany, 1997).

FIG. 22. Leon Golub, *The Site,* 1991. Acrylic on linen. *(Courtesy Ronald Feldman Fine Arts, New York City.)*

abraded, scraped canvases, such paintings suggest the ambiguous, impersonal, and potentially violent power relationships that characterize the enveloping corporate mentality of modern Western culture. With particular respect to Brown's slave images from a century earlier, the most analogous aspect of Golub's work is that it combines intentional provocation with matter-of-fact neutrality, confronting the viewer with uncomfortable truths about the reality of human nature while refusing to condemn outright the immoral behavior that it portrays.

In conclusion, art historical context and sociopolitical analysis notwithstanding, it may seem presumptuous to argue for the importance of designs for public monuments that were never actually completed. Nevertheless, just as on a personal level we often learn more from mistakes than from successes, Brown's failed monuments to slavery do offer valuable lessons regarding the execution, interpretation, and ultimate validity of public works of art. In any event, unique and provocative in their own right, Brown's

Thinking Negro and pediment for the South Carolina Statehouse deserve a place not only in the history of American sculpture but also in the history of socially conscious American art, especially with regard to race and ethnicity. Certainly, understanding Brown's genuine attempts to monumentalize in stone the American practice of slavery, an institution he wished to condemn rather than celebrate, provides insight into the complicated relationship that exists between public monumental sculpture and the political, social, or moral values it is expected to defend or, in this case, to defy.

PLATE 1. Constantino Brumidi, "War," scene from *The Apotheosis of Washington* fresco. *(Courtesy Office of Architect of the Capitol.)*

PLATE 2. Brumidi's canopy fresco in the eye of the dome and the frieze encircling the base of the dome. *(Courtesy Office of Architect of the Capitol.)*

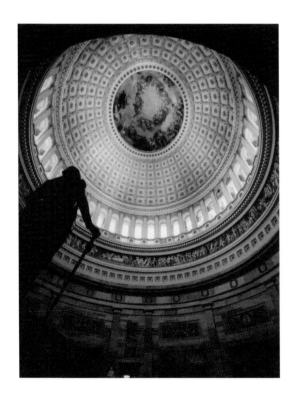

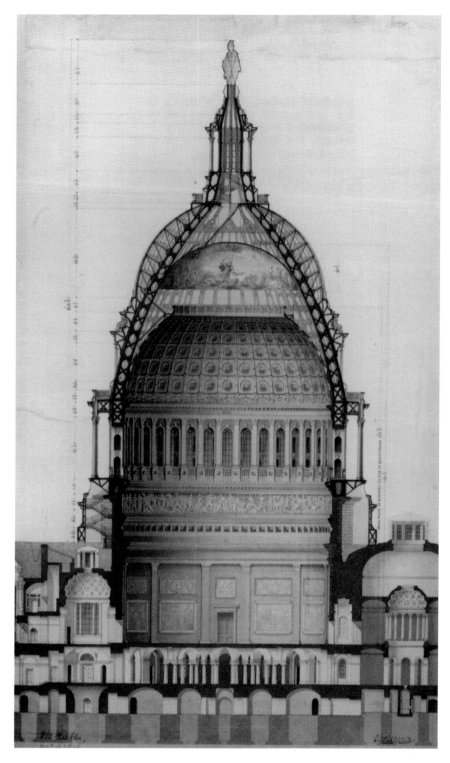

PLATE 3. Thomas U. Walter's drawing, "Section through Dome of U.S. Capitol," 1859, included Brumidi's canopy fresco design. *(Courtesy Office of Architect of the Capitol.)*

PLATE 4. Brumidi's color study of 1856 indicates he conceived the two connecting rooms for the Senate Naval Affairs and Military Affairs committees as a unit decorated in the Pompeian style. *(Courtesy Office of Architect of the Capitol.)*

PLATE 5. Constantino Brumidi, *The Boston Massacre, 1770,* 1871, in room S-128, originally the Senate Military Affairs Committee Room. *(Courtesy Office of Architect of the Capitol.)*

Photographing the Interior Sky

A Photographer's View of State Capitols

ERIC OXENDORF

(Editor's note: Beginning in 1985, photographer Eric Oxendorf photographed the interior of every state capitol dome or central space. He collaborated with historian William Seale to publish his photographs in the collection *Domes of America* [1994].)

ARRIVING AT THE DOOR OF MY FIRST STOP, THE INDIANA STATE HOUSE, I HAD NO IDEA WHAT awaited me inside. There in the rotunda, I looked up and this entire project unfolded before my eyes. I sat on the floor and set the parameters for the project: I would use the same camera and lens, set the tripod the same distance from the floor, and take each location "as is" with no additional lighting.

In retrospect, there was nothing really creative about this project. I became a technician who analyzed the location, dealt with the logistical problems, set up the camera equipment, and then put beautiful three-dimensional edifices onto two-dimensional film.

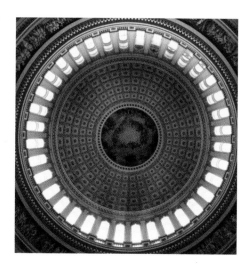

PLATE 6. The U.S. Capitol, 1793–1865. *(Courtesy Eric Oxendorf.)*

PLATE 7. New Jersey Statehouse, 1794, 1845, 1871–72. *(Courtesy Eric Oxendorf.)*

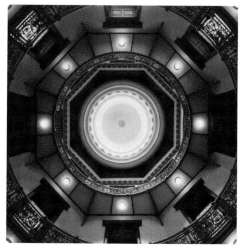

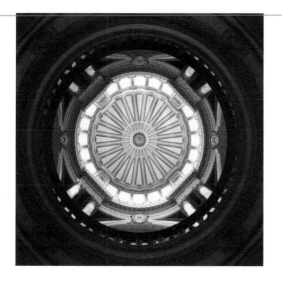

PLATE 8. Mississippi State Capitol, 1901–3. *(Courtesy Eric Oxendorf.)*

PLATE 9. Utah State Capitol, 1913–16. *(Courtesy Eric Oxendorf.)*

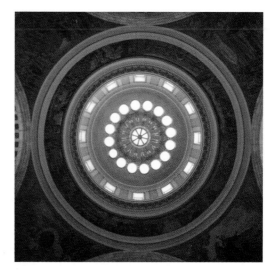

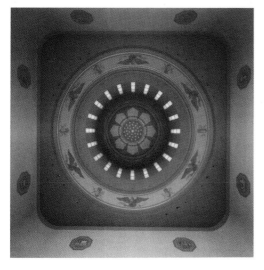

PLATE 10. Oregon State Capitol, 1936–38. *(Courtesy Eric Oxendorf.)*

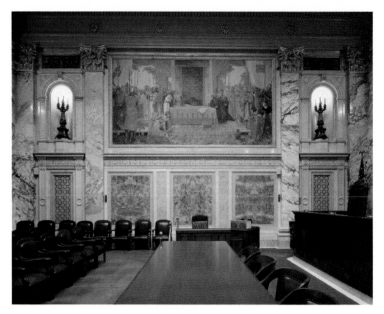

PLATE 11. Albert Herter. *The Signing of the Magna Charta* (ca. 1917).
Mural in Supreme Court Chamber, Wisconsin State Capitol, Madison.
Photograph by Eric Oxendorf. *(Courtesy Eric Oxendorf.)*

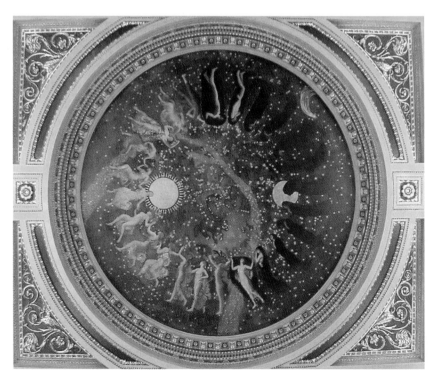

PLATE 12. Edwin Austin Abbey. *The Hours* (1908–10), House Chamber, Pennsyl-
vania State Capitol, Harrisburg. Photograph by Steve Miller. *(Courtesy Steve Miller
Productions.)*

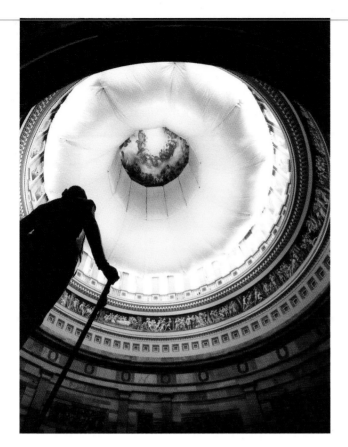

PLATE 13. Protective netting allowed visitors to view the fresco during rehabilitation of the dome in 1999. *(Courtesy Office of Architect of the Capitol.)*

PLATE 14. Ruthadell Anderson. Tapestry mural in House Chamber (1971). Hawaii State Capitol, Honolulu. *(Courtesy Ruthadell Anderson.)*

PLATE 15. John Trumbull, *The Surrender of Lord Cornwallis at Yorktown,* 1820. U.S. Capitol rotunda. *(Courtesy Office of Architect of the Capitol.)*

PLATE 16. Oil sketch for *The Surrender of Lord Cornwallis at Yorktown,* 1787. *(Courtesy Detroit Institute of Arts.)*

Masking Slavery in and on the United States Capitol Rotunda

VIVIEN GREEN FRYD

I NEVER THOUGHT THAT I WOULD RETURN TO THE U.S. CAPITOL, RECONSIDERING Thomas Crawford's *Statue of Freedom* (fig. 1), 1858, seven years after the publication of my book on this subject.[1] My current speculations derive from my reading W. E. B. Du Bois's *The Souls of Black Folk* (1903), in which he discusses "the veil of slavery" and its impact upon African Americans before, during, and after Reconstruction.[2] Throughout Du Bois's book, bondage and freedom, chains and liberty are intertwined and caught within what he calls the "Veil of Race" in the same way that they are in the *Statue of Freedom*. But my rethinking about this colossal statue atop the Capitol dome has also been inspired by a recent photograph by Carlton Wilkinson, a colleague of mine, who took this shot during the Million Man March in the U.S. capital city in 1995 (fig. 2). Immediately upon seeing the photograph, I realized that it could form a basis not only for my reformulating the relationship between slavery and the *Statue of Freedom,* but also the relationship between slavery and Constantino Brumidi's dome fresco (fig. 3), in which Liberty and Minerva once again emerge separately with masked references to the "peculiar institution."

Let me begin by reviewing the material I originally uncovered about Crawford's *Statue of Freedom.* Thomas U. Walter, the architect of the U.S. Capitol, had first suggested in a preliminary drawing of 1855 (fig. 4) that a monumental statue decorate the

[1] Vivien Green Fryd, *Art and Empire: The Politics of Ethnicity in the U.S. Capitol, 1815–1860* (New Haven, 1992).
[2] Du Bois, *The Souls of Black Folk* (New York, 1989).

FIG. 1. Thomas Crawford, model for *Statue of Freedom,* 1858. Plaster. *(Courtesy Office of Architect of the Capitol.)*

FIG. 2. Carlton Wilkinson, *Million Mile March. (Photograph courtesy Carlton Wilkinson.)*

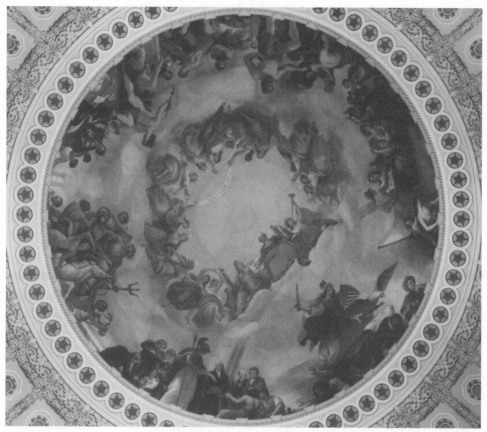

FIG. 3. Constantino Brumidi, *Apotheosis of Washington,* 1864. *(Courtesy Office of Architect of the Capitol.)*

new dome.[3] In creating an allegorical female figure who holds a pole surmounted by a cap, Walter appropriated the well-known iconography of Libertas, first codified in eighteenth-century emblem books. During the French and American revolutions, Libertas symbolized freedom from tyranny, as is evident in Paul Revere's masthead for the *Massachusetts Spy* in 1781 (fig. 5). But the liberty cap and staff that Augustin Dupré depicted on the coin *Libertas Americana* in 1781 (fig. 6) disappeared from the first American pattern dime of 1792 because some considered the symbols of Roman manumission too loaded in content for their inclusion on American coins. By the 1850s, when Walter first suggested this allegory, Libertas already existed throughout American art and culture, containing uneasy references to freedom and slavery that threatened the link between North and South.[4]

[3]Thomas U. Walter to Rest Fenner, May 25, 1869, Library of Congress, Manuscript Collection.

[4]For the iconography of Libertas in the United States and France, see Yvonne Korshak, "The Liberty Cap as Revolutionary Symbol in America and France," *Smithsonian Studies in American Art* 1 (1987):53–69. For the iconography of America as Liberty, see Vivien Green Fryd, "Hiram Powers's America: Triumphant as Liberty and in Unity," *American Art Journal* 18 (1986):54–75.

FIG. 4. Thomas U. Walter, *Original Sketch for Statue and U.S. Capitol Elevation,* 1855. *(Courtesy Office of Architect of the Capitol.)*

FIG. 5. Paul Revere, masthead for *Massachusetts Spy.* *(Courtesy American Antiquarian Society.)*

FIG. 6. Augustin Dupré, *Libertas Americana,* 1781. *(Courtesy Massachusetts Historical Society.)*

FIG. 7. Thomas Crawford, *Freedom Triumphant in War and Peace,* 1855. *(Courtesy Library of Congress.)*

Thomas Crawford's first design (fig. 7) inexplicably departs from Walter's initial design and the tradition for Libertas. His *Freedom Triumphant in War and Peace,* 1855, fails to include the well-known symbols of cap or pole. Instead, Crawford rendered a female figure with two symbols associated with war and peace—the sword and olive branch—creating a vague preliminary design that lacks a sense of clarity in meaning and in composition.

Four months later, Crawford submitted an altered design known until recently only through his verbal description to Montgomery Meigs, the financial and engineering supervisor of the Capitol Extension. As Crawford explained, in this second design, which he called "Armed Freedom," he established more clearly the work's signification of Liberty by placing the cap upon her head. He also located her over the globe of the world, holding a sword in her right hand, "ready for use whenever required," as a means to protect "the *American* world."[5]

Since the publication of my book in 1992, someone in the Library of Congress accidentally discovered a photograph of the second design (fig. 8) in an unlabeled box that contained material soon to be discarded.[6] Fortunately, this employee rummaged through the box one more time before destroying the contents and recognized the significance of this photograph. The plaster cast shows a more successful allegory in which the female figure in long robes with sword and wreath still stands on the globe. She now wears the pileus, a symbol instantly recognizable as referring to freedom. But

[5]Crawford to Meigs, June 20, 1855, Meigs Letterbook, Office of the Architect of the Capitol.

[6]I am indebted to Barbara Wolanin, curator of the Architect of the Capitol, for informing me of this discovered photograph.

FIG. 8. Thomas Crawford, *Armed Freedom,*
1863. *(Courtesy Library of Congress.)*

as Dupré's *Libertas Americana* indicates,
already in the eighteenth century the
meaning of this cap contained conflicting
messages concerning liberty and its oppo-
site, slavery, that directly related to prob-
lems inherent in the American democratic
republic, where southern plantations re-
lied upon bondsmen for their labor.

Jefferson Davis, the secretary of war in
charge of the Capitol Extension, immedi-
ately recognized the dangerous contradic-
tions inherent in this cap in Crawford's
second proposal. As he argued, the cap's
"history renders it inappropriate to a
people who were born free and would not
be enslaved." He instead recommended
that "armed Liberty wear a helmet," given
"that her conflict [is] over, her cause tri-
umphant."[7] This plantation slaveholder
from Mississippi who argued vehemently
in behalf of the slave system and the
extension of slavery into newly acquired
lands while in the House and Senate and as secretary of war, understood fully the orig-
inal meaning of slavery in ancient Rome, and he employed semantics to argue that this
ancient model had differed from the South. As Meigs had explained earlier to Craw-
ford in relation to the design for another sculpture for the Capitol, "Mr. Davis says
that he does not like the cap of Liberty introduced into the composition [because]
American Liberty is original & not the liberty of the free slave."[8] Meigs further ex-
plained that Davis claimed that the cap employed in France during its revolution de-
rived from "the Roman custom of liberating slaves thence called freedmen & allowed
to wear this cap."[9] Davis clearly understood the practice of manumission in ancient

[7]Jefferson Davis to Meigs, Jan. 15, 1856, Meigs Letterbook.
[8]Meigs to Crawford, Apr. 24, 1854, Meigs Letterbook.
[9]Ibid.

Rome, when freed slaves covered their newly shorn heads with the pileus cap while magistrates touched them with a rod (the *vindicta*). But he failed to acknowledge that the slaves on his plantation also desired the same type of freedom. He refused to allow any work of art in the Capitol that alluded to slavery either overtly or covertly via the cap, perhaps hoping that its visible absence would mask or erase the tensions that existed between the North and the South over this volatile issue.

In response to Davis's objections, Crawford replaced the undesirable cap with a helmet and eagle feathers, transforming what had clearly been an allegory of Liberty into a confusing monument that combines three traditional personifications: Liberty signified by the title, Minerva, and America. By adding the eagle feathers to the helmet, Crawford associated America with Liberty, an iconographic tradition that began before and during the Revolutionary War, when the Indian princess with tobacco leaf skirt and headdress held the cap and pole, as in Paul Revere's masthead.[10] A majestic and robust female figure, *Statue of Freedom* also evokes Minerva, the ancient Roman goddess of war and of the city, protector of civilized life, and embodiment of wisdom and reason. Crawford's figure in fact emulates Phidias's fabled Athena Parthenos, a work reconstructed by Quatrèmere de Quincy in *Restitution de la Minerve en or et en ivoire, de Phidias, au Parthénon* (1825), which Crawford must have consulted. Both the ancient and modern works include the helmet, the breast medallion, and the shield along the side. Even the fluted cloak that gathers from the lower right to the upper left shoulder corresponds in these two matron types, whose immobility, severity of facial expression, military accoutrements, and colossal size express sternness and control. Few people understand the meanings of this work because of its confusing combination of these allegorical traditions; this conflation of three allegories obscures the meanings of each, resulting in an image that loses its sharp iconographic focus. Most visitors mistakenly view *Freedom* as an Indian princess. Those like Carlton Wilkinson, who have a "vague recognition that the statue represents liberty,"[11] however, cannot see how the statue directly embodies issues related to slavery during the 1850s, when the North and South attempted to resolve this contentious issue. This statue, in fact, participated in the battle between these two regions, with Jefferson Davis using his position as the secretary of war to consciously eliminate any references to slavery in this public building that belonged to both the North and South. The very process that Davis took to control the absence of the liberty cap becomes the lightning rod in this work; this process, which cannot be visible to the unlearned viewer, forms one central focus in the work's masked meaning.

[10]For the iconography of America as an Indian princess, see McClung Fleming, "The American Image as Indian Princess, 1765–1783," *Winterthur Portfolio* 2 (1965):65–81, and "From Indian Princess to Greek Goddess: The American Image, 1783–1815," *Winterthur Portfolio* 3 (1967):65–81.

[11]Interview with artist, Apr. 6, 1999.

FIG. 9. Constantino Brumidi, "Science," scene from *The Apotheosis of Washington* fresco. *(Courtesy Office of Architect of the Capitol.)*

The confusing conflation between Liberty and Minerva found in Crawford's statue becomes resolved in her numerous manifestations in the Capitol dome fresco done by Brumidi before and during the Civil War. Minerva appears twice: first in the canopy beside "Science," where she stands more sedately as she points to an electric generator (fig. 9). In her second rendition, Minerva exists directly below the Apotheosis of Washington. Here (fig. 10; color plate 1) she wears the same helmet with stars found in Crawford's *Statue of Freedom,* replacing the feathers with an actual eagle. This figure also holds the American shield in her left hand and a sword in her right, thus reiterating symbols found outside the dome. Whether the cap is also masked in Brumidi's goddess of war is unknown. Brumidi first conceived of her presence in 1859, two years after Jefferson Davis left his post as the secretary of war. Although S. D. Wyeth in his 1866 description of Brumidi's allegorical fresco refers to this figure as "Freedom, terrible in vengeance, with upraised sword," we have no evidence that Brumidi, in copying

Fig. 10. Constantino Brumidi, "War," scene from *The Apotheosis of Washington* fresco. (See also color plate 1.) *(Courtesy Office of Architect of the Capitol.)*

Crawford's helmet and accoutrements, intended also to emulate the masked meaning of Liberty.[12] I doubt that Brumidi understood the history of Crawford's statue and Davis's role in redirecting and reshaping his conception of Armed Freedom.

Because of Davis's absence from control over the dome fresco, Libertas with the cap on her head also can be found in two places in the rotunda fresco. She is significantly seated beside George Washington, looking toward him in reverence while holding an open book in one hand and the fasces in the other (fig. 11). The cap reappears on the head of Young America, who holds the reigns of the horses for Ceres, the goddess of agriculture (fig. 12)

[12]S. D. Wyeth, Description of Brumidi's Allegorical Painting with the Canopy of the Rotunda (Washington, D.C., 1866), p. 114. Others in their descriptions of this canopy identify the figure as Armed Freedom; see John B. Ellis, *The Sights and Secrets of the National Capitol* (Chicago, 1869), p. 73 ("War-Freedom with drawn sword and in full armor"), and George C. Hazelton, Jr., *The National Capitol: Its Architecture, Art and History* (New York, 1897), p. 96 ("armed Liberty with shield and sword").

FIG. 11. Constantino Brumidi, Central group of Washington with Liberty and Victory/Fame from *The Apotheosis of Washington* fresco. *(Courtesy Office of Architect of the Capitol.)*

As Francis O'Connor points out, "Brumidi submitted his design and began negotiating his commission for the dome painting during the autumn of 1862, while the Capitol was being used as a hospital for wounded soldiers. He worked on the cartoons while the battle raged, from early 1863. . . . When finally, in late 1864, the canopy was installed and Brumidi was able to start painting, the war had still not ended."[13] This takes on significance also because Jefferson Davis had not been involved in the Capitol dome's completion since 1857; he became provisional president of the Confederate States in February 1861 and was inaugurated one year later. Hence, while Davis ran the Confederacy and raised their armies, Brumidi peopled the Capitol dome with two figures of the formerly banished Liberty and two of Minerva. Whereas Crawford's goddess stands immobile because her battle is over, Brumidi's Minerva actively raises her sword and shield to combat Tyranny and Kingly Power (fig. 13).[14] According to a contemporary of Brumidi, George Hazelton, the artist provided recognizable facial fea-

[13]Francis O'Connor, "Symbolism in the Rotunda," in *Constantino Brumidi: Artist of the Capitol,* ed. Barbara Wolanin (Washington, D.C, 1998), p. 141.

[14]The guidebooks to the U.S. Capitol provide slightly different identifications of these allegories. Wyeth identifies the figures as "Tyranny and Kingly Power," Ellis identifies them as "Tyranny and Oppression," while Hazelton calls one allegory "Royalty." See Wyeth, *Description of Brumidi's Allegorical Painting,* p. 114; Ellis, *Sights and Secrets of the National Capitol,* p. 73; and Hazelton, *National Capitol,* p. 96. See also Barbara Wolanin, "Painting the Apotheosis of Washington," in idem, *Constantino Brumidi,* p. 133.

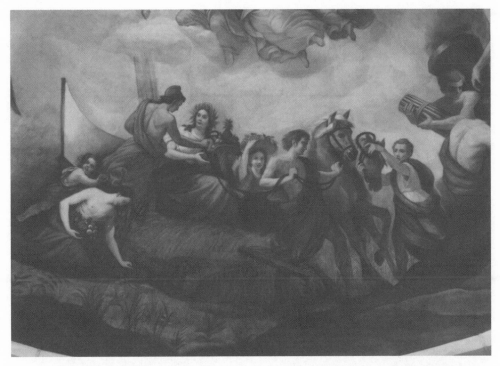

Fɪɢ. 12. Constantino Brumidi, "Agriculture," scene from *The Apotheosis of Washington* fresco. (*Courtesy Office of Architect of the Capitol.*)

tures for Revenge (who holds two lighted torches) and Anger (struck by a thunderbolt and biting his finger): Jefferson Davis and Alexander H. Stephens, the vice president of the Confederacy.[15] John B. Floyd, the secretary of war under President Buchanan who was fired for the misuse of funds in the Capitol Extension and who later became a Confederate soldier, and Robert E. Lee, the commander of the southern forces, also appear in the faces for the gray-bearded Tyranny on the left and for Discord. Brumidi was completing these figures in April 1865, the same month that both General Lee surrendered and President Lincoln was assassinated.[16] The following month, when Brumidi was starting the scene of "Science" that included Liberty, Union troops captured Davis in Georgia. As Hazelton elaborated, "The scene itself is certainly suggestive of the stamping out of the Rebellion: a thunder-bolt, representing the wrath of the Gods, is being hurled from on high at Stephens; while the President of the Confederacy . . . is fleeing from the wrath of the colossal figure of armed Liberty above."[17]

[15]Wolanin, *Constantino Brumidi,* p. 129.

[16]Hazelton, *National Capitol,* p. 97. Hazelton goes on to comment that "it is not possible that Brumidi intended these as portraits; for he was the friend of most of the Confederate leaders, and probably the last to see Jefferson Davis before he left the capital for the South." Although he first identifies the figures and then rejects his own identification, the likenesses are too similar to discount. Wolanin identifies the figure with torches as Discord, but a news release by her office identifies this figure as Revenge. Wolanin, *Constantino Brumidi,* p. 139 n. 16.

[17]Hazelton, *National Capitol,* p. 97.

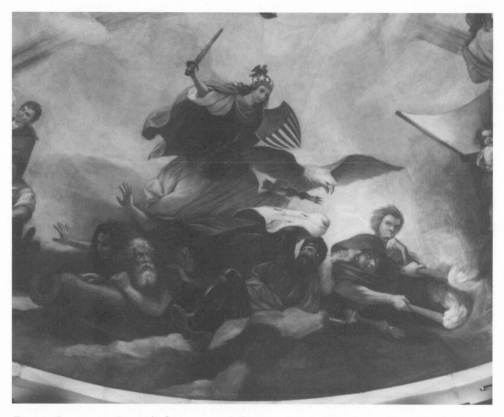

FIG. 13. Constantino Brumidi, figures trampled by Freedom in "War," scene from *The Apotheosis of Washington* fresco. *(Courtesy Office of Architect of the Capitol.)*

When Thomas U. Walter in 1859 had done his cross-section of the dome that includes Brumidi's vigilant Minerva inside and Crawford's *Statue of Freedom* outside and above (fig. 14), he could not have foreseen these future events. But this cross-section makes clear that the two figures of Minerva, outside and immobile, inside and actively pursuing the southern leaders of the Confederacy, must be seen in relationship to each other. Within the context of future events, the *Statue of Freedom*'s serenity and strength indicates her victory not only on behalf of the Union but also on behalf of the emancipation of slavery. When Brumidi decided in 1862 to include allegories of the thirteen original states surrounding George Washington, he could not have known of the future freeing of the slaves. But the placement of a southern state—Georgia—with cotton boll wreaths beside Liberty takes on additional meanings within this context.[18] Liberty finally can wear her cap because Jefferson Davis could not mask or erase its presence; she can be seated between the South and first president of the United States because by

[18]Identity of this figure as Georgia can be found in "Description of the Decoration of the Canopy of the Rotunda of the United States Capitol" and Ellis, *Sights and Secrets of the National Capitol,* p. 73.

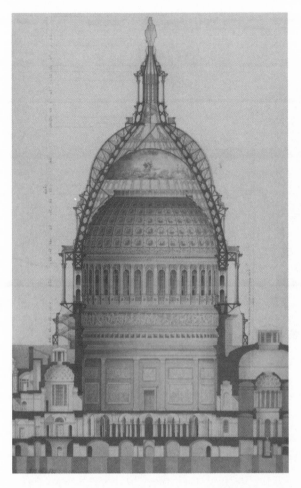

FIG. 14. Detail of Walter's cross-section of the dome. *(Courtesy Office of Architect of the Capitol.)*

1863 freedom existed in this region as it had under Washington's presidency. Whereas Liberty signified during the time of George Washington freedom from Great Britain, by 1863, Liberty also referred to enslaved African Americans. Liberty's enthroned position directly above the vanquished southern leaders also takes on a similar meaning; she now can emerge separate from Minerva, seated beside the South, as the promise of freedom for all that Davis had attempted to banish from Crawford's *Statue of Freedom*.

Thomas Nast understood the relationship between Crawford's *Statue of Freedom* and Lincoln's Emancipation Proclamation. His *The Emancipation of the Negroes—The Past and the Future,* published in *Harper's Weekly* on January 24, 1863 (fig. 15), shows Crawford's proud and triumphant statue now atop an oval frame in which an African American family, together at last, participates in domestic activities under the watchful eyes of Lincoln, whose picture is located by the fireplace. Given the forced separation of slave families prior to 1863, the presence of the mother, father, sons, and daughters takes on significance, indicating that Lincoln's act enabled former slaves to form a tight nuclear family. The outer vignettes on the left side illustrate the hardships of slave life, including beatings, auctioning male bodies for slavery, tearing families apart, and forced labor. The right side shows the freedom, prosperity, and family life that African Americans will enjoy as free people; they exchange money at a bank, attend school, and exist as a family. Nast placed the *Statue of Freedom* in front of the word *Emancipation,* which is emblazoned by light and clouds, clearly connecting the statue with the very conditions of African American southern life that entailed slavery and the hope for freedom. Justice at the

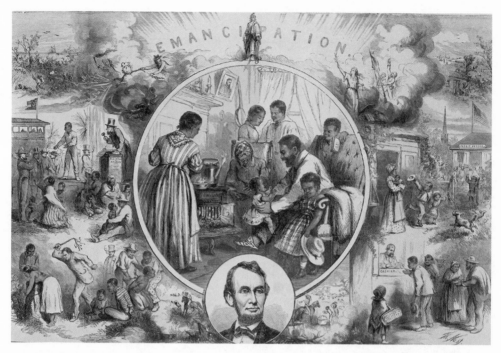

FIG. 15. Thomas Nast, *The Emancipation of the Negroes, January, 1863—The Past and the Future,* in *Harper's Weekly. (Courtesy Library of Congress.)*

top right weighs the scales, while on the left allegorical figures, perhaps of the Demons of Slavery, chase slaves in a field. Nast implies that Crawford's statue promised emancipation and now stands triumphantly and proudly as she views the scenes below. The wood engraving furthermore evokes Christ in the Last Judgment. Here Crawford's statue replaces Christ to become a secular savior; on her left appear the saved African Americans who are free; on her right are the damned who suffer under slavery.[19] Both Lincoln and the statue, Nast suggests, ended the horrors of the past and issued forth the promise of the future that seems to be illustrated in the smaller encircled motif below where Father Time holds a white child on his lap, forming a masculine version of the Madonna and child. Father Time and the child appear to take the chains off of the African American man standing before them.

By the time Du Bois wrote his essays in 1903 about what he called "the Negro Problem" that pervaded the "great republic" even after emancipation and Reconstruction, slavery existed, in his opinion, as "the sum of all villainies, the cause of all sorrow, the root of all prejudice"; for him, "the freedman has not yet found in freedom his promised land."[20] Freedom as a concept resonates throughout his book as an ideal previously

[19]Traditionally, the damned are located on Christ's left and the saved on the right. This engraving may reverse the positions.
[20]Du Bois, *Souls of Black Folk,* pp. 7, 12.

sought for by slaves and one achieved by freedmen who nevertheless remained chained through their poverty. Du Bois argued that blacks still longed for freedom after the passage of the Fifteenth Amendment in 1870 that granted citizenship and equal rights to Negroes, including the right to vote.

Du Bois in his *Soul of Black Folk* asserts through the powerful metaphor of the veil that whites fail to see blacks. This opaque veil must be lifted to make visible the invisible reality of racism and to free the blacks who exist as "prisoned souls within the Veil."[21] In his moving reminiscence of losing his son, Du Bois expresses his fear that his baby was born "within the Veil," where he will live with "a hope not hopeless but unhopeful" given his existence in "a land whose freedom is to us a mockery and whose liberty a lie." As Du Bois watched "the shadow of the Veil as it passed over" his child, he viewed what he called "the cold city towering above the blood-red land." For Du Bois, his son achieves freedom only through death; he finally exists "above the Veil" in this state outside of life.[22]

Du Bois's metaphor of the "cold city" that towers "above the blood-red land" takes on significance in this recent photograph taken by Wilkinson. This African American photographer captured what he "saw as interesting,"[23] creating an image that resonates with meanings masked even to the artist, who knew the statue referred to liberty but who did not know its direct participation in the fight over slavery between the North and South in the 1850s nor the presence of Liberty and Minerva inside the rotunda. The photograph juxtaposes a group of African American men on the right, the oppressed Du Bois addresses in his book, with the statue and dome on the left that tower above "the Promised Land" Du Bois seeks outside the Veil.[24] Wilkinson effectively cropped the image so that the trees in the foreground cover the lower building and establish a contrast between dark and light, uneven and smooth, horizontal and vertical. The horizontal seep of the foreground foliage connects with the African American men who similarly move across a surface now above a building rather than below, forming undulating contours that continue those of the leaves.

The figures atop buildings form a series of similarities and polarities. The black men and the *Statue of Freedom* both establish dark anthropomorphic shapes against the blue sky: the statue in the distance and smaller, the men in the foreground and larger. The height of the statue that seems pushed upward by the gleaming Capitol dome competes for attention with these proud men who seem to stand on top of the building not only to view the masses in attendance at this march, but also to assert their claim on the building and consequently their position in the United States as

[21]Donald B. Gibson, introduction to *Souls of Black Folk*, p. xiv. As Du Bois states, "the Veil . . . hung between us and Opportunity" (see p. 57).

[22]Du Bois, *Souls of Black Folk*, pp. 170–75.

[23]Interview with Carleton Wilkinson, April 6, 1999.

[24]Du Bois, *Souls of Black Folk*, p. 90.

African American men who will lead their people toward unified goals of prosperity and education. The live men are free, but their ancestors may have been enslaved in the South. Even if this is not the case, African Americans in the United States today attribute some of their current difficulties to the heritage of slavery that affects all black people. The female statue, on the other hand, symbolizes the very oppression of black people that these men march to protest against. She stands unmovable with the sword in hand supposedly ready to enforce democracy throughout the world, but for Jefferson Davis in the 1850s, democracy could not apply to his slaves. Her immobility contrasts with the men who stand still but are poised for action, ready to move forward with their freedom and claim it as their human right, to achieve Du Bois's dream that "on American soil two world-races may give each to each those characteristics both so sadly lack" to achieve "a common humanity and a common destiny."[25]

Through this photograph, Wilkinson reflects the "double-consciousness" that exists, according to Du Bois, for every black person who has a "sense of always looking at one's self through the eyes of others." As Caucasians gaze at the photograph, they become that Other who views the black men. For Du Bois, the white gaze contains "contempt and pity" that forces the African American to always be aware of "his twoness" as American and Negro, with "two souls, two thoughts, two unreconciled strivings; two warring ideals in one dark body, whose dogged strength alone keeps it from being torn asunder." "The history of the American Negro," according to Du Bois, "is the history of this strife—this longing to attain self-conscious manhood, to merge his double self into a better and truer self." Wilkinson's photograph powerfully visualizes Du Bois's hope that the black man "simply wishes to make it possible for a man to be both a Negro and an American, without being cursed and spit upon by his fellows, without having the doors of Opportunity closed roughly in his face." They stand opposite the *Statue of Freedom* in the same elevated space in their attempt to be the "co-worker[s] in the kingdom of culture" that Du Bois aspired for; each man, like Du Bois, hope to "escape death and isolation, to husband and use his best powers and his latent genius that had previously "been strangely wasted, dispersed, or forgotten." "The worlds within and without the Veil of Color are changing," Du Bois observed in 1903, but "not at the same rate, not in the same way." The "double life, with double thoughts, double duties, and double social classes" that result in the "double words and double ideas" that Du Bois addresses are embodied within Wilkinson's photograph, where the white Capitol still represents and symbolizes white Americans. The blacks stand outside the building, seemingly separate from nationhood, full equality, and common humanity as symbolized by the statue. The veil remains, according to this photograph,

[25]Ibid., pp. 11, 150.

separating the two races of white and black and resulting in the existence of double-ness caught within the liminal space of both worlds. Wilkinson's photograph visual-izes the disjunction between black political activism and white cultural codes that the veil serves to obscure. "The awful shadow of the Veil" that Du Bois so eloquently ad-dressed remains present with this statue and hence in the U.S. Capitol, making it clear that the ideal of equality and freedom for all remains elusive for some Americans. In other words, the embracing of liberty and presence of Minerva's victory over southern tyranny inside the Capitol dome are masked by the outside white marble casing of the structure. These hopes and dreams visualized inside the Capitol rotunda still need to be realized for the African American men who wait outside, some looking directly at the *Statue of Freedom* for hope.[26]

[26]Ibid., pp. 5–6, 164–65.

Vinnie Ream's *Lincoln* (1871)

The Sexual Politics of a Sculptor's Studio

KIRK SAVAGE

IN 1866, WHEN THE U.S. CONGRESS DECIDED TO COMMISSION ITS FIRST STATUE of Abraham Lincoln, public statuary was still a relatively rare commodity. Only a handful of heroic monuments stood in the capital city, none of them to Lincoln. Before the great wave of Civil War memorials and other public monuments washed over the American landscape in the last third of the nineteenth century, it was still possible to think that Congress's modest initiative for a single statue inside the Capitol was an act of great national importance. Massachusetts Sen. Charles Sumner, reflecting on the gravity of the moment, asserted that "[Lincoln] deserves a statue, and it should be here in Washington. But you cannot expect to have even of him more than one statue here in Washington."[1] After all, he argued, there was only one of Washington and one of Jefferson and one of Jackson. Sumner could never have predicted that within ten years there would be three full-length statues of Lincoln in Washington and more on the way, not to mention the dozens that would be erected elsewhere in the nineteenth century. But in the summer of 1866 Sumner and others could still believe that the congressional statue might become the definitive image of Lincoln, not only for the capital but perhaps for the whole nation.[2]

Congress gave this momentous commission, without any open competition, to the

[1] *Congressional Globe,* July 27, 1866, 39th Cong., 1st sess., p. 4231.

[2] For an inventory and description of Lincoln statues in the nineteenth century, see F. Lauriston Bullard, *Lincoln in Marble and Bronze* (New Brunswick, N.J., 1952).

FIG. 1. Vinnie Ream. Photograph by Matthew Brady. *(Courtesy Library of Congress.)*

most unlikely artist imaginable—a sculptor virtually unknown to the art public, still a teenager, and a woman to boot. Her name was Vinnie Ream (fig. 1), and she was soon to become one of the most controversial public sculptors of the nineteenth century. After a short, checkered career, she married in 1878, abandoning sculpture entirely for many years before returning to it late in life. After her death in 1914, she lapsed into obscurity, not even meriting a footnote in standard surveys of American sculpture. Her reputation began to revive only in the 1980s after art historians had begun to look more seriously at neglected women artists of the past.[3]

In this essay, I will explore the sexual politics surrounding Vinnie Ream and her remarkable Lincoln commission. What interests me is not so much whether she deserved the commission in the first place, or even whether her final product justified her selection. Instead I will focus on how she—and her supporters and critics—negotiated the conflicts between her gender, which she did not choose, and her profession, which she did. Ream was caught between two identities usually conceived as incompatible: her social identity as a young unmarried woman in the mid-nineteenth century and

[3]Ream is not mentioned in the standard survey of American sculpture by Wayne Craven, *Sculpture in America* (New York, 1968). The newer literature on Ream includes Joan A. Lemp, "Vinnie Ream and *Abraham Lincoln,*" *Woman's Art Journal* 6 (1985/86):24–29; Carmine Prioli, "'Wonder Girl from the West': Vinnie Ream and the Congressional Statue of Abraham Lincoln," *Journal of American Culture* 12 (1989):1–20; and, most recently, Glenn V. Sherwood, *Labor of Love: The Life and Art of Vinnie Ream* (Hygiene, Colo., 1997).

her professional identity as a sculptor striving to represent the great men of the age. The nineteenth-century notion of "separate spheres" for men and women created a wall between them, but there were cracks through which an enterprising strategist such as Ream could squeeze. As we shall see, Ream put both her gender and her sexuality to work in a highly masculine public sphere. In the process, her career brought to the surface some of the complexities and contradictions of a highly gender-conscious public realm in the aftermath of the Civil War.

By 1866, when she burst into the public eye, there was already a thriving group of American women practicing sculpture in Italy, a group which Henry James famously referred to as the "white marmorean flock."[4] The success of expatriate women sculptors like Harriet Hosmer in the 1850s and 1860s is one of the most surprising episodes in the history of American art. We do not really understand why women made a particular mark in sculpture, the fine-art medium most identified with notions of the masculine. Michelangelo hacking away at a huge block of marble represents the traditional image of sculpture: hard, dirty, physical work requiring great strength and endurance, certainly not the kind of activity associated with middle-class Victorian women. As Leonardo had famously observed, "[the sculptor's] face is smeared and dusted all over with marble powder so that he looks like a baker, and he is completely covered with little chips of marble, so that it seems as if his back had been snowed on; and his house is full of splinters of stone and dust."[5] But one of the reasons that women could enter this profession by the mid-nineteenth century is that it had changed enormously, and in fact most sculptors did not do the manual labor of carving stone anymore. Sculptors made models in clay and left the physical work of transferring the model into plaster and stone to skilled studio assistants or outside contractors. Moreover, the most prized subject matter of marble sculpture was the so-called ideal, that ethereal realm associated with the Italian antique and with the higher spiritual plane that women were supposed to inhabit. If women were themselves ideal creatures, as the Victorian ideology of gender proclaimed, then surely they had some special qualifications for transmitting that ideal into artistic form.[6]

It is useful to look, for a moment, at the career of the most famous of the expatriate women sculptors, Harriet Hosmer, because she will serve as a standard of comparison for Vinnie Ream—and indeed the two often were compared, usually not in Ream's favor. Typically, biographical accounts of Hosmer emphasized that her mother died

[4]James quotation from *William Wetmore Story and His Friends* (1903; reprint ed., New York, 1969), p. 257.

[5]The Leonardo quotation is from his *Codex urbinas latinus* of 1270. For a slightly different translation, see Leonardo da Vinci, *Treatise on Painting*, trans. A. Philip McMahon, 2 vols. (Princeton, 1956), 1:36.

[6]Harriet Hosmer, "The Process of Sculpture," *Atlantic Monthly* 14 (1864):734–37; William H. Gerdts, *American Neo-Classic Sculpture: The Marble Resurrection* (New York, 1973); Joy Kasson, *Marble Queens and Captives* (New Haven, 1990).

early in her life and that she was then encouraged by her father to take up masculine pursuits—including traveling alone by riverboat in the West. When she adopted the life of an artist in Rome, she continued to project this image; her short cropped hair and mannish clothing were often noted, as was her habit of riding around on horseback by herself. She never married, and she maintained close friendships with a circle of so-called emancipated women, such as the actress Charlotte Cushman. It is tempting to view these biographical details as hints of a lesbian sexuality, but having no evidence of (or actual interest in) her real sexuality, I would suggest an alternative interpretation: that she was in fact desexualizing herself, adopting a persona that effectively removed herself as an object of male sexual desire, courtship, and marriage. She negotiated the conflict between woman and artist by forsaking the customary role and persona of eligible woman. Her sculpture, however, was dominated by female subjects; she built her career on ideal female figures sold to private patrons, and when she tried later to secure public commissions for monuments to great men, she had only limited success.[7]

Now let us turn to Ream. If we are to believe numerous biographical accounts and the letters in her archive, she was from her early teenage years constantly pursued by male suitors of all different ages. She was often noted for her feminine beauty, particularly her dark eyes and her extravagantly curled long hair. Here is one description among many that appeared in the press, this from the *National Anti-Slavery Standard:* "I queried whether fairer picture, than she made, with her soft dark-brown curls floating over neck and shoulders, closely fitting calico dress and long check apron, was ever presented to vision."[8] Numerous photographs record these features and give a sense of how she constructed and experimented with her feminine image. Ream actually copyrighted some of these photographs of herself and offered them for sale, an unusual promotional strategy that gave ammunition to her critics.[9] What makes the comparison with Hosmer so neat and symmetrical is not only Ream's image but also her career, which was the opposite of Hosmer's. While Hosmer went to Italy and made her reputation on ideal female subjects, Ream made her success in Washington modeling

[7]Dolly Sherwood, *Harriet Hosmer, American Sculptor 1830–1908* (Columbia, Mo., 1991). Sherwood sidesteps the issue of her sexuality, with one brief reference on page 87. Earlier accounts of her life on which my summary is based include an essay in *Eminent Women of the Age* (Hartford, Conn., 1869); *St. Louis Globe-Democrat,* Dec. 13, 1888, clipping in Harriet Goodhue Hosmer Collection, Schlesinger Library, Radcliffe College; Lilian Whiting, *Women Who Have Ennobled Life* (Philadelphia, 1915), pp. 209–34. On her unsuccessful efforts to secure a commission for a monument to Lincoln, see Kirk Savage, *Standing Soldiers, Kneeling Slaves: Race, War, and Monument in Nineteenth-Century America* (Princeton, 1997), pp. 92–103, 125–28.

[8]*National Anti-Slavery Standard,* Sept. 14, 1867, clipping in Vinnie Ream Hoxie Papers, Library of Congress (hereafter Hoxie Papers).

[9]Sherwood, *Labor of Love,* pp. 210, 395. Criticism of this practice appears, for example, in Mary Clemmer Ames, "Miss Ream's Statue of Lincoln," unidentified clipping, and "Vivacious Vinnie," *Iowa State Register,* Feb. 9, 1873; both clippings in Hoxie Papers.

portraits of famous male politicians and then securing commissions for monuments to great men. Although Ream did do some ideal subject matter—and even took an extended trip to Italy after she had modeled the Lincoln statue—her bread and butter were not in the dreamworld of the Italian antique but in the hustle and bustle of public life, which was then a man's world. Ream pushed the conflict between her social and professional identities to an extreme by cultivating her feminine image at the same time that she pursued a career that put her right in the thick of the most political and masculine of American places.[10]

So much innuendo and intimation of scandal surrounds Ream that it is effectively impossible, at our distance, to separate fact from fancy in her life and career. "Vinnie what have you ever done, to cause your name to be hawked about, and mixed up in such a manner," her father wrote in early 1868.[11] The stories began to circulate years before, almost as soon as she began the practice of sculpture. She started sculpting sometime in 1864 by studying in the Capitol studio of Clark Mills, famous for his equestrian monument to Andrew Jackson and for a plaster casting technique that allowed him to take life masks of many of the well-known politicians of the day. So there was a teenage girl, by all accounts charming and vivacious, spending long hours in a man's studio in the Capitol. A year or so later, the man's sons joined him, and one of them—Fisk Mills—was often seen working together with Ream. Fisk did a bust portrait of her that was unusually revealing for the time and place, and some critics even suggested that some of the ideal nude busts on view in her studio were actually self-portraits. A Mills family descendant in the 1960s claimed that Ream may have had an affair with the elder Mills. There is no evidence for or against this rumor, but it is consistent with the sort of gossip that dogged Ream before she married.[12]

One point that does clearly emerge from the correspondence Ream carefully saved is that she cultivated a string of romantic or quasi-romantic relationships with older men who were in a position to help her career. The list includes such notable figures as the painter George Caleb Bingham, Union general William Tecumseh Sherman and Confederate generals Albert Pike and Jubal Early. The letters from Sherman and Pike are especially ardent, and their talk of kisses and cozy coach rides does suggest that Ream, at the very least, permitted some degree of erotic fantasy in these relationships. All of these men lobbied on her behalf, either in the press or behind the scenes;

[10]Ream spent almost all her career in Washington, D.C., except for short stints in Italy and New York.

[11]Robert Ream to Vinnie Ream, Jan. 3, 1868, Hoxie Papers.

[12]On the bust rumor, see Sherwood, *Labor of Love,* pp. 69, 193. Sherwood publishes Fisk Mills's bust of Ream on page 21. Fisk's relationship with Ream is discussed in several unidentified newspaper clippings in the Hoxie Papers. The rumor about Clark Mills's affair with Ream is discussed in Rosemary Hopkins, "Clark Mills: The First Native American Sculptor," master's thesis, University of Maryland, 1966.

Sherman, for example, was instrumental in helping her win her second major commission, for a monument to Admiral Farragut in Washington.[13]

This helps to explain why Ream chose Clark Mills as her initial mentor: he gave her both instruction and entrée in the sphere of male power. Mills was not a European-trained sculptor, and the art establishment in the United States mercilessly ridiculed him. But Mills knew the world of federal politics like no other sculptor, and he knew how to get commissions both for public monuments and for private portraits. He had deep connections in both political parties. Whatever Ream learned from Mills about sculptural technique, she probably learned much more about the business of making a career in sculpture in the nation's capital. Ream took advantage of Mills's connections, and soon enough she was making her own. Remarkably, by 1866, at the age of eighteen, she was able to produce a testimonial on her behalf signed by 178 prominent men, among them President Andrew Johnson, General Grant, various members of the cabinet and of Congress, and a few artists of reputation.[14]

Mills had received a fair amount of criticism for his lobbying practices, so it should come as no surprise that Ream, a woman less than half his age, would come under even greater attack. The firestorm began in the U.S. Senate in July 1866, when it considered the House resolution naming Ream as the sculptor of the Lincoln statue. Ream had gotten herself named in this bill on the strength of a bust of Lincoln she had made over the previous year. And of course it did not hurt that she had also made two powerful allies—John Rice, the chairman of the House committee on public buildings and grounds, and Pennsylvania Republican Thaddeus Stevens, soon to become one of the chief architects of Reconstruction. They arranged things so that the bill would get as little attention and debate as possible, bringing it to a vote in the House the day before Congress adjourned, though when the bill came to the Senate, Charles Sumner insisted on debating it. He launched into a lengthy analysis of the art in the Capitol, but his point was really a simple one: Ream was totally unqualified for the job. "*You* might as well place her on the staff of General Grant," he argued, "or put General Grant aside and place her on horseback in his stead."[15]

[13]Numerous letters from Sherman and Pike are preserved in the Hoxie Papers, even though Sherman advised Ream to destroy his (letter dated Apr. 19, 1873). The cozy coach ride is anticipated in a letter of May 6, 1874, while in a letter of February 8, 1875, he talks of "toying with your long tresses." A recent biographer of Sherman uses the letters to claim that there was "a nook in her studio holding the bed they had shared" (Michael Fellman, *Citizen Sherman: A Life of William Tecumseh Sherman* [New York, 1995], p. 357). But artist's studios at this time were semipublic places, and a close reading of the letters does not provide any evidence for this claim, although a sexual relationship was certainly possible. Some of Pike's letters are actually racier: he talks about kissing and fondling in a letter of July 29, 1868, and in an undated letter, "Saturday evening," circa 1877.

[14]The testimonial of April 1866 is reproduced in Sherwood, *Labor of Love,* pp. 39–44.

[15]Prioli, "'Wonder Girl from the West,'" pp. 4–5. Sumner's quotation appears in *Congressional Globe,* July 27, 1866, 39th Cong., 1st sess., p. 4231.

It is to be expected that men like Sumner would draw such analogies, and the use of the military metaphor was the ultimate clincher, making it seem self-evident that Ream's gender was an insurmountable obstacle to her success. Here I cannot resist making the comparison once again with Harriet Hosmer, for not only was she a superior horseback rider and fox hunter, but she was also the manager of a studio filled with male subordinates. Judging from this photograph of Hosmer with her Italian workmen, she might well have replaced Grant and ridden in his stead. But Ream, as we have seen, projected a very different sort of image. The real surprise is not that men like Sumner were outraged at her commission but that women took up the campaign against her where he left off. The opening salvo in the public campaign against Ream came from the noted feminist and antislavery journalist Jane Grey Swisshelm, who published in August 1866 a withering assault on Ream's character, uttering through the news media everything Sumner probably had been thinking but could not say out loud. It is worth quoting Swisshelm at some length:

> She is a young girl, about twenty; has only been studying her art a few months; never made a statue; has some plaster busts on exhibition in the Capitol, including her own, minus clothing to the waist; has a pretty face, with a turn-up nose, bright black eyes, long dark curls and plenty of them; wears a jockey hat and a good deal of jewelry; sees all the members at their lodgings or the reception rooms at the Capitol; urges her claims fluently and confidently; sits in the galleries in a conspicuous position and in her most bewitching dress, while those claims are discussed on the floor, and nods and smiles as a member rises and delivers his opinion on the merits of the case, with the air of a man sitting for his picture; and so she carries the day over Powers, and Crawford, and Hosmer, and who not![16]

In her pithy way, Swisshelm sets forth all the essential points in the case against Ream. It was not simply that she was young and inexperienced in sculpture, but, more important, that she was using her sexual appeal to influence public decision making. Thus the importance of the physical description, the attention to the jewelry and the bewitching dress, and the scandalous suggestion that she was exhibiting her own bare chest in the Capitol in the form of plaster busts; later critics would run with this idea by playing on the double meaning of the word *bust*.[17] Then there is the discussion of her lobbying practices, with the charges that she met members of Congress in their lodgings and that she sat in the congressional galleries and used her charms to influence the public behavior of elected politicians. All of this adds up to a picture of a woman who is polluting public life.

[16]Swisshelm is quoted in full in Sherwood, *Labor of Love,* p. 69, and in several clippings in the Hoxie Papers.
[17]H. G., "Woman's Emancipation," *New Republic* (Chicago), ca. 1867, clipping in Hoxie Papers.

Swisshelm's attack is reminiscent of age-old arguments against women in public life going back as far as Aristotle. Such thinkers held that women, if included in public deliberations, would distract men from the serious business of reasoned, dispassionate discussion; women represented carnality and passion and therefore had to be excluded from the public domain of reason.[18] The question is why Swisshelm, an advocate of female suffrage, would appeal—even indirectly—to this oppressive view of women in public life.

One possible answer to this question is that Swisshelm, like many other activist women of her time, entered the public sphere as a moral reformer. The "separate spheres" ideology, although it tried to confine women to caretaking roles within the family, did accord women a moral voice, for the family was understood to be critical in the moral development of the nation's citizens. As wives and mothers, women thus had a legitimate moral influence on men and men-to-be. Female abolitionists, temperance advocates, and other moral reformers used their traditional moral role within the family as a platform from which to extend their moral influence into the sphere of politics—by writing, lecturing, organizing. Perhaps the most famous example is Harriet Beecher Stowe, who catapulted the abolitionist movement onto the national stage by writing her novel *Uncle Tom's Cabin;* the novel constructed a moral argument against slavery on the grounds that it destroyed the very institutions that women were supposed to uphold—marriage and family. Similarly, Swisshelm used her pen to combat slavery and male abuses within the family. Ream, on the other hand, did not enter the public sphere as a reformer or a voice for the moral concerns of women. Unlike Swisshelm, Ream was not even married, so she did not have a legitimate position from which to speak for those moral concerns. She was simply competing for work that men traditionally performed, for no other reason, it seemed, than to gain notoriety. Moreover, for Swisshelm and others, Ream gave women in public life a bad name. By intruding sexuality rather than morality into the public sphere, she lent credence to the old theory that women disrupted reasoned public discussion.[19]

Swisshelm's accusations colored the discussion surrounding Ream for many years. In 1871 Hiram Powers echoed Swisshelm in a bitter letter in which he described Ream

[18]For eighteenth-century arguments against women in public life, see John Barrell, *The Political Theory of Painting from Reynolds to Hazlitt: "The Body of the Public"* (New Haven, 1986), pp. 65–68. For a survey of this kind of thought (including Aristotle) see Jean Bethke Elshtain, *Public Man, Private Woman: Women in Social and Political Thought* (Princeton, 1981).

[19]On Stowe see for example Jane Tompkins, *Sensational Designs: The Cultural Work of American Fiction, 1790–1860* (New York, 1985). The notion of "separate spheres" has come under attack in recent years, for example in Monika M. Elbert, ed., *Separate Spheres No More: Gender Convergence in American Literature, 1830–1930* (Tuscaloosa, Ala., 2000), and Cathy N. Davidson and Jessamyn Hatcher, eds., *No More Separate Spheres!* (Raleigh, N.C., 2002). The recent scholarship has stressed that men and women, and even masculinity and femininity, were not in fact sorted tidily into separate spheres. My study of Ream certainly confirms that insight, although Ream's difficulties show how much the ideal of separate spheres maintained a hold over the cultural imagination.

as a talentless "lobby member" and "mountebank" who was contributing to "prostitution in art."[20] In the same year, the *New York Tribune* called her a "fraud," and as late as 1876 the same paper alluded to her as a "phenomenon of successful impudence such as no country but America ever did or ever could produce."[21] The tenor of the discussion certainly made Ream much more vulnerable to scandal, and scandal followed her as she worked away at the Lincoln commission. Repeatedly, Ream had to fend off accusations that her work was not her own. First the charge was made that Fisk Mills was doing her work for her, and in 1871, just before the Lincoln statue was to be unveiled, the *New York Tribune* charged that the statue had been designed and made by Italian workmen. The latter accusation seems particularly absurd given that all sculptors at that time used Italian carvers to transfer models to marble; Ream probably did more work than was typical for a sculptor simply because she was so financially strapped and could not afford the sort of studio operation that Hosmer and others had. In 1868 Ream became embroiled in a political scandal; she was nearly evicted from her studio in the Capitol on the suspicion that she had been trying to influence the swing vote in the Andrew Johnson impeachment trial—Sen. Edmund Ross from Kansas, who knew her family and was actually lodging at her family home at the time. Even before this happened, there had been whispers in the press that Ream had not been entirely loyal to the Union cause. All of this negative publicity took a toll on her health and well-being, yet she continued in her chosen profession.[22]

Despite the beating she took throughout her career, Ream was not a passive victim of the news media. She did indeed endeavor actively to control her public image in order to justify her work as a woman in the public sphere. The public image she fashioned was multifaceted, even contradictory, because it took advantage of various different cracks in the ideology of separate spheres. On the one hand, she emphasized her humble origins, her lack of privilege. She fashioned an identity as a "westerner" (she was born in Wisconsin, near what was then the Indian frontier) and as a hardworking girl driven by necessity to earn money to support her parents. There was certainly some truth to all of this. She took a job as a teenager during wartime in the dead-letter section of the post office, in part because her father's often uncertain income did not

[20]*New York Post,* June 19, 1871, quoted in Sherwood, *Labor of Love,* p. 189.

[21]"In Re Ream," *New York Tribune,* Jan. 31, 1871. The humbug reference appears in the *Tribune* of March 11, 1876; Ream is suggested but not explicitly mentioned.

[22]Sherwood, *Labor of Love,* pp. 106–10, discusses the Fisk Mills accusation. The later accusation appears "In Re Ream," *New York Tribune,* Jan. 31, 1871, and in various newspaper clippings rebutting the accusation in the Hoxie Papers (Harriet Hosmer wrote from Italy to defend Ream from this accusation). The Ross controversy is covered in Sherwood, *Labor of Love,* pp. 85–106. Earlier allusions to Ream's disloyalty appear in *New York Citizen,* Jan. 19, 1867, clipping in the Hoxie Papers, and an unidentified clipping entitled "Political and Artistic Gossip" dated from Willard's Hotel, January 16, 1867.

cover the family expenses. Here was a major crack in the wall separating the spheres of men and women: women could not always be angels in the house if men did not always earn the necessary bread. One of Ream's more articulate defenders, the *New Republic* of Chicago, actually suggested that Ream's critics were the same people who did not understand why some women had to "toil away at four dollars per week."[23] Mary Clemmer Ames acknowledged that "a refined and sensitive woman" would not willingly have photographs of herself "hawked about the street," but "it is charitable to remember the curse of the want of money, and that the pressing need of it may have urged Miss Ream to this 'trick of the trade.'"[24] Ream, as breadwinner, could be excused in this fashion, but she could also be glorified, made to embody some of the virtues more commonly associated with masculinity: industry, perseverance, pluck, strength. And thus her cause was defended by some men and women who advanced the idea of "woman's emancipation." In one piece, Abby Ferree wrote that after visiting Ream's studio, she left "with brighter thoughts and a grander vision of woman—the woman of America; we see her side by side with man in the Senate Chamber, as well as in the legislative halls (not always a looker on from the galleries)."[25]

On the other hand, Ream crafted a more conventionally feminine image, the image of an innocent, unaffected girl exercising her natural talent for artistic pursuits. Writers often compared her to a bird flitting about, as if she were an ethereal creature oblivious to man's world of politics and money. Ream was clearly adept at disguising the professional side of herself when she needed to and projecting a pure devotion to art that was consistent with the Victorian ideal of genteel femininity. After all, the separate-sphere system did grant women artistic taste, since art was associated with the feminine realm of morality and spirit; and women were encouraged to develop artistic proficiency as long as they remained amateurs. Some commentators went even further, suggesting—as the *Boston Journal* did in 1874—that "nature has evidently fitted woman for art labor. The gentler sex not only surpass the sterner in taste, fancy, and imagination, but in those intuitions of character, truth and beauty which are essentially

[23]H. G., "A Woman's Emancipation," *New Republic* (Chicago), undated clipping [early 1867] in Hoxie Papers. Mary Clemmer Ames, in "A Woman's Letter from Washington," *Independent,* Feb. 1871, argued similarly that Ream's accomplishment made the case for womankind's "complete recognition as a worker in the race." On the strained family finances, see Sherwood, *Labor of Love,* pp. 16, 184, 194; though Prioli, "'Wonder Girl from the West,'" p. 18, n. 14, reports that Ream may have exaggerated the family's financial problems.

[24]Mary Clemmer Ames, "Miss Ream's Statue of Lincoln," unidentified clipping in the Hoxie Papers.

[25]Abby M. Lafflin Ferree, "Miss Vinnie Ream," unidentified clipping [May 1867], in the Hoxie Papers. Like many observers, Ferree emphasized Ream's work ethic: "self-made and self-poised . . . 'Industry' is written around her." Other notable defenses of Ream include a letter to the editor in *Revolution,* Feb. 23, 1871; articles by Lizzie Boynton and Mary Clemmer Ames; articles in *New Republic* (Chicago), early 1867, all in the Hoxie Papers.

womanly."[26] The nineteenth-century essentialism that supported separate spheres could be used to argue that women were better suited for art than men.

Hence these two very different images of Ream—the industrious breadwinner and the ethereal girl—served the same goal, namely to create legitimate avenues of entry into the male public sphere. Ream projected this multifaceted self-image in two key ways, in her biography and in her studio. Thus her biography emphasized her roots as a westerner, her family's financial hardship, her work at the federal post office—all key elements of the story she had publicized through the newspapers. Later, a more dramatic element would be added to the story: the claim that she got to know Lincoln personally through a series of sittings he gave her for a portrait bust just before his death. Lincoln agreed to the sittings, the story goes, because he felt an affinity with the "poor and friendless girl." The Lincoln story first appears, as far as I can tell, in 1871, when the statue was finished and unveiled, and then Ream expanded and elaborated it much later in her life. In 1866, when she got the commission and the controversy first started, her supporters in the press were not saying that her Lincoln bust was made from life but rather that she had the opportunity in Clark Mills's studio to study *his* life mask and bust of Lincoln.[27] The point is not really that Ream lied about her relationship with Lincoln (though I believe the facts suggest that she did). The point is that Ream, like other artists, stretched her personal biography to create a particular public identity. Thus, when she was working on the Lincoln commission, she did not choose to mention that her brother had fought on the Confederate side or that she had sewn a flag for the first Confederate regiment from Arkansas, but when she was competing years later for a monument to Robert E. Lee, she made public use of these points to paint herself as a Confederate sympathizer.[28]

Even more important to Ream than her biography was her studio, because it was in this space that she could literally fashion her image and present it to people who shaped public opinion. Artists' studios were extremely important in this time period, a source of great fascination to art critics and art buyers alike. It was not at all unusual to find

[26]"Vinnie Ream," *Boston Daily Journal,* Apr. 28, 1874. This idea is echoed in an article entitled "Vinnie Ream" in the *Wheeling Weekly* [Oct. 1877]: "Woman lives more in an ideal world than man does; her imagination is quicker and brighter." The image of Ream as innocent and "artless" appears frequently, in "Gossip from the Capital," *Daily National Democrat,* Feb. 19, 1871, Hoxie Papers; "Vinnie Ream, the Sculptress," *Brooklyn Daily Times,* May 16, 1871, Hoxie Papers; George Caleb Bingham to James Rollins, quoted in Sherwood, *Labor of Love,* p. 252. The bird analogy also appears frequently; for example, in *Labor of Love,* p. 70; in various clippings in the Hoxie Papers, such as *National Anti-Slavery Standard,* Sept. 14, 1867; and in Ferree, "Miss Vinnie Ream."

[27]A letter in defense of Ream, dated August 29, 1866, published in the *Washington Star,* says that Ream studied Mills's bust, the last one done while Lincoln was still alive (clipping in Hoxie Papers). An unidentified clipping entitled "Miss Ream's Bust of Lincoln" [ca. 1866] corroborates this (Hoxie Papers). Several documents from 1867–68 assert that Ream made her study of Lincoln from life, but they do not actually claim that Lincoln gave her a sitting ("Studios of Washington," *New Republic* [Chicago], May 9, 1867; letter from John Rice, Jan. 14, 1868; both in Hoxie Papers). These are consistent with the earlier newspaper articles that say she had opportunities to study his face when she saw him in public situations. Prioli, "'Wonder Girl from the West,'" concurs.

[28]"Vinnie Ream," *Wheeling Weekly* [Oct. 1877], Hoxie Papers.

lengthy descriptions of artists' studios in newspapers and magazines. Studios were treated as a kind of inner sanctum revealing something of the artist's temperament and genius; they were also the key space in which artists defined and marketed their professional image. Artists worked in their studios, but they also regularly accepted visitors (usually during certain specified hours of the day) so that the studio became a space not only of production but of display (fig. 2). From 1866 to 1869, while she was working on the Lincoln statue, Ream's studio held particular interest because of its location: the basement of the Capitol. Ream began her career in Clark Mills's studio in the Capitol (before he was evicted on suspicion of disloyalty to the Union), and other sculptors worked there from time to time because politicians were a great market; they ordered portrait busts to make themselves look like noble and wise statesmen. When Ream took over Mills's studio, it became the most famous and most discussed of these Capitol studios. Here was a space that she could design and control, where she could meet journalists, politicians, customers, and gawkers on her own terms. It was a curious space, neither entirely private nor public, but in a sense mediating between these two realms. Here Ream fashioned an inner sanctum of feminine domesticity and opened it up to the observation of the outside world. The location inside the Capitol made it all the more unexpected and alluring.[29]

Photographs of the space give very little indication of what most observers noticed and found intriguing. Typically, the descriptions of the studio space merged with physical descriptions of Ream herself. Thus one journalist, after describing her "lustrous black eyes," moves directly to an account of the studio as a "charming retreat" within the Capitol: "it has one large window, shaded with the American flag, a fireplace, with a bright wood fire, a music-box ever playing sweet strains, doves, gold fish, canary birds, books, busts, pictures and flowers, and a galaxy of great men of our day, some in clay, some in flesh and blood."[30]

This description, like many others, comments on the peculiar combination of the domestic and the political, female and male, private and public. On the one hand, there is the pretty young woman surrounded by music, birds, flowers, and art; and on the other hand, there are the great men of the day who come to visit her and who appear in bust form amidst the profusion of feminine display. In another account, this juxtaposition is brought to an extreme. After describing the studio as "full of sunshine, vines, flowers, and birds," the writer reports that "a tiny creature, in a tunic that half

[29]One newspaper article gives exact directions to the basement studio, *Daily Gazette* (Cincinnati), Mar. 2, 1869, Hoxie Papers. Sherwood, *Labor of Love,* p. 382, identifies the room as HB-25 in the current building, though the rooms have been much altered since Ream's time. For more on artists' studios in the nineteenth century, see Sarah Burns, *Inventing the Modern Artist: Art and Culture in Gilded Age America* (New Haven, 1996) and Linda Graham, "Therapy, Commodities, and the Decorated Studio: Images of the Studio of William Merritt Chase," Ph.D. diss., University of California at Berkeley, 1996.

[30]"Vinnie Ream," unidentified clipping [1868] in Hoxie Papers.

FIG. 2. Vinnie Ream in her studio. *(Courtesy Library of Congress.)*

hid her shape, her black eyes dancing, her teeth sparkling, her long black hair streaming down her back . . . she flitted about among the countless busts and faultless likenesses of Senators and Representatives, and the colossal plaster cast of the statue of Lincoln, like a bird herself." So in this account Ream becomes birdlike herself, flitting about among the silent still images of the great men of the day. But the description gets even better: "sprightly in all her conversation, with sentiment for this one and jests for that one, now a whistle to the canaries, now an absent-minded bit of song, now holding a turtle-dove on her shoulder with its bill between her scarlet lips, she was a fascinating sight."[31] Here the writer's imagery begins to waver between feminine innocence and eroticism. The bill in the scarlet lips suggests not only a childlike rapport with birds but an adult sexuality on display.

This is the nub of the matter, the ambiguity intrinsic to Ream's person and her studio space. The studio appeared as a feminine, indeed childlike retreat from the public and masculine world of affairs in which it was located; but it could easily assume erotic overtones as well (fig. 3). Thus those nude female busts, which were a staple in studios of other sculptors, including Hosmer's, could here be linked erotically to the person of Ream herself. To enter Ream's studio and retreat from the public world of reason was to let the imagination take flight like a bird. Imagination could easily enter the world

[31]Originally from *Harper's Bazaar,* reprinted in an unidentified clipping in the Hoxie Papers.

of the erotic, especially since that world was strictly excluded from the all-male do-main of public life. And to complicate matters, this imaginative feminine world of the innocent and the erotic was not really separated from the public world of men within Ream's studio; the two were intertwined from the outset, and that was made visible in the busts of the famous men interspersed among the flowers and the birds and the nude statuary.

What visitors to Ream's studio found, therefore, was a unique liminal space, at once a public world and a retreat from that world, at once innocent and erotic, artistic and political. The same qualities that made Ream and her studio vulnerable to innuendo and scandal also made her fascinating and appealing. When "public man" entered Ream's studio, he found himself surrounded not by instruments of reason but by em-blems of nature, innocence, sentiment, and sexuality. Human desires and feelings ex-cluded from the public world of reason could be recognized and indulged in Ream's studio and its space of femininity. I do not mean to suggest that there was anything necessarily liberating about Ream's studio. After all, retreating to a liminal space like Ream's studio does not mean that the person came back into the public world a changed man. But Ream's studio was in fact different from a home or a brothel, where public man could escape and find comfort or pleasure. What was different was that it was lo-cated within the public sphere and its occupant was working on a great public work, a statue of Lincoln ordered by the federal government. To some observers, like Abby Ferree, the studio actually suggested an alternative vision of public life, embodying a fuller sense of humanity—a sense of humanity that might encompass women and the human values traditionally assigned to woman's sphere.[32]

When the Lincoln statue (fig. 4) was finally unveiled, in February 1871, some commentators claimed this as Ream's achievement—that she had humanized Lincoln, found the man of feeling underneath the rough public shell. One writer recalled how the work in progress had appeared in her studio: "the statue from the first was kept decorated with flowers, and their fragrance rising up to her seemed to inspire her when modeling the dead man's face, and has helped her to bring out in it all the true goodness of his character."[33] It was as if Lincoln himself had been transformed in the magical environment of Ream's studio, under her feminine touch. Most critics agreed that Ream's statue was true to Lincoln's plain exterior while at the same time revealing the profound emotions within that guided his public conduct—"the sadness mingled with benevolence," to cite the often quoted description by the painter Miner Kellogg.[34] The

[32]Ferree, "Miss Vinnie Ream."

[33]"Gossip from the Capital," *Daily National Democrat,* Feb. 19, 1871, clipping in the Hoxie Papers.

[34]Kellogg's text is reprinted in full in Richard L. Hoxie's privately printed *Vinnie Ream* (1908), p. 5, and is ex-cerpted in numerous clippings in the Hoxie Papers.

FIG. 3. Vinnie Ream posed in an evocative photograph in her Capitol studio. *(Courtesy State Historical Society of Wisconsin.)*

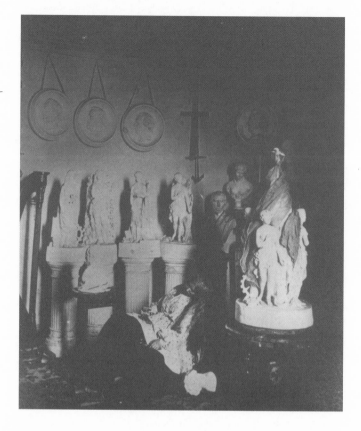

act Ream chose to represent was of course the issuing of the Emancipation Proclamation, shown in his right hand, a common choice for sculptors in this period. But if we compare it with Henry Kirke Brown's *Lincoln* in Brooklyn, for example, we see that Ream did not choose the visual rhetoric of oratory as Brown did, but rather the intimacy of a more personal encounter. Ream's narrative could certainly be read in a paternalistic way, as Kellogg did when he claimed that Lincoln was looking down upon "the defenceless beings who are about to receive the inestimable boon of freedom."[35] But that image of paternalistic authority was replaced, in other readings, by an image of feminine compassion. A letter published in the Washington *Chronicle* asserted that "it was the true heart of a woman that could interpret the divine impulse of [Lincoln's] soul in that solemn glad hour—the sublimest which ever came to man, even [more than] the birth of a nation—then when his heart was laid upon the heart of God. What other expression should we ask other than the tenderness and humility of the womanly soul that was in the man? Such at least is the reading which I find in that purest of marble statues."[36] This reading was the most explicitly gendered formulation of Ream's

[35]Ibid.
[36]Letter from P. W. Davis to the *Washington Chronicle,* undated clipping in the Hoxie Papers.

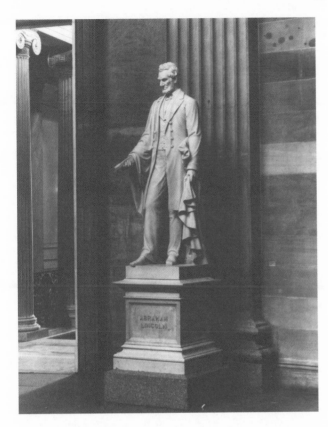

F<small>IG</small>. 4. *Lincoln,* 1871, by Vinnie Ream. *(Courtesy Office of Architect of the Capitol.)*

achievement, that she had revealed the womanly soul within the great public man. Although composed in 1871, this reading sounds like it might come from the late twentieth century because it assumes that men can be womanly and women can be manly, that masculinity and femininity are not fixed; they represent culturally determined sets of values that men and women can share.

Looking at Ream's *Lincoln* today, few observers would imagine that such gender negotiations had anything to do with this simple image of a man holding a cloak and a scroll. But if we view the statue through the prism of its maker, a fascinating, controversial woman negotiating the dilemmas of womanhood in the most public of places, we can see that the statue is not simply a reflection on Lincoln but is a product of her struggle to define herself and her role in public life. If the lesson of Ream's statue is that women—and values like tenderness and humility that are traditionally assigned to women—have a legitimate place in public life, then the statue does indeed have an important story to tell us even today.

Mythology, Allegory, and History

Brumidi's Frescoes for the New Dome

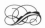

BARBARA A. WOLANIN

ONSTANTINO BRUMIDI, THE ROMAN-BORN ARTIST WHO IMMIGRATED TO THE United States in 1852, created the frescoes that are focal points of the rotunda today (figs. 1 and 2; color plate 2). Indeed, if Brumidi's proven talents and skills had not been available, architect Thomas U. Walter would not have planned for a painting to be seen through the eye of his new dome.

Brumidi (1805–1880) was introduced to construction superintendent Capt. Montgomery C. Meigs in late 1854, only days after Walter had completed his first dome design. Communicating in broken French, their only common language, the Italian artist told the American engineer of the palaces and churches for which he had painted frescoes in Rome and offered his services for the Capitol. Meigs was pleased to have finally found someone who knew fresco, the medium he wanted to use on the walls of the Capitol.[1] True fresco, used in the Italian Renaissance by such artists as Raphael and Michelangelo, had been revived in Rome during Brumidi's student years. Despite his efforts, Meigs had not been able to find an American artist willing to learn the difficult

[1] Entry in the Montgomery C. Meigs Journal, Dec. 28, 1854, Papers of Montgomery C. Meigs, Manuscript Division, Library of Congress, transcribed by William Mohr for the U.S. Senate Bicentennial Commission (hereafter MCM Journal). Entries related to the Capitol have been published under the auspices of the U.S. Senate Historical Office as *Capitol Builder: The Shorthand Journals of Montgomery C. Meigs, 1853–1859, 1861,* ed. Wendy Wolff (Washington, D.C., 2001), see pp. 180–81. The sections of the journal related to Brumidi's first fresco are also included in appendix A of the author's *Constantino Brumidi: Artist of the Capitol* (Washington, D.C., 1998). Related talks given by the author in previous USCHS symposia include "The Artist of the Capitol" in 1994 and "Montgomery C. Meigs, Art Patron" in 1996.

Fig. 1. Constantino Brumidi with his palette ca. 1866, at the height of his career after the completion of the canopy fresco in the rotunda. Photograph by Matthew Brady. *(Courtesy Office of Architect of the Capitol.)*

Fig. 2. Brumidi's canopy fresco in the eye of the dome and the frieze encircling the base of the dome. (See also color plate 2.) *(Courtesy Office of Architect of the Capitol.)*

technique, which involves painting on sections of fresh plaster so that the pigments are bonded into the wall.

Brumidi had been thoroughly trained according to the seventeenth-century academic tradition in which students began by drawing from sculpture and copying paintings by the masters. He thus developed skill in rendering forms, in depicting the human figure and architectural spaces, and in handling color. His painting teachers, among them Vincenzo Cammucini, were part of a neoclassical revival that looked to such Renaissance artists as Raphael for inspiration.[2] Brumidi learned to paint murals in fresco and other techniques in Rome.

Brumidi evidently also was trained in sculpture. Documents show that in 1837 he undertook a commission for the Weld-Clifford Chapel in the Church of San Marcello al Corso to create reliefs and figures in marble.[3] Although we do not know whether Brumidi did the modeling or carving himself, it is evident that he understood how to compose in three dimensions. At the Accademia di San Luca, he had studied under two of the master sculptors of the time, Bertel Thorwaldsen and Antonio Canova. Brumidi's expertise in depicting forms in space would be essential for his rotunda designs.

It is clear that by the time he began work at the Capitol, Brumidi had full command of his artistic means, including the skillful use of a variety of painting media, the ability to paint the human figure in action, and an understanding of how to create the illusion of three-dimensional forms through light and shade. Brumidi also had depicted a wide range of subjects in Rome. Many of his paintings were allegorical. In the palace of Prince Alessandro Torlonia (later destroyed) he painted murals, including a frieze depicting the Glory of Constantine, that may have been one of his best preparations for his future work in the rotunda (fig. 3). He also painted murals with scenes from classical history or mythology, such as *The Judgment of Paris* in the theater of the Villa Torlonia.[4] Many of his subjects were religious, such as the *Immaculate Conception* in the dome of the Church of the Madonna de l'Archetto, his last Roman commission. Brumidi is also thought to have been responsible for the decoration of the many rooms in the theater of the Villa Torlonia. However, there is no evidence he ever undertook any single composition on the scale of the canopy in the rotunda in Washington.

At the Capitol, Meigs gave Brumidi the opportunity to demonstrate his skill. The engineer provided the dimensions of a lunette (the semicircular section of wall under

[2]For a general background on the context in which Brumidi was trained, see Claudio Poppi, "From Avant-Garde to the Academy," in Roberta J. M. Olson, *Ottocento: Romanticism and Revolution in Nineteenth-Century Italian Painting* (New York, 1992), pp. 43–50.

[3]Alberta Campitelli and Barbara Steindl, "Constantino Brumidi da Roma a Washington," *Ricerche di Storia dell'arte: Pittori fra Rivoluzione e Restaurazione* 46 (1992):9–59, and Maria Sofia Lilli, *Aspetti dell'arte neoclassic: Sculture nelle Chiese romane 1780–1846* (Rome, 1991), pp. 55–58.

[4]Alberta Campitelli et al., *Villa Torlonia: l'Ultima Impresa del Mercenatismo Romano* (Rome, 1997), pp.191–227.

FIG. 3. One of the frescoes Brumidi may have painted in the Torlonia Palace in Rome in the late 1830s includes a figure seated on a cloud and an illusionistic sculpted relief that prepared him for frescoes he would later paint in the rotunda. *(Photograph courtesy of Marco Fabio Appollonia.)*

a vault) at one end of the room the engineer had taken over as his office, and the artist promised to send him a "design for an allegorical painting of agriculture," since the room was intended for the Committee on Agriculture.[5]

Brumidi applied all of his skills to his trial piece, which he was to paint at his own expense. Meigs said that they agreed upon the subject of Cincinnatus called from the plow to defend his country, a subject he knew would be relatively easy for the Roman artist. Brumidi expressed uncertainties about painting American dress, but he was thoroughly familiar with Roman togas, armor, and classical landscape. Meigs noted that the story of the Roman hero of the fifth century B.C.E. was "a favorite subject with all educated Americans, who associate with that name the Father of our Country."[6] George Washington was known as the American Cincinnatus and was the first president of the Society of the Cincinnati.

Brumidi's first lunette met with approval, and Secretary of War Jefferson Davis

[5] MCM Journal, Dec. 28, 1854, in Wolff, *Capitol Builder,* p. 180.
[6] MCM to John Durand, Oct. 11, 1856, Capitol Extension and New Dome Letterbooks, Records of the Architect of the Capitol (hereafter cited as AOC).

authorized Meigs to pay the artist for his work and to put him on the payroll to complete the decoration of the room in fresco. The ceiling that he created, with illusionistic views of the Four Seasons floating on clouds in a framework of carved stone, and the relief portraits of Washington and Jefferson on the walls show his amazing ability to make forms appear three dimensional (figs. 4 and 5).

Almost without having to think, Meigs focused on George Washington as the obvious theme for the room and for the decoration of the Capitol. Washington and the battles and heroes of the Revolutionary War period would appear in many of the rooms Brumidi designed for the Capitol, including the central fresco in the rotunda. Veneration of Washington was widespread in the mid-nineteenth century. Prints of the first president could be seen in many American homes and meeting places, and his image first appeared on a postage stamp in 1847. Washington's life was the theme of books designed for children.[7] One of them advocated that "the first word of infancy should be mother, the second father, and the third WASHINGTON."[8] In the 1850s, a writer claimed that "in all branches of Art and in all shapes of Literature, WASHINGTON is now the leading subject."[9] In the 1850s, at a time of increasing sectional tensions, no one could argue about Washington's or the Revolution's importance, and, in fact, during the years preceding and into the Civil War, "the first president's name was invoked by both North and South in support of their respective causes. His image, however, was virtually co-opted by Northerners."[10] Even today, although pictures of Washington do not hang in every home and school, he was recently listed as eleventh among famous people who are the subjects of books held by the Library of Congress.[11]

It is likely that Brumidi became familiar with the story of the American Revolution while he was living in Rome. He probably knew Carlo Botta's four-volume *Storia della guerra dell'independenze degli Stati Uniti d'America* (Story of the War of Independence of the United States of America), first published in 1809. The American Revolution was an inspiration for the republican uprisings taking place throughout Europe. Later, Brumidi asked Meigs to get a copy of Botta's *History of America* for him from the Library of Congress.[12] Although Meigs and others undoubtedly made suggestions about subject matter, Brumidi proposed iconography for rooms and conducted his own research by searching for historical prints and portraits as well as by consulting history books.

Brumidi does not appear to have been strongly political. While in Rome, he was

[7]Mark Edward Thistlethwaite, "Introduction," *The Image of George Washington: Studies in Mid-Nineteenth-Century American History Painting* (New York, 1979), pp. 4, 10, 27.

[8]H. H. Weld, *Life of George Washington* (Philadelphia, 1845), quoted by Thistlethwaite, *Image of George Washington,* p. 27.

[9]*The Home Journal,* Nov. 26, 1859, quoted in Thistlethwaite, *Image of George Washington,* p. 10.

[10]Barbara J. Mitnick, ed., *George Washington: American Symbol* (New York, 1999), p. 103.

[11]"Book World," *Washington Post,* Sept. 12, 1999.

[12]MCM to Representative Tyson, May 1, 1856, Capitol Extension and New Dome Letterbooks, AOC.

FIG. 4. The ceiling of the room painted by Brumidi for the House Agriculture Committee (H-144), completed in 1856, includes figures representing the Seasons sitting on clouds surrounded by illusionistic sculpted stone relief. *(Courtesy Office of Architect of the Capitol.)*

FIG. 5. South wall of the room painted for the House Agricultural Committee includes an illusionistic relief portrait of George Washington, which shows the artist's skill in making a flat painting appear three dimensional. *(Courtesy Office of Architect of the Capitol.)*

a captain of the Civic Guard established with the blessing of Pope Pius IX in 1847. Brumidi apparently undertook this role reluctantly and tried unsuccessfully to resign. During the period of republican rule after the pope fled the city, he apparently removed church property for safekeeping when soldiers were to be housed in a monastery and convent. After the pope was restored to power by French troops, Brumidi's earlier actions led to his being accused of various crimes, arrested, and imprisoned in February 1851. He remained in prison for more than a year. He pleaded to be transferred to a less harsh prison and asked to see a doctor for his health problems. Tried, convicted, and sentenced to eighteen years in prison, despite numerous testimonials in his favor, he was finally pardoned by the pope with the understanding that he would immigrate to the United States. These experiences in Rome made him value deeply the liberty he found in America.[13]

In addition to American Revolutionary history, new technology is a major theme in the decoration of the Capitol, including the canopy fresco in the rotunda. Brumidi's interest and pride in new technology preceded any collaboration with Meigs, as shown in the tondo *Progress* that he painted for a home in New York in 1853 (fig. 6). The *Baltic* (the name inscribed on the ship in the background) was one of the fastest steamships crossing the Atlantic at the time. A steam locomotive appears on the right. Meigs wanted Brumidi to depict the McCormick Reaper in the Agriculture Committee Room and obtained a daguerreotype of it for the artist to consult.[14]

Once this first room was acknowledged a success, Meigs asked Brumidi to create designs for many of the unfinished rooms in the Senate wing. Brumidi was at his busiest between 1856 and 1859, with crews working under his direction in rooms such as the Naval Affairs Committee Room and the President's Room.

The Rotunda Canopy Fresco

Both an enormous fresco on a bowl-shaped canopy under the dome and a carved frieze were incorporated in Thomas U. Walter's elevation of the new dome dated December 9, 1859 (fig. 7; color plate 3). Thus, it is probable that Brumidi began working on ideas for the canopy in 1859, although the exact dating of three round preliminary oil sketches for the fresco is uncertain. Brumidi's final composition appears in watercolor in Walter's elevation, but an ink sketch of a different composition with an enthroned figure and

[13]Records of the Tribunal Supremo della Sagra Consulta, Processi Politici, 1849–51, Italian State Archives, Palazzo della Sapienza, Rome. See Pellegrino Nazzaro, "The Italian Years," in *Constantino Brumidi: Artist of the Capitol,* chap. 2.

[14]MCM to Mr. Engle, Feb. 6, 1856, and MCM to Mr. Elliott, Feb. 9, 1856, Capitol Extension and New Dome Letterbooks, AOC.

FIG. 6. *Progress,* painted in oil on canvas by Constantino Brumidi in 1853 for a private home on Long Island, New York. Donated to the U.S. Capitol by Howard and Sara Pratt through the U.S. Capitol Historical Society. *(Courtesy Office of Architect of the Capitol.)*

horses appears faintly beneath the watercolor. The watercolor could have been part of the elevation in 1859 or it could have been added in 1863, when the authorization for the fresco was being questioned.

The theme of all three sketches is the apotheosis of Washington. Honoring the first president in the rotunda made great sense, in light of William Thornton's proposed design for a monument for the center of the Capitol and the early intention to have Washington interred two levels below the rotunda. At the time of the centennial of Washington's birth in 1832, it became clear that his remains would remain at Mount Vernon, and the Congress commissioned Horatio Greenough to create a sculptured portrait of Washington for the center of the rotunda. His Zeus-like Washington was in the rotunda only between 1841 and 1843; by Brumidi's time, it was positioned outside

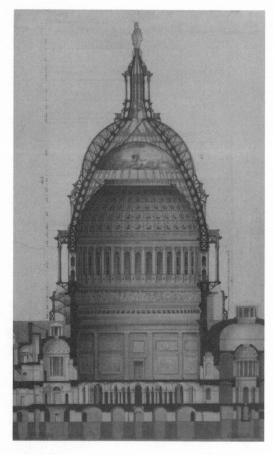

Fig. 7. Thomas U. Walter's drawing, "Section through Dome of U.S. Capitol," 1859, included Brumidi's canopy fresco design. (See also color plate 3.) *(Courtesy Office of Architect of the Capitol.)*

on the east Capitol grounds, facing the rotunda door (fig. 8).[15] Images of Washington's apotheosis had appeared soon after his death, first in an 1802 print by John James Barralet that was copied on English-made pitchers. The image of Washington as a godlike figure rising to sit in glory was a familiar one. Brumidi's great fresco in the figure of Washington that echoes Greenough's pose while clothed in a uniform and a lap robe, is the culmination of this tradition.[16]

Of the three known designs for the canopy, the smallest is logically the first (fig. 9). It shows Washington standing in the center of the composition. As Francis V. O'Connor points out, his head is actually at the exact center.[17] Washington is shown in his general's uniform and is surrounded by a number of the figures who will be included in the final fresco. He is flanked by Liberty with a fasces and Minerva listening to Benjamin Franklin. The lower groups contain a mixture of Olympic gods and alle-

[15]For a discussion of Greenough's statue and its symbolism, see Vivien Green Fryd, *Art and Empire: The Politics of Ethnicity in the United States Capitol, 1815–1860* (New Haven, 1992), chap. 3, or her article, "Horatio Greenough's *George Washington:* A President in Apotheosis," *Augustan Age* 1 (1987):70–86. See also Richard H. Saunders, *Horatio Greenough: An American Sculptor's Drawings* (Middlebury, Vt., 1999).

[16]Margaret Brown Klapthor and Howard Alexander Morrison, *George Washington: A Figure upon the Stage* (Washington, D.C., 1982), p. 229, and Michael Kammen, *Meadows of Memory* (Austin, 1992), p. 4.

[17]Francis V. O'Connor, "Symbolism in the Rotunda" in *Constantino Brumidi: Artist of the Capitol,* chap. 10. See chapter 9 for details on the painting of the canopy and chapter 14 by Bernard Rabin and Constance S. Silver on "Conserving the Rotunda Frescoes." See also Barbara A. Wolanin, "Constantino Brumidi's Frescoes in the United States Capitol," in *The Italian Presence in American Art, 1760–1860,* ed. Irma B. Jaffe (New York, 1989), and Francis V. O'Connor, "The Murals by Constantino Brumidi for the United States Capitol Rotunda, 1860–1880: An Iconographic Interpretation," in *The Italian Presence in American Art, 1860–1920,* ed. Irma B. Jaffe (New York, 1992).

FIG 8. Horatio Greenough, *George Washington,* 1841. Positioned on the east Capitol grounds after its removal from the rotunda. *(Courtesy Office of Architect of the Capitol.)*

gorical figures: Victory, Peace, and Mercury (representing Commerce) on the left, and Plenty, Neptune, and Vulcan on the right. Above them soars the eagle with the American flag, and the United States is shown on the planet below. The appearance of thirty-three maidens encircling Washington points to a date of 1859 or after, since it was in that year that Oregon, the thirty-third state, was admitted to the Union. The composition was thus a statement of hopeful belief that the nation would not be split apart. There was clearly a problem with this design, however, because the majority of viewers would not see Washington or the other figures upright. This scene was composed like a picture that should be seen vertically but was painted on the ceiling, following one traditional mode of Italian ceiling painting.

In what is apparently the second sketch, Washington is depicted in a framed portrait flanked by Liberty and Victory/Fame, with a rainbow underneath (fig. 10). The eagle below him attacks tyrants, and thirteen maidens are featured. The thirty-three stars above them again indicate that this sketch could have been painted as early as 1859, as pointed out by Kent Ahrens.[18]

By 1862, the new cast-iron dome was being raised piece by piece. The country was

[18] Kent Ahrens, "Constantino Brumidi's 'Apotheosis of Washington' in the Rotunda of the United States Capitol," *Records of the Columbia Historical Society of Washington, D.C.* 49 (1973–74):187–208.

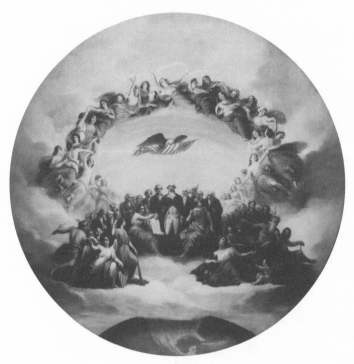

FIG. 9. Brumidi's first sketch for *The Apotheosis of Washington* was designed to be seen from only one direction. *(Courtesy the Athenaeum of Philadelphia.)*

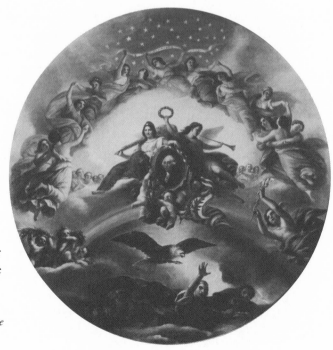

FIG. 10. The second design for the canopy fresco included the attacking eagle and rainbow but showed Washington as a painted portrait. *(Courtesy Office of Architect of the Capitol.)*

FIG. 11. The final oil sketch for *The Apotheosis of Washington* closely resembled the final fresco. This photograph of the sketch, now in a private collection, was published in 1866. *(Courtesy Office of Architect of the Capitol.)*

at war, and Union troops twice had been stationed in the Capitol, once in April 1861 and again in September and October 1862. On August 18, 1862, Walter made a formal written request to Brumidi for a design for the canopy shortly before the troops moved in. Since Brumidi's design and accompanying description were submitted just three weeks later, it seems likely that he had already worked out his ideas. Brumidi wrote in his September letter: "The six groups around the border represent, as you will see, War, Science, Marine, Commerce, Manufactures and Agriculture. The leading figures will measure some 16 feet. In the centre is an Apotheosis of Washington, surrounded by allegorical figures, and the 13 original Sister States."[19]

The final sketch, a yard in diameter, pushes the spatial concept further to a full *del sotto in su;* that is, it shows forms as if seen from below, with the space of the heavens seeming to soar above to infinity, with Washington rising like the saint in the ceiling of a Renaissance or Baroque church (fig. 11). Washington is facing east, toward those entering the main doorway, echoing the orientation of a statue of a god in a classical

[19]Thomas U. Walter (hereafter TUW) to Constantino Brumidi (hereafter CB), Aug. 18, 1862, Capitol Extension and New Dome Letterbooks, AOC, and Thomas U. Walter Papers, Manuscript Division, Library of Congress (hereafter LC). CB to TUW, Sept. 8, 1862, RG 42, National Archives and Records Administration (hereafter NARA). The copy of the letter in the Capitol Extension and New Dome Letterbook, AOC, is different, using "Navigation" instead of "Marine," "15" instead of "16" feet, and describes Washington as "surrounded by allegorical figures representing the several states, and figures of eminent men of the times of Washington, which latter will be likenesses."

temple. The other characters are arranged in six groups, each one centered on an Olympian god or goddess.

The first of the bureaucratic obstacles to the creation of the actual fresco was negotiating a price. Brumidi set his price at $50,000, but Walter asked him to reduce the amount: "should you execute this work it will be the great work of your life; it will therefore be worth, on your part, some sacrifice to accomplish so great an achievement."[20] Brumidi reluctantly agreed to take $40,000, adding that the amount "is lower, considering the subject, the curved form of the surface on which it is to be painted, and the square feet of the painting it contains, than any real fresco picture ever painted."[21] This fee would end up equaling his total earnings for all of his other work at the Capitol over twenty-five years.

In January 1863 Brumidi's proposal was accepted, and he started work on his full-scale drawings shortly after receiving Walter's March 11 letter authorizing him to proceed. However, in May another bureaucratic obstacle stalled the project. Control over the construction of the Capitol had been transferred to the Department of the Interior, and the new secretary, John P. Usher, questioned the validity of Brumidi's contract and ordered work stopped. Walter provided copies of all the previous correspondence related to the canopy fresco, and Commissioner of Public Buildings B. B. French was able to convince Usher that the painting was part of the original plan approved by Congress. French had written that he was certain there was "no artist in the United States, capable of executing a real fresco painting as it should be done, especially so important a work as the one in contemplation, except Mr. Brumidi."[22] Since Walter's drawing was a key part of the argument, it may have been at this point that the watercolor of Brumidi's design was added. Finally, in July 1863, Brumidi was allowed to resume work.[23] By November, after a total of about seven months of work, he had completed all of the cartoons. He was paid $10,000 for this work, and several of his canceled checks for payments in $2,000 installments have survived in the records of the Architect of the Capitol.

To assist Brumidi in gauging the effect of the curved surface on the cartoons, with figures three times his own height, Walter had a studio built for him with a ceiling with the same curve as the canopy so he could test the foreshortening and perspective. The accounts show the number of days the carpenters worked between November 1863

[20]TUW to CB, Dec. 24, 1862, Capitol Extension and New Dome Letterbook, AOC.

[21]CB to TUW, Dec. 27, 1862 (photocopy in Walter Papers, LC).

[22]Benjamin Brown French to TUW, Jan. 3, 1863, Walter Papers, LC.

[23]TUW to CB, Mar. 11, 1863, Capitol Extension and New Dome Letterbook, AOC. John P. Usher to Benjamin Brown French, May 2, 1863, Department of the Interior Letterbook pp. 26–27, RG 48, NARA; John P. Usher to Clement S. West, July 7, 1863, Department of Interior Letterbook p. 42, RG 48, NARA; TUW to Charles Fowler, Apr. 4, 1864, Thomas U. Walter Papers, Athenaeum of Philadelphia, microfilmed by Archives of American Art, Smithsonian Institution, reel 4141 (hereinafter cited as AAA).

and February 1864 and the amount of lumber, shingles, and nails used, but no sketch or photograph of the studio has been found.[24]

The most difficult hurdle was the physical completion of the dome and the support for the canopy structure. The exterior of the dome was essentially finished by December 1863, when the Statue of Freedom was finally set in place, but the interior canopy had not yet been started. Walter worried: "I am afraid he will lose his spirit." In February, he was fearful that Brumidi "will be too old to paint the picture before the place is ready for him." In March, he urged the ironworkers to hurry and finish, noting, "Brumidi is very impatient, and so are we." He also was worried that Congress might stop the canopy fresco completely.[25] When the canopy structure was finally ready in December 1864, Brumidi was paid for adjustments to the cartoons he had made a year earlier.

A roof made of overlapping tin plates, designed to protect the fresco from being damaged by moisture or impact, was laid over the canopy at the end of April. Logically, this would have occurred after the rough coat of plaster was applied; this work most likely could be done only when the weather had turned warm. The rough brown coat, the *arriccio,* mixed with hair and hemp, was troweled on and secured by being pushed into the slots in the curved, fan-shaped, cast-iron plates that formed the upside-down bowl of the canopy (fig. 12). The *intonaco,* the finer white coat, was then laid in sections as Brumidi was ready to paint. Together, both layers measure only three-quarters of an inch in depth.

Documents show that Brumidi could have had access to the canopy for more than a year, but it appears that he was actually frescoing the 4,664 square feet of the canopy only from the end of April, after the tin was applied over the canopy, to October, with a few weeks at the end of December to resolve problems—a total of a little more than six months. This meant that he spent about a month on each scene. The plastering was done by Joseph Beckert, who was on the Capitol payroll. There are no records of any painting assistants, because Brumidi would have paid anyone himself out of his fee. He probably had help mixing paint and possibly painting backgrounds, but there is no evidence of different hands or variation in style in the fresco.

Brumidi started with the central section. The booklet published by S. J. Wyeth in 1866 and sold in the rotunda includes descriptions of the scenes and is our primary source for information about the iconography. The scenes are listed in the order that Brumidi painted them. The central group shows Washington flanked by the "GODDESS

[24]"C. Brumidi," ledger beginning November 1863, Records of the Capitol Extension and New Dome, stamped p. 149, AOC.

[25]TUW to Charles Fowler, Dec. 21, 1863, Capitol Extension and New Dome Letterbook, AOC; TUW to Edward R. James, Feb. 12, 1864, Letterbooks, reel 4141, AAA; TUW to Janes, Fowler, Kirtland and Company, Mar. 21, 1864, Capitol Extension and New Dome Letterbook, AOC.

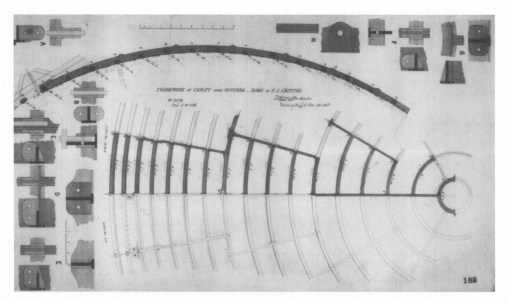

Fig. 12. A drawing details the iron structure to which the plaster for Brumidi's fresco was attached. *(Courtesy Office of Architect of the Capitol.)*

of liberty" and "a winged idealization of victory and fame—sounding a trumpet, and in triumph displaying the victor's palm" (fig. 13). A rainbow arcs under their feet. The maidens represent the first thirteen states. Wyeth states that they are arranged *"geographically,* and *not* according to the order in which they adopted the federal constitution." The figure to the left of Washington is New Hampshire; Georgia, with cotton bolls in her hair and corresponding changes in colors and plants, is on his right. Some of the maidens hold a banner with the national motto, "E Pluribus Unum."[26]

Each scene around the perimeter combines classical gods with American history and technology. The scene "Science," called "The Arts and Sciences" by Wyeth, is dominated by Minerva, the Roman goddess of Wisdom (fig. 14). Looking up at her are Benjamin Franklin, Samuel F. B. Morse, and Robert Fulton. The geometry teacher at the left echoes a figure in Raphael's School of Athens in the Vatican. Samuel F. B. Morse, who was white-bearded, is represented by a portrait of architect Thomas U. Walter based on a photograph of Walter now in the Library of Congress. In using a contemporary person's portrait to represent a historical figure, Brumidi followed a tradition set by Raphael in the early sixteenth century. He further tied the scene to contemporary American technology with the early generator and batteries depicted at the lower right.[27]

[26]S. D. Wyeth, *Description of Brumidi's Allegorical Painting* (Washington, D.C., 1866).

[27]Daniel W. Mattausch, an expert on nineteenth-century gas lighting, believes that a generator like the one in the fresco provided the electricity to ignite the gas jets that lit the canopy and the rest of the rotunda.

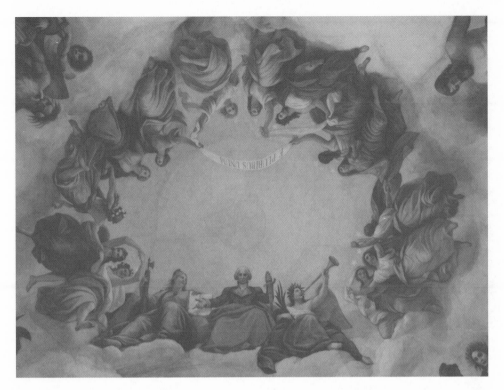

FIG. 13. Central group from *The Apotheosis of Washington,* the first section painted by Brumidi. *(Courtesy Office of Architect of the Capitol.)*

The scene "War" is dominated by Freedom, as if the statue had come down off the dome above to vanquish the enemies of liberty (fig. 15; color plate 1). The gray-bearded man is Tyranny, and the ermine robe upheld by a soldier in armor obviously represents the kingly power, as does the hand-topped scepter, the "main de justice" of French kings from the time of Charlemagne.[28] Revenge, bearing torches, is said to be a portrait of Confederate President Jefferson Davis, while Anger biting his finger may represent Alexander H. Stephens. George C. Hazelton, Jr., commented in 1897:

> Just before his death, Brumidi was criticised, especially in the papers of the South, for an alleged caricature of the leaders of the Confederacy. Though the artist always denied the accusation, it is interesting to observe the resemblance of the figures to the right of armed Liberty to Jefferson Davis and Alexander H. Stephens, the President and Vice-President of the Confederacy, and of the two figures to the left to General Robert E. Lee and John B. Floyd, the Secretary of war under Buchanan. The scene itself is certainly suggestive of the stamping out of the Rebellion: a thunder-bolt, representing the wrath of the Gods, is being hurled from on high at Stephens; while the

[28]Pointed out by Claire Richter Sherman, curator of "Writing on Hands" at the Folger Shakespeare Library, Washington, D.C., in 2000–2001.

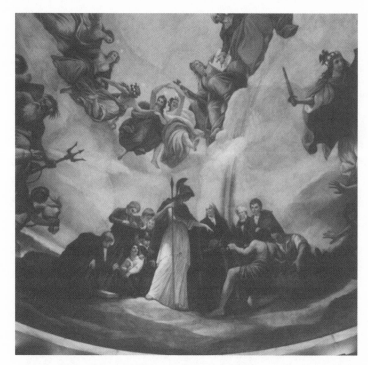

Fig. 14. The scene of "Science" from *The Apotheosis of Washington* with Minerva counseling American inventors Benjamin Franklin, Samuel F. B. Morse, and Robert Fulton. *(Courtesy Office of Architect of the Capitol.)*

President of the Confederacy, with a lighted torch, is reeling from the wrath of the colossal figure of armed Liberty above. But it is not possible that Brumidi intended these as portraits; for he was the friend of most of the Confederate leaders, and probably the last to see Jefferson Davis before he left the capital for the South. When the artist first came to Washington to reside, the government was in the hands of the men who afterward led in the Confederacy.[29]

It has not been possible to trace references to Brumidi in the unnamed southern newspapers to which Hazelton refers. The fact that very similar caricatures of the forces being vanquished appear in the final oil sketch, unlike that of Morse/Walter that appears only in the fresco, supports Hazelton's belief that the resemblances may be coincidental. More convincing, based on comparisons of photographs of her, is the suggestion that Freedom is a portrait of Brumidi's American wife, Lola Germon Brumidi.

"Agriculture" includes Ceres with a horn of plenty seated on a McCormick Reaper, which Wyeth calls an "American reaper." Young America wears a liberty cap, while Flora gathers flowers and Pomona holds a basket of fruit.

"Mechanics" is centered on Vulcan, who stands with his hammer and anvil and rests his foot on a cannon (fig. 16). A steam engine is seen in the background. Charles Thomas, who was the head of the iron workers and was in charge of placing Freedom on the dome, claimed that his portrait is seen on the figure to Vulcan's left.

[29]George C. Hazelton, Jr., *The National Capitol: Its Architecture and History* (New York, 1897), pp. 97–98.

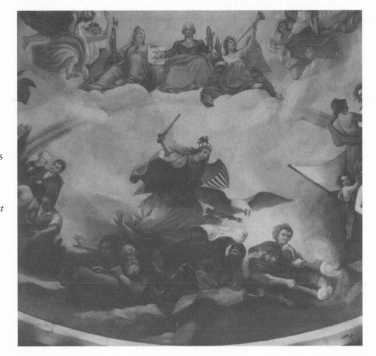

Fig. 15. The scene of "War" includes a central figure of Freedom vanquishing Tyranny and Kingly Power. A number of the faces were said to be portraits of Confederate leaders. (See also color plate 1.) *(Courtesy Office of Architect of the Capitol.)*

"Commerce" is represented by Mercury, the Olympian messenger who protects travelers and merchants, holding out a bag of gold to Robert Morris, the financier of the American Revolution. Next to his face for a brief time was a portrait of Montgomery Meigs, who requested that it be scraped out.[30] On the crate below, Brumidi signed the fresco and dated it 1865 (fig. 17).

"Marine" is dominated by Neptune, god of the sea, with his trident (fig. 18). Venus helps him lay the transatlantic telegraph cable, which was being laid as Brumidi was painting. A cable that worked for only a short period was laid under the ocean between America and England in 1858, the year before Brumidi may have made his first sketch. Montgomery Meigs met the man who laid the first cable, Captain Hudson, and may have suggested that Brumidi include the subject.[31] A second cable was laid beginning in mid-1865. The twin-stacked ironclad ship may represent one of the riverboats converted for military use by Charles Ellet, an engineer who died from injuries suffered during the capture of Memphis in 1862.[32]

Brumidi had finished painting the fresco in October, but he asked to have at least six weeks to allow the mortar to dry completely so that he could see the changes in the final colors before he went back to "cover the connections of the pieces of plaster . . . giving more union to the colors at the said junctions, for obtain the artistic effect." He

[30]MCM Pocket Diary entry for Sept. 3, 1865, MCM Papers, LC.
[31]MCM Journal, Jan. 17, 1859, in Wolff, *Capitol Builder,* p. 698.
[32]The identification of the ironclad was made by Dennis Peter Myers.

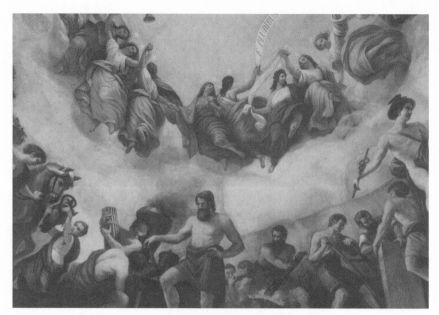

Fig. 16. "Mechanics" shows Vulcan at his forge with a modern cannon and the smokestack of a steam engine. *(Courtesy Office of Architect of the Capitol.)*

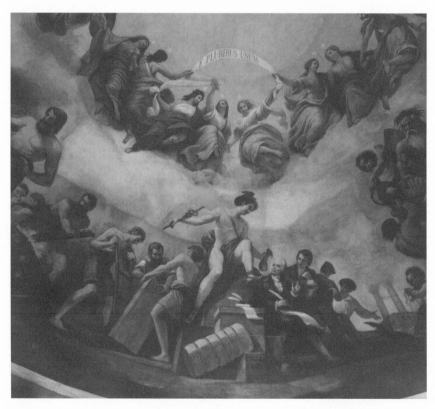

Fig. 17. "Commerce" shows Mercury handing a bag of money to Robert Morris, a financier of the American Revolution. *(Courtesy Office of Architect of the Capitol.)*

also wanted to see the fresco under the gas lights and with the mirrors reflecting light from the windows, by which it would be seen at night and day. Although he wanted to wait until spring "because the winter is too damp,"[33] he was forced to come back to work, and the scaffold was taken down in early January. Because Walter was no longer in charge of work on the dome, it took until June to sort out the red tape so that Brumidi could get paid. Five hundred dollars was withheld from his payment in anticipation that he would work further on reducing the effect of the joins between the patches of plaster. He never had the opportunity to do so, even though in 1879 Congress authorized funds to pay Brumidi and to construct a scaffold.[34]

The first review of the fresco was published in the *Daily National Intelligencer* on January 17: "The general effect is inspiring, while the details bear close inspection and command admiration. It is almost a difficulty to realize that some of the sitting or reclining figures are not things of life. . . . Harmony prevails throughout. Men may criticize the mingling of mythologic figures and symbols with the great triumphs of art and science of our day, with their authors; but what picture of the magnitude and dignity of this one of Brumidi can be made impressive, interesting, or beautiful without mythologic figures and devices? . . . we do not hesitate to say that both in design and execution it is worthy of the Capitol and of the nation."[35]

Both Meigs and Walter, neither still working at the Capitol, took great interest in the canopy. Meigs wrote to Brumidi: "I find the drawing and coloring most agreeable and beautiful. The perspective is so well managed. . . . The figures appear to take their places in space with the illusion of a diorama. I am glad the country at length possesses a Cupola on whose vault is painted a fresco picture after the manner of the great edifices of the old world." Walter commented: "As to the merits of the painting I have come to the conclusion that it is a decided success." Commissioner B. B. French thought "that picture, as a work of art, surpasses any one in the world. . . . It is a chef d'oeuvre."[36]

The Rotunda Frieze

Soon after the canopy was finished, the question of the frieze was brought up, and Architect of the Capitol Edward Clark and Secretary of the Interior Orville H. Browning unsuccessfully sought congressional authorization for Brumidi to paint it in fresco.[37]

[33]CB to Edward Clark, Sept. 19, 1865, AOC.

[34]Appropriation to Department of the Interior, Public Buildings, 45th Cong, 3d sess., chap. 181.

[35]*Daily National Intelligencer* (Washington, D.C.), Jan. 17, 1866, p. 2.

[36]MCM to CB, Jan. 1866, Copy in Capitol Extension and New Dome Letterbook, AOC; TUW to Benjamin Brown French, February 17, 1866, Letterbooks, Walter Papers, reel 4141, AAA; Jan. 12, 1866, Benjamin Brown French, *Witness to the Young Republic,* ed. Donald B. Cole and John J. McDonough (Hanover, N.H., 1989), p. 497.

[37]*Report of the Architect of the Capitol Extension,* Nov. 1, 1866, and *Annual Report of O.H. Browning, Secretary of the Interior,* 39th Cong., 2d sess., House Ex. Doc. No. 1, p. 13.

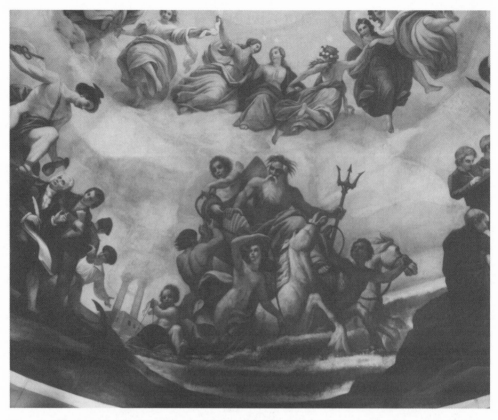

Fig. 18. "Marine" depicts Neptune with Venus holding the Atlantic cable and an ironclad ship in the distance. *(Courtesy Office of Architect of the Capitol.)*

Brumidi would not get approval until 1877 to start to paint the frieze, the designs for which he had signed and dated in 1859, almost twenty years earlier.

When the new dome was authorized in 1855, Walter and Meigs had envisioned a carved marble relief frieze, similar to the one on the Parthenon, encircling the base of the cast-iron dome. Meigs described his vision:

> Above this cornice a vertical wall will be raised, with a deep recessed panel nine feet in height, to be filled with sculpture, forming a continuous frieze three hundred feet in length, of figures in alto rilievo. The subject to be the history of America. The gradual progress of a continent from the depths of barbarism to the height of civilization; the rude and barbarous civilization of some of the Ante-Columbian tribes; the contests of the Aztecs with their less civilized predecessors; their own conquest by the Spanish race; the wilder state of the hunter tribes of our own regions; the discovery, settlement, wars, treaties; the gradual advance of the white, and retreat of the red races; our own revolutionary and other struggles, with the illustration of the higher achievements of our present civilization, will afford a richness and variety of costume, character, and

incident, which may worthily employ our best sculptors in its execution, and which will form for future ages a monument of the present state of the arts in the country.[38]

Thomas Crawford, the sculptor of the Statue of Freedom, proposed to create the frieze for $50,000. The price was considered too high, however, and in any case he died in 1857. Already on the scene was perhaps the only artist in the nation who could create in fresco the appearance of carved relief sculpture.

Meigs was still in charge of construction on March 3, 1859, when Brumidi dated his sketch for the frieze, and the selection of subjects shows his influence. Although Meigs does not mention the frieze sketch in his journal, Francis O'Connor has pointed out how closely nine of the sixteen scenes Brumidi chose to tell the story of American history coincide with those that Emanuel Leutze suggested in an 1857 letter to Meigs.[39] The scenes that Brumidi chose also are among those emphasized in history books published in the 1840s, such as George Bancroft's *History of the Colonization of the United States* (3 vols., 1834-40) and William H. Prescott's *History of the Conquest of Mexico* (1843) and *History of the Conquest of Peru* (1842). Ultimately, no scenes predating Columbus were included. The emphasis was on discovery, exploration, settlement, the Revolutionary War, and the War of 1812. Vivien Green Fryd believes that the inclusion of scenes of Spanish conquest "reflects the congressional debate during the 1850s over whether the nation should expand into Cuba and Central America."[40] The last two scenes jump in time to the conquest of Mexico in 1847 and the discovery of gold in California in 1848, events only a decade in the past at the time Brumidi designed the frieze. When donated to the Capitol, the scroll of scenes was numbered in sequence. Brumidi also inscribed titles for each scene, which sometimes varied from the names used for the frescoed versions.

In his chapter in *Constantino Brumidi: Artist of the Capitol,* O'Connor reintegrates fragments of two scenes, "Indians Hunting Buffalo" and "Lewis and Clarke," that were evidently removed by Brumidi. O'Connor also has explained his belief that Brumidi's designs for the canopy and frieze scenes were influenced by his awareness of the paintings and reliefs in the original part of the rotunda and by his sensitivity to the symbolic meaning of the compass points at which various subjects were placed.[41]

Brumidi created a thirty-foot sketch for the frieze in scale with the three-hundred-foot circumference around the base of the dome (fig. 19). He had been told by Meigs that he had a band nine feet high in which to work. After he received approval to begin

[38]*Annual Report of Capt. M. C. Meigs, Superintendent of the Capitol Extension,* Oct. 14, 1855, 34th Cong., 1st sess., House Ex. Doc. No. 1, pt. 2, p. 117, Nov. 16, 1855.
[39]Emmanuel Leutze to MCM, Feb. 8, 1857, AOC.
[40]Fryd, *Art and Empire,* p. 152.
[41]O'Connor, "Symbolism in the Rotunda," pp. 146–54.

FIG. 19. Brumidi's sketch for the frieze in the rotunda at the time of its donation to the Architect of the Capitol by Mildred Cheney Murdock, who is at the far right. *(Courtesy Office of Architect of the Capitol.)*

working on the cartoons in 1877, he finally got up on the scaffold in the spring of 1878. Only then would he have discovered that he actually had a vertical area of only about eight feet on which to paint, which was further reduced because of the ledge that hid the bottom half foot.

Brumidi began the frieze with an allegorical grouping of America and History with a young Native American woman; he also incorporated a figure from the last scene that he planned for the frieze (the discovery of gold in California), expecting that the first and last scenes would meet as he filled the circumference (fig. 20). The figure of America refers to the central figure in the Senate pediment, as Vivien Green Fryd pointed out in her detailed discussion of the frieze subjects in *Art and Empire;* History resembles the muse Clio on the clock in Statuary Hall. The Indian maiden, who appears in the fresco but not in the sketch, reinforces the theme of America and perhaps replaces the Indians in the scene that had been excised. His next scene, showing the landing of Columbus, was clearly inspired by Persico's sculpture *Discovery* then on the East Front. Fryd also relates the vigor of Columbus's stride down the plank (an attitude apparent in the sketch but not replicated in the fresco) to "the expansionist rhetoric espoused in Congress during the 1850s."[42]

[42]Fryd, *Art and Empire,* pp. 142–43.

Fɪɢ. 20. Brumidi's sketch for the first scene showing "America and History" and "The Landing of Columbus," with a figure at the left that was part of his last planned scene of the discovery of gold in California. *(Courtesy Office of Architect of the Capitol.)*

Each scene was separated from the next one by a vertical element, such as a tree. "Cortez and Montezuma at Mexican Temple" includes the calendar stone that Brumidi would have seen when he was in Mexico City, just before he came to Washington. O'Connor points out that the horizontal composition of "De Soto's Burial in the Mississippi River" should have landed right over the north door, providing a change from the primarily vertical compositions in harmony with the architecture of the building (fig.21). However, because of the miscalculation of the height, and thus proportionately of the width, of each scene, the planned relationship to the entrances did not occur. The tent peg showing at the lower right of the sketch is an indication of the original location of one of the excised scenes, "Indians Hunting Buffalo." Brumidi apparently eliminated such generic scenes in favor of more specific historical events, such as "Landing of the Pilgrims."[43]

Brumidi was seventy-two years old, ill with asthma and other ailments, when he started painting the frieze. He eventually grew too weak to climb up the long flight of stairs and down the twenty-foot-long ladder to the small scaffold. He was then hoisted up in a little cage operated by rope and pulley. He worked slowly, painting half a figure a day. Each scene was composed of dozens of separate patches of plaster, or giornate. He painted boldly and confidently, in an almost impressionistic manner, with just enough strokes of light and dark to create the impression of carved figures.

On October 1, 1879, half-way through painting the scene "William Penn and the Indians" (fig. 22), Brumidi almost fell off the scaffold. He held on to the ladder, hanging

[43]O'Connor, "Symbolism in the Rotunda," p. 153.

Fig. 21. "De Soto's Burial in the Mississippi River," according to Brumidi's original calculations, was to have been seen above the north doorway. *(Courtesy Office of Architect of the Capitol.)*

by his arms for fifteen minutes until rescued. Newspapers reported that he returned to paint the next day, but he then retreated to his studio to work on the cartoons. He continued to work on them until shortly before his death in February.[44]

Although other artists, such as John La Farge, were touted to take over the work,[45] and Edward Van Reuth proposed to redo the rotunda completely in Victorian Gothic style, as shown in the oil, watercolor, and charcoal studies donated by his descendants to the Capitol,[46] Brumidi's recommendation of Filippo Costaggini to be his successor was honored. Costaggini, also trained at the Accademia di San Luca, had come to the United States in 1870. There is no evidence that he ever worked with Brumidi, although they may have met each other in New York City. By September 1880, the Joint Committee on the Library had approved Costaggini, and he was working on finishing "William Penn and the Indians," having made a pencil notation in Italian to indicate where he started. In addition to this note, there is a conspicuous difference between the two artists' styles. Costaggini tended to outline each detail, whether or not it could be seen from the floor; for example, the buckled shoe that he painted on Penn is full of fussy detail in comparison with the one by Brumidi. Costaggini first worked full time on the frieze for several years, and he then began taking breaks for other projects. His only major deviation was to eliminate Brumidi's unique small scene, "Decatur at Tripoli" (fig. 23), when he redesigned and enlarged "Death of Tecumseh" (fig. 24) in 1884. He signed his scene of Tecumseh at the base of the tree whose trunk contains the suggestion of a hooded face, apparently a self-portrait. By this point, Costaggini had

[44]"The Allegorical Work at the Capitol," *Forney's Sunday Chronicle* (Washington, D.C.), Oct. 12, 1879, and "Death of a Great Artist," *Washington Post,* Feb. 20, 1880.

[45]"Brumidi and His Successor," *Daily Telegraph* (Philadelphia), Feb. 20, 1880, p. 4.

[46]Felix van Van Reuth to Edward Clark, Aug. 12, 1880, AOC.

FIG. 22. The scene "William Penn and the Indians" was both Brumidi's last and Filippo Costaggini's first. *(Courtesy Office of Architect of the Capitol.)*

realized that Brumidi's sketch would not fill the entire three hundred feet, and he had begun to enlarge the figures and scenes. He also proposed an additional scene, "Driving the Last Spike in the Pacific Railroad," but it was not approved. He signed and dated "American Army entering the City of Mexico" in 1885, and in May 1889 he came back to execute Brumidi's last scene, "Discovery of Gold in California," which he signed on an even bigger scale. Left vacant was a space of more than thirty feet between this final scene and the "America and History" group.

A resolution to allow Costaggini to complete the frieze was passed in 1896. Yet, his three proposed subjects were not approved. The next year he submitted sketches showing the Emancipation Proclamation and the Civil War. Congress still could not agree on the subjects, and Costaggini died in 1904 with the frieze still unfinished. By this date some sections were already badly streaked from leaks during a storm.

Many artists applied to complete or redo the frieze over the years. Sculptor Gutzon Borglum proposed redoing the frieze in marble in 1905 and artist Karl Yens prepared sketches in 1909. In 1914 a bill to complete the frieze was introduced, and new topics were discussed. In 1918 Charles Ayer Whipple was allowed to try out a trial scene, "Spirit of 1917," but it was not well received and he was not allowed to paint three additional scenes as he had hoped (fig. 25). In 1919 a joint resolution was passed to restore and complete the frieze but no action was taken. In the 1920s and 1930s different artists proposed scenes every few years. In the 1940s, there was discussion of replacing the frieze with one in marble, in conjunction with redoing the whole dome in masonry. The expense proved to be enormous, so Congress and the Architect returned to the idea of finishing Brumidi's painted frieze. A bill was introduced in 1948, legislation to paint the last three scenes passed in 1950, and the funding was provided in 1951.[47]

Out of ten artists who applied, Allyn Cox was rated best by John Walker, director

[47]Correspondence and legislative history on file in the curator's office, AOC.

Fig. 23. "Decatur at Tripoli" and "Col. Johnson & Tecumseh" as designed by Brumidi. *(Courtesy Office of Architect of the Capitol.)*

Fig. 24. Filippo Costaggini changed Brumidi's sketch into one scene of the "Death of Tecumseh," painting a face that could be a self-portrait seemingly carved into the tree above his signature. *(Courtesy Office of Architect of the Capitol.)*

Fig. 25. The frieze in the rotunda with the gap that remained between 1889 and 1952 temporarily filled with Charles Ayer Whipple's "Spirit of 1917." *(Courtesy Office of Architect of the Capitol.)*

F IG. 26. Allyn Cox's designs for the three scenes that finally filled the gap in the frieze. *(Courtesy Office of Architect of the Capitol.)*

of the National Gallery of Art. Cox proposed three scenes: "Peace at the End of the Civil War," "Naval Gun Crew in the Spanish-American War," and "The Birth of Aviation" (fig. 26). Cox made numerous sketches and mock-ups and obtained approval from the Joint Committee on the Library. He worked in true fresco, as had Brumidi, and also was paid to clean the nineteenth-century part of the frieze and to repaint the entire background. The frieze was finally dedicated in May 1954, almost a century after Brumidi made his first sketch.

Brumidi's frescoes are in good condition today. The frieze was conserved in 1986–87, and subsequent repairs were made after some damage was caused by leaks. The canopy, which Cox painted over in 1959, was conserved in 1987–88. Its painstaking conservation by a team took a year, longer than the original painting took for one man.[48]

During the recent work on the cast-iron dome, great pains were taken to protect the canopy. An enormous white donut-shaped netting system was specially designed and installed to allow the rotunda to stay open and Brumidi's *Apotheosis* to remain visible to the throngs of visitors who feel its impact each day (color plate 13). Brumidi's frescoes are integral to the design of the dome and to the experience of the Capitol rotunda.

[48]See chaps. 13 and 14 by Bernard Rabin and Constance Silver in *Constantino Brumidi: Artist of the Capitol.*

Constantino Brumidi as Decorator
and History Painter

An Iconographic Analysis of Two Rooms
in the United States Capitol

Francis V. O'Connor

ITH THE RECENT RESTORATION OF MOST OF THE MAJOR ROOMS BY Constantino Brumidi in the U.S. Capitol, we can now see what this artist achieved, not only in the rotunda, but also in the many spaces throughout the building that are not readily accessible to the public.[1]

What has been recently revealed places Brumidi as one of the first major American muralists, one of a short but eminent list of foreign-born wall painters who have made major contributions to our visual culture, going back to Michele Felice Cornè and ahead to Sir Frank Brangwyn and Diego Rivera. Although he was a naturalized citizen, Brumidi's foreign birth made him unpopular during his lifetime among envious American artists who couldn't paint a wall to save their lives. Their spleen has tainted

[1] For a discussion of the restoration, see Barbara Wolanin, "Constantino Brumidi's Frescoes in the United States Capitol," in *The Italian Presence in American Art, 1760–1860,* ed. Irma B. Jaffe (New York, 1989), pp. 150–64, as well as Wolanin, *Constantino Brumidi: Artist of the Capitol* (Washington, D.C., 1998), chaps. 13–15. I would like to thank Dr. Wolanin, curator for the Architect of the Capitol, for her continued support of my research on the murals in the U.S. Capitol, which was begun under a U.S. Capitol Historical Society Fellowship in 1987. The material in this essay has been excerpted from my forthcoming book, "The Mural in America: A History of Wall Painting from Native America to Postmodernism."

the literature about him to this day.[2] Also, the dismal condition of his rotunda and rooms until just recently and the all-too-great visibility of his atelier's hybrid and now grossly overpainted corridor decorations, has prevented art historians from giving this great master of the mural his just due.[3]

The purpose of this essay, then, is to demonstrate Brumidi's skill as a great environmental muralist by reconstructing and interpreting the intentions behind two of his most beautiful rooms in the Capitol: those originally dedicated to the Senate Committees on Naval and Military Affairs. These intentions must be reconstructed, since the state of the surviving documentation does not permit easy proof of what the eye can see. This requires some historical background.

An exasperating part of the duties of any official who controlled a budget in midnineteenth-century America—President Lincoln not excepted—was dealing with the office seekers who swarmed the anterooms of power. At the Capitol it was common for artists to lobby Congress for portrait commissions. Over time, the Capitol rotunda came to resemble a teeming art expo, for the government was one of the few institutions capable of large-scale patronage.[4]

The superintendent of the Capitol Extension, Montgomery Cunningham Meigs, came to realize this in his first years at the Capitol, so it was not unusual that one day early in 1855 Constantino Brumidi walked into Meigs's office and asked to paint exactly what the superintendent wanted: a fresco.[5]

Brumidi was fifty years old and well experienced in his craft.[6] Meigs put him to work

[2]In putting down Brumidi's work in the Capitol, it has been found useful to consult those two great art critics, Walt Whitman and Mark Twain. Thus Virgil Barker, in his once popular textbook, quotes the poet writing to his brother:
> The incredible gorgeousness. . . . Costly frescoes of the style of Taylor's saloon in Broadway, only really the best and choicest of their sort. . . . (Imagine the work you see on the fine china vases in Tiffany's, the paintings of Cupids and goddesses, etc. spread recklessly over the arched ceiling and broad panels of a big room . . .) by far the richest and gayest, and most un-American and inappropriate ornamenting and finest interior workmanship I ever conceived possible. . . . The style is without grandeur, and without simplicity.
(*American Painting: History and Interpretation* [New York, 1960], p. 559)
Twain's mot that Brumidi's "Apotheosis of Washington" was "the delirium tremens of art" is quoted by William H. Gerdts and Mark Thistlethwaite in *Grand Illusions: History Painting in America* (Fort Worth, Tex., 1988), p. 33.

[3]It ought to be noted that while it was long traditional to attribute the Capitol's murals and painted corridors to Brumidi alone, it is plain that no one man, especially one in the second half of his life, could have done so much by himself—and in so many different styles. The truth of the matter was that he presided over what can be called an "atelier." For the details of all this, see Wolanin, *Brumidi: Artist of the Capitol,* chap. 6 and appendix B.

[4]For the rotunda of the Capitol as an art expo, it should be noted that Emanuel Leutze exhibited his *Washington Crossing the Delaware* there in 1852 in the hope that Congress would acquire it. For a somewhat later, but quite vivid, description of the rotunda as a marketplace, see "Art in Washington," *Art Journal* 1 (1875):221–22.

[5]Meigs described the incident in a letter of October 11, 1856, to John Durand, the editor of the *Crayon,* who had criticized Meigs for hiring foreign painters. See Archive of the Architect of the Capitol (hereafter AOC), Capitol Dome and Post Office Letters, January–December 1856, vol. 4, pp. 909–15.

[6]For Brumidi's previous activities as an artist, see Pelligrino Nazzaro, "The Italian Years," in Wolanin, *Brumidi: Artist of the Capitol,* chap. 2.

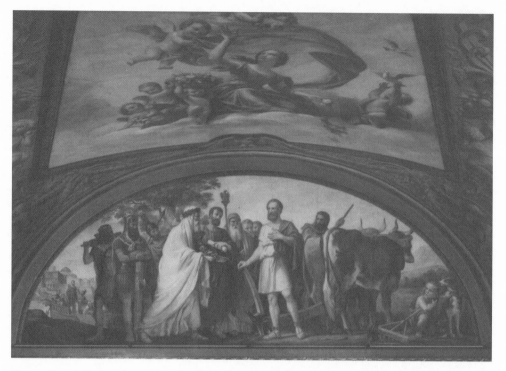

Fig. 1. Brumidi's first frescoes in the Capitol included the *Calling of Cincinnatus from the Plow* in the lunette on the east wall and the *Four Seasons* in the ceiling arches of the room designed for the House Agriculture Committee. The room, H-144, is now occupied by the House Appropriations Committee. *(Courtesy Office of Architect of the Capitol.)*

decorating the room assigned to the House Committee on Agriculture, and his frescoes there (fig. 1) so impressed him that Brumidi was soon acknowledged the master artist in residence.[7] While not immune from pecking-order disputes and wasteful bureaucratic delays, he so dominated the Capitol's art for the next twenty-five years that until recently no distinction has been made between works from his hand, the work of what I call his "atelier," and the depredations of subsequent "restorers."

Brumidi was the first truly accomplished American muralist to expound that aristocratic European stylistic tradition that American critics found so unsuitable to the central edifice of democracy. His style was not, however, unsuitable to the architecture of the Capitol, and, as we know, a similarly aristocratic spin-off of the French Beaux Arts school would soon be the mural style of choice for every state capitol that aped that of the central government.[8]

[7]See the "Excerpts from the Journals of Montgomery C. Meigs," in which he describes Brumidi painting his first fresco in the Capitol, in Wolanin, *Brumidi: Artist of the Capitol,* appendix A, pp. 216–20. This text constitutes the first eyewitness account of the painting of a mural in the United States.
[8]See my essay "The United States Capitol Rotunda and the Decoration of the State Capitols: 1870–1930," in this volume.

But the secret of Brumidi's genius was not so much in the style to which he was born, but in his capacity to see the whole from its parts and to find the inevitable formal and iconographic solution to any pictorial environment he was asked to create. It is plain that none of the other highly skilled but artistically limited artists in his atelier, such as Emmerich Carstens, James Leslie, or Joseph Rakemann, or those who came after him, such as Filippo Costaggini or Allyn Cox, could match him with a similar totality of vision, and this is amply demonstrated by his work in the rotunda and various committee rooms throughout the Capitol.

To give a sense of his breadth and unity of vision, I shall discuss two similar but contrasting rooms Brumidi painted—rooms that demonstrate his best strengths both as a decorator and history painter. These are the Senate Naval Affairs Room (fig. 2) and the somewhat later Senate Military Affairs Room (fig. 3).

On the other side of the new Capitol from the House Agriculture Committee room, which, as we have seen, was his sampler to prove his abilities as a painter of fresco, were two large, almost identical chambers in the Senate wing, overlooking the city of Washington to the west, in which Brumidi expended his greatest efforts from about 1856 to the 1870s. A color study by Brumidi, approved by Meigs on August 20, 1856, survives (fig. 4; color plate 4). Once thought to be an early proposal for a corridor, and later for the naval room, it would seem to be a composite design for both committee rooms. I would suggest Brumidi, who always saw things as wholes, conceived the two connecting rooms as a unit and planned to decorate them in the Pompeian style, which had been popular in the late eighteenth century throughout Europe, and which he would have known in one of its more flamboyant manifestations at the Vatican Library.

The rooms had doors on the east, north, and south sides and were each two bays long with groined ceilings. The left side of the sketch (and despite the warships in the lunette) would seem to indicate that for the military affairs room Brumidi planned red walls with Pompeian allegories surmounting cartouches of putti, and crowned with escutcheons bearing the national colors. Over the doors would be rampant eagles with wreaths of victory set under illusionistic canopies, and in the lunette above, a central pavilion would be flanked by symbols of war and peace: a crossbow and olive branch. On the ceilings he devised four cartouches of putti at sacrificial altars with an elaborate central motif of spears overlapping to form an octagon and surrounded by eight images of the caduceus. Traditionally, the caduceus is a symbol of moral equilibrium and the balancing of forces; the octagon, intermediate between square and circle, of regeneration—two concepts well suited to the resolution of military affairs. But, as we shall see, the military affairs room was never done in this way. Brumidi's concept for the naval room, however, seems to have met with approval, and it was begun in 1858.

The most striking aspect of the naval room (which follows the 1856 study exactly, except for the depiction of Columbus discovering America in the lunette) when first

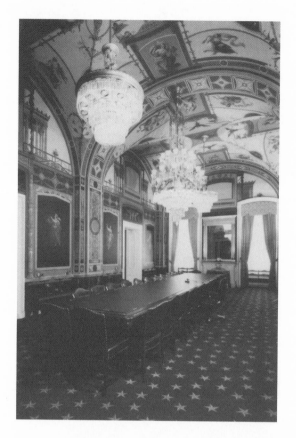

Fig. 2. Originally intended for the Senate Naval Affairs Committee, room S-127 is now a hearing room of the Senate Appropriations Committee. It features Brumidi's masterpieces in the Pompeian style. *(Courtesy Office of Architect of the Capitol.)*

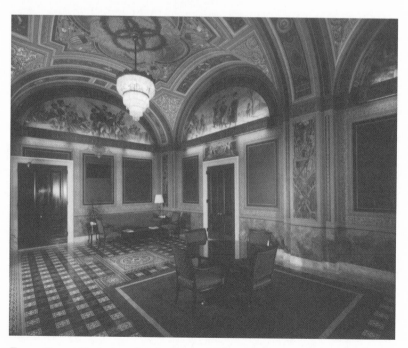

Fig. 3. Brumidi's designs for the Senate Military Affairs Committee Room, now S-128, featured martial scenes from the American Revolution. *(Courtesy Office of Architect of the Capitol.)*

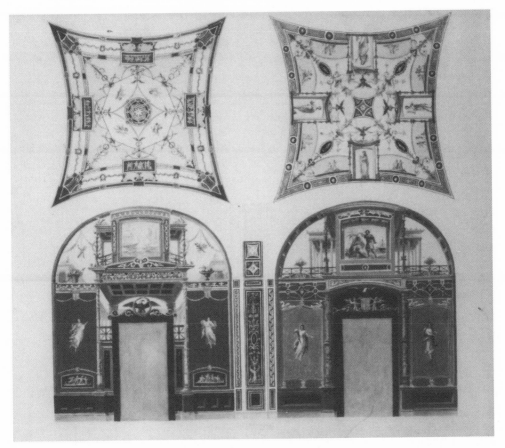

Fig. 4. Brumidi's color study of 1856 indicates he conceived the two connecting rooms as a unit decorated in the Pompeian style. (See also color plate 4.) *(Courtesy Office of Architect of the Capitol.)*

entered through the east door, is the sense of spaciousness created by the floating female allegories at the center of each main wall panel and the illusionistic classical pavilions painted in the lunettes. Above, the ceiling presents eight portraits of gods and goddesses related to the sea, and sixteen nereids or sea nymphs with various sea creatures, all set within an elegant fantasy of garlands, cartouches, national escutcheons, and rampant bald eagles (fig. 5).

Standing at the east end of the room, looking west along the initial ceiling quadrant, one first sees Venus, goddess of calm seas (from which she was born), flanked by nereids riding her sacred swans. Oceanus, god of the primal waters and fount of all the world's seas and rivers, presides to the north, flanked by dolphins, the wisest of sea creatures. The ancient father of the nereids, Nereus, stands to the south, where his flanking daughters discreetly ride tortoises. To the east of Venus is enthroned Thetis, one of Nereus's more famous daughters, who is renowned for her helpfulness, especially to Hephaestus, god of artisans, whom she hid in the sea for nine years. Her sisters cavort with Tritons (who are half man, half dolphin).

Walking to the center of the room, the western quadrant of the ceiling is presided over by America in the guise of an Indian maiden (fig. 6). To the south is the sea god Neptune, flanked by seahorses. To the north, Aeolus, god of the winds, is escorted by a sea goat and sea tiger, no doubt to emphasize the danger and unpredictability of his domain. And, opposite the nereid Amphitrite, wife of Neptune and queen of the sea, is accompanied, as is America, by Tritons. (One notes the absence of mermaids—the bane of sailors.)

Along the walls, the female allegories bear nautical devices. On the east wall next to the door, a graceful maiden supported by putti gathers strings of pearls from a shell. To the south, from east to west, her sisters hold a pennant with stars, a sextant, a pennant with the national colors, and a map—all used, it might be noted, above sea level

Fig. 5. Iconographic diagram of Brumidi's Naval Affairs Committee Room, ca. 1856, looking up at the groin-vaulted ceiling (north and south reversed), by the author. The six lunettes contain Pompeian aedicules set against the sky. The nine wall panels (A–I) below the lunettes contain sea nymphs holding pearls, fish and net, level, anchor, compass and telescope, map, flag pennant, sextant, and star pennant. The vaults between the cartouches of sea deities contain (1) Nymph with Triton; (2) Youth with Mermaid; (3, 4) Nymphs with Dolphins; (5, 6) Nymphs with Swans; (7, 8) Nymphs with Turtles; (9, 10) Nymphs with Tritons; (11) Nymph with Sea Tiger; (12) Nymph with Sea Goat; (13, 14) Nymphs with Tritons; and (15, 16) Nymphs with Seahorses. *(Courtesy the author.)*

Fig. 6. In the ceiling of the
Naval Affairs Committee
Room, Brumidi depicted
America as an Indian maiden
dressed in deerskin holding a
bow and arrows. *(Courtesy
Office of Architect of the Capitol.)*

(fig. 7). To the north, in keeping with that direction's sense of depth and mystery, they hold, from east to west, a fish and net, a level, an anchor, and a compass and telescope.

It takes a certain re-creative imagination to see this room as it once was when new. The original sketch shows the nine allegorical wall panels had blue backgrounds; today they are dark green. Similarly, the white background of the ceiling, typical of Pompeian decoration, is now various shades of cream and buff. It is evident that several generations of inexperienced restorers have carefully matched the progressively yellowing colors until now the whites are very much to the yellow scale of values, and blue (plus yellowing dirt) has become green. Indeed, just a glance at one of the wall panels in a raking light reveals the many layers of new paint that have created a ridge outlining each of the delicate allegories.[9]

But if one sees this chamber not in terms of the dullish yellow/green tonality prevailing today, but as similar to that of the Vatican Library, one can imagine an airy fantasy

[9]Perhaps I should say that this room has not been recently restored. On the other hand, recent conservation has revealed the original blue paint under the moldings around these panels. Private communication from Barbara Wolanin.

FIG. 7. The floating maidens on the walls of the southeast corner of the naval affairs room hold pearls (on the left) and a pennant with stars (on the right). *(Courtesy Office of Architect of the Capitol.)*

in blue and white and get a whiff of the salt-sea breezes Brumidi tried to waft through his illusionistic pavilions, the better to refresh those entrusted with naval policy.

Of course, sea deities do not lack humor, and presiding in this room since 1911 over the Senate Appropriations Committee, it is perhaps not without import that they have let their walls age to the color of filthy lucre!

While there is evidence that the contiguous military affairs room was begun about the same time as the naval committee's, it is unclear just when Brumidi began work there—though there is evidence that the room was not completed until 1871, when he was paid for three of the five lunettes. The work at the Capitol during these years was enormous, and the efforts of the master artist and his atelier were often interrupted by various immediate factors. Brumidi himself was probably engaged more in making designs for the decorations to be executed by others than in actually painting. A document dated 1857 indicates that if he were to finish the military affairs room he would be taken from more important preparations in the south wing, where the chamber of the House of Representatives was to be occupied for the first time the next month.[10]

This may indicate he had already begun and had most likely established his program by this time. The changes from the early design for the two rooms may well

[10]Room file; Carstens to Meigs, Nov. 6, 1857, AOC.

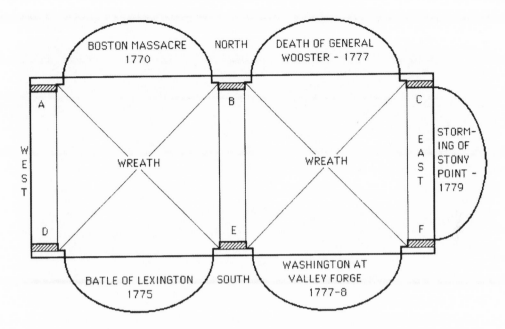

FIG. 8. Iconographic diagram of the Senate Military Affairs Committee Room, looking down into the groin-vaulted room, by the author. The five lunettes are by Brumidi, ca. 1871, and the six pilasters of military trophies (A–F) are by James Leslie, circa 1856. *(Courtesy the author.)*

have been requested. It is likely the design was thought too temperate for the affairs of war. One can almost hear some senator asking, "Where are the battle scenes?" In any event, battle scenes there would be—though it is of interest that Brumidi did not finish this room until nearly sixteen years later.

Unlike the naval room, and in sharp contrast to the iconography of reconciliation on the surviving design for both rooms, Brumidi finally decided to emphasize the lunettes rather than the ceiling, filling them with battle scenes, and to blazon the latter with sumptuous laurel wreaths, with a decorator's version of gold braid around everything else. As a result, this room, more than any other in the Capitol, provides a fine example of Brumidi's skill at assembling an environment centered on history paintings (fig. 8).

It is unclear how the room's program was determined. There is virtually no documentation, but one can fairly assume that Brumidi and Meigs were in close contact and that the many artists, critics, and government officials with whom Meigs consulted provided a lively interchange of ideas. In this respect it is notable that a number of subjects mentioned in a long letter from Emanuel Leutze to Meigs concerning the decoration of the Capitol eventually appear in Brumidi's rotunda frieze.[11]

It also is quite likely that interested congressmen—especially those who chaired the

[11]See my "Symbolism in the Rotunda," in Wolanin, *Brumidi: Artist of the Capitol,* chap. 10, pp. 149ff.

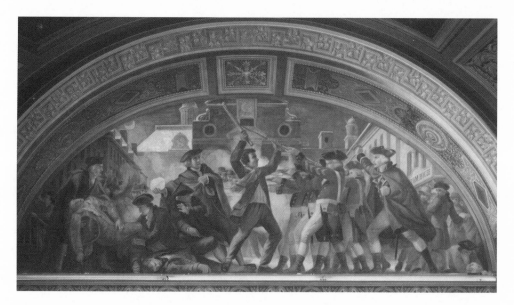

Fig. 9. Constantino Brumidi, *The Boston Massacre, 1770,* 1871, in room S-128, originally the Senate Military Affairs Committee Room. (See also color plate 5.) *(Courtesy Office of Architect of the Capitol.)*

committees for whom the rooms Brumidi was painting were intended—provided suggestions. Here Brumidi's experiences working at the Vatican and for noble Italian patrons surely gave him some skill in the accommodation of princes.

What is striking in the Military Affairs Committee Room is the emphasis on war's human suffering rather than on idealized mayhem and heroic victory. The symbols Brumidi integrated into his first conception of this room—the caduceus and the octagon of spears—referred to the means of inducing peace more than war. If such subtlety were not suitable, and more militant emblems and depictions required, then an artist who was himself a victim of war's havoc would set something of its cost before the eyes of those mandated to declare and fund it in the future.

In the two northern lunettes, the enemy has the upper hand in conflict with the colonists. The *Boston Massacre* of 1770 (fig. 9; color plate 5) shows the British firing into the crowd of colonials led by Crispus Attucks, who stands at the center, futilely brandishing a club against muskets just before his death. Opposite, the British Major Pitcairn is shown (possibly inaccurately) firing at the colonial militia in the *Battle of Lexington* in 1775 (fig. 10). Both scenes show active contention and colonial defeat and emphasize casualties—though the Boston Tea Party and the British defeat at the Battle of Concord (the very afternoon of the encounter at Lexington) might have been chosen instead.

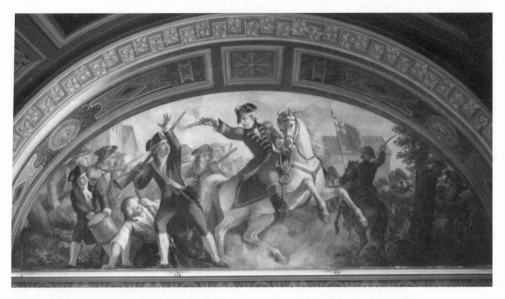

Fig. 10. Constantino Brumidi, *The Battle of Lexington,* 1858, in room S-128, originally the Senate Military Affairs Committee Room. *(Courtesy Office of Architect of the Capitol.)*

In the southern lunettes, the theme of the passive suffering induced by war is intensified with depictions of the *Death of General Wooster* in 1777 (fig. 11) during an unimportant skirmish and *Washington at Valley Forge* (fig. 12). Dominating the room in the east lunette is the wounded "Mad" Anthony Wayne being carried to his victory during the *Storming of Stony Point* (fig. 13) in 1779, literally wrapped in the flag. To the right, the Frenchman, Fleury, presents the British flag, which he has just ripped from its pole, while in the background the Continental troops are seen scaling the presumably impregnable walls of the enemy fortress. One wonders why this battle, important as it was, finds room here rather than one more crucial or famous. Could it be that the officer seen to the right mounting the battlements is one of its more obscure participants, Col. Return Jonathan Meigs, of whom the local commandant of art was understandably proud?[12]

Stylistically, these scenes are rather conventional. The first two mentioned above are composed about triangles that fill each lunette. The *Wooster* is structured around two interlocking triangles, and the more active *Stony Brook* is built of a great "X," which sweeps up from either side of the composition and intersects at the flag. Only the *Valley Forge* differs from these. Here Brumidi isolates the three groupings in a

[12]See Russell F. Weigley, *Quartermaster General of the Union Army: A Biography of M. C. Meigs* (New York, 1959), pp. 21–22.

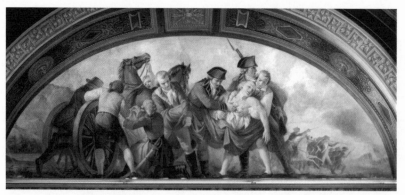

FIG. 11. Constantino Brumidi, *Death of General Wooster, 1777,* 1858, in room S-128, originally the Senate Military Affairs Committee Room. *(Courtesy Office of Architect of the Capitol.)*

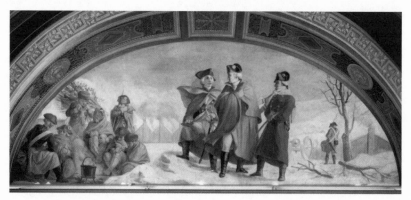

FIG. 12. Constantino Brumidi, *Washington at Valley Forge, 1778,* 1871, in room S-128, originally the Senate Military Affairs Committee Room. *(Courtesy Office of Architect of the Capitol.)*

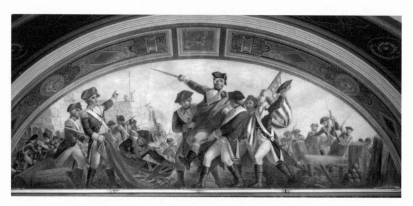

FIG. 13. Constantino Brumidi, *Storming of Stony Point, 1779,* 1871, in room S-128, originally the Senate Military Affairs Committee Room. *(Courtesy Office of Architect of the Capitol.)*

FIG. 14. Trophy panel by James Leslie is one of six different pilaster panels by the English artist in room S-128, originally the Senate Military Affairs Committee Room. *(Courtesy Office of Architect of the Capitol.)*

desolation of cold and snow, creating the most expressive, if least active, of the five lunettes.

Below the lunettes are six elegant pilasters bearing complex "trophies" of military weapons by James Leslie (fig. 14).[13] These depict the history of weapons from spear and cutlass days up to the Wellington rifle used during the Civil War. They are by far the best examples of this artist's work in the Capitol. Little is known of Leslie, who died in his thirties in 1860, but lunettes and ceiling cartouches in his style appear elsewhere in the Capitol, and it is likely that his position as an independent artist working under Brumidi was obtained for him by Meigs.[14]

The naval and military affairs rooms in the Senate wing display some of Brumidi's most impressive efforts in the Capitol as both decorator and history painter and, along with the House Agriculture Committee Room, stand evidence of his genius against the relentless disparagement he

[13]Very little is known about James Leslie. Documents in the AOC indicate that in August 1856 he was commissioned to work in the room of the House Committee on Territories, on the ceiling of which he painted four quatrefoils filled with what appear to be devices composed of Native American weapons and feathered headdresses. By December 1857 he had finished painting the military trophies on the six pilasters of the Military Affairs Committee Room. In 1858 Leslie was working in the corridors, which suggests, given his penchant for military trophies, that the two large grisaille lunettes at the north end of the Capitol's transverse corridor, and other similar decorations, are his work or from his designs. In March 1859, Leslie applied to Meigs for the vacant foreman's job, but he did not get it. He states in his letter that "Mr. Brumidi has permitted me to say that he believes me fully capable to occupy the position and should prefer me to any other in that post, as I have been always able to work in harmony with him and come nearest to his intentions in carrying out his designs." Leslie was a young man and virtually nothing is known about him or his training except that when he died on October 16, 1860, of typhoid, his Masonic Lodge notified his brother George M. Leslie in England.

[14]While it is only speculation, it is of some specific interest that when Captain Meigs was a cadet at West Point taking drawing in his second year, 1833–34, the professor of drawing was the eminent American expatriate painter Charles Robert Leslie (1794–1859). It is unclear whether Meigs actually studied with him or his assistant, since the Military Academy informs me the records for the period are lost. His biographer is clear, however, that Meigs discovered in himself at this time a "measure of talent for the quickly placed but expressive line [and] would count sketching among his favorite diversions" (Weigley, *Quartermaster General of the Union Army,* p. 27). It is possible James Leslie was related in some way to Charles Leslie, who died in England the year before he did, or to one of his American sisters, and that Meigs was repaying an old debt by employing at the Capitol, for which he had such high artistic hopes, this link to his own artistic initiation. Obviously, further research is needed on James Leslie, as well as the rather esoteric artistic tradition of trophy painting he so ably represents.

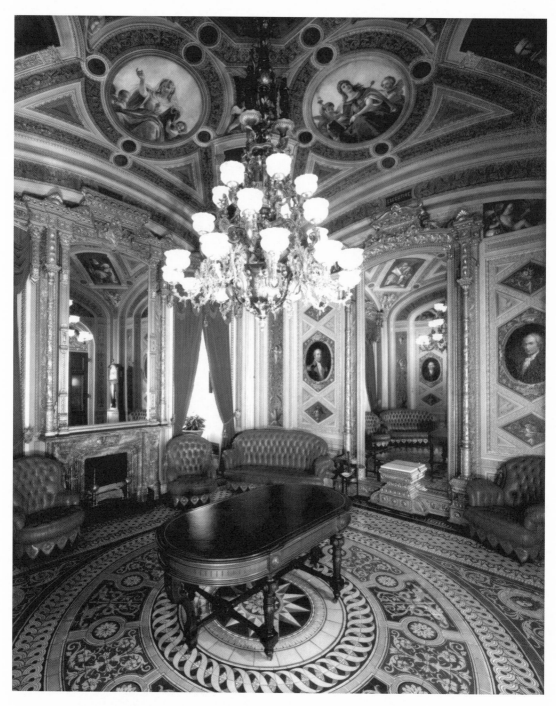

Fig. 15. The President's Room, S-216. *(Courtesy Office of Architect of the Capitol.)*

has suffered for more than a century. It is interesting to note, however, that after the naval room he does not seem to have worked again in the Pompeian style, except perhaps to supply designs for the ongoing work in the Senate corridors. One gathers this style was considered a bit frivolous, or obviously foreign, and he certainly felt those who executed his designs in the corridors—mostly Germans, it might be noted—did not always grasp its subtleties. But the more formal style he first demonstrated in the House Agriculture Committee Room, and later in the Senate Military Affairs Room —that is, history paintings set in rich decorative contexts—was the one he maintained later in the 1870s throughout the Senate wing, most notably in the President's Room (fig. 15) and the Senate Library.

These must be left to a more comprehensively detailed history of the murals in the Capitol. But Brumidi's frescoes in the Naval and Military Affairs Committee Rooms of the U.S. Capitol demonstrate his genius as a muralist who could both celebrate an environment with a delightful and light-filled fantasy and comment in another on the scourge of war with eloquent compassion.[15]

[15]The time has come, now that so many of the Brumidi rooms have been so beautifully restored, to open them permanently to the public. Their continued use by Congress as office space endangers them for the future. They should be designated and secured as museum spaces, in a manner similar to the old Senate and Supreme Court chambers, and included on regular Capitol tours. Brumidi's reputation has for too long been based on only the rotunda and the corridors; the public and the scholarly community ought to have free access to his best small-scale work.

Gender and Public Space

Women and Art in the United States Capitol, 1860–2001

Teresa B. Lachin

J UNE 1997 MARKED THE CULMINATION OF AN INTENSIVE POLITICAL CRUSADE TO
relocate Adelaide Johnson's *Portrait Monument* (1921) from the crypt to the ro-
tunda of the U.S. Capitol (fig. 1). Originally dedicated in the rotunda in 1921 to
celebrate ratification of the Nineteenth Amendment, the *Portrait Monument* was trans-
ferred the same year to the first-floor crypt, where it remained on continuous display
until the 1997 rededication ceremony.[1] Organized by a coalition of women's groups,

[1] Soon after the *Portrait Monument* was moved to the Crypt in 1921, Adelaide Johnson and Alice Paul urged
the Joint Committee on the Library to return the sculpture to the rotunda. Committee Chairman Frank R.
Brandegee (R-CT), an opponent of ratification, refused to relocate the eight-ton statue and was quoted as saying
that it was "too large" for the rotunda and "would spoil the symetry [*sic*] of the room." See Adelaide Johnson to
Alice Paul, May 22, 1921; Alice Paul to Adelaide Johnson, May 29, 1921, Adelaide Johnson, Correspondence
Files of 1921, Manuscript Division of the Library of Congress. From 1921 to the early 1990s, the monument was
a focal point for periodic observances of Susan B. Anthony's birthday anniversary and other commemorative
rituals sponsored by the NWP and women's business and professional groups. Representatives of these organi-
zations frequently complained to Capitol officials about the Crypt location and cited reports of "disrespect" and
ridicule of the unorthodox statue ("Three Old Ladies in a Bathtub"). See Louise Siefert, [Detroit Federation of
Womens' Clubs] to Rep. Florence P. Kahn, Jan. 2, 1931; David Lynn to Rep. Florence P. Kahn, Feb. 14, 1931;
Doris Van Slyke [Florida Division of American Association of University Women] to Capitol Architect, May 3,
1948; Tom Kelly, "Battle for Her Sex: Susan Is Suffraging from Neglect," *Washington Daily News,* Feb. 16, 1965,
p. 5; "Monument to Women's Work Lies Forgotten in Crypt," *Florida Business Women's Magazine,* Jan. 27, 1966,
p. 9; Lester Bell, "Three Stony-Faced Heroines Stand Watch Over Equal Rights for Women," *Post Advocate*
(Alhambra, Calif.), Feb. 22, 1969; Solveig Eggersz, "Susan, George and Abe Unite," *Washington Daily News,*
Feb. 16, 1971; Rep. Gary A. Lee to George M. White, Jan. 11, 1980; George M. White to Congressman [Gary A.]
Lee, Feb. 21, 1980; George M. White to [NWP President] Mrs. Elizabeth L. Chittick, Apr. 7, 1983; Francis X.
Clines, "About Washington: The Occupation of Civil Life," *New York Times,* Apr. 11, 1981, Records of the
Architect of the Capitol (hereafter AOC Records).

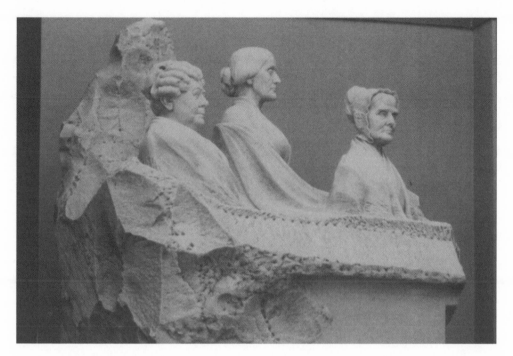

Fɪɢ. 1. Adelaide Johnson, *The Portrait Monument*, 1921. *(Courtesy Office of Architect of the Capitol.)*

the Women's Suffrage Statue ("Raise the Statue") Campaign was premised on the idea that Adelaide Johnson's massive tribute to Lucretia Mott, Elizabeth Cady Stanton, and Susan B. Anthony represented a "powerful visual symbol" of women's long struggle for political equality and contributions to national life and history.[2]

In ensuring a "place of honor" for American women in the Capitol rotunda, the

[2]The current relocation initiative was launched on August 26, 1990 (Equality Day), during the seventieth anniversary celebration of the Nineteenth Amendment. See Raj Kamal Jhe, "Cry of Liberation for Suffragists: Effort Launched to Move Statue from Capitol Basement," *Washington Post,* Aug. 27, 1990, B1, 7. Organized by a coalition of women's organizations, the movement gained political support throughout the early 1990s as Capitol officials weighed the pros and cons of placing the thirteen-ton sculpture assembly (e.g., statue and bases) on the masonry floor of the rotunda. In June 1995, Capitol Architect George M. White commissioned an engineering study to assess the structural limitations of masonry supports and feasibility of the proposed relocation. In early July, Capitol engineers reported the sculpture assembly could be supported safely by placing it directly above the columns below the rotunda. See Newell R. Anderson to George M. White, *Memorandum on Women's Statue Relocation, July 7, 1995,* AOC Records. On July 17, 1995, the Senate approved a resolution authorizing relocation of the statue to the rotunda; House members did not approve the transfer until September 1996, and they specified, among other things, that project costs would not be funded by the federal government. See: *S. Con. Res. 21,* 104th Cong., 1st Sess., passed July 17, 1995; *House Con. Res. 216,* 104th Cong., 2d sess., passed by House, Sept. 26, 1996, and Senate Sept. 27, 1996; "Brief Chronology of the Portrait Monument to Lucretia Mott, Elizabeth Cady Stanton, and Susan B. Anthony: Memorandum Prepared by Curator's Office, Architect of the Capitol, June 1997"; Alice A. Love, "House Skips Its Chance to Relocate Women's Suffrage Statue; Architect's Memo is Blamed," *Roll Call,* Aug. 10, 1995, p. 9, AOC Records; Edith Mayo, "Remembering Women in the 'City of Symbols,'" *Organization of American History Newsletter* 25 (1997):1, 8–9.

coalition raised $75,000 in private contributions to move the eight-ton statue to the site of its 1921 dedication and held ground on a number of other fronts, including an official protest by the National Political Caucus of Black Women, which in 1996 objected to the artistic exclusion of African American suffragist Sojourner Truth from the relocation campaign.[3] The "Raise the Statue" coalition also rejected a House proposal authorizing the placement of Statuary Hall tributes to suffragists Esther Hobart Morris (Wyoming, 1960) or Maria Sanford (Minnesota, 1958) in the rotunda as substitutes for the *Portrait Monument* and subsequently mustered bipartisan support from the 104th Congress to elevate the suffrage icon from "the basement to the living room" of national history and tradition (figs. 2 and 3).[4] Sojourner Truth, whose historical legacy was invoked frequently in the 1997 rededication ceremony, still awaits artistic tribute in the Capitol; Morris and Sanford remain in National Statuary Hall, their contributions to the suffrage cause overshadowed by those of their more famous nineteenth-century counterparts.[5]

In reality, the "Raise the Statue" campaign was one in a series of recent initiatives commemorating women's history in Washington's civic spaces, specifically the National Museum of Women in the Arts (1987), the *National Vietnam Women's Memorial* (1993), and the *Women in Military Service Memorial* in Arlington National Cemetery (1997). Like the *Portrait Monument,* these projects were sponsored by women's organizations and designed by women artists to celebrate various aspects of women's history in the

[3]In February 1996, Sen. John Warner (R-VA) pledged his support of a national fund-raising drive to raise $75,000 in private contributions to move the statue. See "Warner Teams with Coalition to Raise Funds for Statue," Press Release from the Office of Sen. John Warner, Washington, D.C., Feb. 15, 1996; Joan Meacham, *Minutes of Press Conference on the "One Dollar" Campaign, February 15, 1996, Capitol Crypt;* Alice A. Love, "Women's Groups to Raise $75,000 to Move the Statue," *Roll Call,* Feb. 19, 1996, p. 6, AOC Records. For information on the Sojourner Truth controversy, see Adrienne T. Washington, "Truth Deserves Spot in Capitol Rotunda," *Washington Times,* Feb. 25, 1997; Julianne Malveaux, "Our History Too," *Metro Herald* (Boston)*,* Mar. 21, 1997; Dorothy Gilliam, "Measuring a Statue By Its Truth," *Washington Post,* Mar. 22, 1997, C1, 5; Kevin Merida, "A Vote against Suffrage Statue," *Washington Post,* Apr. 14, 1997, A1, 7; *Roll Call,* Apr. 17, 1997; Susan Trausch, "Women's Elevation," *Boston Globe,* Apr. 25, 1997; Donna Britt, "History's Matter of Truth," *Washington Post,* May 2, 1997, B1, 6; "Another Moment for Truth," *Roll Call,* May 5, 1997, AOC Records.

[4]Juliet Elperin, "House GOP Women Spark New Round in Statue Fight: Their Plan to Move Esther Morris to Rotunda Draws Fire from Senate, Others," *Roll Call,* Apr. 1, 1996; Timothy J. Burger, "Aftershocks: Continued Suffering," *Roll Call,* Apr. 8, 1996, p. 3; Juliet Elperin, "Suffragists Statue Stalemate Could Come to an End; Compromise Proposal Would Create Traveling Exhibit," *Roll Call,* June 3, 1996, p. 10, AOC Records.

[5]Reps. Louise Slaughter (D-NY) and Connie Morella (R-MD) were among those who praised Sojourner Truth's role in the suffrage crusade. See *Rededication Ceremony of the Portrait Monument to Lucretia Mott, Elizabeth Cady Stanton, and Susan B. Anthony, United States Capitol Rotunda, Thursday, the Twenty-Sixth of June, Nineteen Hundred and Ninety-Seven.* In April 1997, a House resolution (Senate concurring) was introduced authorizing a bust or statue of Sojourner Truth for the Capitol. The location was to be determined by the Joint Committee on the Library and $50,000 in federal funds was specified for this commission. The resolution was referred to the House Oversight Committee. See: *H. Con. Res. 62,* 105th Cong., 1st sess., referred Apr. 15, 1997, AOC Records. Two weeks later, House members who opposed the relocation of the *Portrait Monument* introduced a concurrent resolution authorizing a special commission to study the matter for one year. This resolution was also referred to the House Oversight Committee. See *H.C. Res. 72,* 105th Cong., 1st sess., referred May 1, 1997, AOC Records.

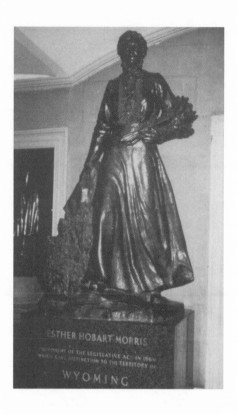

Fig. 2. Avard Fairbanks, *Esther Hobart Morris,*
1960. *(Courtesy Office of Architect of the Capitol.)*

Fig. 3. Evelyn Raymond, *Maria Sanford,* 1958.
(Courtesy Office of Architect of the Capitol.)

Fig. 4. Adelaide Johnson. (*Courtesy Office of Architect of the Capitol.*)

nation's capital city.[6] Taken collectively, these and other commemorative arts projects have democratized Washington's civic landscape and stimulated public interest in both women's and minority history.[7] But given the famous individuals which the *Portrait Monument* commemorates, its imposing and unorthodox design, the charismatic and eccentric personality of its creator, Adelaide Johnson (fig. 4), the abiding —even maternal—devotion it has engendered among women's groups, and its newly elevated status in the Capitol building, the *Portrait Monument* is likely to remain one of the most well-known works of its kind.[8]

Despite numerous claims to the contrary, the *Portrait Monument* is not the only nor was it the first work of art sponsored and designed by women for the Capitol, a distinction held by the 1905 Statuary Hall tribute to temperance crusader Frances Willard of Illinois (fig. 5).[9] Indeed, long before the Nineteenth Amendment was ratified in 1920, works by women artists were commissioned or purchased by Congress for display in the Capitol and its legislative buildings. Since the 1860s, women have participated actively in the Capitol arts program, both collectively, as sponsors of contributed works, and as individual painters, sculptors, and craftspeople.

[6]The *National Women's Vietnam Memorial,* a sculptural addition to the *National Vietnam Veterans Memorial* (1982), was designed by Glenna Goodacre and sponsored by a group of women Vietnam veterans. *The Women in Military Service Memorial* (1997) was designed by architect Marion Weiss. See Marylou Tousignant, "U.S. Honors the Daughters Who Served," *Washington Post,* Oct. 18, 1997, A1, 13.

[7]In addition to a proposed monument honoring black patriots of the Revolutionary War, a national memorial to Martin Luther King, Jr., is scheduled for construction on the Tidal Basin and a memorial to African Americans who fought in the Civil War was completed in 1998.

[8]Ann Lyman Henderson, "Adelaide Johnson: Issues of Professionalism for a Woman Artist," Ph.D. diss., George Washington University, 1981; Edith Mayo, "Johnson, A.," in *Notable American Women: The Modern Period* (Cambridge, Mass., 1980), pp. 380–81; Frank Faragasso and Doug Stover, "Adelaide Johnson: A Marriage of Art and Politics," *Cultural Resource Management* 20 (1997); Charles E. Fairman, *Art and Artists of the Capitol of the United States of America* (Washington, D.C., 1927), pp. 383–88; Charlotte Streiffer Rubinstein, *American Women Sculptors: A History of Women Working in Three Dimensions* (Boston, 1990), pp. 136–38.

[9]Willard, whose support of the suffrage cause was not widely endorsed within the temperance community, was designated in 1898 for her leadership of the temperance movement. See Carolyn DeSwarte Gifford, "Frances Willard and the Woman's Christian Temperance Union's Conversion to Woman's Suffrage," in *One Woman, One Vote,* ed. Marjorie Spruill Wheeler (Troutdale, Ore., 1995), pp. 117–33.

Fɪɢ. 5. Helen Farnsworth Mears, *Frances Willard,* 1905. *(Courtesy Office of Architect of the Capitol.)*

Currently there are sixty-eight individual works by fifty women artists housed in the Capitol and its legislative buildings. A majority of these works (approximately 70 percent) are on display in the Capitol's public viewing areas (rotunda, National Statuary Hall, and House and Senate connecting corridors) or restricted spaces (the President's Room, House and Senate chambers, and press galleries). Like those created by male artists, these works embrace a diversity of aesthetic styles and media from history painting, sculpture, and portraiture of the Gilded Age to the international modernism of the mid to late twentieth century.[10] Marisol Escobar's distinctive bronze statue of Father Joseph Damien (Hawaii, 1969) is, to date, the only modernist work in the Statuary Hall collection (fig. 6). And while there are only a few works that specifically honor American women, the Capitol arts program has afforded significant professional opportunities for women artists for more than 130 years. Furthermore, women's organizations have initiated, sponsored, and/or commissioned numerous works for the

[10]Marisol Escobar's modernist interpretation of Belgian missionary Joseph Damien (Hawaii, 1969) is a reverent adaptation of her satirical "pop-assemblages." See H. H. Arnason, *History of Modern Art: Painting, Sculpture, and Architecture,* 2d éd. (Englewood Cliffs, N.J., 1978), pp. 642–43; Wayne Craven, *American Art: History and Culture* (New York, 1994), pp. 602–3; Rubinstein, *American Women Sculptors,* pp. 417–22.

FIG. 6. Marisol Escobar, *Father Joseph Damien,* 1969. *(Courtesy Office of Architect of the Capitol.)*

Capitol, thereby shaping the scope, content, and commemorative character of the overall collection.

Women's involvement in public art, which began in the mid-nineteenth century and increased steadily throughout the Gilded Age and Progressive era, emerged during the 1970s as a topic of scholarly research on the study of women in the arts and the history of fine arts patronage in American society. This study extends to the history and development of the visual arts in Washington, D.C., and women's varied roles in local arts communities and institutions. A number of women artists represented in the Capitol collection operated studios in Washington and contributed to the civic and cultural life of the city (Cornelia Fassett, Adelaide Johnson, and Wendy Ross, among others).[11]

The suffrage crusade, which the *Portrait Monument* and other projects honoring women commemorate, promoted political, social, and economic equality and, by ex-

[11]Robert R. Preato, "The Genius of the Fair Muse: Academic and Other Influences on American Women Painters and Sculptors," in *The Genius of the Fair Muse: Painting and Sculpture Celebrating American Women Artists, 1875 to 1945* (New York, 1987), pp. 2–26; Andrew J. Cosentino and Henry Glassie, *The Capital Image: Painters in Washington, 1800–1915* (Washington, D.C., 1983); Betty Ross, *A Museum Guide to Washington: Museums, Historic Houses, Art Galleries, Libraries, and Special Places Open to the Public in the Nation's Capital and Vicinity* (Washington, D.C., 1986); *Dictionary of Women Artists,* ed. Delia Gaze (London and Chicago, 1977); Madeleine Weimann, *The Fair Women: The True Story of the Women's Building, World's Columbian Exposition* (Chicago, 1981).

tension, the right of equal access to training, opportunity, and advancement in all professions, including the fine arts. In our time, we have come to appreciate the cultural dimensions of the suffrage movement and women's struggle for cultural authority, specifically an unrestricted "voice" in constructing women's history and a participatory role in shaping broader historical narratives and commemorative artifacts.

Like their male counterparts, women have operated within the conservative aesthetic conventions and ideological traditions of public art and have been dependent upon powerful benefactors (for example, lawmakers, philanthropists, and interest groups) to sanction and support arts projects within the commemorative arena, both in the U.S. Capitol and elsewhere. For women, the politics of inclusion within that arena frequently has necessitated subtle, and sometimes dramatic, reshaping(s) of feminist ideals, actions, and/or rhetoric within the more general apparatus of commemorative discourse and iconography.[12] But it also effectively situated women within a new commemorative idiom grounded in historical events, gender-based experience, and enterprise, rather than the traditions of allegory, literature, or decorative subordination.

In documenting women's participation in the Capitol arts program we diversify contemporary understanding of women's history in general and that of the Capitol arts collection per se. This essay focuses primarily on sculpture created by women artists for the U.S. Capitol and features a discussion of National Statuary Hall, which includes a significant number of works by women artists and six individual state tributes to women honorees, most of which were initiated and/or sponsored by women's organizations.[13]

Women Artists of the Capitol, 1860–1987

The Civil War marked a new era in the history of the Capitol arts program, as it did for most aspects of American life. From the early to the mid-nineteenth century, federal lawmakers exercised considerable influence over the Capitol's acquisitions,

[12]Kirk Savage, *Standing Soldiers, Kneeling Slaves: Race, War, and Monument in Nineteenth Century America* (Princeton, 1997), pp. 3–8; Michele H. Bogart, *Public Sculpture and the Civic Ideal in New York City, 1890–1930* (Chicago, 1989), pp. 3–7; Rozsika Parker and Griselda Pollock, *Old Mistresses: Women, Art, and Ideology* (New York, 1981); Linda Nochlin, *Women, Art, and Power and Other Essays* (New York, 1988); Whitney Chadwick, "Toward Utopia: Moral Reform and American Art in the Nineteenth Century" in *Women, Art, and Society* (London, 1990), pp. 191–235. For information on the Capitol arts collection, see Fairman, *Art and Artists; Art in the United States Capitol* (Washington, D.C., 1978); Vivien Green Fryd, *Art and Empire: The Politics of Ethnicity in the U.S. Capitol, 1815–1860* (New Haven, 1992); Barbara A. Wolanin et al., *Constantino Brumidi: Artist of the Capitol* (Washington, D.C., 1998); Donald R. Kennon, ed., *The United States Capitol: Designing and Decorating a National Icon* (Athens, Ohio, 2000).

[13]In 1998–99, the state of North Dakota proposed the designation of Sakakawea (Sacajawea), the Native American guide for the Lewis and Clark expedition. If approved, Sakakawea will become the seventh woman honored in National Statuary Hall. See Rep. Earl J. Pomeroy to Architect of the Capitol Alan Hantman, Dec. 14, 1998; Alan M. Hantman to Sen. Ted Stevens, Jan. 6, 1999; Alan M. Hantman to Barbara A. Wolanin, *Memorandum of October 12, 1999,* AOC Records. (Ed's. note: The statue of Sakakawea was unveiled in the Capitol on October 16, 2003).

commissioning, and decorative arts policies, as Vivien Green Fryd's skillful analysis of this early period has documented.[14] During the 1860s, Congress effectively deregulated arts policies of preceding decades, chiefly through the 1864 legislation authorizing National Statuary Hall, which created unprecedented opportunities for acquiring new works of art to the collection.[15] It was also during this period that the Capitol acquired the first works by women artists, many of whom were experienced professionals with connections to Washington's political and civic infrastructures. By 1870, the collection included three new works by women artists: two sculpted images of Abraham Lincoln by Sarah Fisher Ames and Vinnie Ream, and an oil portrait of Congressman Joshua R. Giddings by Caroline Ransom. Taken collectively, these three works recapitulate the political temperament and tensions of the immediate postwar and Reconstruction era.

Joshua Giddings, an Ohio abolitionist, was censured by Congress in 1842 for his advocacy of militant antislavery tactics and was subsequently appointed consul general to Canada by Abraham Lincoln in the early 1860s. His death in 1864 prompted Caroline Ransom, an Ohio native, to paint his portrait and offer it for sale to Congress in 1867. Ransom, a friend of Ohio Congressman James Garfield, operated a studio in Washington and was a founding member of the Classical Club and DAR Society.[16] Presumably, Ransom's unsparing portrait of Giddings as the haggard statesman of the antebellum conflict vindicated his memory and appealed to the political mood of early Reconstruction (fig. 7).[17] In 1900, the Capitol acquired a second work by Ransom, an oil portrait of former House Speaker John W. Taylor.[18]

Vinnie Ream's imposing statue of Abraham Lincoln (1871), is one of the best known and most controversial public art commissions of the post–Civil War period. The first congressional commission awarded to a female artist, the Lincoln statue deserves to be reexamined within the context of other works created by women for the Capitol, specifically Sarah Fisher Ames's bust of Abraham Lincoln, which was purchased by Congress in 1868.[19] Both Sarah Fisher Ames (1817–1901) and Vinnie Ream (1847–1914)

[14]Fryd, *Art and Empire.*

[15]Teresa B. Lachin, "'Worthy of National Commemoration': National Statuary Hall and the Heroic Ideal, 1864–1997," in Kennon, *The United States Capitol,* pp. 274–304.

[16]Fairman, *Art and Artists,* pp. 249–51; Cosentino and Glassie, *Capitol Image,* p. 146; "Miss Caroline L. Ormes Ransom: Portrait, Figure, and Landscape Painter," *Washington Star,* Dec. 19, 1903, AOC Records.

[17]Eric Foner, *A Short History of Reconstruction, 1863–1877* (New York, 1990); Michael Kammen, *Mystic Chords of Memory: The Transformation of Tradition in American Culture* (New York, 1991); Eric Foner and Olivia Mahoney, *America's Reconstruction: People and Politics after the Civil War* (New York, 1995).

[18]Fairman, *Art and Artists,* pp. 249–51; George M. White to Mrs. Robert L. Eastwood, July 31, 1975, AOC Records.

[19]See Architect of the Capitol, "Bust of Abraham Lincoln," Accession Sheet, Dec. 11, 1975, AOC Records. According to Fairman, a pedestal of Scotch granite was donated by admirers of Lincoln in Scotland. See Fairman, *Art and Artists,* p. 352; *Art in U.S. Capitol,* p. 197.

FIG. 7. Caroline Ransom, *Joshua R. Giddings,* purchased 1867. *(Courtesy Office of Architect of the Capitol.)*

were among the first generation of women to study art in Rome ("white marmorean flock") and establish careers in America as professional sculptors.[20] Both women were active in Washington's civic and cultural life and each claimed to have had personal access to Lincoln for portrait sittings in the White House, although Ream's claim is questioned by contemporary scholars.[21] During the late 1860s, however, Ames was a respected Washington matron who had supervised the Capitol's Civil War hospital (fig. 8). Vinnie Ream, a youthful upstart from the Wisconsin frontier, alternately outraged and dazzled Washington society with her stunning good looks and brash self-confidence.[22]

Their artistic interpretations of Lincoln draw on two distinct aesthetic conventions: the neoclassicism of the early nineteenth century and the naturalism of the middle and

[20]For a discussion of Ames's life and career, see Rubinstein, *American Women Sculptors,* pp. 91–92; Fairman, *Art and Artists,* pp. 249, 266. For information on Vinnie Ream see Rubinstein, *American Women Sculptors,* pp. 66–75; Fairman, *Art and Artists,* pp. 234–35, 266, 383.

[21]Carmine A. Prioli, "'Wonder Girl from the West': Vinnie Ream and the Congressional Statue of Abraham Lincoln," *Journal of American Culture* 12 (1989):1–20.

[22]Ibid., pp. 2–10.

FIG. 8. Sarah Fisher Ames. *(Courtesy Office of Architect of the Capitol.)*

FIG. 9. Sarah Fisher Ames, *Abraham Lincoln,* 1868 copy of 1862 original. *(Courtesy Office of Architect of the Capitol.)*

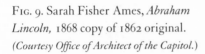

later decades. In retrospect, this pair of works recapitulates the initial shaping of Lincoln's memory in the aftermath of his 1865 assassination.[23] The Ames bust (a copy of her 1862 original, which she copyrighted in 1866) depicts Lincoln in the early years of his presidency: an idealized statesman committed to preserving the Union. Lincoln's nobility of purpose is expressed in a classical drape, deep facial shadows, and stoic, pensive gaze (fig. 9).[24] Vinnie Ream's full-figure statue, famously commissioned by Congress in 1866, is a naturalistic portrait of Lincoln, "The Great Emancipator," his lanky figure clothed in contemporary dress and loosely draped in the mantle of freedom, offering, as Kirk Savage has suggested, the document of emancipation to the easily imagined kneeling figure of an African American slave (figs. 10 and 11).[25]

The Ream commission sparked intense political and aesthetic debate. Her detractors insisted that a national tribute to Lincoln should be entrusted only to an experienced professional trained in the grand European neoclassical tradition rather than an untested ingenue from the American frontier. Ream's supporters, however, compared her "native genius" to that of Abraham Lincoln, her "fellow Westerner," and claimed

[23]Wayne Craven, "The First Expatriates: Neoclassicism vs. Naturalism," in *Sculpture in America,* pp. 100–143; Merrill D. Peterson, *Lincoln in American Memory* (New York, 1994), pp. 3–81; Jeffrey Hearn, "Congress and the Commemoration of Abraham Lincoln," *Capitol Dome* 27 (1992):2–3.

[24]Rubinstein, *American Women Sculptors,* p. 92.

[25]Kirk Savage, *Standing Soldiers,* pp. 81–83.

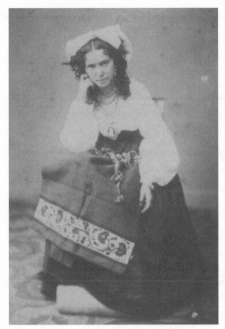

Fig. 10. Vinnie Ream. *(Courtesy Office of Architect of the Capitol.)*

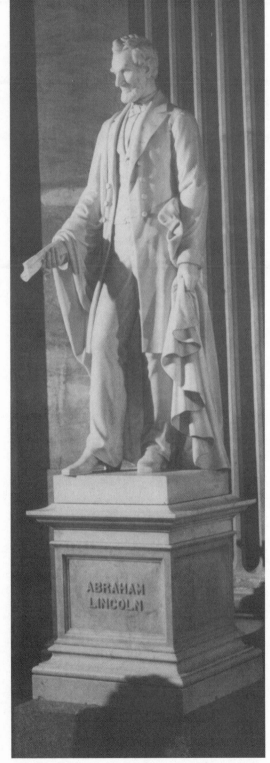

Fig. 11. Vinnie Ream, *Abraham Lincoln,* 1871. *(Courtesy Office of Architect of the Capitol.)*

that in executing the Lincoln statue she would inspire and advance the future course of American civilization and art.[26]

Ultimately, Congress purchased Sarah Ames's neoclassical bust of Lincoln and approved the controversial Ream commission, a fortuitous outcome for the Capitol collection, which gained two noteworthy postwar images of Lincoln, and the women artists themselves. Ames's bust of Lincoln has been featured in numerous reproductions and a 1938 commemorative stamp; Vinnie Ream's statue, unveiled in 1871, occupies a place of honor in the Capitol rotunda.[27] Ream was commissioned to sculpt two additional statues for National Statuary Hall: Oklahoma's 1917 tribute to Cherokee leader Sequoyah and a 1913 statue honoring Samuel J. Kirkwood, the "War Governor" of Iowa. Ironically, Kirkwood was among the group of senators who had opposed Ream in the 1866 debates over the Lincoln statue commission.[28]

Like Ames and Ream, painters Cornelia Adele Fassett (1831–1898) and Imogene Robinson Morrell (1818?–1908) were active in Washington's artistic milieu and social life.[29] Morrell's oil portrait of Sen. John Dix was purchased for the Capitol in 1883, and Fassett documented the political conflicts of the mid-1870s in her ambitious history painting, *The Florida Commission* (1879), which depicts one in a series of hearings to resolve the disputed Hayes-Tilden election of 1876 (fig. 12).[30] Fassett (fig. 13) scrupulously

[26]*The Congressional Globe-Appendix,* 39th Cong., 1st sess., July 28, 1866, p. 432; *Congressional Globe-Senate,* July 26, 1866, pp. 4169–70; *Congressional Globe-House,* July 27, 1866, p. 4274; *Congressional Globe-Senate,* July 27, 1866, pp. 4225–26, 4230-36, 4246, 4274, 4282.

[27]A replica of the Ames bust is displayed in the Massachusetts State House in Boston. For information on the 1938 Lincoln commemorative stamp, see Randle Bond Truett, *Lincoln in Philately* (Washington, D.C., 1959), AOC Records. In 1897, Vinnie Ream wrote to Edward Clark asking that the Lincoln statue be moved from Statuary Hall back to the rotunda. In June 1898, Elliott Woods refused Ream's request, citing concerns about the scale of the statue within the "magnitude of the surroundings" of the rotunda. According to Charles Fairman, the statue was located in the rotunda in 1908 when Congress accepted Gutzon Borglum's monumental bust of Lincoln. See Vinnie Ream Hoxie to Edward Clark, May 24, 1897; Elliott Woods to Vinnie Ream Hoxie, June 18, 1898, AOC Records; Fairman, *Art and Artists,* p. 383.

[28]The Kirkwood statue was commissioned by the state of Iowa and dedicated in 1913. The bronze statue of Cherokee leader Sequoyah (b. George Guess) was completed by sculptor G. J. Zolnay following Ream's death in 1914. See *Art in U.S. Capitol,* pp. 250, 262; Fairman, *Art and Artists,* pp. 421, 434. For Kirkwood's voting record on the Lincoln commission, see *The Congressional Globe,* 39th Cong., 1st sess., July 27, 1866, pp. 4225–26, 4230, 4236.

[29]For Fassett's life and career, see George C. Croce and David H. Wallace, *The New York Historical Society's Dictionary of Artists in America, 1564–1860* (New Haven, 1975), p. 221; Jim Collins and Glenn B. Opitz, eds., *Women Artists in America, Eighteenth Century to the Present, 1790–1980* (Poughkeepsie, N.Y., 1980); *Highlights from Washington's Newest, and Oldest, Museums: National Museum of Women in the Arts and the U. S. Capitol Arts Collection* (Arlington, Va., 1984), AOC Records; Fairman, *Art and Artists,* p. 314; Charlotte Streifer Rubinstein, *American Women Artists: From Early Indian Times to the Present* (Boston, 1982), pp. 55–56. For Morrell's life and career, see Rubinstein, *American Women Artists,* pp. 56–58; Cosentino and Glassie, *Capital Image,* p. 131; Gaze, *Dictionary of Women Artists,* p. 134; "Probe Artist's Death," *Washington Post,* Nov. 23, 1908, AOC Records.

[30]For information on the John Dix portrait, see *Catalogue of American Portraits in the New York Historical Society* (Princeton, 1974),1:219; Fairman, *Art and Artists,* pp. 314–15. The disputed election of 1876 is discussed in Sean Dennis Cashman, *America in the Gilded Age: From the Death of Lincoln to the Rise of Theodore Roosevelt,* 3d ed. (New York, 1993), pp. 230–33.

re-created the interior of the Old Supreme Court Chamber where commission hearings convened and featured 258 individual life portraits (including a self-portrait, lower right center) of jurists, politicians, reporters, and famous visitors who had crowded the chamber to hear testimony and debate. The encyclopedic grouping includes Frederick Douglass (then marshal of the District of Columbia), Washington philanthropist William W. Corcoran, painter Imogene Robinson Morrell, Hannibal Hamlin, and other notable men and women of the day.[31] This well-known painting, popularized in numerous reproductions of the late nineteenth and early twentieth centuries, was purchased for $7,500 in 1886, after several years of Congressional debate over whether it was appropriate to acquire and display a work of recent political controversy. Today, *The Florida Commission* is an important documentary resource and one of the most famous paintings in the Capitol arts collection.[32]

The Gilded Age afforded unprecedented opportunities for a new generation of American women artists active in national and international art expositions and professional arts organizations.[33] Throughout the late nineteenth and early twentieth centuries, the Capitol collection expanded in several directions, including the commissioning of new works honoring former vice presidents, House Speakers, and other political figures. In establishing the collection of vice presidential portraits in 1886, the Joint Committee on the Library authorized former vice presidents (or their surviving relatives) to appoint their own sculptors and encouraged the selection of artists from their respective home states, a tradition that has been observed also in the commissioning of House Speaker portraits.[34] Cecilia Beaux (*Sereno E. Payne,* 1912), Lucy Stanton (*Howell Cobb,* 1912), and Ellen Day Hale (*John G. Carlisle,* 1911) are among the

[31]Fairman, *Art and Artists,* pp. 311–14; Cosentino and Glassie, *Capital Image,* pp. 139–40; *Art in U.S. Capitol,* pp. 149–51; Rubinstein, *American Women Artists,* pp. 55–56; "Art in Chicago: Mrs. Fassett's Portrait-Work," *Chicago Tribune,* Sept. 18, 1881, p. 6, AOC Records.

[32]*The Florida Commission,* Fassett's best-known work, has been popularized in news articles on voting rights and the history of the Electoral College. See Harry Louis Selden, "The Electoral College: Does It Choose the Best Man?" *American Heritage* 13 (1962):12–19; *DAR Magazine* (cover), 106 (Nov. 1972); George F. Bason, Jr., "Why Not Rule on Fairness of '72 Election?" *Sunday Star and Daily News* (Washington, D.C.), June 17, 1973; Richard P. Claude, "Once More into the Thicket of Election Law Dispute," *Washington Post,* Mar. 7, 1976, C2, AOC Records. For congressional debate over this acquisition, see *The Congressional Record-Senate,* 45th Cong., Feb. 28, 1879, pp. 2078-80; Mar. 1, 1879, pp. 2166–67; *The Congressional Record,* 48th Cong., 1st sess., Apr. 16–May 16, 1884, pp. 3025–4240; *The Congressional Record-House,* 48th Cong., Apr. 24, 1884, p. 3354. *American Architect and Building News* 17 (1885), p. 37; Architect of the Capitol, "Painting—Electoral Commission, Florida Case of 1877," Accession Sheet, Apr. 28, 1975, AOC Records.

[33]Craven, *Sculpture in America,* pp. 372–513; Rubinstein, *American Women Sculptors,* pp. 97–208; Donald Martin Reynolds, *Masters of American Sculpture: The Figurative Tradition from the American Renaissance to the Millennium* (New York, 1993).

[34]On May 13, 1886, the Senate adopted a resolution authorizing the Joint Committee on the Library to commission portrait busts of former vice presidents for display in the vacant niches of the Senate chamber. Fairman, *Art and Artists,* pp. 324–45, 456–70; *Minutes of the Joint Committee on the Library,* May 20, 1886, AOC Records.

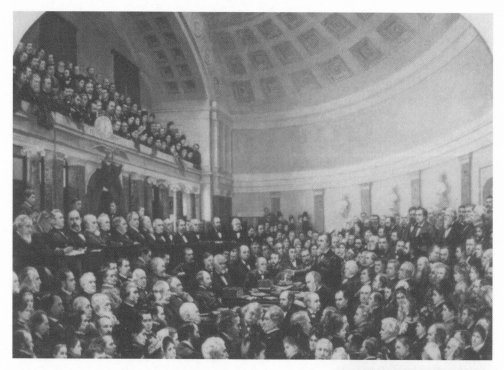

FIG. 12. Cornelia Adele Fassett, *The Florida Commission,*
1879. *(Courtesy Office of Architect of the Capitol.)*

FIG. 13. Cornelia Adele Fassett, self-portrait, photograph.
(Courtesy Office of Architect of the Capitol.)

twenty-three women artists whose portraits of House
Speakers and committee chairman were commissioned
or acquired since 1886.[35]

Bessie Potter Vonnoh, best known for genre sculp-
ture and garden statuary, was awarded the 1911 com-
mission to sculpt a marble bust of James S. Sherman for
the Capitol's collection of vice presidential portraits (fig. 14). Created in the heyday of
her early New York career, Vonnoh's vigorous depiction of Sherman is one of her rare

[35]This group includes Cecilia Beaux (*Sereno Payne*); Margaret Preble Brisbane (*Royal C. Johnson, John E. Rankin*); Betty Beaumont Brown (*William M. Colmer*); Kathryne Cooksey Dimmitt (*Samuel J. Randall*); Dorothy Hart Drew (*George A. Dondero*); Anna Glenny Dunbar (*Walter G. Andrews*); Esther Edmonds (*James L. Orr*); Kate Flournoy Edwards (*Philip P. Barbour*); Frances M. Goodwin (*Schuyler P. Colfax*); Ellen Day Hale (*John G. Carlisle*); Elaine Hartley (*Mary T. Norton*); E. Sophonisba Hergesheimer (*Joseph W. Byrns*); Willie Betty Newman (*John Bell*); Mabel Pugh (*Herbert Bonner, Harold D. Cooley, Clifford R. Hope*); Caroline L. Ormes (*John W. Taylor*); Charln Jeffry (*Don Young*); Dalton Shourds (*John W. Flannagan, Hampton P. Fulmer*); Suzanne Silver-cruys (*Joseph W. Martin, Jr.*); Louise Kidder Sparrow (*Theodore Burton*); Jean Van Vliet Spencer (*Daniel Alden Reed*); Lucy M. Stanton (*Howell Cobb*); Bessie Potter Vonnoh (*James S. Sherman*); and Emily B. Waite (*Philip J. Philbin*).

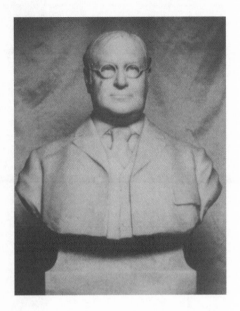

Fɪɢ. 14. Robert Vonnoh, *Bessie Potter Vonnoh,* in Charles B Fairman, *Art and Artists of the Capitol of the United States of America* (Washington, D.C., 1927), p. 340. *(Courtesy Office of Architect of the Capitol.)*

Fɪɢ. 15. Bessie Potter Vonnoh, *James S. Sherman,* 1911. *(Courtesy Office of Architect of the Capitol.)*

forays into the realm of portraiture and one of the most distinctive works in the vice presidential collection (fig. 15).[36] Frances Goodwin's marble bust of Indiana Republican Schuyler P. Colfax was purchased by Congress in 1897. His widow, Ellen Colfax, exercised considerable influence over this commission, both in the selection of Goodwin, an Indiana native, and in the artistic interpretation of her late husband, a former vice president (fig. 16).[37]

Sculptor Emma Cadwalader-Guild (1843–1911) is relatively unknown today but was celebrated throughout the Gilded Age for allegorical, genre, and portrait sculpture (fig. 17).[38] Active in Berlin and America, Cadwalader-Guild hoped to sculpt a portrait of William McKinley, her fellow Ohioan, during his presidency. Saddened by his assassination in 1901, she completed a bronze bust of McKinley (1903) from photographs and exhibited the sculpture in Washington, where she prevailed upon the Ohio congressional delegation to sponsor a resolution authorizing its purchase. According to press reports, the McKinley bust received "unqualified approval," and, through the efforts

[36]Craven, *Sculpture in America,* pp. 501–2; Rubinstein, *American Women Sculptors,* pp. 110–15; Fairman, *Art and Artists,* p. 338; Jules Heller and Nancy G. Heller, *North American Women Artists of the Twentieth Century: A Biographical Dictionary* (New York, 1995), pp. 560–61; *Dictionary of Women Artists,* 2:1412–13.

[37]Fairman, *Art and Artists,* p. 335; Mary Q. Burnet, *Art and Artists of Indiana* (New York, 1921), pp. 339–41, AOC Records.

[38]Fairman, *Art and Artists,* p. 345; Rubinstein, *American Women Sculptors,* p. 141.

Fig. 16. Frances Goodwin with Schuyler P. Colfax bust. *(Courtesy Office of Architect of the Capitol.)*

of Sen. Mark Hanna (R-Ohio), it was purchased by Congress for $2,000 and placed in the President's Room, where it has remained on continuous display (fig. 18).[39]

Throughout the early 1900s, a number of works by women artists were acquired for the Capitol, including Louise Kidder Sparrow's plaster bust of Sen. Theodore E. Burton (1929) and Anna Glenny Dunbar's bronze tribute to Walter G. Andrews (1936), former chairman of the House Armed Services Committee.[40]

Their more well-known contemporaries, Laura Gardin Fraser (1889–1966) and Brenda Putman (1890–1975) were among seven sculptors commissioned to design

[39]Marcus (Mark) Hanna (1837–1904), a proponent of "Big Business" and a ruling power in the Ohio and national Republican party, orchestrated McKinley's 1891 and 1893 gubernatorial campaigns and later organized his 1896 presidential nomination. For information on the McKinley acquisition, see 57th Cong., 2d sess., *P. L. No. 157, Statutes at Large,* 32:1144, approved Mar. 3, 1903; *Pearson's Magazine* [n.d.], pp. 172–74; Grace Whitworth, "A Woman Sculptor of Genius," *Current Literature* 11 (1906):42–46; "Around the Studios," *American Art News* 3 (1905):2, AOC Records.

[40]For information on Louise Kidder Sparrow and Anna Glenny Dunbar, see *Louise Kidder Sparrow, Sculptor* (1930); *Cleveland Plain Dealer,* Dec. 8, 1929; "Artist Displays General Gorgon Bust," *Washington Evening Star,* Oct. 9, 1930; *The Congressional Record-Appendix,* July 8, 1965, p. A3606, AOC Records. See also Rubinstein, *American Women Sculptors,* p. 289; *Art in U.S. Capitol,* p. 402.

FIG. 17. Emma Cadwalader-Guild. *(Courtesy Office of Architect of the Capitol.)*

FIG. 18. Emma Cadwalader-Guild, *President William McKinley,* 1903. *(Courtesy Office of Architect of the Capitol.)*

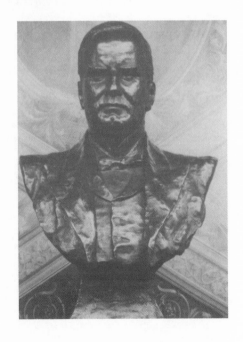

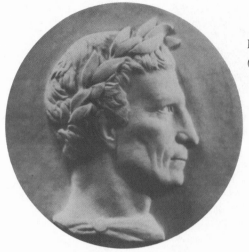

FIG. 19. Laura Gardin Fraser, *Papinian*, 1950.
(Courtesy Office of Architect of the Capitol.)

marble relief portraits of the "World's Greatest Lawgivers" for the House chamber during the remodeling project of 1949–50. Fraser and Putman, who executed numerous public arts projects throughout their careers, each designed three portrait medallions of "Lawgivers" who were selected for the series by a panel of historians and congressional advisers (figs. 19 and 20).[41] Shortly after the House project was completed in 1950, Congressman John Rankin of Mississippi openly denounced the relief series as "un-American" and demanded (unsuccessfully) the removal of the "ghastly placards" commemorating only two Americans (George Mason and Thomas Jefferson) among "foreigners" of the ancient world, Catholic papacy, and European monarchies.[42] Rankin's sentiments, fueled by Cold War xenophobia, were circulated in press reports

[41]"Lawgivers" were nominated by scholars from the University of Pennsylvania and the Columbia Historical Society of Washington, D.C., in consultation "with authoritative staff members of Congress." The final selection was approved by a special commission of House members, Architect of the Capitol David Lynn, and his associates. *Art in U.S. Capitol*, p. 282; Selwyn B. Walter, "Library of Congress Reference Service: Relief Portraits Located on the Walls of the Rayburn House Office Building Terminal of the House Subway and Over the Gallery Doors in the House Chamber" (Washington, D.C., Sept. 20, 1966), AOC Records. The series includes *Hammurabi, Blackstone,* and *Gregory IX* by Thomas Hudson Jones; *Alphonso X, The "Wise," De Montfort, Justinian I,* and *George Mason* by Gaetano Cecere; *Grotius, Thomas Jefferson, Lycurgus,* and *Napoleon I* by C. Paul Jennewein; *Pothier, Suleiman, Gaius,* and *Innocent III* by Joseph Kiselewski; *Moses* and *St. Louis* by Jean de Marco; *Edward I, Colbert,* and *Papinian* by Laura Gardin Fraser; *Tribonian, Solon,* and *Maimonides* by Brenda Putnam. For information on Laura Gardin Fraser, see Rubinstein, *American Women Sculptors,* pp. 191–94; Jules Heller, *North American Women Artists,* p. 193; James M. Goode, *The Outdoor Sculpture of Washington, D.C.: A Comprehensive Historical Guide* (Washington, D.C., 1974), p. 351; Katherine T. Hobson, "Laura Gardin Fraser—Seen through Stars," *National Sculpture Review* 15 (1966):18–19, 29; Beatrice Gilman Proske, "Laura Gardin Fraser," in *Brookgreen Gardens Sculpture* (1968), pp. 249–51; Sam Eastman, "Models of the Statuary That Will Honor President Theodore Roosevelt," *Washington Evening Star,* Nov. 17, 1959, B1, AOC Records. For information on Brenda Putnam see Rubinstein, *American Women Sculptors,* pp. 248–49; Goode, *Outdoor Sculpture of Washington,* p. 83; Heller, *North American Women Artists,* p. 454; Proske, *Brookgreen Gardens Sculpture,* pp. 244–45; biographies and correspondence in artist's files, AOC Records.

[42]"Rankin Assails House Plaques of Non-American Lawmakers," *Washington Evening Star,* Jan. 4, 1951; "Rankin Wants 'Foreigners' Out of House," (no source), Jan. 4, 1951; "Plaque Photos: 'Unknown' of House to Be Identified," *Washington Post,* Jan. 26, 1951, AOC Records.

Fɪɢ. 20. Brenda Putnam, *Maimonides,* 1950.
(Courtesy Office of Architect of the Capitol.)

and serve as a chilling reminder of the frequently controversial relationship between public art and politics.

Women sculptors of the mid to late twentieth century completed a number of noteworthy projects for the Capitol, sometimes working with national women's organizations in commissioning specific works for the collection. In 1962, Suzanne Silvercruys, the Beligan-born sculptor who created Arizona's Statuary Hall tribute to Jesuit missionary Eusebio Kino (1965), was commissioned by the National Federation of Republican Women to sculpt a marble bust of Massachusetts Congressman Joseph W. Martin, Jr., a former minority leader and House Speaker (fig. 21).[43] In 1966, Martin was defeated in a midterm primary by Margaret M. Heckler, who was characterized in press reports as a "perky redhead."[44] A member of Congress in the 1970s, Heckler prevailed upon Architect of the Capitol George M. White to replace the "inferior" wooden stand

[43]Suzanne Silvercruys emigrated from Belgium in 1915 and established a studio in Chaplin, Connecticut. See "Suzanne Silvercruys, Belgian Sculptor" (obituary), *Washington Star and News,* Apr. 2, 1973, B5; "Noted Sculptor, Author Lecturer" (obituary), *Washington Post,* Apr. 3, 1973, C5. For information on the Kino statue, see *Unveiling and Presentation of the Statue of Eusebio Francisco Kino, S.J., Washington, D.C., February 14, 1965;* 89th Cong., 1st session, H. Doc. No. 158, *Acceptance of the Statue of Eusebio Francisco Kino Presented by the State of Arizona: Proceedings in the Rotunda, United States Capitol, February 14, 1965* (Washington, D.C., 1965); Donald A. Foskett, "Sculptress Finishes Work for Capitol Statuary Hall," *Catholic Standard,* Nov. 21, 1964, p. 12; Father Vincent J. Hope, "Statuary Hall in Capitol to Add Jesuit Missioner," *Catholic Standard,* Sept. 27, 1963, p. 11; "Missioner to Join Notables Sunday in Statuary Hall," *Catholic Standard,* Feb. 12, 1965, p. 3, AOC Records. For information on the Martin bust, see Mrs. Emory Ireland, President (Massachusetts Federation of Republican Women's Organizations), to Rep. Omar Burleson, Mar. 13, 1961; "Joe Martin Tribute Set for Sunday," *Roll Call,* Mar. 22, 1961; Rep. F. Bradford Morse to George Stewart, May 3, 1961; Marie Smith, "Representative Martin Has Date with History," *Washington Post,* Dec. 17, 1961, F-4; "Republicans Unveil a Bust of Martin," *Evening Star,* Apr. 16, 1962, B8; *Presentation by the National Federation of Republican Women of the Bust of the Honorable Joseph W. Martin, Jr. of Massachusetts in the Caucus Room of the Old House Office Building, United States Capitol, Washington, D.C., Sunday, April 15, 1962, 4:00 P.M.,* AOC Records.

[44]Richard L. Lyons, "Woman Challenges Joe Martin for Seat He Has Held 42 Years," *Washington Post,* Sept. 11, 1966; Robert K. Walsh, "Joe Martin's Era Ends," *Evening Star,* Sept. 14, 1966, AOC Records.

Fig. 21. Suzanne Silvercruys. *(Courtesy Office of Architect of the Capitol.)*

Fig. 22. Suzanne Silvercruys, *Joseph W. Martin, Jr.,* 1962. *(Courtesy Office of Architect of the Capitol.)*

displaying Martin's bust with a marble pedestal. Thus, Joseph Martin was honored in the Capitol through the initiatives of women who sponsored and created his tribute and ultimately placed him upon the proverbial pedestal for all time (fig. 22).[45]

Works honoring Lyndon B. Johnson and Sen. Henry Jackson, two of the most important political figures of the 1960s, were sculpted by women who, like many of their nineteenth-century predecessors, have longstanding ties to Washington's artistic community. Jimilu Mason's 1966 marble bust of Johnson, commissioned for the vice presidential collection, was designed in numerous sittings at the White House and LBJ Ranch. Mason's stately depiction of Johnson betrays nothing of the escalating Vietnam crisis and was reportedly one of his favorite images, second only to an early 1960s *Look* magazine cover by illustrator Norman Rockwell (fig. 23).[46] Mason (fig. 24), an Arlington, Virginia, artist, also sculpted a marble bust of the Capitol's muralist Constantino Brumidi that was purchased by Congress in 1966.[47] During the 1970s and 1980s, she

[45]Rep. Margaret M. Heckler to George M. White, June 9, 1975; George M. White to Rep. Margaret Heckler, June 17, 1976. Martin's bust was placed in the Cannon House Office Building rotunda in 1962 and moved to the House corridor in 1965. See *Fact Sheet: "Honorable Joseph W. Martin, Jr.,* [n.d.], AOC Records.

[46]Philip L. Roof, "Bust of Former Vice President Lyndon Johnson," Memorandum, Mar. 21, 1966; "Biographical Sketch Prepared by Col. L. Addison Brookover," Apr. 8, 1966; Hermine Levy, "This Mason Builds in Bronze," *Washington Daily News,* Aug. 31, 1959, p. 23; untitled news article, *Washington Star,* Mar. 20, 1966; "Oh, Come Now," *Sunday Star,* Mar. 26, 1967, D4; Agnes Vaghi, "The President Gets a Bust," *Washington Star Sunday Magazine,* Apr. 24, 1966, pp. 4–5; "Sculpture Gets a Head Start," *Washington Post,* Jan. 7, 1967, C1, AOC Records.

[47]Reps. Omar Burleson and B. Everett Jordan to Jimilu Mason, Mar. 15, 1967; "Bust of Brumidi to be Sculptured [*sic*] by Jimilu Mason," *Sunday Star,* Mar. 19, 1967, A14, AOC Records.

FIG. 23. Jimilu Mason, *Lyndon B. Johnson,* 1966.
(Courtesy Office of Architect of the Capitol.)

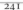

FIG. 25. Wendy Ross with bust of Sen.
Henry Jackson. *(Courtesy Office of Architect
of the Capitol.)*

FIG. 24. Jimilu Mason. *(Courtesy
Office of Architect of the Capitol.)*

turned to religious and social themes, notably sculpture dramatizing the plight of the homeless and urban poor.[48] In 1987, Wendy Ross sculpted a heroic bronze bust of Sen. Henry "Scoop" Jackson, a project commissioned by his widow, Helen Jackson, and the Henry M. Jackson Foundation. This bust is currently on display in the Russell Senate Office Building (fig. 25). In addition to numerous public arts projects (*Justice William O. Douglas,* 1977; *Phillip Burton Memorial,* 1986), Ross was selected in 2000 to sculpt a seated bronze statue of Revolutionary hero George Mason for a new memorial complex in East Potomac Park.[49]

[48]Jimilu Mason to Barbara Wolanin, Sept. 1991; Jimilu Mason to Barbara Wolanin, Christmas card, 1986, AOC Records.
[49]"Wendy Ross, Sculptor—Artist Resume," [n.d.]; Wendy Ross, "The Private Life of a Public Artist," [n.d.]; *The Portrait Sculptures of Wendy Ross: Biographies in Bronze* [n.d.]; Susan Davidson, "Wendy Ross—Heroic Sculptures," *Washingtonian Magazine,* Feb. 1986; Ross Anderson, "Sculptor Preserves Memory of Jackson," *Seattle Times,* May 30, 1985, A1, 7; Barbara Wolanin, "Jackson Bust Unveiled in Russell Building," *Capitol Dome* 23 (1988):5; Linda Charlton, "Officials and Nature Join to Hail Justice Douglas, *New York Times,* May 18, 1977, B1, AOC Records; Wendy Ross, interview with the author, Sept. 1, 1998, Bethesda, Md.; Linda Wheeler, "George Mason's Memorial Niche," *Washington Post,* Oct. 19, 2000, B3; "Profile of a Patriot," *Washington Post,* June 28, 2001, B7.

The Women of National Statuary Hall, 1873–2001

National Statuary Hall is the nation's oldest collection of commemorative portrait sculpture and an important resource for documenting the role of women in the Capitol arts program (fig. 26). Authorized by the 38th Congress in 1864, Statuary Hall democratized the Capitol's decorative arts policies by allowing each to designate without restriction "two deceased illustrious citizens" and dedicate portrait statues of them in the "Old Hall" of the House of Representatives.[50] An initial draft of the Statuary Hall bill specified "distinguished men" but was amended in committee to "distinguished persons," indicating that federal lawmakers of the 1860s anticipated state designations of both men and women honorees.[51]

Since 1870, when Rhode Island dedicated the first statue honoring Gen. Nathanael Greene, the states have commemorated ninety-seven individuals in Statuary Hall, demonstrating an overwhelming preference for male politicians, military heroes, religious and ethnic leaders, scientists, and humanitarians.[52] There are, however, six state tributes to women, all of whom were designated by states of the Midwest and West, regions of the country where woman's suffrage gained an early but tenuous foothold.[53] Frances Willard (Illinois, 1905), Maria Sanford (Minnesota, 1958), Dr. Florence Sabin (Colorado, 1959), Esther Hobart Morris (Wyoming, 1960), Mother Joseph (Washington, 1980), and Jeannette Rankin (Montana, 1985) were commemorated by their respective states for advocating women's rights and initiating humanitarian efforts on

[50]See Section 1814 of *Revised Statutes (40 U.S.C. 187)*. By the late 1890s, Statuary Hall was overcrowded with statues, raising concerns about the weight of sculpture on the masonry floor of the "Old Hall" and the congested appearance of the collection. Since that time the collection has been reorganized twice, once in 1933, in accordance with *H. C. Res. No. 47,* and again in 1976, following the restoration of Statuary Hall. See George M. White to Rep. Hank Brown, Sept. 15, 1982, AOC Records. For a history of Statuary Hall from 1864 to 1927, see Fairman, *Art and Artists,* pp. 222–24, 243–44, 388–448, 493; "The National Statuary Hall Collection," Memorandum prepared by Office of the Curator, January 1992; "National Statuary Hall (Old Hall of the House)," Memorandum prepared by the Office of the Curator, January 1992.

[51]*Legislation Creating the National Statuary Hall in the Capitol with Proceedings in Congress Relating to the Statues Placed in National Statuary Hall,* compiled by H. A. Vale (Washington, D.C., 1916); Fairman, *Art and Artists,* pp. 222–24. In 2000, Congress passed a resolution granting each state the option of replacing one of its contributed statues with a new statue, provided that the statue to be replaced had been part of the collection for more than ten years, among other restrictions. See section 311 of *H.R. 4615, FY 12001 Appropriations Legislation.*

[52]For a discussion of regional and geographical patterns of state designations, see Lachin, "'Worthy of National Commemoration,'" in Kennon, *The United States Capitol.*

[53]See also Marjorie Spruill Wheeler, "A Short History of the Woman Suffrage Movement in America," *One Woman, One Vote,* pp. 9–19; Beverly Beeton, "How the West Was Won for Woman Suffrage" in *One Woman, One Vote,* pp. 99–116; T. A. Larson, "Wyoming's Contribution to the Regional and National Women's Rights Movement," *Annals of Wyoming* 52 (1980):2–15. Three states have yet to dedicate their quota of two statues. New Mexico has selected Popé, a Native American leader, whose statue is being currently designed for installation in 2002; North Dakota is raising funds for the statue of Sakakawea slated for installation in 2003 during the 200th anniversary of the Lewis and Clark Expedition; Nevada has yet to designate a second honoree. See Barbara A. Wolanin to Alan M. Hantman, Memorandum of Oct. 12, 1999, AOC Records.

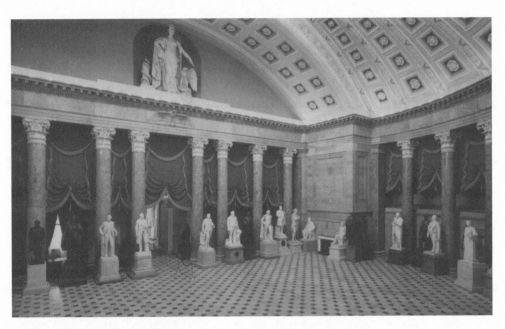

Fig. 26. National Statuary Hall. *(Courtesy Office of Architect of the Capitol.)*

behalf of women and the oppressed.[54] All too frequently, however, women honorees were characterized in designation bills and dedication speeches as "trailblazers" or "stalwart pioneers," epithets that contextualized suffrage militancy and humanitarian activism within regional traditions of Anglo-American colonization and patriarchy.[55]

Beyond the obvious disparity in the sheer number of works honoring men and women lies a more complex reality. The collection includes sixteen works by thirteen women artists, many of which were projects that launched, promoted, or enhanced the

[54]Frances Willard (1839–1898) was honored as founder of the Woman's Christian Temperance Union. Maria Sanford (1836–1920) was the first woman professor in America, a leader in adult education and an advocate for the rights of women, African Americans, and Native Americans. Dr. Florence R. Sabin (1871–1953) was a noted teacher, scientist, and author of the Sabin Health Laws. Esther Hobart Morris (1813/14?–1902), "Mother of Suffrage in Wyoming," advocated women's rights in the Wyoming Territory and was the first woman elected to public office. Mother Joseph (b. Elizabeth Pariseaux, 1823–1902) was a Catholic missionary and educator. Pacifist Jeannette Rankin (1880–1973) was the first woman elected to Congress. See *Art in U.S. Capitol,* pp. 256, 261, 271.

[55]Rankin was cited in 1985 dedication speeches for her feminist beliefs and dedication to the international peace movement; she was also described as epitomizing the "rugged individualism" and "feisty determination" of the American frontier and was hailed as "one of the great trailblazers of our time." *Dedication of the Statue of Jeannette Rankin, Rotunda, United States Capitol, Wednesday, May 1, 1985,* S. Doc. 99–32 (Washington, D.C., 1985). Mother Joseph was characterized as a "pioneer builder" in publicity and fund-raising statements. The inscription on Esther Morris's statue described her as a "stalwart pioneer" who became the nation's first woman justice of the peace. See *Art in U.S. Capitol,* p. 256. At the 1960 dedication of her statue, former Wyoming Gov. Nellie T. Ross listed Morris's achievements and described her as a "lady in the best sense of the word . . . fastidious in dress . . . (with) iron in her blood aplenty." *Acceptance of the Statue of Esther Morris . . . April 6, 1960,* S. Doc. 69 (Washington, D.C., 1961), pp. 28–34.

artists' professional careers.[56] In 1873, Anne Whitney (1821–1915) was commissioned to sculpt Massachusetts' tribute to Sam Adams, one of the first works dedicated in Statuary Hall (1876) and the first created for the new collection by a woman artist (fig. 27). Whitney's forceful interpretation of Adams as a defiant revolutionary was carved in Italy and exhibited in Boston, where a bronze replica of the statue was commissioned in 1880 for Faneuil Hall (fig. 28). Despite the overwhelming success of the Adams portrait, Whitney subsequently was denied the opportunity to sculpt Boston's tribute to abolitionist Charles Sumner due to blatant sexism among the memorial commission members. According to Wayne Craven and Charlotte Rubinstein, Whitney vowed never again to enter a memorial competition and devoted her long career to projects that advanced human rights and equal justice.[57]

Iowa's tribute to Sen. James Harlan (1910) was sculpted by Nellie Verne Walker (1874–1973), who, like her contemporaries Adelaide Johnson, Anne Whitney, and Vinnie Ream, had exhibited sculpture in the Woman's Building at the 1893 World's Columbian Exposition.[58] A protégé of Lorado Taft, Walker completed numerous private commissions and public arts projects throughout the Midwest, including the *Iowa Suffrage Memorial* (1934) for the state capitol in Des Moines.[59]

In 1878, Philadelphia sculptor Blanche Nevin (1841–1925) was awarded a commission to sculpt Pennsylvania's tribute to John P. G. Muhlenberg, "hero-priest" of the Revolution (fig. 29). Nevin dramatically portrayed Muhlenberg discarding his clerical robes to take up arms against the British monarchy.[60] A student of the Pennsylvania Academy of Fine Arts, Nevin enjoyed early success with exhibits at the 1876 Centennial

[56]Women artists represented in Statuary Hall include Anne Whitney (*Sam Adams*, 1876); Blanche Nevin (*John P. G. Muhlenberg*, 1889); Helen Farnsworth Mears (*Frances Willard*, 1905); Elizabeth Ney (*Stephen Austin* and *Sam Houston*, 1905); Nellie Verne Walker (*James Harlan*, 1910); Vinnie Ream (*Samuel J. Kirkwood*, 1913; *Sequoyah*, 1917); Belle Kinney Scholz (*Andrew Jackson*, 1928; *John Sevier*, 1931); Evelyn Raymond (*Maria Sanford*, 1958); Joy Buba (*Florence R. Sabin*, 1959); Yolande Jacobson (*Patrick McCarran*, 1960); Suzanne Silvercruys (*Eusebio Kino*, 1965); Marisol Escobar (*Joseph Damien*, 1969); and Teresa Minmaugh (*Jeannette Rankin*, 1985).

[57]Elizabeth Rogers Payne, "Anne Whitney, Sculptor," *Art Quarterly* 25 (1962):244–61; Elizabeth Rogers Payne, "Anne Whitney: Sculptures—Art and Social Justice," *Massachusetts Review* 12 (1971):245–60; Craven, *Sculpture in America*, pp. 228–32; Rubinstein, *American Women Sculptors*, pp. 45–51; Fairman, *Art and Artists*, p. 394. Sam Adams and John Winthrop were designated by the Commonwealth of Massachusetts in 1872. See *House Document No. 377, Chapter 64 of the Resolves of 1872, 93rd General Court*, approved May 6, 1872; *Congressional Record-Senate*, Dec. 19, 1876, pp. 280–84, AOC Records.

[58]*Dictionary of Women Artists*, pp. 134–36; Preato, *Genius of the Fair Muse*, pp. 13–16; Rubinstein, *American Women Sculptors*, pp. 100–102.

[59]Louise Noun, "Making Her Mark: Nellie Verne Walker," *Palimpsest* 68 (1987):160–73; Craven, *Sculpture in America*, pp. 121–23.

[60]See Simon Cameron and George De B. Keim, *Report of Statuary Commission to (Pennsylvania) Senate*, Jan. 7, 1879; *Report Concerning Pennsylvania Statuary Placed in National Statuary Hall, Washington, D.C., June 1884*; *Laws of Pennsylvania, Act No. 73*, approved Apr. 18, 1877; *Act No. 61*, approved June 7, 1881; *Congressional Record-House*, 50th Cong., 2d sess., Feb. 28, 1889, pp. 2477–2480; *Congressional Record-Senate*, 50th Cong., 2d sess., Mar. 2, 1889, p. 2618; W. W. Griest to George Peabody Wetmore, Dec. 30, 1902, AOC Records; David Sellin, "The First Pose: Howard Roberts, Thomas Eakins, and a Century of Philadelphia Nudes," *Bulletin-Philadelphia Museum of Art* 70 (1975):5–56.

FIG. 27. Anne Whitney. *(Courtesy Office of Architect of the Capitol.)*

FIG. 28. Anne Whitney, *Sam Adams,* 1876.
(Courtesy Office of Architect of the Capitol.)

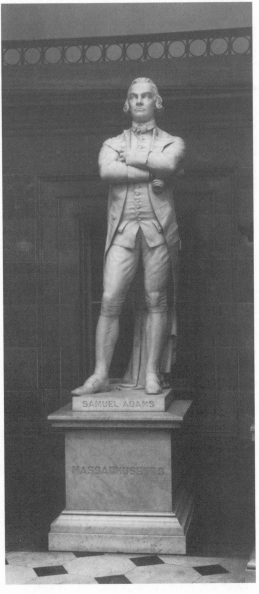

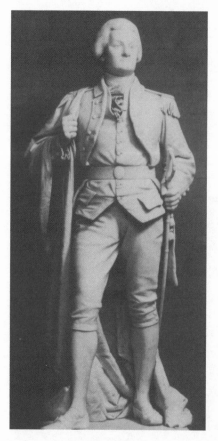

Fig. 29. Blanche Nevin, *John P. G. Muhlenberg,* 1884.
(Courtesy Office of Architect of the Capitol.)

Exposition. However, the pressures of executing a major project for the U.S. Capitol while abroad in Italy postponed dedication of the Muhlenberg statue until 1889.[61] Like its companion piece, Howard Roberts's seated figure of inventor Robert Fulton (Pennsylvania, 1883), the Muhlenberg statue received mixed reviews. Indeed, Nevin's statue was sharply criticized by Lorado Taft, who dismissed the Muhlenberg portrait as "insignificant."[62] Nevin, like Adelaide Johnson and other women artists of her generation, struggled with professional isolation and the lack of institutional patronage and support of her work.

However, by the early 1900s, the number of women's professional, cultural, and philanthropic organizations had increased throughout the country, providing an infrastructure for sponsoring, among other objectives, commemorative arts projects on the local, state, and national levels.[63] Throughout the twentieth century, women's groups initiated a number of Statuary Hall tributes to both men and women honorees, guiding these projects through the arduous commissioning and funding process to dedication in the Capitol.[64] In some instances, these groups commissioned women artists of the region or local area.

In the 1890s, the Daughters of the Republic of Texas successfully lobbied state legislators for the designations of Sam Houston and Stephen Austin and subsequently awarded these commissions to German-born feminist sculptor Elisabet Ney, who had

[61]Rubinstein, *American Women Sculptors,* pp. 87–89; Fairman, *Art and Artists,* pp. 391, 394.

[62]Rubinstein, *American Women Sculptors,* pp. 88–89; Lorado Taft, *History of American Sculpture* (New York, 1925), p. 213.

[63]Alice Sheppard, "Suffrage Art and Feminism," in *Aesthetics in Feminist Perspective,* ed. Hilde Hein and Carolyn Korsmeyer (Bloomington, 1993) pp. 77–90; Karen J. Blair, *The Clubwoman as Feminist: True Womanhood Defined, 1868–1914* (New York, 1980); Claire Richter Sherman and Adele M. Holcomb, eds., *Women as Interpreters of the Visual Arts, 1820–1979* (Westport, Conn., 1981); Kathleen McCarthy, *Woman's Culture: American Philanthropy and Art, 1830–1930* (Chicago, 1991); Karen J. Blair, *The Torchbearers: Women and Their Amateur Art Associations in America, 1890–1913* (Bloomington, 1994).

[64]The process takes, on average, six to seven years to complete. See Lachin, "'Worthy of National Commemoration,'" in Kennon, *The United States Capitol,* p. 283.

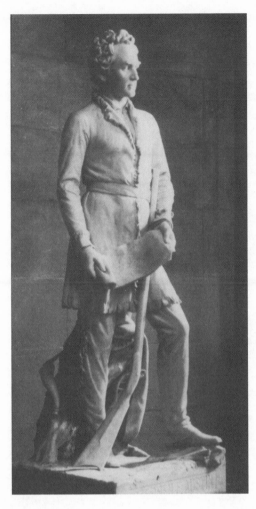

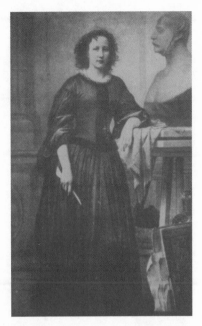

Fɪɢ. 30. Elizabeth Ney. *(Courtesy Office of Architect of the Capitol.)*

Fɪɢ. 31. Elizabeth Ney, *Stephen Austin,* 1904. *(Courtesy Office of Architect of the Capitol.)*

immigrated to Texas in 1873 (figs. 30 and 31).[65] Following Ney's death in 1907, the Daughters of the Republic of Texas purchased her Austin studio and converted it into a "Texas shrine."[66]

During the same period, leaders of the National Woman's Christian Temperance Union lobbied Illinois legislators to designate temperance crusader Frances Willard (1839–1898), the first woman honored in National Statuary Hall (fig. 32). Under the determined leadership of Anna A. Gordon, Willard's secretary and confidante, the

[65]Rubinstein, *American Women Sculptors,* pp. 80–87. For information on the statues of Austin and Houston, see *S.C. Res. No. 17, Concurrent Resolutions, Texas Legislature, 25th Legislature,* approved Apr. 3, 1897; *General Laws of Texas, H.C. Res. No. 1, 28th Legislature,* adopted Jan. 16, 1903, and enrolled Jan. 17, 1903, pp. 238–39; *General Laws of Texas, General Appropriations Bill, first called sess., 28th Legislature,* approved, May 15, 1903, pp. 72–75; *Congressional Record,* 57th Cong., 2d sess., Jan. 12, 1903; A. J. Burleson to Elliott Woods, Dec. 27, 1904; Mrs. Joseph B. Dibrell to Elliott Woods, July 3, 1904; Elliott Woods to Mrs. Joseph B. Dibrell, Nov. 10, 1904, and Mar. 23, 1905; *Statues of Sam Houston and Stephen F. Austin Erected in Statuary Hall of the Capitol Building at Washington: Proceedings in the House of Representatives on the Occasion of the Reception and Acceptance of the Statues from the State of Texas* (Washington, D.C., 1905), AOC Records.

[66]Rubinstein, *American Women Sculptors,* p. 87.

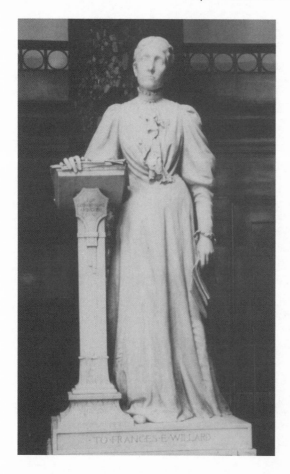

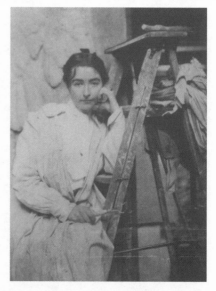

Fig. 32. Helen Farnsworth Mears, *Frances Willard*, 1905. *(Courtesy Office of Architect of the Capitol.)*

Fig. 33. Helen Farnsworth Mears. *(Courtesy Office of Architect of the Capitol.)*

marble statue was dedicated in 1905 and is generally regarded as Helen Farnsworth Mears's finest portrait (fig. 33). She depicted the famed temperance leader in a characteristic pose, gathering her thoughts at the speaker's podium before delivering an address. Following the dedication, Augustus Saint-Gaudens, Mears's former teacher, praised the Willard portrait as "strong as a man's work [and] exceedingly rare and spiritual."[67]

Throughout the New South of the 1920s and 1930s, chapters of the United Daughters of the Confederacy and Daughters of the American Revolution helped coordinate

[67]Saint-Gaudens's comments on the Willard statue are quoted in Rubinstein, *American Women Sculptors,* pp. 130–31. For information on the Willard statue commission, see Fairman, *Art and Artists,* p. 445; *Journal of the House of Representatives,* 58th Cong., 3d sess., Feb. 17, 1905, p. 335; Anna A. Gordon to Elliott Woods, Dec. 31, 1904; *Statue of Miss Frances E. Willard Erected in Statuary Hall of the Capitol Building at Washington: Proceedings in the Senate and House of Representatives on the Occasion of the Reception and Acceptance of the Statue from the State of Illinois* (Washington, D.C., 1905); *Congressional Record-House,* 58th Cong., 3d sess., Feb. 17, 1905, pp. 2801–9; Mary Earhart, *Frances Willard: From Prayers to Politics* (Chicago, 1944), pp. 1–3, 385–87, AOC Records.

designations of antebellum statesmen (*John Calhoun,* South Carolina 1910; *Wade Hampton,* South Carolina, 1929), occasionally providing important commissions for women artists, such as Belle Kinney Scholz, who sculpted Tennessee's tributes to Andrew Jackson (1928) and John Sevier (1931).[68] Colorado's 1959 statue of medical researcher Dr. Florence R. Sabin was sculpted by New York artist Joy Buba and sponsored by the Colorado Division of the American Association of University Women (AAUW), which raised $15,000 in private contributions to fund the Sabin tribute (fig. 34).[69] The AAUW, Missoula Women for Peace, and other women's organizations coordinated Montana's 1983 designation of pacifist Jeannette Rankin, the first woman elected to serve in Congress (1916). Following a statewide design competition, Teresa Minmaugh, a native of Great Falls, Montana, was selected to sculpt Rankin's statue (fig. 35).[70]

In other areas of the country, women have demonstrated the same persistence and dedication as the 1990s "Raise the Statue" campaign. The Minnesota Federation of Women's Clubs lobbied nearly twenty years to obtain the designation of Professor Maria L. Sanford, insisting that Minnesota legislators appropriate public funds for the Sanford tribute as their predecessors had in 1913 for the statue of Sen. Henry Mower Rice (1916).[71] Sanford's statue was dedicated in 1958 and is the work of Evelyn

[68]For information on the statues of John Calhoun and Wade Hampton statues, see *Proceedings in Statuary Hall and the Senate and House of Representatives upon the Unveiling, Reception, and Acceptance from the State of South Carolina of the Statue of the Honorable John C. Calhoun, March 12, 1910,* pp. 19–20; Charles E. Lee to J. George Stewart, Mar. 27, 1963; *Acts and Joint Resolutions of the General Assembly of the State of South Carolina, 1927,* p. 696; *J. Res. No. 268,* approved Apr. 9, 1927, p. 696, AOC Records. For information on the statues of Andrew Jackson and John Sevier, see *Chapter 119, Senate Bill No. 359, Public Acts of the General Assembly of the State of Tennessee for 1925,* passed Apr. 10, 1925; *Program of Exercises Attending the Unveiling of the Statue of General Andrew Jackson, Seventh President of the United States, in Statuary Hall, of the National Capitol, Washington, D.C., Sunday Afternoon, April 15, 1928, at Three O'clock;* 70th Cong., 1st sess., H. Doc. 430, *Statue of Andrew Jackson Presented to the United States by the State of Tennessee: Proceedings in Congress and in Statuary Hall* (Washington, D.C., 1929); 72d Cong., 1st sess., H. Doc. 101, *Acceptance and Unveiling of the Statue of General John Sevier Presented by the State of Tennessee: Proceedings in Congress and in Statuary Hall, United States Capitol* (Washington, D.C., 1932); "President Extols Andrew Jackson's Nationalist Spirit," *Washington Post,* Apr. 16, 1928; Blanche Scott Jackson, "Southern Personalities: Belle Kinney, Sculptor," *Holland's,* May 1935, AOC Records.

[69]*Acceptance of the Statue of Doctor Florence Rena Sabin Presented by the State of Colorado: Proceedings in the Congress and in the Rotunda, United States Capitol,* 85th Cong., 2d sess., S. Doc. 132 (Washington, D.C., 1959); *The Presentation of the Statue of Dr. Florence Rena Sabin of Colorado in the Rotunda of the National Capitol, Thursday, February 26 (1959),* program brochure; Joy Buba, "Artist's Statement Prepared for Mrs. Florian Thayn of the Architect of the U.S. Capitol's Art and Reference Library, Winter 1973"; "Statue of Woman Doctor to Be Unveiled in Capitol," *Washington Post and Times Herald,* Feb. 23, 1959; "Statue Honors Woman Scientist," *New York Times,* Feb. 27, 1959; Elizabeth Ford, "Colorado Immortalizes Woman Doctor," *Washington Post and Times Herald,* Feb. 27, 1959, AOC Records.

[70]*Dedication of the Statue of Jeanette Rankin, Rotunda, United States Capitol, Wednesday, May 1, 1985, 11:00 A.M.; Jeannette Rankin, Dedication of Sculpture, The Rotunda, United States Capitol, Washington, D.C., 11 A.M., May 1, 1985, Program of Dedication Ceremonies,* 99th Cong., 1st sess., S. Doc. 99–32; "The Hill's Newest Statue," *Roll Call,* May 5, 1985; Norman Smith, "Lost Women: The Woman Who Said No to War—A Day in the Life of Jeannette Rankin," *Ms. Magazine,* Mar. 1986, pp. 86, 88–89, AOC Records.

[71]Henry Mower Rice (1816–1894) was designated by the Minnesota legislature in 1913; $7,500 in state funds was appropriated for the Rice sculpture. See *38th Sess. (1913), General Laws, Chapter 583, H.F. no. 1246, Section 15,* approved by Governor Apr. 28, 1913.

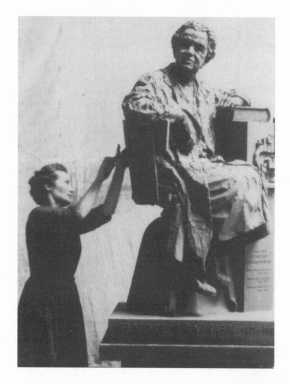

Fig. 34. Joy Buba and statue of Florence R. Sabin. *(Courtesy Office of Architect of the Capitol.)*

Fig. 35. Teresa Minmaugh and statue of Jeannette Rankin. *(Courtesy Office of Architect of the Capitol.)*

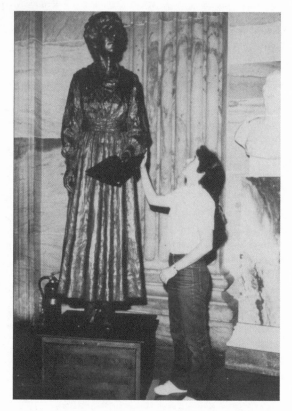

FIG. 36. Evelyn Raymond. *(Courtesy Office of Architect of the Capitol.)*

Raymond, "dean of Minnesota women sculptors" (fig. 36).[72] In 1960, the Wyoming House of Representatives designated suffragist Esther Hobart Morris to represent the "Equality State" in Statuary Hall. The bill was guided through the House by Rep. Edness Kimball Wilkins and Nellie Tayloe Ross, the nation's first elected woman governor. When the Morris designation stalled in the Wyoming Senate, women throughout the state sent an avalanche of telegrams protesting the recalcitrance of their state senators, demanding immediate passage of the bill. It was quickly reintroduced and passed the Senate with only one dissenting vote.[73]

Conclusions, 1997–2001

In the five years since the *Portrait Monument* was rededicated in the Capitol rotunda, members of the "Raise the Statue" coalition have coordinated plans for a National Museum of Women's History, and the National Park Service has inaugurated women's history projects at various sites throughout the country (fig. 37).[74] In 1998, the 150th anniversary of the 1848 Women's Rights Convention was celebrated in Seneca Falls, New York, while Congress debated several proposals to reissue the Susan B. Anthony

[72]*Acceptance of the Statue of Maria L. Sanford Presented by the State of Minnesota: Proceedings in the Congress and in the Rotunda, United States Capitol,* 86th Cong., 2d sess., S. Doc. No. 134 (Washington, D.C., 1960), pp. xvi–xviii, 1–9, 31, 40–42; *Maria L. Sanford Statue, Program for Unveiling Ceremony, Rotunda of United States Capitol, Washington, D.C., November 12, 1958, 2:00 P.M.,* AOC Records.

[73]*Senate Report No. 625, Statue of Esther Morris Presented by the State of Wyoming for the National Statuary Hall Collection, August 6, 1959,* 86th Cong., 1st sess.; *Acceptance of the Statue of Esther Morris Presented by the State of Wyoming: Proceedings in the Congress and in the Rotunda, United States Capitol, April 6, 1960,* 86th Cong., 1st sess., S. Doc. 69 (Washington, D.C., 1961), pp. 40–43; "To Women's Rights Statue Adds Stature," *Washington Post,* Apr. 3, 1960, F8, AOC Records.

[74]The National Museum of Women's History was launched in 1996–97 by Karen Staser and Joan Meacham, leaders of the "Raise the Statue" campaign. Interview with Joan Meacham and Karen Staser, July 30, 1996, Arlington, Va.

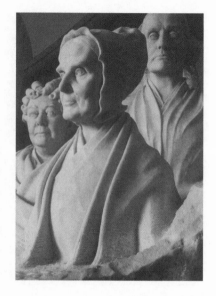

Fig. 37. *Portrait Monument. (Courtesy Office of Architect of the Capitol.)*

dollar of the 1970s and commemorate other aspects of the suffrage movement.[75] At the same time, liberal feminism ("women's lib") of the 1960s and 1970s has been redefined by a new generation of women's rights advocates, while state and federal lawmakers have grappled with the politics of welfare reform, day care, abortion and reproductive rights, and a host of other gender-related issues.[76]

Launched in the 1920s, the Equal Rights Amendment has lapsed into relative obscurity, but women's history has migrated from the margins to the mainstream of public discourse, where it is variously appropriated by an array of feminist ideologies.[77] Karen Staser, who helped coordinate the "Raise the Statue" campaign, is closely involved with the proposed National Museum of Women's History, a project she envisions as "present[ing] a more balanced view of women's history [that will] restore the women's movement to mainstream American culture."[78] In June 1997, the Catholic Alliance featured a full-page reproduction of Adelaide Johnson's *Portrait Monument* in a *Washington Times* advertisement condemning "partial-birth" abortions and calling for a federal ban on the controversial procedure.[79] Alternately, former First Lady Hillary Rodham

[75]Bill McAllister, "Congress May Consign Susan B. Anthony (Dollar) to History," *Washington Post,* Nov. 13, 1997, A21; "Congress Requests Redesign of $1 Coin," *Washington Post,* May 25, 1998, A25; Bill McAllister, "Few Votes for Suffragette: Susan B. Anthony Garners Little Support as Panel Ponders New Design for Dollar Coin," *Washington Post,* June 9, 1998, A12. Ultimately Native American guide Sakakawea was chosen for the new one-dollar coin. See "A Guide to New Dollar," *Washington Post,* May 5, 1999, A29; Kathleen Day, "Sacajawea Comes Up Tails: Public Prefers Paper Bill to Ballyhooed Dollar Coin," *Washington Post,* January 26, 2001, A1,16.

[76]"Poll Shows Women Moving to Right," *Washington Post,* Jan. 29, 1999, A5; Karen J. Winkler, "Constitutional History with a Difference: Studying Women's Civic Obligations," *Chronicle of Higher Education,* Sept. 18, 1998, A17–18; Ginia Bellafonte, "Is Feminism Dead?" *Time,* June 29, 1998, pp. 54–62; Judy Mann, "A Watershed Election for Women's Rights," *Washington Post,* Oct. 27, 2000, C1; Barbara Vobejda, "Child Care Initiative Triggers 'Mommy Wars,'" *Washington Post,* Jan. 26, 1998, A4.

[77]Nancy F. Cott, "Historical Perspectives: The ERA Conflict in the 1920s," in *Conflicts in Feminism,* ed. Marianne Hirsch and Evelyn Fox Keller (New York, 1990), pp. 44–59; Jane J. Mansbridge, *Why We Lost the ERA* (Chicago, 1986).

[78]Karen Staser comments excerpted from *Program Brochure, "Raise the Statue" Fund-Raising Reception, July 25, 1996;* National Museum of Women's History, mission statement and supplemental materials, in the author's collection.

[79]*Washington Times,* May 15, 1997, A5; *Roll Call,* May 19, 1997; Jane Abraham, "Susan B. Anthony's Pro-Life Stand" (letter to the editor), *Washington Post,* July 12, 1997, A19; Dan Balz, "Abortion Debate Endures as Staple of American Politics," *Washington Post,* Jan. 18, 1998, A4.

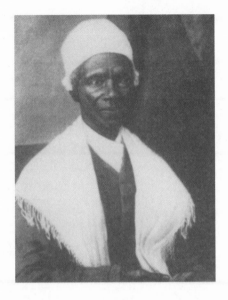

F‍ɪ‍ɢ‍. 38. Sojourner Truth. *(Courtesy Library of Congress.)*

Clinton praised Elizabeth Cady Stanton and Susan B. Anthony as role models of liberal feminism and urged American women to adopt a more aggressive stand on equal employment, health care, and political reform, all of which she cited as consistent with the spirit of the nineteenth-century suffrage crusade.[80]

Discourse on women's history and its relevance to contemporary social issues, while contested, is essential to the construction of public memory in an open democratic society. But our abiding preoccupation with the national leadership of the suffrage crusade glorifies the elites of that movement and tends to perpetuate traditional, even patriarchal, standards of public commemoration. It also fosters a more or less coherent, if not linear, narrative of women's history that minimizes the internal conflicts and historical complexities of the suffrage movement and effectively marginalizes individuals, groups, and minority constituencies (for example, African American suffragists) that contributed to the effort.

Having obtained a "place of honor" for American women in the Capitol rotunda, we can now diversify the scope and content of public discourse on women's history and situate the *Portrait Monument* within the context of women's artistic achievements, professionalism, and commemorative enterprise. In the process, we must direct our energies toward the continued protection and *extension* of equal rights, as we come to redefine them, and cultivate a multicultural understanding of women's history that extends outward toward alternate contexts, dimensions, and locations. Perhaps in the near future we will create a place for Truth in the Capitol, thus making the "People's House" a truly inclusive and gendered space (fig. 38).

[80]John F. Harris, "Hailing Early Feminists, First Lady Urges Women to Keep History Alive," *Washington Post,* Jan. 17, 1998, A3; Michael Grunwald, "Hope, Thy Name Is Hillary, In One Hurting New York Mill Town," *Washington Post,* Mar. 3, 1999, A3.

The United States Capitol Rotunda
and the Decoration of
the State Capitols, 1870–1930

Francis V. O'Connor

AT THE BEGINNING OF HITCHCOCK AND SEALE'S MAGISTERIAL STUDY OF OUR state capitols, *Temples of Democracy,* it is asserted that "skyscrapers and state capitols are America's unique contribution to monumental architecture."[1] If the authors had had as acute an eye for art as they had for architecture, it would be understood that our state capitols have also provided the setting for some of this country's greatest wall painting. The precedent for this was, of course, set at the U.S. Capitol —where our truly monumental mural art first began—and was then more or less emulated during the second and third waves of capitol building that extended from just after the Civil War to the early decades of the twentieth century.

The decoration of these state capitols was primarily influenced by the rotunda of the national Capitol.[2] Its lower walls contain the eight great history paintings created between 1817 and 1855 (fig. 1). These huge paintings on canvas were so installed that they are in effect murals, being set into the walls in trompe l'oeil frames in the manner

[1] Henry Russell Hitchcock and William Seale, *Temples of Democracy: The State Capitols of the U.S.A.* (New York, 1976), p. 3.

[2] State capitol murals are almost always concentrated in their rotundas. Also, while many state capitols contain murals in various meeting and reception rooms, the governor's office, and the legislative chambers, murals on ceilings and in hallways similar to those found in the U.S. Capitol are very rare.

FIG. 1. East wall of U.S. Capitol rotunda showing, *left to right,* Robert Walter Weir, *Embarkation of the Pilgrims at Delft Haven, Holland, July 22nd, 1620* (1843); John Vanderlyn, *Landing of Columbus at the Island of Guanahani, West Indies, October 12th, 1492* (1847); and William Henry Powell, *Discovery of the Mississippi by De Soto in 1541* (1855). *(Courtesy U.S. Capitol Historical Society.)*

of the overmantels of the day.[3] Constantino Brumidi conceived his murals for the upper parts of the rotunda between circa 1855 and 1859, integrating his iconographic program with the existing history paintings.[4] His dome was executed during the Civil War from 1863 to 1865, and most of the frieze from 1877 until his death in 1880. It was later finished by Filippo Costaggini and Allyn Cox.

It would be incorrect to make any claim that the influence of the U.S. Capitol's rotunda on the state capitols was specific or direct. Rather, the core of the national Capitol became a model and an inspiration for several generations of mostly Beaux Arts architects and artists to build and decorate somewhat dissimilar spaces in the state capitols.

For instance, the U.S. Capitol's central extension upward to the dome (fig. 2) was erected directly upon the original rotunda that was based on the Roman Pantheon, and not on the Renaissance basilica—such as St. Peter's. This latter model, however, became the favorite that the Beaux Arts capitol builders emulated after about 1870. One observes, in consequence, that in the state capitols there is no example of a continuous frieze encircling the drum of the dome, due to the arches used to uphold Baroque

[3]This and other interpretive comments passim, unless otherwise noted, are taken from the text of my work in progress, "The Mural in America: Wall Painting from Native America to Postmodernism."

[4]See the author's "Symbolism in the Rotunda" in Barbara A. Wolanin, *Constantino Brumidi: Artist of the Capitol* (Washington, D.C., 1998), pp. 140–55.

FIG. 2. View looking up
from the northwest into the
extended dome of the U.S.
Capitol showing Constantino
Brumidi's *Apotheosis of Wash-*
ington (1859–62) in the dome,
and at the bottom a section of
his *Frieze of American History*
(1859–80). *(Courtesy U.S. Capitol*
Historical Society.)

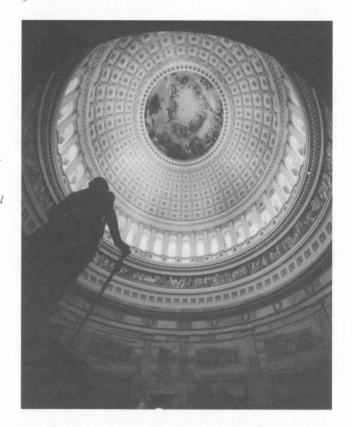

domes—and which form monumental entrances to the often vast naves that extend
from the rotunda to the legislative chambers, supreme court, and executive offices. The
frieze was thus replaced by pendentives that required more or less discrete rather than
continuous images—or at best by a running inscription in the entablature.[5]

Further, state capitols acquired their murals and decorations over the years by hit-
or-miss processes no different than those by which legislation is crafted into law amid
the throes of political contention, connivance, and compromise. The only difference is
that while bad law can be repealed or ruled unconstitutional, bad art is seldom even
recognized as such. As a result, most of our state capitols are burdened with some of
the best and worst of our murals. In general, most of the academic murals in place
when these buildings first opened tend to be artistically competent; later murals, espe-
cially those painted after 1945, are most often failures as wall paintings—for reasons that
shall be discussed. All, of course, are of the greatest historical and cultural relevance,
whatever their worth as art, since they tell us what their patrons chose to make per-
manent in the seat of their government.

There is also the intractable problem of inadvertent vandalism caused by the chang-

[5]See Eric Oxendorf (photographs) and William Seale (text), *Domes of America* (San Francisco, 1994), for nu-
merous photographs illustrating the quadripartite organization of these domes that results in the mural spaces
usually being limited to the pendentives and dome canopy.

Fig. 3 Diagrams of the architectural elements found in most state capitols built between 1870 and 1920 showing typical mural placements indicated by dark gray tone. *(Courtesy of the author.)*

ing function of spaces, incompetent restoration, and mindless renovation—air conditioning ducts and fluorescent lights being the chief offenders here. One of the many reasons academic murals in Beaux Arts buildings have been condemned outright as bad art is because, until very recently, they were only seen lit by color-erasing lights through scrims of dirt. Fortunately, in many instances these conditions have been corrected—one thinks especially of Dr. Barbara Wolanin's heroic and successful efforts at the U.S. Capitol and Library of Congress, and the recent restorations of the Pennsylvania Capitol at Harrisburg and the Wisconsin Capitol at Madison.[6]

LET ME TURN to a description of the typical state capitol (fig. 3). For the most part, it follows the general plan of the U.S. Capitol, with a central rotunda and two lateral wings for the legislative chambers. Occasionally, as at Kentucky, Minnesota, and Wisconsin (the latter has four wings), there is a space for the supreme court.

The central rotunda typically contains lower and upper levels connected visually by a well centered directly beneath the dome.[7] Murals are usually confined to lunettes, pendentives, and domes—and some of these buildings have secondary domes in their

[6]Unfortunately, those who may have glimpsed the unrestored state of things are not likely to correct entrenched views by going back to take another look—and those misjudgments, mixed with modernist prejudices against communal art projects, and postmodernist biases based on political and gender issues, stand against one of the most productive eras in the history of the American mural—specifically that between 1875 and 1930. But this unfortunate situation should change when a new generation of students rebels against subjective ideological interpretation and gets back to objective scholarship.

[7]The lower rotunda at the U.S. Capitol, of course, was first meant to be George Washington's tomb—and when that did not happen, Trumbull at one point envisioned stairs from it leading up to what would have been a virtual panorama of his history paintings. See Egon Verheyen, "John Trumbull and the U.S. Capitol: Reconsidering the Evidence," in Helen A. Cooper, *John Trumbull: The Hand and the Spirit of a Painter* (New Haven, 1982), pp. 260–71, especially figs. 115 and 116, p. 267.

two wings that are similarly decorated. Standing in the typical regional capitol's lower rotunda, one sees murals painted on its surrounding walls, or vaulted ceiling, and through the well the great pendentives and canopy murals of the upper tower and dome. Extending laterally on both levels from the rotunda are two halls that may contain lunettes with murals. Climbing the stairs at either end of these galleries to the level of the legislative chambers and upper rotunda reveals occasional murals in the stairwells. Murals are also located on the walls of the chambers behind the rostrum, on the walls and ceilings of the governor's ceremonial office, in the lounge areas of both chambers, and occasionally in the supreme court chamber. These murals, needless to say, can teach us a great deal about the social and political history of this country. They span close to a century and demonstrate the evolution of the academic and modern mural through two generations of wall painters.

BEFORE 1855, of course, it was hardly necessary to speak of "generations" of muralists, since there were very few individuals who engaged in the art form and only three individuals can be considered prominent and productive. The first, Michele Felice Cornè (1752–1845), who was born on the island of Elba, painted murals at Salem, Boston, and Newport through about 1822 and died in 1845. The second, Rufus Porter (1792–1884), painted walls with a group of itinerant muralists between 1824 and 1845 along the east coast from New England to Virginia.[8] Only Constantino Brumidi (1805–1880), born and trained in Italy, spent most of his career as a mural painter, working in Philadelphia, Baltimore, and New York—as well as at the national Capitol between about 1855 and 1880.[9]

There was not, however, anything resembling a generation of experienced and stylistically consistent muralists in this country until the last quarter of the nineteenth century, when there was a marked increase in mural activity. But it was slow to develop,

[8]For Cornè, see Edward B. Allen, *Early American Wall Painting: 1710–1850* (New Haven, 1926), pp. 26–45, and Philip Chadwick Foster Smith, *Michele Felice Cornè, 1752–1845: Versatile Neapolitan Painter of Salem, Boston, and Newport* (Salem, Mass., 1972). For Porter, see Jean Lipman, *Rufus Porter Rediscovered: Artist, Inventor, Journalist, 1792–1884* (Yonkers, N.Y., 1980).

[9]See Wolanin, *Brumidi: Artist of the Capitol,* passim. Thanks to this book, the history of the mural in the United States can now be construed to begin in earnest with Constantino Brumidi. During the first half of the nineteenth century there was really no monumental mural painting done here until Brumidi began working at the Capitol in 1855. After the completion of most of his projects at the Capitol in 1865, he returned to a number of murals and easel paintings for St. Stephen's in New York City. Brumidi's splendid *Crucifixion* mural there is signed and dated 1868. He also created a similarly fine *Crucifixion* at the Church of the Holy Innocents, also in New York City, in the early 1870s. Both of these murals were the centerpieces of extensive mural decorations throughout both churches that are similar to those in the U.S. Capitol. Given the dates, extent, and quality of these works, it can no longer be claimed that serious American mural painting began with John La Farge's decorations at Trinity Church in Boston in 1876–78 or with William Morris Hunt's contemporaneous murals for the New York State Capitol at Albany in 1878. Brumidi has twenty years priority on that claim, what with his extensive work at the Capitol, his many other mural commissions, and his work at St. Stephen's and Holy Inno-

with the first great concentration of activity taking place in the 1890s, starting with the Columbian Exposition at Chicago in 1893.[10]

As a result, and with a few exceptions, most of the muralists active around 1900 did not get to paint a major wall until they were in their forties or older.[11] This says something about the patronage of the time—and may also imply the mature experience needed to undertake a mural. Yet, again with a few exceptions, none of the academic artists who engaged in mural painting during this period were specifically trained in the art form either in Europe—where many had studied at the Ecole des Beaux Arts —or here. They learned from experience and common sense—impelled perhaps by the Progressive era's sense of social brotherhood and aesthetic idealism that anticipated in its way the ideological commitment of the 1930s generation—so that those best inclined to the large scale and environmental conceptualization required in the muralist's craft found their skills and opportunities.

The first generation of academic muralists was born in the mid- to late 1840s to mid-1850s. This can justly be called Edwin Howland Blashfield's generation, his life spanning from 1848 to 1936 (fig. 4). Indeed, he lived long enough to condemn the WPA![12] It also spanned the second generation, which began for the most part in the 1860s and might well be named after the Welshman Sir Frank Brangwyn (1867–1956) (fig. 5), who would influence and expand the development of the academic tradition through the 1930s—his last American wall being at Rockefeller Center in New York City.[13]

A third generation, which took a modified academic tradition into the modernist and New Deal eras, was born in the 1880s and is the cohort of Regionalists Thomas Hart Benton and James Steuart Curry, who worked in the Missouri (1936) and Kansas (circa 1938) state capitols, respectively (see figs. 7 and 16).

A fourth generation, born in the early 1900s, can be identified with the 1930s and the New Deal era. It boldly rejected academic conventions for modernist innovations

cents. Any comparison of his two Crucifixion murals with La Farge's comparable *Ascension* of 1888, in New York's Episcopal Church of the Ascension, all of which cover the entire wall behind the altar, will show artists of comparable skills and command of the mural as an art form. Indeed, the question now is, What did La Farge, a Roman Catholic, learn from Brumidi? If one takes into account that Brumidi, and his assistants, were also decorating the rest of the churches with trompe l'oeil decorations and murals, one would have to say that these churches rivaled the Capitol in a splendor that recent restorations by Constance S. Silver are just beginning to reveal. For St. Stephen's, see Judith H. Dobrzynski, "Saving a Master's Murals at a Manhattan Church," *New York Times,* Sept. 24, 1997, pp. E1, 6.

[10]For an overview of this era, see Brooklyn Museum, *The American Renaissance,* exhibit catalog (New York, 1979).

[11]A few, such as Edwin Blashfield and John La Farge, did murals for private residences earlier.

[12]For his murals, see Leonard N. Amico, *The Mural Decorations of Edwin Howland Blashfield, 1848–1936* (Williamstown, Mass., 1978).

[13]For his murals, see Vincent Galloway, *The Oils and Murals of Sir Frank Brangwyn* (Leigh-on-Sea, England, 1962).

FIG. 4. Edwin Howland Blashfield, *The Evolution of Civilization* (1897). Mural in the collar of the dome of the Library of Congress showing Abraham Lincoln as the allegory of America. *(Courtesy Library of Congress.)*

—and ultimately led to the final important generation of Community Muralists who came into their own during the 1960s.

Neither of these last two generations, of course, had anything to do with state capitols, for the simple reason there were hardly any new state capitols to decorate. Indeed, state capitol murals are essentially the product of the period of Edwin Howland Blashfield's and Frank Brangwyn's generations of wall painters. Their styles saw an evolution in these decorations marked by a subtle change in the academic understanding of allegory.[14] Listen, for instance, to Blashfield, in 1916, defining the idea of Decorative Art:

> Decoration . . . is essentially fitted to its purpose, to its locality . . . and to its environment. Deriving from a common origin with the words decorum and decorous, it is something suited to something else. . . . Decorative Art is at once an embellisher, a celebrant and a recorder. It records the happenings of the state, it lends significance to the walls, it celebrates actions and immortalizes the features of worthy citizens. . . . In sum, mural painting is an integral and essential part of that public and municipal art which is a public and municipal educator.[15]

Thus, the way Blashfield thinks, *Decorative Art*—capitalized—takes on a metaphysical existence and agency similar to a personification of Beauty, Justice, or Commerce. The

[14]Richard Murray of the Smithsonian American Art Museum first pointed this out to me in conversation.
[15]*The Brochure of the Mural Painters: A National Society* (New York, 1916), pp. 7, 10.

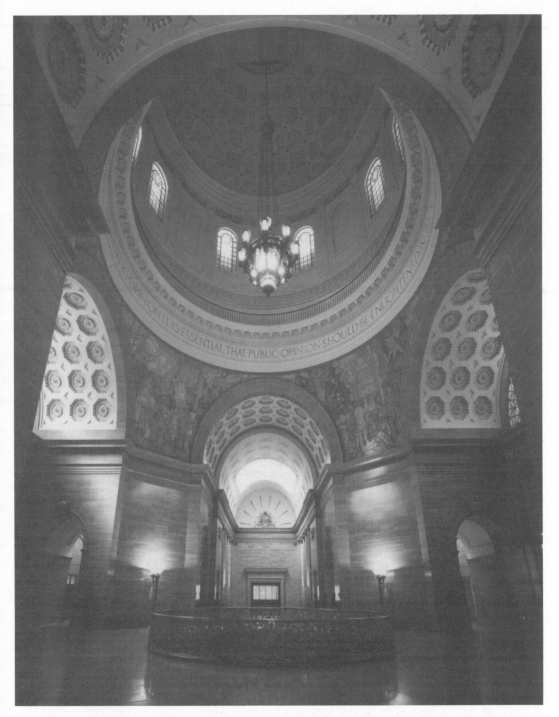

Fig. 5. Sir Frank Brangwyn. View of murals (1919–25) in the pendentives of the upper rotunda, Missouri State Capitol, Jefferson City. Photograph by Lloyd Grotjan. *(Courtesy Full Spectrum Photo.)*

abstract idea exists as a Platonic form, from which all examples of it are akin to those famous tables that flow from the Idea of Table. This was the essence of the "Classic Point of View" that Kenyon Cox wrote so eloquently about in his book of that title,[16] and which filled our state capitols with allegories of Ceres, the goddess of Agriculture; Hermes, god of Commerce; and Vulcan, god of forging railroad tracks.

Needless to say, wherever you find a Platonist, there is an Aristotelian hiding in the bushes—here, literally, Sir Frank Brangwyn astir in his bosky Art Nouveau dell. He and his generation of academics wanted to bring allegory back down to earth. He naturally thought that if one were going to "embellish the background of life as a municipal educator," one ought to use more generally recognizable images that did not presume a classical education. Thus the Goddess of Agriculture became a rustic farm wife; the four elements became, not goddesses holding attributes such as a trowel, fan, torch, and pitcher, but ordinary people plowing, running a windmill, starting a fire, or going fishing. This more democratic form of allegory began in the early twentieth-century and paralleled other social developments—such as the transition at the Metropolitan Opera from Wagner's heavily symbolic *gesamtkunstwerks* to the *verismo* of Verdi and Puccini. It can also be found in the institutional structures of Freemasonry—the guiding spiritual force, by the way, behind Blashfield's generation—from a very secretive and ritualistic society to an organization devoted to a greater popular outreach and philanthropy.

That said, let us turn to a century's worth of major state capitols beginning in 1869, just a bit after Brumidi finished his rotunda dome—when we find a new concept of the rotunda in the first state capitol to be erected in the post–U.S. Capitol era.

Kansas State Capitol (1869–1903)

The Kansas State House grew in stages from the years just after the Civil War, with its east wing completed about 1870, the west one in 1880, and the central rotunda and dome by 1903—although most of the interior was completed about seven years earlier.[17] It is plain that the architect(s) were looking in general at the exterior of the U.S. Capitol, but the interior articulation smacks of a certain eclecticism more in keeping with the taste of the 1870s.

The rotunda area conforms to the general pattern of lower and upper levels, and

[16]Kenyon Cox, *The Classic Point of View* (1911; reprint ed., with introductory notes by Pierce Rice and Henry Hope Reed, New York, 1980).

[17]Information taken from *Kansas Capitol Square,* color brochure published by Bill Graves, Secretary of State, ca. 1987.

F<small>IG</small>. 6. Crossman and Study, Chicago. *Plenty* (1902). Allegory on north side of rotunda, Kansas State Capitol, Topeka. *(Photograph by the author.)*

the history of its murals dates from 1898. I put it that way because the first set of decorations placed in the soffit under the dome were commissioned when the legislature was controlled by the Populist party. These were created by a certain Jerome Fedeli, whose presumably populist designs included nude Grecian women—or "naked telephone girls," as they were described in a later Republican denunciation. That party took over Kansas in 1902, and, in keeping with its economic principles, employed not an individual artist but a Chicago decorating company, Crossman and Study. Its artisans removed Fedeli's work and painted the present, fully clothed allegories of *Knowledge* flanked by *Religion* and *Temperance, Power* consorting with veterans of the Civil and Spanish wars, *Plenty* (fig. 6) dependent on *Agriculture* and *Labor,* and *Peace* graciously permitting *Art* and *Science.*[18]

There are 1930s murals by John Steuart Curry (fig. 7) on the second floor,[19] and a number of mural panels by Lumen Martin Winter were installed in 1978 in the spaces that Curry never filled because of his dispute with the legislature.[20]

[18]See ibid., p. 25, for color reproductions.
[19]See M. Sue Kendall, *Rethinking Regionalism: John Steuart Curry and the Kansas Mural Controversy* (Washington, D.C., 1986).
[20]See *Kansas Capitol Square,* pp. 18–19, for color reproductions.

FIG. 7. John Steuart Curry. *The Tragic Prelude [John Brown]* (1937–42). Mural in corridor off rotunda, Kansas State Capitol, Topeka. *(Photograph by the author.)*

In general, I would have to say that the art in the Topeka state capitol is among the poorest to be found in any such building I have seen. A true mural is supposed to define the purpose of a space. Aside from the rather awkwardly placed, commercial designs of the academic lunettes tucked into the soffit under the dome—that at least make some sort of statement concerning prevailing civic ideals—the rest of the wall paintings, including Curry's, are typical of artists working within an individualistic, modernist easel-painting tradition and who more or less bridle at the idea of conforming their vision to that of their patrons. Of course, Kansas legislators seem to have been more than cantankerous, but we shall see this problem in other places, where modernist artists with no understanding of decoration in its deeper, academic sense of decorum and appropriateness failed at an art form that requires a truly communal and environmental sensibility.

Pennsylvania State Capitol (1898–1907)

One of the country's most spectacular academic mural ensembles is to be found in Joseph Miller Huston's Pennsylvania state capitol at Harrisburg. It was created in the first quarter of the twentieth-century by Edwin Austin Abbey (1865–1937), who

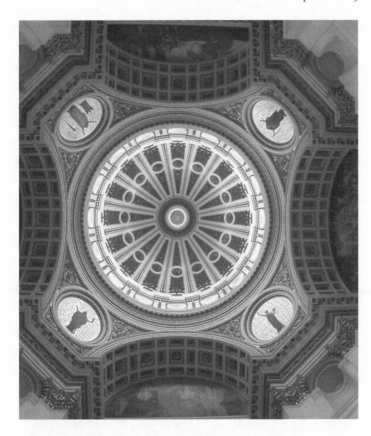

FIG. 8. Edwin Austin Abbey. View of murals in rotunda of the Pennsylvania State Capitol, Harrisburg (1908–10). *Clockwise from lower left,* the pendentives represent *Science, Religion, Law,* and *Art; bottom lunette, Religious Liberty; upper lunette, Science and the Earth.* Photograph by Steve Miller. *(Courtesy Steve Miller Productions.)*

worked there between 1908 and 1910,[21] and Violet Oakley (1874–1961), whose many contributions span 1905 to 1925.[22]

Pennsylvania-born Edwin Austin Abbey's work is found in the rotunda and the chamber of the House of Representatives. His rotunda (fig. 8) consisted of four huge lunettes and four medallions on the pendentives. On entering the rotunda, one is faced on the east with a lunette depicting *The Spirit of Religious Liberty, Accompanied by Faith and Hope Guiding the Ships of the Early Settlers to the New World.* To the south is *The Spirit of Light,* which is a quite remarkable—indeed, daring—conflation of oil derricks with an airborne bevy of personified sparks. Opposite it, on the north, is an evocation of the other major industry of the state, in *The Spirit of Vulcan, The Genius of the Workers in Iron and Steel.*

Alternating with the lunettes are the pendentives, which bear large medallions inscribed on gold with hortatory statements about *Religion, Law, Science,* and *Art.*

[21]For his murals, see Edward V. Lucas, *Edwin Austin Abbey,* 2 vols. (New York, 1921).
[22]For her murals, see Patricia Likos, "Violet Oakley (1874–1961)," *Bulletin of the Philadelphia Museum of Art* 75 (1979):1–32.

FIG. 9. Edwin Austin
Abbey. *The Apotheosis of
William Penn* (1908–10),
House Chamber, Penn-
sylvania State Capitol,
Harrisburg. Photograph
by Steve Miller. *(Courtesy
Steve Miller Productions.)*

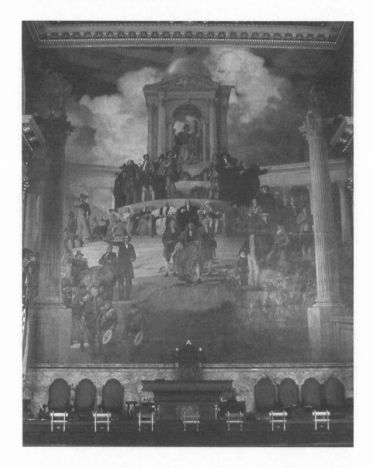

In the House Chamber, the wall behind the rostrum is dominated by a vast, stupe-
fying depiction of the great men of Pennsylvania grouped, like protesters in Trafalgar
Square, about a classical aedicule within which is enthroned a statue of the Genius
of the State—all of which in turn occupies the center of a stately peristyle. Titled *The
Apotheosis of William Penn* and containing any number of finely painted vignettes, it is,
as a whole, absurd (fig. 9). It is not helped by the two flanking panels over the doors that
depict, to the left, *Penn's Treaty with the Indians,* and, on the right, *The First Reading of
the Declaration of Independence.* All these works clash—especially with their depicted
architectural elements—with the flamboyant architectural decoration of the chamber.

Redeeming this ambitious but failed conception is Abbey's charming circular ceil-
ing painting depicting *The Hours*—twenty-four maidens who traverse the heavens,
assuming and shedding the dark cloak of night, with the sun, moon, stars, and Milky
Way forming a glittering background (fig. 10; color plate 12). Here, on his own best
scale, is a little masterpiece of academic allegorizing to which the Pennsylvania's House
can raise its eyes when weary of the awkwardly clashing pomposities and formal anom-
alies at which it must stare while about their public toil.

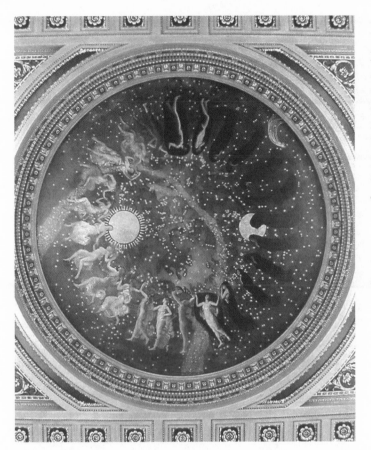

FIG. 10. Edwin Austin Abbey. *The Hours* (1908–10), House Chamber, Pennsylvania State Capitol, Harrisburg. (See also color plate 12.) Photograph by Steve Miller. *(Courtesy Steve Miller Productions.)*

In Abbey's rotunda it is the ensemble of murals, decorative sculpture, and architecture that works as a unit; most of the pictorial efforts fail upon close inspection. Abbey's skills are best suited to smaller, more intimate work—as in his *The Hours*—or the *Holy Grail* sequence in the Boston Public Library.

Violet Oakley, also a citizen of Pennsylvania, was a muralist with a better developed sense of decorum. She was first asked in 1902 to paint murals in the Governor's Reception Room in the new capitol on the theme of *The Founding of the Colony of Pennsylvania*. She did so with eighteen panels that came to depict, after extensive research, the origins of that colony. Her *The Holy Experiment—The Founding of the State of Liberty Spiritual* portrayed the history of religious liberty in England, the rise of the Society of Friends, and William Penn's relationship to these events up to his voyage to America in 1682.

The success of these murals led to a commission for others in the Senate Chamber, which was completed in 1920 (fig. 11). These are everything Abbey's in the House are not, despite her task of having to compete with a jungle of Edwardian architectural decor and light fixtures that would have eclipsed any lesser artist. Instead, she managed

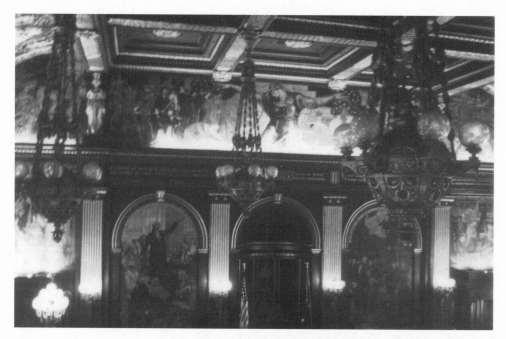

Fig. 11. Violet Oakley. *The Manifestation of Enlightenment in International Unity—Prophecy of William Penn,* with *The Constitutional Convention (below right)* and *The Gettysburg Address (below left),* all ca. 1920. Senate Chamber, Pennsylvania State Capitol, Harrisburg. *(Photograph by the author.)*

to integrate its variegated patterns—especially those upon the cove of the ceiling—into her own designs with such skill that the murals dominate the room and eclipse its clutter.

Oakley brought to her work a passionate belief in a moral and political universalism that she found humanity's best hope against war and oppression. In this, the thinking of William Penn played an important role. These are the themes that resound with the greatest visual eloquence from the wall of the Pennsylvania Senate. The top of the wall consists of a three-part frieze. Its outer, curved panels depict, on the left, *The Armies of the Earth Striving Together to Take the Kingdom of Unity by Violence,* and, on the right, *The Slaves of the Earth Driven Forward and Upward by Their Slave Drivers, Greed and Ignorance and Fear.* At the center is a long narrow rectangle that shows a huge, kneeling figure—titled *The Manifestation of Enlightenment in International Unity-Prophecy of William Penn*—rising from affliction and flanked by scenes representing, to the left, *The End of Warfare,* and, on the right, *The End of Slavery.*

If this upper frieze sets forth allegorically the two great scourges of our nation: war and slavery, the four lower panels depict the hopeful historical resolution of such conflicts of political and moral values. To the left is depicted Revolutionary War troops in the outer panel, and flanking the rostrum, the figure of George Washington dominates

The Constitutional Convention and the Creation of the True Union—Philadelphia—May—1787. On the right, Civil War soldiers march toward the panel in which Abraham Lincoln is shown giving his most famous address, *The Preservation of Unity—Gettysburg—November, 1863.*

All seven mural panels on this great wall are painted in a bold and carefully delineated style that carries the space and harmonizes triumphantly with the environment. Thus the word most conspicuously inscribed over the rostrum—"Unity"—prevails here not only as a philosophical imperative but also visually as the embodiment of the academic ideal.

From 1917 to 1927, Violet Oakley decorated the Supreme Court Room of the Pennsylvania capitol with a suite of sixteen panels on *The Opening of the Book of the Law.* By this time her style had developed toward the art deco, with strong Celtic overtones.

Wisconsin State Capitol (1906–1917)

The Wisconsin State House at Madison, designed by George B. Post and Sons between 1906 and 1917, is unique in that it has four, rather than two, wings that accommodate a supreme court chamber and a large hearing room. In respect to murals, it provides a nice comparison of the two generations of muralists mentioned earlier: those of Blashfield and Brangwyn.

Blashfield's two contributions to the Wisconsin state capitol—the *Wisconsin between Past and Present* of 1908 in the Assembly Chamber (fig. 12) and his dome depicting *The Resources of Wisconsin* of 1912 (fig. 13)—fail for these reasons. The former is simply an uninspiring row of figures set in what looks like Siegfried's forest, whose only saving grace is not a warbling forest bird, but a curious badger, the state's mascot (whose snout heraldically adorns the rotunda's marble keystones), emerging from the bushes to the lower right.

The dome, an impressive work in itself, is so far above the viewer as to be virtually invisible. Instead, what the viewer does encounter in the rotunda of this vast building is Kenyon Cox's circular designs for the pendentives, showing his usual hieratic allegories snug in their enclosing frames, stubbornly ignoring the expanding space about them (fig. 14).[23] Of all the surfaces the Beaux Arts architect provides the muralist, the pendentive—a curved triangle usually forming a transition between square and circle—requires dynamic, not closed, forms. Similarly, Cox's relentlessly symmetrical *The Marriage of the Atlantic and Pacific,* celebrating the opening of the Panama Canal in the Senate Chamber, is a static bore and iconographic puzzle.

[23] For his murals, see H. Wayne Morgan, *Kenyon Cox (1856–1919): A Life in American Art* (Kent, Ohio, 1994).

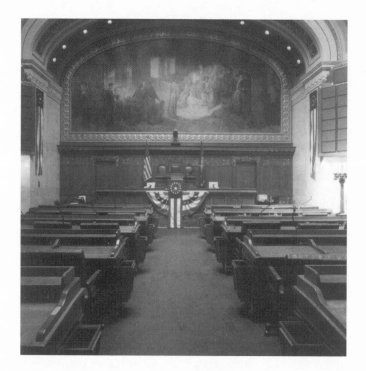

FIG. 12. Edwin Howland Blashfield. *Wisconsin between Past and Present* (1908). Assembly Chamber, Wisconsin State Capitol, Madison. Photograph by Eric Oxendorf. *(Courtesy Eric Oxendorf.)*

FIG. 13. Edwin Howland Blashfield. *Resources of Wisconsin* (1912). Dome of rotunda, Wisconsin State Capitol, Madison. Photograph by Eric Oxendorf. *(Courtesy Eric Oxendorf.)*

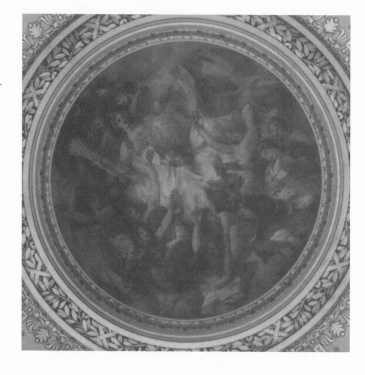

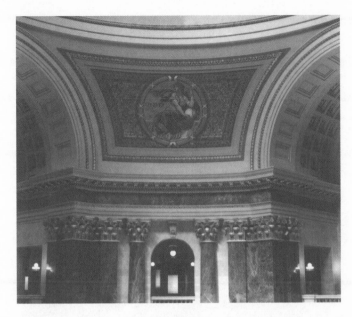

Fig. 14. Kenyon Cox.
Liberty (1912). Mural in
rotunda pendentive,
Wisconsin State Capitol,
Madison. Photograph by
Eric Oxendorf. *(Courtesy
Eric Oxendorf.)*

At first glance, the historical panels Albert Herter (1871–1950) created for the Wisconsin Supreme Court Room may seem mere illustrative history paintings when compared to the academic allegories seen elsewhere. Herter, at forty-six, was a mature member of Brangwyn's generation and far more open to mural art that avoided the allegories of Blashfield and Cox. He came to terms with the need to communicate directly to the viewer, both iconically and aesthetically.[24]

In the Wisconsin Supreme Court Chamber, Herter placed four concrete historical events, unencumbered by either allegory or abstraction (fig. 15; color plate 11). Over the bench to the east is depicted *The Signing of the Constitution,* the basis of American law. On the west wall is a scene of litigation: *The Appeal of the Legionary to Caesar Augustus.* To the north is *The Signing of the Magna Charta,* the origin of our common law, and to the south stands an episode from early Wisconsin history: *The Trial of Chief OshKosh by Judge James Duane Doty.*

Herter achieved an almost uncanny visual decorum between the architecture and his murals. They are centered high on each of the four walls of the square room, the corners of which are filled with light embrasures on their same level. Floor-to-ceiling pilasters unite the upper and lower registers of the walls—which are paneled in marbles the colors of whose veining the artist has integrated into his schemes for these carefully composed and iconically legible historical subjects. All four murals produce a

[24]There is virtually nothing published about Herter. He was a scion of the family that owned the renowned decorating firm of Herter Brothers and the father of future Secretary of State Christian Herter. As an artist he was a member of the National Society of Mural Painters and noted for his wall paintings and book illustrations. He was also one of the first artists to take up residence at East Hampton, New York, which became a famous artist colony.

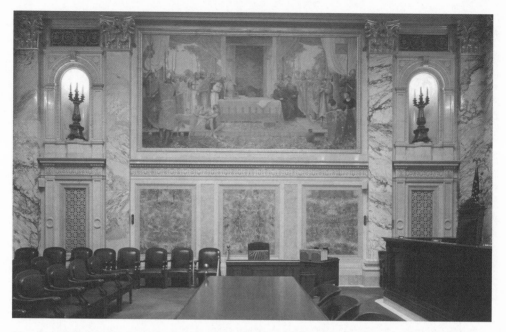

Fig. 15. Albert Herter. *The Signing of the Magna Charta* (ca. 1917). Mural in Supreme Court Chamber, Wisconsin State Capitol, Madison. (See also color plate 11.) Photograph by Eric Oxendorf. *(Courtesy Eric Oxendorf.)*

visual ensemble that is perhaps the most successful example of pure academic decorum in the country. For Herter understood that the architecture is not so much a frame for a mural as its artistic accompaniment. Blashfield, on the other hand, while not opposed to such a view, could not help but find the architecture more a proscenium for his private operas.

Missouri State Capitol (1913–1918)

Of all the state capitols in the country, that of Missouri at Jefferson City is perhaps the most impressive in the quality and quantity of its murals. Designed by Tracy and Swartout, with an iconographic program by Prof. John Pickard—it was completed and decorated between 1913 and 1918.[25] One of the last of the Beaux Arts buildings, it

[25]John Pickard was the *arbiter elegantiae* of Missouri from the 1890s to the 1930s. Educated at Dartmouth during the 1880s, he took his Ph.D. at Munich in 1892 and became professor of the history of art at the University of Missouri the same year. He was president of the Capitol Decoration Commission from 1917 to 1928. His fellow commission members included William Keeney Bixby, a distinguished businessman, bibliophile, and art lover who was the president of both the City Art Museum of St. Louis and Washington University, and Arthur A. Kocian, a St. Louis art dealer. Pickard's detailed, illustrated report of 1928 is the source of much of the following information. I am also indebted to Jeffrey L. Ball of the Museum of Art and Archaeology, University of Missouri-Columbia, for helping to arrange my second visit to the capitol in Jefferson City and for his generosity in sharing research materials he prepared for the exhibition *Missouri Murals: Studies for the State Capitol Decora-*

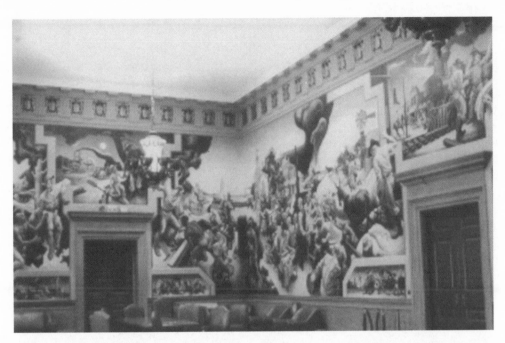

Fɪɢ. 16. Thomas Hart Benton. View of murals in House lounge depicting *A Social History of the State of Missouri* (1936). Missouri State Capitol, Jefferson City. *(Photograph by the author.)*

contains more than seventy-five murals—including two of the country's greatest mural environments, Sir Frank Brangwyn's rotunda (1919–25) (see fig. 5) and Thomas Hart Benton's cycle for the House lounge mentioned earlier (fig. 16).

With the exception of the later Bentons, all this is the achievement of the remarkable chairman of the capitol's Decoration Commission, Prof. John Pickard, who supervised every detail of the vast building's embellishments. He was not afraid to go outside Missouri for whatever talent he found lacking at home. And so he ventured as far afield as England for the major academic artist he considered the most compatible with the populist sentiments of his state, or to Taos, New Mexico, for a notable group of painters capable of rendering the "American scene."[26]

tion, which traveled in his state during 1989–90. This show consisted mainly of the mural studies Pickard solicited for his university's museum from the artists who worked in the capitol. A catalog of this exhibition, *Missouri State Capitol Murals: 1917–1928,* has been published by the Missouri State Museum in 1989.

[26]Another reason so many murals in state capitols are mediocre as art was (and still is in certain states) the tendency of legislatures to favor local artists. This was generally successful in a state like Pennsylvania but failed in the midwestern states, which lacked well-established art schools and the motivating influence of strong cultural institutions. Blashfield was often thwarted in his ambitions to paint murals in the western states because of local chauvinism. He railed against the notion that home-grown art seemed better than the imported variety to the culturally illiterate politicians of "Cloudland," whose inexperienced and superficially trained native son "John Smith" all too frequently obtained local commissions beyond his competence (see Edwin Howland Blashfield, *Mural Painting in America: The Scammon Lectures* [New York, 1913], pp. 82–84). Thus the animosity of the Know-Nothings and their descendants toward the Italian Brumidi and his atelier of foreigners at the U.S. Capitol was perpetuated even against outlanders from New York and Boston well into the twentieth century when they proposed to paint murals for the state capitols of our heartland.

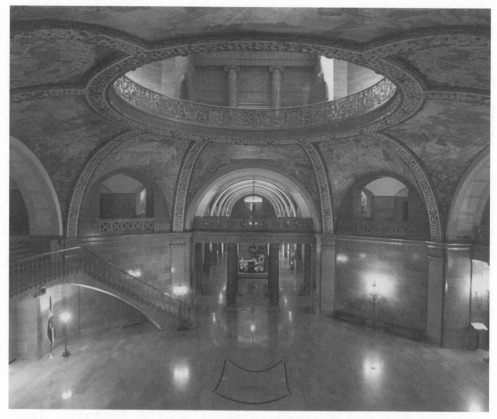

FIG. 17. Sir Frank Brangwyn. Murals in lower rotunda (1919–25). Missouri State Capitol, Jefferson City. Photograph by Lloyd Grotjan. *(Courtesy Full Spectrum Photo.)*

The lower rotunda (fig. 17) is richly painted in Brangwyn's most seductive Art Nouveau style, with binary rather than primary colors predominating. Its eight segments alternate in depicting the Four Elements in the lateral spaces—you can see Air represented by a flying parrot, and Earth by laborers and potters—and in the vertical spaces, Education (as here), the Arts, Husbandry and Science.

In the upper rotunda (see fig. 5), the pendentives depict scenes of the state's settlement: pioneers engaged in homemaking and building up the cities. The dome contains allegories of Agriculture, Education, Science, and Commerce (fig. 18).

Brangwyn's assistant, Alan True, created the murals in the pendentives of the semidomes—using a single model, his boss—to stand for all the major historical figures he depicts.

Extending from the lower rotunda on the first and second floors were originally a Soldiers and Sailors Museum and a Resources Museum, dedicated to the state's military

and natural history, and the sixteen large lunettes, each sixteen by eight feet, in their second-floor galleries, were consequently divided between battle scenes and landscapes by the Taos artists.

As might be expected, the battle scenes provide the greater visual interest. Fine examples of their kind include Oscar E. Berninghous's *The Attack on St. Louis in 1780;* Fred C. Carpenter's *Battle of Sacramento, 1847,* and *The Entry into Havana, 1898;* and N. C. Wyeth's *Battle of Westport, 1864.* Standing out among the landscapes is Frank B. Nuderscher's *The Artery of Trade*—a fine portrait of the Eads Bridge across the Mississippi at St. Louis (which Brangwyn shows under construction in his *Builders* pendentive).

The whole tendency of this era was away from the tradition-bound sensibility of the academic classic spirits and toward a greater openness and clarity of iconic discourse. Note that Brangwyn places allegorical personifications only at the highest point of his mural program—the dome—leaving the rest of his themes to be represented by ordinary people engaged in everyday labors. The realistic sensibility of Eakins and the artists of the Ash Can school was not their sole invention; it was the tentative tenor of the times. In consequence, the academic mural would soon fade into art deco variations and vanish before the populist tidal wave of the New Deal.

FIG. 19. Augustus Vincent
Tack. Murals in dome and
lunettes of governor's office
(circa 1922). Nebraska State
Capitol, Lincoln. *(Courtesy
Nebraska State Archives, Sid Spelts
Collection.)*

Similarly, the ceremonial architecture that framed the old tradition gave way to
new visions. Indeed, one of the symbols of this transition could be the vanishing cen-
trality of the rotunda—as can be seen at the last two of our state capitols—with which
I shall conclude.

THE NEBRASKA STATE capitol at Lincoln was designed by Bertram Goodhue, with an
iconographic program by Prof. Hartley B. Alexander.[27] It was erected and decorated
between 1922 and 1932.

Augustus Vincent Tack created an elegant ceiling in the domed office of the gover-

[27]Hartley Burr Alexander (1873–1939), like John Pickard, developed the iconographic program of the
Nebraska State Capitol. See Margaret Dale Masters, *Hartley Burr Alexander, Writer-in-Stone* ([Lincoln, Neb.?],
1992), for basic information, and Frederick C. Luebke, The Nebraska State Capitol (Lincoln, Neb., 1990).
Alexander's interest in the State of Nebraska seems to have first found iconic expression in his *The Pageant of
Lincoln,* presented in 1915 by the Lincoln Commercial Club and the Alumni Association of the University of
Nebraska, Lincoln, Nebraska, June 4–5, and published by the State Printing Company. This was repeated in
The Pageant of Lincoln, MCMXVII, "Nebraska," a masque presented at the Coliseum on the state fairgrounds at
Lincoln, Nebraska, June 12–14, 1917, under the same auspices. Pageants are foreign to us today but provided
opportunities for our pre-media culture to act out an understanding of historical roots and civic values, and they
had an influence on a number of earlier academic murals. See Trudy Baltz, "Pageantry and Mural Painting:
Community Rituals in Allegorical Form," *Winterthur Portfolio* 5 (1980):211–28, who discusses Blashfield's 1905
mural *Westward* in the Iowa state capitol in this context.

FIG. 20. Hildreth Meière. Terrazzo floor at crossing of nave depicting allegories of the *Earth Mother* surrounded by *Earth, Air, Fire,* and *Water* (ca. 1930). Nebraska State Capitol, Lincoln. *(Courtesy Nebraska State Archives, Sid Spelts Collection.)*

nor (fig. 19), as well as a contiguous reception room. Hildreth Meière is responsible for the ceramic tile decorations of the narthex dome and arches of the great nave (fig. 20). She also designed the elegant inlaid floor after that at Orvieto Cathedral in Italy.

When this state capitol was planned, spaces were left on the walls of its upper balconies for murals to be painted fifty years later. These were duly executed in modernist styles that unfortunately clash with the original decorations and show little interest in the decorum that was at the heart of the old idea of a mural.

OUR LAST STATE capitol—that of Honolulu, Hawaii, was designed and erected between 1965 and 1969 by Belt, Lemmon, and Lo with John Carl Warnecke. The sloping walls of the legislative chambers were decorated with two huge tapestries, each thirty-nine by thirty-two feet, designed by Ruthadell Anderson using native Hawaiian motifs (fig. 21; color plate 14).

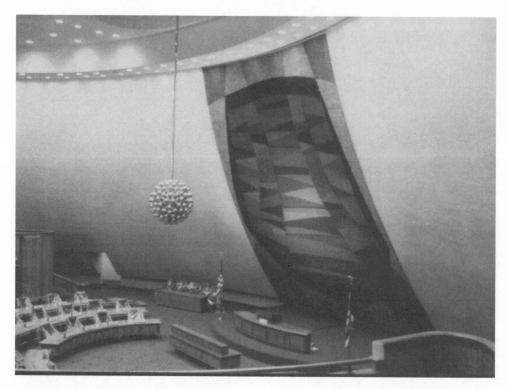

Fig. 21. Ruthadell Anderson. Tapestry mural in House Chamber (1971). Hawaii State Capitol, Honolulu. (See also color plate 14.) *(Courtesy Ruthadell Anderson.)*

These sloping walls are the last vestiges of a state capitol rotunda—being in the general shape of a volcano vent—the perhaps unintended expression at that time of New Age attitudes toward political hyperventilation. But then, volcanoes are an old symbol of political revolution and nature's—and art's—capacity for unceasing change.

Contributors

William C. Allen has been the architectural historian in the Office of Architect of the Capitol since 1982. He previously served as chief architectural historian for the state of Mississippi. His recent publication, *History of the United States Capitol: A Chronicle of Design, Construction, and Politics* (2001), is the most comprehensive architectural history of the Capitol.

Vivien Green Fryd teaches American art, nineteenth-century European art, methods, contemporary art, and American Studies at Vanderbilt University. She is the author of *Edward Hopper and Georgia O'Keeffe: Art and the Crisis of Marriage* (2003) and *Art and Empire: The Politics of Ethnicity in the U.S. Capitol, 1815–1860* (1992), as well as numerous journal articles. Her current research is on sexual violence and rape in American art and culture.

Irma B. Jaffe, professor emerita of art history at Fordham University, is the author of *John Trumbull: Patriot-Artist of the American Revolution* (1975) and *Trumbull: The Declaration of Independence* (1976). Her most recent work, coauthored with Gernando Colombardo, is *Shining Eyes, Cruel Fortune: The Lives and Loves of Italian Renaissance Women Poets* (2002).

Teresa B. Lachin is a cultural historian who specializes in material culture and American commemorative art. She teaches American Studies and interdisciplinary humanities courses at universities in the Washington, D.C.–Baltimore, Maryland area. Her research on National Statuary Hall was supported by a fellowship from the U.S. Capitol Historical Society. Dr. Lachin is currently working on a history of Adelaide Johnson's 1921 "Portrait Monument" and works by other women artists in the Capitol arts collection.

Francis V. O'Connor is an independent art historian and scholar in New York City. He is the author of *Jackson Pollock* (1967) and coeditor of a catalogue raisonné of paintings, drawings, and other works by Pollock. Dr. O'Connor is completing *The Mural in America: A History of Wall Painting from Native American Times to Postmodernism.*

Eric Oxendorf is an architectural photographer in Milwaukee, Wisconsin, who collaborated with historian William Seale in the production of *Domes of America* (1994), based on Oxendorf's photographs. He worked with Ansel Adams in the 1970s and has his work in the National Archives, the Smithsonian Institution, and several corporate and private collections.

PAMELA POTTER-HENNESSEY is an assistant professor of art history at Ursinus College. A former Smithsonian Fellow, she has published several articles about the interchange between America and Europe in the nineteenth century. She curated the recent exhibit "Albert Jean Adolphé, an Artist's Journey" at the Berman Museum and is currently writing a book about the origins of American political icons.

KIRK SAVAGE teaches in the Department of History of Art and Architecture at the University of Pittsburgh. He is the author of *Standing Soldiers, Kneeling Slaves: Race, War, and Monument in Nineteenth-Century America* (1997), which won the 1998 John Hope Franklin Prize for best book in American studies. He has published extensively on public monuments in the United States, including essays on the Shaw Memorial, the Freedmen's Memorial to Abraham Lincoln, the Washington Monument, and the Vietnam Veterans Memorial.

THOMAS P. SOMMA is a historian of American art and the director of the Mary Washington College Galleries at Mary Washington College in Fredericksburg, Virginia. He has published and lectured extensively on American sculpture and public art, and his *The Apotheosis of Democracy, 1908–1916: The Pediment for the House Wing of the United States Capitol* (1995) won the University of Delaware Press Award for best manuscript in American art.

BARBARA A. WOLANIN is the curator for the Office of Architect of the Capitol. She previously taught art history at James Madison University and Trinity College in Washington, D.C. She has published a number of exhibition catalogs, articles, and reviews in the field of American art and is the primary author of *Constantino Brumidi: Artist of the Capitol* (1998).

Index

Italic page numbers refer to illustrations.